K8/10 2995

A CONCISE HISTORY OF CANADIAN PAINTING

Second Edition

A CONCISE HISTORY OF CANADIAN PAINTING

Second Edition

Dennis Reid

Toronto OXFORD UNIVERSITY PRESS 1988 Oxford University Press, 70 Wynford Drive, Don Mills, Ontario, M3C 1J9

Toronto Oxford New York Delhi Bombay Calcutta Madras Karachi Petaling Jaya Singapore Hong Kong Tokyo Nairobi Dar es Salaam Cape Town Melbourne Auckland

> and associated companies in Berlin Ibadan

Canadian Cataloguing in Publication Data

Reid, Dennis A concise history of Canadian painting 2nd ed. Includes bibliographical references and index.

ISBN 0-19-540664-8 (bound) ISBN 0-19-540663-X (pbk.) 1. Painting, Canadian—History. I. Title. ND240.R44 1988 759.11 C88-094623-7

Copyright © Oxford University Press Canada 1988 OXFORD is a trademark of Oxford University Press 1 2 3 4 5 - 2 1 0 9 8 Printed in Canada

Contents

	Colour Plates	vi
	Abbreviations	viii
	Preface to the First Edition	ix
	Preface to the Second Edition	xi
Ι.	Painting in New France 1665–1760	I
2.	Painting in British North America 1760–1860	18
3.	French-speaking Artists in Montreal 1785–1830 and	
	Quebec 1820–1860	38
4.	Paul Kane and Cornelius Krieghoff 1845–1865	50
5.	English Immigrant Artists in Canada West 1850–1870	67
6.	Landscape Painters in Montreal and Toronto 1860–1890	78
7.	The 'French' Period in Canadian Art 1880–1915	91
8.	Homer Watson and Ozias Leduc 1880–1930	106
9.	The Canadian Art Club 1907–1915	119
10.	Tom Thomson and the Group of Seven 1913–1931	138
11.	Emily Carr, LeMoine FitzGerald, and David Milne 1912–1950	156
12.	The Canadian Group of Painters	177
13.	John Lyman and the Contemporary Art Society 1939–1948	202
14.	Paul-Émile Borduas and Les Automatistes 1946–1960	226
15.	Painters Eleven 1953–1960	247
16.	A Continuing Tradition 1955–1965	273
17.	The Death and Rebirth of Painting 1965–1980	315
	Acknowlegements	399
	Index	401

Colour Plates

OPPOSIT PAC	
I—Anonymous. La France apportant la foi aux Hurons de la Nouvelle-France, c. 1670. Monastère des Ursulines, Québec.	4
II—Thomas Davies. The Falls of Ste Anne, 1790. NGC.	5
III—Robert Todd. The Ice Cone, Montmorency Falls, c. 1845. NGC.	36
IV—John O'Brien. <i>Halifax Harbour Sunset, c.</i> 1853. Halifax Board of Trade.	36
v—William Berczy. The Woolsey Family, 1809. NGC.	37
BETWEEN PAGES 44 AND 45	
VI—Joseph Légaré. L'Incendie du quartier Saint-Jean à Québec, vue vers l'ouest, 1845. AGO	
VII—Antoine Plamondon. Soeur Saint-Alphonse, 1841. NGC.	
VIII—Paul Kane. The Man That Always Rides, 1849–55. ROM.	
IX—Cornelius Krieghoff. Owl's Head, Lake Memphremagog, 1859. NGC.	
BETWEEN PAGES 76 AND 77	
x—W.G.R. Hind. The Game of Bones, 1861. MMFA.	
XI—Daniel Fowler. Fallen Birch, 1886. NGC.	
XII—Lucius O'Brien. A British Columbian Forest, 1888. NGC.	
XIII—John Fraser. Mount Baker from Stave River, at the Confluence with the Fraser on Line of CPR, 1886. Glenbow Museum, Calgary.	

BETWEEN PAGES 108 AND 109

- XIV-Robert Harris. Harmony, 1886. NGC.
- xv—Paul Peel. A Venetian Bather, 1889. NGC.
- XVI—Homer Watson. *Before the Storm*, 1887. Art Gallery of Windsor, Ont.
- XVII—Ozias Leduc. L'Enfant au pain, 1892–9. NGC.

BETWEEN PAGES 140 AND 141

- XVIII—Horatio Walker. Ploughing—The First Gleam at Dawn, 1900. MQ.
 - XIX—James Wilson Morrice. Return from School, c. 1901. AGO.
 - xx—A.Y. Jackson. Frozen Lake, Early Spring, Algonquin Park, 1914. NGC.
 - XXI—Tom Thomson. Autumn Foliage, 1916. NGC.

BETWEEN PAGES 172 AND 173

- XXII—Emily Carr. Forest Landscape II, c. 1938. NGC.
- XXIII—David Milne. White Poppy, 1946. NGC.
- XXIV—David Milne. Ollie Matson's House in Snow, c. 1932. NGC.
- xxv—Carl Schaefer. Ontario Farmhouse, 1934. NGC.
- XXVI-Lawren S. Harris. Composition No. 1, 1941. VAG.
- XXVII—Fred Varley. The Cloud, Red Mountain, 1927–8. AGO.

OPPOSITE PAGE

XXVIII—John Lyman. Woman With a White Collar, c. 1936. NGC.	204
XXIX—Paul-Émile Borduas. <i>Composition</i> , 1942. Maurice Corbeil, Montreal.	205
xxx—Paul-Émile Borduas. <i>Fence and Defence,</i> 1958. Martha Jackson Gallery New York.	236
xxxI—William Ronald. <i>Gypsy</i> , 1959. Dr and Mrs Sydney Wax, Toror	nto. 237
XXXII—Jack Bush. The White Cross, 1960. AEAC.	268
XXXIII—Guido Molinari. Mutation rhythmique No. 9. NGC.	269
xxxiv—Michael Snow. <i>Beach-hcaeb</i> , 1963. University of Western Onta London, Alumni Collection	rio, 300
XXXV—Greg Curnoe. Camouflaged Piano or French Roundels, 1966. NGG	C. 301
XXXVI—Gershon Iskowitz. Uplands H, 1972. AGO.	301

Abbreviations

- AAM Art Association of Montreal; became the MMFA 1939
- ACA Alberta College of Art of Calgary
- AEAC Agnes Etherington Art Centre, Queen's University, Kingston
- AGH Art Gallery of Hamilton
- AGO Art Gallery of Ontario, Toronto
- AGT Art Gallery of Toronto; became the AGO 1965
- AGW Art Gallery of Windsor
- BAG Beaverbrook Art Gallery, Fredericton, N.B.
- CAS The Contemporary Arts Society, Montreal
- CGP The Canadian Group of Painters
- EAG Edmonton Art Gallery
- HH Hart House, University of Toronto
- MAG Mendel Art Gallery, Saskatoon
- MCC The McCord Museum, McGill University, Montreal
- MCM The McMichael Canadian Collection, Kleinburg, Ont.
- MAC Musée d'art contemporain, Montréal
- MMFA Montreal Museum of Fine Arts
- MQ Musée du Québec, Québec
- NAC National Archives of Canada, Ottawa
- NGC National Gallery of Canada, Ottawa
- NMAG Norman Mackenzie Art Gallery, University of Saskatchewan, Regina
- NSCAD Nova Scotia College of Art and Design, Halifax
- OCA Ontario College of Art, Toronto
- OSA Ontario Society of Arts
- RCA Royal Canadian Academy of Arts
- RMCL Robert McLaughlin Gallery, Oshawa
- ROM Royal Ontario Museum, Toronto
- VAG Vancouver Art Gallery
- VSA Vancouver School of Art
- WAG Winnipeg Art Gallery

Preface to the First Edition

This guide to looking at the work of Canadian painters was written in the belief that of all the arts in Canada, painting is the one that most directly presents the Canadian experience. Painters in Canada have consistently reflected the moulding sensibility of the age: a history of their activities inevitably describes the essence of our cultural evolution. And painting is probably the only one of our cultural activities of which the productions of the 'two nations' can be examined virtually as a whole. There are notable, perhaps even historically essential, interactions between English- and French-speaking painters. Hamel, Borduas, and Molinari, for example, are significant figures in any study of the painting of their English-speaking compatriots, of whom Brymner, Morrice, and Lyman (to choose only three names) are important to an understanding of French-Canadian art.

The recorded history of Canadian painting reflects the major developments in Europe, and more recently the United States, which have largely defined the art as it is now recognized internationally. However, painting in Canada is still 'Canadian', and its history demonstrates an internal continuity from the seventeenth century to the present day.

We still know very little about the activities of even our earliest painters, and the first few chapters of this book reflect that lack of knowledge. After Confederation, however, details begin to accumulate and the story of an inspiring series of co-operations unfolds. Artists' societies, of which there has been a proliferation, and even more conspiratorial—if less formal—associations have been found necessary by our artists to project their vision onto the public consciousness. The remarkable dialectic perpetuated by successive generations—each championing a position opposite to that of its predecessor on the question of whether Canadian painters should seek their measure against an international (i.e., mid-Atlantic) standard or in purely indigenous values—gives the history of x | Preface to the First Edition

our paintings its unique shape. As a historian I have attempted to present the two views objectively in the firm belief that all our best painters have managed to find common ground in their genuine desire to confront the Canadian sensibility through the medium of their art.

I think of this book as a 'guide' because it is both a narrative history and a handbook. The first few chapters are derived from the work of J. Russell Harper, although I have attempted to impose an order on material that in his monumental *Painting in Canada: A History* (University of Toronto Press, 1966), because of its inclusiveness, had to be slightly diffuse. From Chapter 6 on I have relied principally on my own research. Those who are familiar with the literature, however, will frequently recognize my espousal of interpretations first presented by others. I have often discussed paintings that are not reproduced, wishing to encourage the reader to seek them out either in the collections that house them (the NGC, AGO, MCM, HH, AEAC have all published amply illustrated catalogues of their Canadian collections) or in other books on Canadian art.

Because of space limitations arising from the desire to keep the price down, a bibliography could not be included. *Canadian Art Today* (1970) edited by William Townsend for Studio International of London includes a good general bibliography. William Withrow's *Contemporary Canadian Painting* (McClelland and Stewart, Toronto, 1972) contains reading-lists on some modern painters. My own *Bibliography of the Group of Seven* (The National Gallery of Canada, 1971) is another reference. *Early Painters and Engravers in Canada* (University of Toronto Press, 1970) by J. Russell Harper, a biographical dictionary including all Canadian painters born before 1867, has a thorough bibliography. That volume and his *Painting in Canada* are the two firm legs upon which Canadian art history now stands. I offer this work of mine as a small acknowlegement of the respect I feel for Mr Harper.

Ottawa, 1973

NOTE: An asterisk preceding a picture title indicates a black-and-white illustration; a dagger indicates a colour reproduction.

The steady support this book has enjoyed during the fifteen years since it was first published-there are 38,000 copies in print-has encouraged me to prepare this revised and enlarged edition. In it readers familiar with the earlier version will find numerous changes, additions, some reinterpretations, and a few new names. (Unfortunately, owing to inequitable reproduction fees the work of Harold Town has not been illustrated.) The revisions and additions reflect the remarkable growth since 1973 in the study of the history of Canadian art. All the major universities now offer degree programs in art history, and many encourage Canadian studies. Most of the serious publishing in the field, however-with a few notable exceptions-has come from public galleries or museums, usually as exhibition catalogues. Two scholarly journals were inaugurated in 1974, RACAR (Revue d'art canadienne/Canadian Art Review), which, while covering the whole art historical field, has encouraged submissions on Canadian subjects, and The Journal of Canadian Art History/Annales d'histoire de l'art canadien, devoted entirely to Canadian studies. Because no extensive general bibliography of Canadian art has as yet appeared, the serious investigator should seek out the card catalogue (or its 'on-line' equivalent) in a good art-history library, remembering that many important monographic studies will be exhibition catalogues, and that they in turn usually contain extensive bibliographies on their particular subjects.

This Second Edition also contains a long additional chapter devoted to painting of the period 1965–80. It is presented as both a narrative history and a ready reference, consistent with the rest of the book. Although the work of certain key figures has been described at some length and in relation to important events in their artistic lives, many other painters have been situated within what must be considered to be a still-emerging pattern of activity. It has not been possible to discuss all the noteworthy painters of the period, but I have attempted to represent the various xii | Preface to the Second Edition

approaches and concerns in a balanced way. There has been a phenomenal increase in the number of artists working in Canada during the period, and many have been attracted to media other than painting—not only to sculpture and print-making, but also to such new forms as video, installation, and performance. Consequently I am more conscious than ever that in discussing painting alone, I am treating only one aspect of the visual culture of the day. There is no question, however, that painting has continued to develop in many fascinating ways, and that is reason enough for preparing this new edition.

Toronto, August 1988

Painting in New France 1665–1760

There is some evidence that Samuel de Champlain, the 'Father of New France', was an artist, but not enough to allow us to describe him as the father of its painting too. Not a single work from his hand has survived. His engravings illustrating his famous volumes of *Voyages* . . . and some copies, now in Bologna and Providence, R.I., of what might have been original drawings or watercolours of the West Indies are historically fascinating but hardly provide the basis for aesthetic judgement. Paintings by Champlain that decorated the church of Notre-Dame-de-la-Recouvrance in Québec until their destruction by fire in 1640 were described by a near-contemporary as merely 'quelques pauvres images du travail'.

Champlain died in 1635 and for the next three decades New France remained little more than an exploitable resource; its leading town, Québec, was a fur-trade depot. It was only in 1663, when a decision was made to invest in New France the institutions of a province—governor, intendant, and sovereign council—that French civilization really began to take root. In that year Bishop Laval founded the Grand Séminaire* and the first artist left France to settle in Québec. For the rest of the decade, as Louis XIV poured nearly a quarter of a million *livres* a year into the colony, immigration was encouraged and, under the industrious and far-sighted Intendant Jean Talon, New France was transformed. Religion was at its centre, as it had been for the previous thirty years. The Jesuit martyrdoms that had taken place in Huronia in 1648–9 still represented to Frenchmen the noblest ideal of European engagement in the new world, and the intense Counter-Reformation missionary zeal that had so marked the earliest decades of French involvement in America contin-

*The second-oldest institution of higher learning in North America, it became Université Laval in 1852.

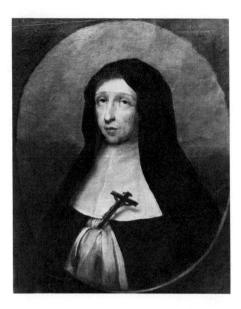

Attributed to L'Abbé Hugues Pommier. La Mère Marie-Catherine de Saint-Augustin, 1668, with later additions. Canvas, 71.4 × 58.6. Hôtel-Dieu, Québec.

ued. Our first artist—in fact every artist who was to work here in the seventeenth century—was a cleric.

ABBÉ HUGUES POMMIER (1637-86), who was born southwest of Paris in the region of Vendôme, arrived in Québec in September 1664 to teach in the Séminaire, a position he held for five years. Although we know nothing of his training, he was apparently called upon from time to time to exercise the skills of a painter. The great pioneer scholar of the art of New France, Gérard Morisset, has attributed to him an oil copy of a 1664 engraving of Le Martyre des Pères Jésuites chez les Hurons (Hôtel-Dieu, Quebec City), but there is no supporting evidence and no reason to believe the work was even painted in the colony. A strangely languorous portrait, *La Mère Marie-Catherine de Saint-Augustin (Hôtel-Dieu, Quebec City), can perhaps be attributed to the abbé with more authority. The Hôtel-Dieu arranged to have a portrait-of-record painted of the dearly loved nun, in the first hours after her death in May 1668. As far as we know, Pommier was then the only painter in the city. Unfortunately the portrait was heavily over-painted early in this century by a nun of the hospital who wanted to give the venerable mother an 'air plus jeune et souriant'. The only other work that can be attributed to Pommier also now exists in a form that is removed from the original. It is a portrait of one of the most famous women of New France-a nun (and an absorbing letter-writer) who alternated as Superior of the Ursuline Convent in

Québec from 1639 until her death in 1672. *La Mère Marie de l'Incarnation* (Monastère des Ursulines, Québec) was painted shortly after she died. Pommier seems again to have been the only possible author (he had been sent out to the missions in 1670, although he frequently returned to Québec) but what we have now appears to be a copy sent to France some time before the original was destroyed by fire in 1686. Pommier returned to France in 1678. Although there exists no real evidence of his ability as an artist, an early commentator remarked that in Québec no one appreciated his paintings, and that 'il espéra qu'en France son talent seroit mieux connu'. We have no information that it was. This uncertainty about Pommier's activities unfortunately extends to our knowledge of the art of the whole period of New France.

In the Monastère des Ursulines at Québec there is a canvas grandly titled *†La France apportant la foi aux Hurons de la Nouvelle-France* that is a mysterious and beautiful symbol of the place of art in seventeenth-century New France, and indeed in the whole of the French colonial period. It also reflects our general ignorance concerning those other ancient pieces of painted canvas, adrift from their sources and enshrouded in centuries of legend, among which we have chosen to place it. Of the few paintings we believe were part of the culture of seventeenth- and eighteenth-century Canada that have survived the many destructive fires, only a small number were certainly painted here. And most of these relics are in such poor condition that they seldom give evidence of their original appearance. La France apportant la foi is at least in sound condition. In it a humble native on the banks of the St Lawrence River, his naked body cloaked with the lilies of France, kneels in respectful awe before a regal female, the figure of France. She in turn instructs him in the Christian faith, and to assist this task she displays a painting that depicts the Trinity surrounded by the Holy Family. As if to stress that the painting is but an image of the holy realm, she points to the heavens where we can see, seated in comfortable glory, the Holy Family itself. To the left of the Indian, among the trees, are two rude chapels, and to the right of the figure of France lies the sturdy ship that brought her across the ocean to New France. We do not know the painting's author, nor are we sure of when or where it was painted, or for what specific purpose it was made. It usually has been attributed to Frère Luc, the only artist to work in New France who is securely connected to the mainstream of French painting. The figure of France is a likeness of Anne of Austria, wife of Louis XIII and mother of Louis XIV, who exercised the prerogatives of the Crown in her son's place from 1643 to 1661—precisely the time when the zealous missionary efforts the painting symbolically represents were in

fullest force. The arms on the stern of the ship are those of Guillaume de Bruc of Nantes in Brittany, one of the founders of the Compagnie de Morbihan, established in 1629 to trade into New France. He died in 1653.

Surviving records document the desire of the Huron of Québec in 1666 to commission a painting for the Jesuit church in order to commemorate their conversion to Christianity, a process that had begun with the Jesuit Jean de Brébeuf's first trip to Huronia in 1629, the year that de Bruc's ships first began to arrive at Québec with goods to trade for furs. That the merchant's apparently incidental role would be given such prominence might suggest, it has been noted, that the picture was painted in Nantes. La France apportant la foi . . . is in style typical of French provincial work of the second half of the seventeenth century-a somewhat naïve and extremely restrained variation on the grand symbolic masterpieces of Rubens or Poussin. It has been argued recently that all of this evidence together points to its being the painting commissioned by the Huron after 1666. A large picture for early Canada—over two metres square—it has been a valued possession of the Ursulines in Québec since before 1817 (when it was described in a travel guide), presumably moved there from the Jesuit church when that building was destroyed in 1807 following the extinction of the order in Canada. It represents simply and directly the noblest intentions of the first Europeans in settling the St Lawrence valley, and as directly proclaims the central role that French culture, and particularly painting, would play in the realization of those intentions.

Painting in Canada was directed to Indians in these early years as much as to whites. As La France apportant la foi . . . shows us, the communicating value of pictures was well recognized. Of the numerous priests who took prints to the Indian missions, or who drew or painted, three Jesuits in particular have been remembered. The most accomplished was probably PÈRE JEAN PIERRON (1631-1700). Born at Dun-sur-Meuse in Lorraine, he was a painter before entering the Jesuit order in 1650 and continued to practise his art until his departure for Québec in April 1667. Three weeks after arriving he was in the Iroquois missions, in what is now upstate New York, where he remained-except for a trip to Québec in 1668 and brief postings to the Beaupré coast-until 1674. He passed that winter in Acadia, and the next year he travelled in disguise through the Protestant territories of New England, Maryland, and Virginia. After three more years with the Iroquois he returned to France where he died, at Pont-à-Mousson, in February 1700. He was a successful missionary, according to Marie de l'Incarnation, because the Iroquois were impressed with his paintings. None have survived, but she has left quite a detailed description of two. One, an 'Enfer', showed demons so horrible that 'on ne peut

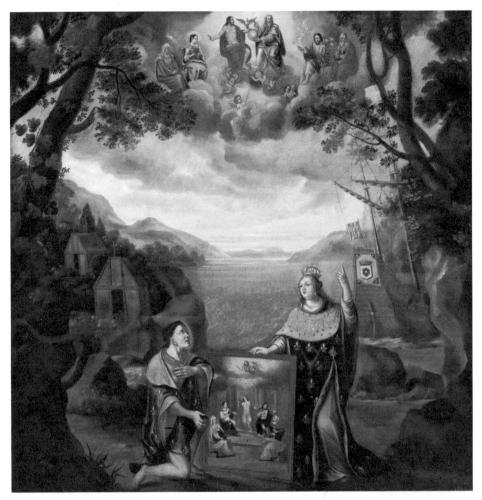

I—Anonymous. La France apportant la foi aux Hurons de la Nouvelle-France, c.1670. Canvas 227.3×227.3 . Monastère des Ursulines, Québec.

II—Thomas Davies. The Falls of Ste Anne, 1790. Watercolour, 51.5 × 34.2. NGC.

les voir sans frémir'. A 'Paradis' showed angels bearing 'les âmes de ceux qui meurent aprés avoir reçu le saint Baptême.' Furthermore, Pierron was so talented that 'il fait ce qu'il veut au moyen de ses peintures'.

PÈRE LOUIS NICOLAS (1634–c.1701) was born in Aubenas in the Ardèche and joined the Jesuits at Toulouse in 1654. Exactly ten years later he landed in Québec, and three years after that (the same year as Pierron) he was sent to the missions. He worked first in the wilderness behind Trois-Rivières, then from a post on the southwestern shore of Lake Superior, and finally, in 1670, he spent a year in the Mohawk Valley with Jean Pierron. He was back in Québec the following year and in 1672 was named curé at nearby Sillery; the following year he was sent to open a mission at Sept-Îles on the Gulf of St Lawrence. Nicolas returned to France in 1675 and left the Jesuit order in 1678.

Like many Jesuits, Nicolas was an accomplished linguist and an amateur of natural science. Recent scholarship indicates that he was also the artist responsible for one of the most significant works of art to have survived from late-seventeenth-century New France, the *Codex Canadiensis* (Thomas Gilcrease Institute of American History and Art, Tulsa, Oklahoma). It is a bound collection of eighty-one watercolours and pen-andink drawings—actually illustrations for an unpublished manuscript by Nicolas, *Histoire naturelle des Indes occidentales*, now in Paris—and internal evidence suggests that it was completed just after 1701. Its contents, however, present visual material collected in the region of the lower Great Lakes and further east as early as thirty years before that date. In fact, it is entirely possible that Nicolas began, and perhaps even largely completed, the drawings in the album during 1670, the year he spent with Jean Pierron in the region of the Mohawk Valley.

Many of the sheets contain studies of the flora and fauna of the area, but perhaps more interesting to us today are the drawings of the native peoples and their utensils, boats, and habitations. *'*Cet icy un depute du bourg de gannachiouavé* . . .', which depicts in the most wonderful fashion a tattooed, pipe-smoking, snake-bearing emissary from an Iroquois village on the north shore of Lake Ontario, is typical in that it reveals a strong graphic sense and an imaginative use of texture, pattern, and line. Although evidently untrained as an artist, Nicolas produced work that is vibrantly intense in observation and presented handsomely on the page.

PÈRE CLAUDE CHAUCHETIÈRE (1645–1709) arrived in New France in 1677, just before the departure of Pierron, and spent the rest of his life there. Born in Poitiers, he had joined the Jesuits at Bordeaux in 1663. He was assigned to the Hurons at Québec upon arrival, and the following year

was posted to the Iroquois mission at Sault Saint-Louis (Caughnawaga). We know he made drawings there to illustrate holy teachings and bound them in book form so that his Iroquois charges could carry them into the field. He also accompanied his reports with drawings, some of which were engraved as illustrations for his Narration annuelle de la Mission du Sault of 1686, and ten of which survive at Bordeaux with the original manuscripts of the Narrations of 1681-6. The great event of Chauchetiere's life took place at Caughnawaga, where he was privileged to know the Mohawk convert and mystic Kateri Tekakwitha. A year after her death in 1680 she appeared to him in a vision, asking him to paint her so that her image might be distributed among the faithful. He ignored the request, so the story goes, and two years later she appeared again. This time he complied and wrote a brief biography as well. A delicate, naïve, full-length portrait now in the Caughnawaga Museum has been associated with this legend. But if Chauchetière's work underlies it, his hand has been obscured by later 'improvements'.

The importance of the missions diminished rapidly after 1663 and interest consequently focused on the growing white settlements. By 1670 Québec was clearly in need of a skilled painter who could decorate the new churches in the manner to which Frenchmen were accustomed. Unfortunately the tiny community was unable to support talent of that order for any length of time, so an accomplished artist was brought in for a period of concentrated work. FRÈRE LUC (1614–85) has since become the star round which the lesser constellations of early Canadian painting revolve. His reputation has perhaps been inflated by the fact that he is the subject of Gérard Morisset's only monographic work on a painter. However, virtually every accomplished seventeenth-century picture in the province has at one time been attributed to him, which demonstrates that his fifteen months in this country left a very great impression indeed.

Born in Amiens, Claude François (Frère Luc's secular name) showed an early interest in drawing and painting and in 1632 was placed in the studio of one of the most prominent of the court painters, Simon Vouet. After three years with Vouet François moved to Rome to continue his studies; when he returned to Paris probably in 1639, Vouet introduced him to the superintendent of the king's buildings, who placed him in the team that was completing the decoration of the Galérie du Bord de l'Eau in the Louvre. (Nicolas Poussin headed this team for eighteen months in 1640–1.) Claude François left this work in 1642, by which time he had received the title of 'king's painter'. After ten years of study, partly under two of the greatest painters of the day, it can be assumed that he would have been prepared for a distinguished career as a painter in the 'grand manner' of Classical Baroque. Instead, at the death of his mother in 1644, he forsook the life of a court painter and joined the Recollet order. It was not an unusual decision during the Counter-Reformation, when piety was expected of most educated men and women and celibacy and self-mortification were common even among the laity. We know of only one work painted prior to 1645, an *Assomption* after a painting by Bassano that was copied in Rome in 1635 (Église de Longueau, France).

François made his profession in 1645, taking the name Frère Luc, after the patron saint of painters. For the next twenty-five years he worked as a painting teacher in the Recollet establishment on the rue Saint-Martin in Paris. (His only student of note was the historian Roger de Piles.) Then, in the spring of 1670, he was one of six Recollets chosen to travel to Québec to re-establish the order and restore the monastery that had been abandoned after the capture of the city by English privateers in 1629. They landed in Québec on August 18. Frère Luc, who had some architectural experience, drew the plans for the new chapel, sketched out the retable to be constructed behind the main altar, and painted the *Assomption* that adorns it. The cornerstone was laid by the Intendant Jean Talon on June 22, 1671, and the first mass was celebrated by Bishop Laval that October. It still stands today, virtually intact, as the chapel of the Hôpital-Général. Frère Luc also designed the wing of the procurator's office of the Séminaire, which was built in 1677–8.

A number of Frère Luc's paintings were mentioned by early commentators. These include some other pictures he painted for the Recollet Chapel that were removed to another location in 1693 and there destroyed by fire a century later. A Sainte-Famille painted for Notre-Dame-de-Québec was destroyed in the English siege of 1759. An Assomption and an Adoration des Mages, painted for the Jesuits, are also lost. A record of 1691 refers to Frère Luc paintings in the churches at l'Ange-Gardien (an unsigned and undated Ange-Gardien, now in the Musée du Québec, was mentioned by Laval in 1671), Château-Richer, Beaupré, Sainte-Famille on the Île d'Orléans, and the Hôtel-Dieu in Québec. It seems an impossible production for a stay in Canada that was a little over a year; Frère Luc undoubtedly brought many of these pictures with him. The only surviving work that we are certain he completed in Québec is the grand altarpiece painted for his order's headquarters. The *Assomption, signed and dated 1671, is a robust example of the French Classical Baroque, though a little shallow in depth and too heavy in modelling. The soft, sensitive colouring in the flesh and sky is thoroughly typical of its period, and the dramatic red and blue robes of the Virgin and the orange drape

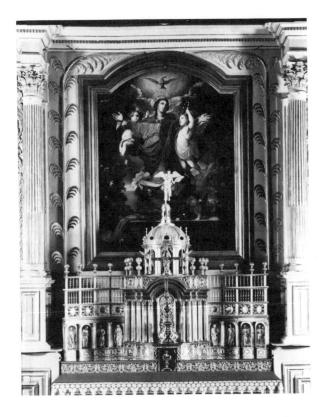

of one of the angels are of that intense, whitened colour so familiar from the luminous draperies of Poussin. The composition is conventional. Rather stiff, even awkward in the light of the artist's contemporaries in France, in Québec in 1671 the *Assomption* must have appeared a very vision of beauty and of inspired religious emotion.

Frère Luc returned to France immediately after the Recollet Chapel was sanctified in October 1671; the following year he was installed in the monastery at Sézanne in Champagne, where he taught and continued to paint. In 1675 he returned to Paris, where once again he became interested in Canada, actively recruiting for its religious houses and even sending pictures. He painted an *Immaculée Conception* (Église de Saint-Philippe, Trois Rivières) about then for the Recollets in Trois-Rivières; it was saved from a fire in 1908 and seems to have been quite heavily restored. A pair of canvases, *Saint Joachim et la Vierge Enfant* (signed and dated 1676) and *La Vierge et l'Enfant Jésus*, were sent by Laval in 1678 to Sainte-Anne-de-Beaupré, where they remain. Not as ambitious as the

earlier *Assomption*, and more severely austere, they show the same swollen modelling, the same predilection for the heightened reds, blues, oranges, and yellows of Poussin, and the same slightly awkward stiffness. Nevertheless, like the *Assomption* they are sincerely motivated expressions of profound religious belief. To some they may verge on the sentimental.

Morisset has attributed a great many more pictures to Frère Luc, and all of them must some day be examined on their individual merits. Five paintings are notable for their interesting subject matter. There are two portraits: *Jean Talon* (Hôtel-Dieu, Quebec City) and *Monseigneur de Laval* (Séminaire de Québec). A *Sainte-Famille à la Huronne* (Monastère des Ursulines, Quebec City) arouses interest because of a Huron girl's presence in the group. (One suspects, however, that it was much repainted in the nineteenth century.) The striking *Une Hospitalière soignant Notre Seigneur dans la personne d'un malade* (Hôtel-Dieu, Quebec City) is very reminiscent of Philippe de Champaigne and its classical feeling has little to do with the more robust Baroque style we expect of Frère Luc's work.

Even though Pommier, Pierron, and Nicolas were all in Québec from time to time during 1670–1, we know of only one person who might actually have been inspired to turn to painting by Frère Luc's brief presence there. ABBÉ JEAN GUYON (1659–87) can lay claim to the distinction of being Canada's first native-born painter. Born at Château-Richer near Québec (his father was an *habitant*), he entered the Petit Séminaire—a secondary school founded in 1668 to prepare students for the Grand Séminaire—in September 1671, and along with studying the usual classics, theology, and mathematics, began to practise painting. He took minor orders late in 1677 and the following summer set off for France to continue his philosophical and theological studies. While there he also took further instruction in painting. Returning to Québec in August 1682, he was ordained on November 21, 1683, appointed canon a year later, and then left for Paris as secretary to Bishop Laval. He died there in January 1687.

Thus Guyon's services as a trained painter were available to his native city for only twenty-seven months, less than twice the time spent there by Frère Luc. The only works ascribed to him with any certainty are a group of botanical studies in water colour that were once in the Séminaire and are now apparently lost. Morisset has also attributed to Guyon an early portrait, that of **La Mère Jeanne-Françoise Juchéreau dite de Saint-Ignace* (Hôtel-Dieu, Quebec City). Juchéreau was elected superior of her convent in November 168₃, the first Canadian to hold the post. Believing that such an occasion would have been commemorated, Morisset dated this

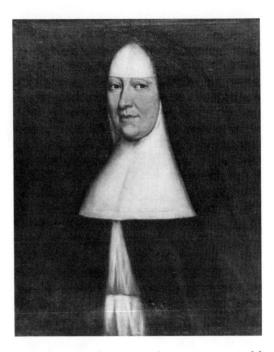

Attributed to L'Abbé Jean Guyon. *La Mère Jeanne-Françoise Juchereau dite de Saint-Ignace, c.*1684, with later additions. Canvas, 68.5 × 56.1. Hôtel-Dieu, Québec.

portrait to early 1684, pointing out that the first Canadian painter would have been the only one in Québec able to do the job. A recent critic of the attribution has observed that the sitter appears to be older than thirty-four, her age in 1684; but that is a moot point, especially since the portrait is now over-painted in many places.

By the last quarter of the century, modest talent with pencil or brush was not uncommon in Québec, even among the laity. A number of cartographers and engineers have left charming examples of their skill. Probably the most accomplished was JEAN-BAPTISTE FRANQUELIN, (*c*.1651–1718) who arrived in Québec first in 1672 and returned several times. Some of his beautiful maps were the first to incorporate the discoveries of Jolliet, La Salle, and Cadillac and were often corroborated by the explorers themselves. Another cartographer, ROBERT DE VILLENEUVE (*c*.1645–after 1692), was in Québec from 1685 to 1692. Although not nearly as well trained or as active as the English topographers who worked in the region a century later, he doubtless entertained and delighted his friends with his sketches of familiar landmarks. CHARLES BÉCARD DE GRAN-VILLE (1675–1703) of Québec, who went to sea as a French marine and then returned to work as a cartographer and engineer, has left a delicate view of his city that was engraved as a map cartouche in 1699.

Rudimentary art instruction was apparently part of most formal education by the end of the century, and was by then available in Montréal. PIERRE LE BER (1669-1707), issue of two of the wealthiest families in the city and a pious and generous man, in 1688 assisted Francois Charon de la Barre, another wealthy Montrealer, in founding an alms-house. The Le Ber family contributed a farm towards the support of the venture and Pierre designed a three-storey stone building to house the institution, inaugurated in 1694. In 1700 it was awarded letters patent designating it as a formal religious community—the only male community ever founded in Canada—and its members soon became known popularly as les Frères Charon. Pierre Le Ber moved in, apparently helping to direct the small craft manufacturies that were established there to support charity work, and perhaps teaching drawing. He was a painter of some seriousness, for the inventory drawn up at his death includes, as well as some paintings, a studio full of paints, brushes, canvas, and other supplies one associates with a professional. We know very litte about him. Because he apparently never left the country, it has been suggested that he studied painting in Québec, although there is no record of this. His father owned a number of paintings, however; encouraged by such a home environment, Pierre may have taught himself. He is known to have erected a chapel to Sainte-Anne outside of Montréal in 1697 and to have decorated it with his own paintings. Nothing remains of it today. The Hôpital-Général in Montréal took over the Charon institution when it failed in 1747, and it once was assumed that some of the pictures preserved in the Hôpital are by Le Ber. None have been so identified. Le Ber's sister Jeanne was in her day a famous benefactor and recluse of the Congrégation de Notre-Dame in Montréal, and Morisset has attributed certain pictures there to her brother. But only one is supported by documentation: a severe, primitive portrait of the founder of the congregation, *Marguerite Bourgeoys (Les Soeurs de la Congrégation de Notre-Dame), painted immediately after her death in January 1700 and preserved in the convent since then—though 'preserved' is perhaps too generous a word. During restoration in 1964 the portrait thought to be by Le Ber turned out to be the second over-painting; neither it, nor the painting immediately beneath, in any way resembled the stark, powerful image of a strongwilled woman revealed by their removal. The compelling design, the raw, immediate force of this one remarkable work of Le Ber's-certainly the single most moving image to survive from the French period-obliges us to designate him the great talent of his age.

Subsequent research has attributed to Le Ber on stylistic grounds four other portraits in Montréal-area religious institutions, but none of these

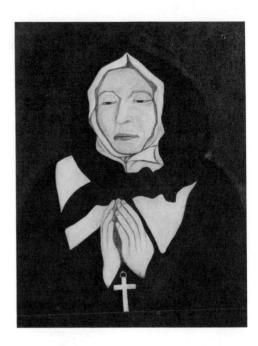

Pierre Le Ber. *Marguerite Bourgeoys*, 1700. Canvas, 62.3 × 49.5. Congrégation de Notre-Dame, Montréal.

have been physically examined as closely as the *Marguerite Bourgeoys*, nor is there specific documentation to support Le Ber's authorship. Further research and some fortunate turns of circumstance are needed before the major Canadian artistic personality of the seventeenth century will stand revealed.

We begin to notice signs of a richer cultural life resulting from an expanding community in the eighteenth century. The population of New France was growing steadily. In 1698 there were 13,815 whites in the colony (Québec had just under 2,000, Montréal 1,200), 16,500 in 1706, 21,000 in 1720, and 42,500 by 1740. In 1705 the first 'local' man was appointed governor. The Marquis de Vaudreuil, although not a native Canadian, had been in the country for eighteen years, had risen through the ranks of the local administration, and had married a Canadian. Thirty years of peace (1713–43) also helped to stimulate vigorous expansion and prosperity and the development of virtual self-sufficiency in the colony. Early in the eighteenth century, as one historian has remarked, 'Québec could boast of more and finer public buildings than could any other colonial capital north of Mexico City.'

This trend was revealed as well in the number of paintings acquired and displayed by the churches (the church in as remote a place as Détroit had no less than sixteen in 1711) and even by private individuals. A man named Cugnet appears to have been a collector of sorts. An inventory drawn up at his death in 1742 lists twenty-eight pictures; they were mainly religious, but there were also three mythological scenes, five landscapes, two royal portraits, five family portraits, and three still-lifes. Finer homes were now expected to contain one or two devotional pictures, perhaps a portrait of the king or of a member of one's family; there is actually a record of a group portrait. Paradoxically the increasing interest in painting did not seem to lead to an increase in the number or quality of painters but almost to the contrary. Morisset has explained this by drawing attention to the great number of French pictures imported at the time—paintings being one of the principal luxury importations before the Conquest. Almost exclusively church or private devotional pictures, and all by lesser artists, they represented the backbone of the local market in paintings.

Painters none the less continued to work in the colony and for the first time some were non-clerics. JEAN BERGER (1682–after 1710) was one of the first of these secular artists and certainly the most colourful. Born near Lyons, he arrived in Québec in 1700 as a marine and somehow became involved with a group from Wells, Maine, who had been carried to Québec as prisoners of the Abenakis. Charged with counterfeiting cardmoney, Berger was jailed in Montréal with some of them for a brief period. A year or so later in Québec he married one of the women of this same group, a certain Rachel Storer. Then in 1707 he set himself up in Montréal as a painter. Deported two years later for having written an insulting song on the subject of justice in New France while he was in jail on an assault charge, he probably lived the rest of his life with his wife in the English colonies to the south. The only documented work by this interesting character is an altar frontal painted for a church on the Île d'Orléans in 1706 and now lost.

Jules Bazin suggests the attribution to Berger of two portraits now in the McCord Museum: those of the Hertel brothers of Trois-Rivières. They both served as officers in the colonial army but neither left New France, so their portraits must have been painted here about 1710. Morisset believed the Hertel portraits belonged to another secular painter who worked in New France early in the eighteenth century, MICHEL DESSAIL-LIANT DE RICHETERRE (active 1701–23). We know nothing of de Richeterre's early life. He is first recorded in Montréal in 1701 selling a portrait of a prominent local figure, *Mme de Repentigny*, that has never been found. He may have been in Détroit in 1706 to paint a large retable for the Sieur de Cadillac; he was recorded in Québec at the end of that year; in Montréal in 1707; and he went back to Québec where he was recorded a number of times before 1723. The Hôpital-Général there has a 1708 death-

portrait of *Mère Louise Soumande de Saint-Augustin* bearing an old label that attributes it to him.

Dessailliant is best known, however, as the supposed author of a number of early ex-votos—naïve painted offerings meant to record gratitude for miraculous salvation that began to appear early in the eighteenth century in the ports of Brittany and Normandy, and in New France. While often very crude (their efficacy bore no relation to their aesthetic force), they are also vivid and moving depictions of ordinary people caught in crisis. One of the most stirring of those attributed to Dessailliant, the *Ex-voto du capitaine Edouin* (Sainte-Anne-de-Beaupré), is over a metre-and-a-half high and vigorously conceived. While on a trip from Plaisance, Nfld, to Québec in 1709, Captain Edouin's ship was caught in a crushing storm and survived only because Sainte-Anne interceded in answer to the prayers of a priest on board. The picture was commissioned as a thankoffering. The almost-as-large *Ex-voto de Louis Prat* and the much smaller *Ex-voto de Madame Riverin*, both also at Sainte-Anne-de-Beaupré, are sometimes attributed to Desailliant as well.

The most spectacular of the pictures ascribed to him, however, is the **Ex-voto de l'Ange-gardien* (Hôtel-Dieu, Quebec City) of about 1707. Based on a French Baroque engraving, it owes the dramatically successful pose of the angel to that source. But its real quality lies in the evocative exaggeration of the angel's figure, its huge legs taking up almost two-thirds of the body's bulk. A little girl stands beside the forward-thrust leg, seeming frail in comparison with that vigorous limb. Her fingers touching in prayer, she turns her head as the giant angel gently rests its hand on her shoulder. The girl's face—supposedly a portrait of the child whose placement under the protection of the angel the picture celebrates—is one of the most sensitively modelled to survive from the period.

A signed *Marie Madeleine repentante* (Cap-de-la-Madeleine) of 1720 and its pendant, a *Madone tenant son enfant*, are the only known paintings by JEAN JACQUIER dit LEBLOND (1688–after 1724), a Belgian who arrived in Canada about 1712 and married in Montréal in 1715. An undistinguished artist on the evidence of these two pictures, Jacquier was also a sculptor and, it appears, an importer-dealer in works of art. One suspects that such a thorough business approach to the market for art was widespread in New France during the early eighteenth century.

Only two painters of some merit are known from the last decades of the French era. One, PÈRE FRANÇOIS (Jean-Melchior Brekenmacher), reintroduces the artist-priest of the sort that held exclusive sway during the previous century. Probably German-born, he was ordained in Québec in 1713 and was first mentioned as an artist in 1735, the date of a payment

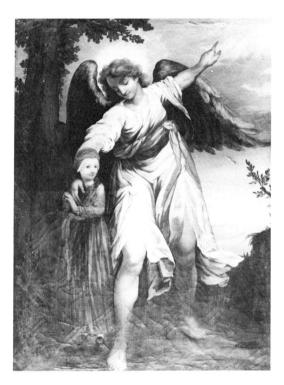

Attributed to Michel Dessailliant de Richeterre. *Ex-voto de l'Ange-gardien,* c.1707. Canvas, 118.0 × 83.8. Hôtel-Dieu, Québec.

for a 'grand tableau de Sainte-Anne' he painted for the church at Varennes. Morisset attributes a number of other works to Père François, the most interesting of which is the portrait of **Le Père Emmanuel Crespel* (MQ) of about 1756. The open, almost ingenuous face of the Recollet is convincingly modelled. The simple gesture of his right hand, thoughtfully positioned in relation to the face and other hand to draw the viewer's eyes around the composition in an endless circle of delightful exploration, denotes an artist of considerable training and ability. PAUL MALLEPART DE GRAND MAISON dit BEAUCOUR (generally known as Paul Beaucour, 1700-56), who was born in Paris, arrived in New France as a soldier in 1720 and was stationed there for the next twenty years, principally at Laprairie near Montréal. He left the army in 1741 and then rather surprisingly established himself in Québec as a painter. Two works signed by him (1746) have recently been lost, but on the basis of stylistic analysis Morisset has made of Beaucour the principal ex-voto painter of the second half of the eighteenth century. There is, however, considerable variation in technique and ability in those unsigned works to which his name has

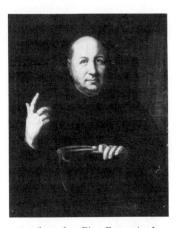

Attributed to Père François. *Le Père Emmanuel Crespel*, c.1756. Canvas, 80.5 × 64.7. MQ.

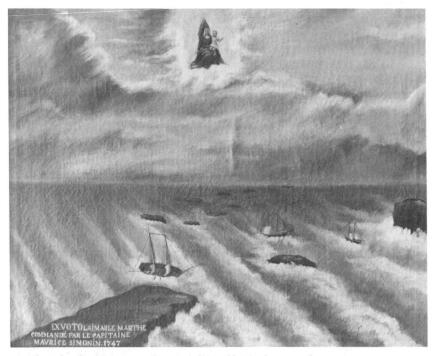

Attributed to Paul Beaucour. Ex-voto de l'Aimable Marthe, 1747. Canvas, 63.5 × 82.5. MQ.

been attached. The well-known *Ex-voto des trois naufragés de Lévis* (Sainte-Anne-de-Beaupré) of 1754, though charming, is extremely naïve and even crude in its handling of detail. The *Ex-voto de Notre-Dame de Liesse* (Rivière-Ouelle) of about 1745, on the other hand, is sophisticated in its treatment of faces, more imaginative in composition, and in every detail shows a considerable knowledge of the art of painting. These two works could not be from the same hand. A third painting, the spectacular **Ex-voto de l'Aimable Marthe* (Notre-Dame-des-Victoires, Quebec City) of 1747, reveals yet another distinct talent. Sensitive in colour, exciting in its breadth of conception, and realistic in its depiction of the foundering ship, it is impossible to reconcile with any of the other canvases we identify with Beaucour.

Until more research is applied to it, painting in New France from the beginning to the end must remain a body of isolated artefacts tentatively associated with a few elusive artists.

Painting in British North America 1760–1860

Halifax was established as a British military colony in 1749, Québec was taken in 1759, and Montréal surrendered to British troops in 1760. With the Treaty of Paris in 1763 Canada was ceded to Britain. Some English-speaking civilians soon began to settle adjacent to the garrisons—working in the civil service, as merchants, or in the lucrative fur trade—and their numbers increased greatly after 1783 with the influx of political refugees from the United States. These immigrants forced a change in British policy. Prior to their arrival in Canada, the maintenance of the garrisons was the overriding reason for the British presence. After the newcomers settled, new towns gradually appeared that were in large part independent of the military, and Montréal and Québec began to lose the look of occupied cities. In 1791 a constitutional government was established in the administrative areas of Upper and Lower Canada, with one capital at Newark (Niagara-on-the-Lake)—which was moved to York (Toronto) in 1796—and another in Lower Canada, at Québec.

The imperial garrison at Québec was the second oldest in Canada and endured into the 1870s, but it was the most isolated from the vital life of its host city. It was, after all, a British army of occupation in a city of French culture, and French was the language of most of the townsfolk. With its sizeable group of high-ranking officers—often accompanied by family—the garrison was itself a community of sophisticated culture. It figures prominently in the 'first Canadian novel', Frances Brooke's *The History of Emily Montague* (1769), and it possessed its own accomplished artists.

These were officers whose training—usually at the Royal Military Academy at Woolwich—included instruction in the taking of topographical views. Such objective, precise depictions of landscape were of obvious military use before the days of the camera. Drawings by HERVEY SMYTH (1734–1811), aide-de-camp to General Wolfe, were engraved and published in London in 1760 as *Six Views of the Most Remarkable Places of the Gulf and River St Lawrence*. The most famous of them shows the unsuccessful attack (on July 31, 1759) made by Wolfe at Montmorency Falls. There is also an engraving of a Smyth drawing of the landing at Wolfe's Cove before the Battle of the Plains of Abraham in September, but it was not included in the St Lawrence series. RICHARD SHORT (active 1759–61), a purser on HMS *Prince of Orange*, made sketches of Halifax and Québec in 1759 that were later engraved in London and sold as two sets. There are seven views of Halifax and twelve of Québec, which Short visited with the conquering British forces. The Québec views are mostly of prominent buildings and show the damage resulting from the bombardment. Both handsome and accurate, they are among the finest Canadian prints from the eighteenth century and would have found a ready market in England, where such scenes of far-flung corners of the empire were in demand.

The topographical views of military officers were in fact simply one manifestation of the romantic inclination of English gentlemen of the later eighteenth century to delight in the splendours of natural scenery or in anything they found in their travels that was charmingly primitive, rough, quaint, or exotic—in a word, picturesque. Every young Englishman taking his grand tour was either proficient with pencil or brush or was accompanied by his personal artist. Sustained largely by the enthusiasm of amateurs and refined and heightened by numerous dissertations on the correct limits of the taste (Uvedale Price's *An Essay on the Picturesque* (1794) is one of the better-known manuals describing the rich rewards of such a developed sensibility), the English craze for the picturesque by the beginning of the nineteenth century had spread to most of Europe.

Although the production of the English topographers is mainly of historical value, a few of them produced work that reveals a truly creative response to the Canadian scene. The earliest of these talented authentic artists was THOMAS DAVIES (*c*.1737–1812). He was an officer in the Royal Regiment of Artillery who ultimately rose to the rank of lieutenant-general. Though his four visits to Canada were brief—and usually violent —he always found time to produce sketches. He first saw Canada in 1757 when he was posted to Halifax and took part in the capture of Louisbourg and the burning of the French settlements on the St John River. Then in 1758 he served on Lake Champlain and the following year took part in the capture of Montréal. One of his drawings, now in the National Archives of Canada, shows General Amherst's flotilla running the rapids of the St Lawrence. He did two charming watercolour views of Montréal:

20 | Painting in British North America

one from St Helen's Island in 1762 and the other from the mountain, painted in 1812, the year of his death and long after he left Canada. He often made watercolours from sketches produced years earlier, presumably for exhibition. (He showed with the Royal Academy whenever he was in London between postings. An amateur naturalist as well, he was elected a Fellow of the Royal Society in 1781, and later a Fellow of the Linnaean Society of London.) Davies saw Halifax again several times during the American Revolution when he was engaged in campaigns around Boston and New York. In 1786 he returned to Canada when he was posted to Québec for four years of peace. Although he was always an accomplished draughtsman, the watercolours from this last Canadian tour are surpassingly beautiful. Their colour is vibrant-most are set in full autumn-and their line is alive. Detail is multiplied in rhythmic patterns that swell into forms that seem to breathe, to be organic. And, as in *†The Falls of St Anne* (NGC) of 1790, virtually every picture shows civilized men enjoying themselves amidst splendid natural scenery. Those four years must have been among the happiest of his life.

Six views of North American waterfalls by Davies were engraved about 1768 and thirty years later other watercolours were reproduced in a travel book. These were the only examples of Davies' work known to Canadians before 1953, when most of the watercolours we treasure so highly today were first released from one of the great English private libraries, that of the Earl of Derby.

Another outstanding view-painter, GEORGE HERIOT (1759–1839), had a long residence in the garrison community of Québec. In fact he was probably Canada's first resident English-speaking artist. His earliest Canadian paintings, such as the various views of the *Ruins of the Intendant's Palace*, *Québec* (ROM) of 1798–9, could have been painted anywhere there were Englishmen. The ruins were the result of British bombardment some thirty-five years before, but Heriot seems to have imagined himself inside some ruined castle. Although more topographically exact, **West View of Château-Richer* (NGC) of *c*.1792, still evokes the space, atmosphere, and polished finish of an English park, an impression heightened by the manor-like appearance of the residence. This is a good example of Heriot's large 'finished' watercolours. He had great facility in the medium and could handle space with ease.

Born in Scotland into a middle-class family, Heriot attended the Royal High School in Edinburgh, graduating in 1774. He then likely received some sort of art training, and in 1777 left for London to become an artist. Within the year he was in the West Indies, remaining until 1781 when he enrolled in the Royal Military Academy at Woolwich. About two years

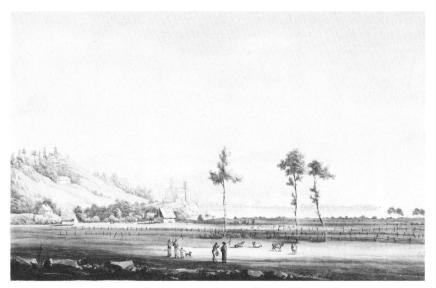

George Heriot. West View of Château-Richer, c.1792. Watercolour, 21.4 × 32.4. NGC.

later he took a position as clerk of the Arsenal there, which he held until 1792 when he left for Québec to become clerk of cheque in Ordnance. Heriot returned to London in 1796 for two years, exhibiting at the Royal Academy in 1797. Within three years of his return to Québec he was named deputy postmaster general of British North America, a post he held until 1816 when, in conflict with his superior, he was asked to resign and returned to England. Resident in London the last two decades of his life, he frequently travelled in Europe pursuing his interests as a topographical artist.

Heriot's position in Québec was peculiarly suited to his avocation. He had to visit and inspect all the post offices from Halifax to the Detroit River, and always carried a sketch-book. (Two sketch-books in the McCord Museum in Montreal alone contain some 200 small wash sketches.) Upon his return to Québec he would work some of these up into finished watercolours. Some also were later reproduced as aquatint illustrations in his *Travels Through the Canadas* (2 vols, London, 1807). A classic Canadian contribution to the picturesque travel book, it was popular enough to appear in a pirated edition in 1809 and was reissued in the United States in 1813. To this day it remains a satisfying book, crammed with interesting details of life in Canada and including a dictionary of the Algonkian language. Earlier, in 1781 after his return

from the West Indies, Heriot had published some poetry and, in 1804, the first volume of a never-finished *History of Canada from Its First Discovery*.

The third of these most talented garrison artists is JAMES PATTISON COCK-BURN (1779–1847), who arrived in Québec in 1826. (He actually was first posted there for seven months beginning in November 1822, but no pictures have been dated to then.) Like Heriot a student of the Roval Military Academy at Woolwich—he entered in 1793, the year after Heriot left his position in the Arsenal there—and like him a dedicated artist, traveller, and author, Cockburn unlike Heriot pursued an active career as a soldier rather than as a colonial administrator. Ultimately to rise to the rank of major-general, he served exactly six years at Québec as Commander of the Royal Artillery in Canada, a position that necessitated regular tours of inspection throughout both the upper and lower portions of the province. He seems always to have carried his sketching supplies with him. Before his Québec posting Cockburn had published at least six books of European tours. After his arrival in Canada he published Quebec and its Environs (1831), illustrated with his own views, and two years later he brought out in London folios of prints of Niagara Falls and Québec. Writing to a niece in 1831, Lady Aylmer, the governor's wife, described Cockburn's amazing energy. 'He continues (at his present age)', she wrote, 'to be indefatigable and his passion for the beauties of nature can only be gratified by his unceasing perseverance in delineating them.' As he was well into middle age when he arrived in Québec and, as has been suggested, had probably given up more strenuous amusements in favour of sketching, this was probably his daily recreation for most of the time he spent in Canada.

As a painter Cockburn is uneven compared to Heriot. His working sketches are mere notations, often stiff and awkward, with limited aesthetic appeal. His medium-sized watercolours, on the other hand, are often surprisingly accomplished. *Passenger Pigeon Net, St Anne's Lower Canada* (NAC) of 1829 is strikingly composed and deftly executed, most likely with the aid of a *camera lucida*, a box-like viewing device that projected a scene, reversed and upside-down, through a pin-hole lens onto a piece of fogged glass from which it could be traced. Most satisfying of all, perhaps, are the many similar watercolours of urban scenes, mainly of Québec and Montréal. Exact in the depiction of architectural monuments, yet open and airy in colour and lively with human anecdote, paintings like his **Québec Market* (MQ) of 1830 are clearly the work of a dedicated artist. They—and the larger, highly finished, romantic pictures of Canada's most famous pleasure spots that he prepared for publication—have rightly become national treasures.

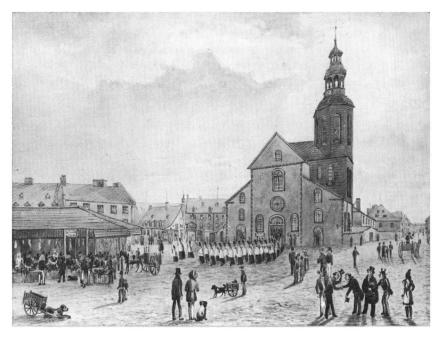

James Cockburn. Quebec Market, 1830. Watercolour, 27.0 × 37.5. MQ.

ROBERT TODD (1809–67), who emigrated from Edinburgh to Québec in 1834, is the only long-resident English-speaking 'professional' artist of interest to work in Québec prior to Krieghoff's arrival in 1853. Todd advertised himself as a 'house, carriage and ornamental painter', painting coats-of-arms and such for the garrison and gentry, and his production of pictures, as presently known, appears to have been secondary to his occupation as a decorative painter. Todd's most famous painting is *†The lce Cone, Montmorency Falls* (NGC) of about 1845. It has been suggested that this beautiful scene was painted as a portrait of the dashing team of horses in the foreground, and the fact that the horse in another Todd painting of Montmorency is named in an inscription supports this view. The scarcity of known paintings by Todd could be explained by the fact that his work was taken away by army officers and colonial officials at the conclusions of their postings.

It seems likely that the naïve quality of his paintings precluded Todd's being treated seriously as an artist in Québec and that he himself thought of them as being related to the 'ornamental' work that he advertised. He left Québec late in 1853. It is not known whether he had exhausted the demand for his line of work or whether the competition of Cornelius

Krieghoff (see p. 58 ff.) forced him out. Todd settled in Toronto and remained there—complaining in 1861 that 'Toronto is too new and too poor to support an ornamental artist'—until his death.

The English-speaking civilian population of Québec was relatively small and could not support professional artists during the early years, although it enjoyed the work of the French-speaking painters of the city. It was around Joseph Légaré and Antoine Plamondon (see the next chapter) that the city's art scene really developed.

To offset the French fort at Louisbourg, Halifax was founded in 1749 as a planned colonial town and military post. Its garrison grew steadily after the siege of Louisbourg in 1758 and then during the American Revolution; after 1783, 13,000 political refugees arrived from New England. Most moved on to New Brunswick and elsewhere, but enough stayed that by 1794 and the arrival of Prince Edward—the son of George III (and later the father of Queen Victoria)-Halifax was a bustling town of 7,000. Prince Edward, burdened with debts from student days, had been sent by his father to command the garrison. Finding an ugly makeshift town that had seen too many thousands pass through, he immediately began to indulge his favourite habit of spending money by rebuilding the fortifications and military buildings and putting up a villa for himself and a number of striking public buildings. With his beautiful mistress Mme Saint-Laurent he also entertained lavishly. Society reached a peak of brilliance in Halifax and further improvements over the next six years made the whole town shine. The impetus of this moment sustained the cultural pretensions of the community for decades.

With the departure of the Prince—now the Duke of Kent—in 1800, construction stopped on all military works and the city went into a depression. 'But', as Thomas Raddall writes in his history of Halifax, 'the golden crust of Halifax, the circle of well-salaried officials and the war-enriched merchants and speculators still managed to do themselves well.' It was from this segment of society that the membership of the first Canadian art club was drawn: the Halifax Chess, Pencil and Brush Club. Founded about 1787, it persisted until about 1817. Richard Bulkeley, the secretary of the province, was president of the club, whose sole purpose was the promotion of drawing and watercolour painting (as well as chess) as polite pursuits. It was also this privileged society that encouraged the settlement of Halifax's first resident professional artist.

Halifax was on the northern periphery of an English provincial culture that had developed along the Atlantic seaboard. Over the past century or more the English colonies to the south had created a cultural environment that was in most ways similar to the milieu that existed in provincial centres in England. Once a certain level of affluence had been reached, American merchants and landowners, like the British gentry, sought to demonstrate their stature by commissioning portraits reflecting their pride in themselves and their understanding of the values of cultivated society. The prominent citizens of Halifax, many of whom were American by birth and upbringing, felt this need and commissioned portraits from American painters, including the famous John Singleton Copley. Inevitably the time came when Halifax was ready to welcome a skilful portraitist of its own.

In May 1808 ROBERT FIELD (*c*.1769–1819) set up a studio in a bookshop on King Street. Born in Gloucestershire, he had studied painting at the Royal Academy School in London. He immigrated to the United States in 1794 and worked as a portraitist in Baltimore, Washington, and Boston. The approaching war with Britain attracted him to Halifax: in 1808 it had a population, with the garrison, that was almost half that of Boston. Field obviously had the social connections then essential to a portraitist; the year of his arrival, 1808, he painted both the lieutenant-governor, Sir George Prevost, and Sir John Wentworth, the New Hampshire Loyalist who had been the previous lieutenant-governor. The latter portrait was the first of a series of three-quarter lengths completed for the Rockingham Club, whose membership was drawn exclusively from the 'better' classes of Halifax. With their patronage Field was kept busy for eight years.

Most of Field's Halifax portraits in oil seem to have been painted before 1814, by which time he had probably satisfied virtually everyone who was willing and able to pay. Nevertheless he continued to find a steady demand for miniature portraits painted on ivory. His local fame as a portraitist and the relative inexpensiveness of miniatures meant that he was required to produce these almost until the day he left Halifax. Probably late in the summer of 1816 he departed for Kingston, Jamaica, a town built—like Halifax—around a British garrison. A newspaper notice announcing his impending departure suggests that he may have intended to return to Halifax, but premature death in Jamaica from yellow fever put an end to his plans.

From pictures like *Lieutenant Provo William Parry Wallis (NGC) of 1813 it is apparent that Field relished formal dress with its rich adornments, the subtleties of flesh tints, and the sensuousness or beauty in a face; surface qualities such as these gave him an opportunity to highlight his paintings with sparkling, sophisticated brushwork. This painter of lively and attractive likenesses has been compared to the famous American portraitist Gilbert Stuart and (more outlandishly) to Sir Joshua Reynolds. But in that company he was merely a talented journeyman.

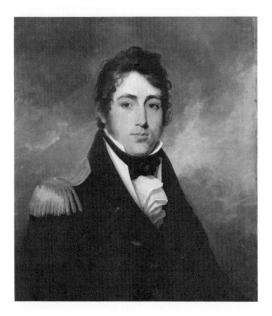

Robert Field. *Lieutenant Provo William Parry Wallis*, 1813. Canvas, 76.2 × 63.5. NGC.

Yet Field is the best painter Halifax would enjoy in the nineteenth century. One who might have challenged him was lost to the city. Harry Piers in his *Artists in Nova Scotia* (1914) has called GILBERT STUART NEWTON (1794–1835)—the nephew of the American painter—'unquestionably the greatest artist Nova Scotia has ever produced'. It is true that Newton was born in Halifax and spent the first nine years of his life there, but when his father died in 1803 his mother returned to Boston—her husband had been a Loyalist—and young Gilbert was raised there to be a painter by his namesake uncle. He never returned to Halifax.

As elsewhere in British North America, artists connected with the garrison were the first to practise landscape painting, and, indeed, sustained what interest there was in picturesque topography in Halifax for the first eighty years of its history. Those most worthy of mention produced prints of views in Halifax and its environs, and included Lieutenant-Colonel EDWARD HICKS (active 1778–87), who was resident in the city 1778–82; GEORGE ISHAM PARKYNS (1749/50–C.1820), an English itinerant topographer who published four views of Halifax in London in 1801; and JOHN ELLIOTT WOOLFORD (1778–1866), another professional topographer (a member of the household of the Earl of Dalhousie, Lieutenant-Governor of Nova Scotia 1816–19), who published four views in 1819, believed to have been the first etchings made in Halifax. Mention should also be made of JOSEPH BROWN COMINGO (1784–1821), a Yarmouth, N.S.-born artist

best known for his miniature portraits, who worked periodically under Field's shadow in Halifax, but who passed most of his career as an itinerant around Nova Scotia and New Brunswick.

A slow but steady stream of itinerant painters passed through Halifax during the first half of the century. One, a certain W.H. JONES (active 1829–31) from Boston and Philadelphia, conducted fashionable classes on the Parade at Dalhousie College during 1829 and 1830. The highlight of his visit was Halifax's—and, indeed, British North America's—first art exhibition, sponsored and organized largely by members of the garrison. It was held in Jones's rooms at Dalhousie from May 10 to 29, 1830, and most of the works on display were by Jones's students: ladies and gentlemen of both garrison and town, with the balance decidedly weighted towards the garrison. The exhibit was augmented with drawings by the lieutenant-governor, Sir Peregrine Maitland (and with war booty in the possession of the chief justice!). A similar exhibition was held the next year, following which Jones disappeared from sight.

Only one of Jones's students, MARIA MORRIS (later Miller, 1813–75), went on to become a professional. She ran her own drawing school and later was well known in the province for her botanical studies. It was the Irishborn WILLIAM EAGAR (*c*.1796–1839), however, who was to succeed Jones as a general catalyst for the small Halifax art scene. Settled in St John's, Nfld, as early as 1819, Eagar appears to have established himself as an artist there ten years later. Presumably finding little work for a topographical painter in that maritime outpost, he moved to Halifax in 1834 to open a drawing academy. In 1836 Eagar began to publish engraved views of the region, and later offered a number of lithographs as well. But more important, in 1838, the year before his death, he organized a large exhibition that, like Jones's, included not only the work of his students, but that of one or two other aspiring professionals in the city, and prized possessions belonging to most of the area's owners of works of art.

There were a couple of commercial exhibitions in Halifax in the mid-1840s, but the next one to focus public attention on the local progress in art did not take place until a decade later. In 1831 a Mechanics' Institute had been founded in Halifax where drawing classes and lectures on art were held.* Local amateurs met in the Institute's reading room and hung their works on its walls. In 1848 a committee of the Mechanics' Institute

^{*}The first Mechanics' Institute was founded in England in 1823 by public-spirited middleclass professionals to promote self-education among the working classes through evening courses, lectures, literary readings, and art exhibitions. They were found in Canada in some numbers by 1835 and from that time a broader, more popular basis for the support of art appeared possible.

organized the most extensive art exhibition to that date, which presented all of the best pictures in the city, including a number of Robert Field portraits, still treasured by aged sitters or their proud descendants. Nevertheless, the change in the base of art patronage that this promised was never fully accomplished, though a greater involvement of the middle class in artistic matters did help to bring another portraitist into prominence.

WILLIAM VALENTINE (1798–1849) was born in England and immigrated to Halifax in 1818. He is said to have had a 'passion' for painting throughout his whole life. Arriving two years after Field's departure, the self-taught Valentine was the antithesis of that fashionable painter. Valentine was a Methodist, which made him very *un*fashionable, and although by 1819 he had opened a drawing school, he still had to paint houses to make a living. He was on the founding committee of the Mechanics' Institute and painted portraits of two of its presidents, which he donated to the Institute. He also drew virtually all of his commissions from the middleclass merchants and professionals who supported the Institute; there is only one military man among his known sitters and he is depicted in civilian clothes. The fashions and values of the society whose tone was set by the garrison did not loom very large in Valentine's life.

Early in 1836 Valentine visited London, staying about six months. He apparently took no formal instruction there but copied portraits by the famous Academicians, which he exhibited in Eagar's 1838 exhibition and which later ended up in the Mechanics' Institute. This experience improved his technique markedly, and the period from his return to Halifax to about 1845 was his most prolific and accomplished. Seeking to satisfy his clients' needs for inexpensive yet accurate portraits, Valentine introduced the daguerreotype* to Halifax in 1842. He died seven years later. Valentine is difficult to evaluate. Little effort has been made to discover the extent of his production (there has never been a comprehensive exhibition of his painting). The excuse is often made that a studio fire shortly before his death destroyed a large amount of his work. But this could not have included the many commissioned portraits that formed the bulk of his output. From the evidence of the few that have been available for examination-including the Reverend William Black (Mrs H. Connor, Halifax) of 1827 and a Self-Portrait (Provincial Archives, Halifax) of about 1840-we would expect to find that Valentine's portraiture was generally relaxed and informal, revealing the human warmth of the sitter and, in the later work, rich and warm in tone.

The activities around the Mechanics' Institute suggest that the years *A photographic process invented in Paris in 1839 by Louis Jacques Mandé Daguerre.

just before and after Valentine's death might represent a high point of artistic production and civilian patronage in Halifax. Adding considerably to this moment, with marine paintings like *†Halifax Harbour, Sunset* (Halifax Board of Trade) of c.1853, was JOHN O'BRIEN (1831-91). Along with Valentine, O'Brien was as close to being a native artist of stature as Halifax was to see in the nineteenth century. Born in the city, he appears to have been self-trained. He was first noticed as an artist in November 1850 and advertised himself as a professional beginning in July 1853. Some interested Haligonians, impressed with his talent as a ship 'portraitist', arranged for him to travel to England to study in June 1857. After his return in April the following year, he continued to pursue the profession of marine artist, but he also tinted photographs, a skill he had learned in London. Few works survive from the sixties or seventies, and those of the eighties are heavy in handling and unsubtle in colouring-lending credence to the suggestion that alcholism destroyed his health and affected his abilities as a painter.

Painters of ability failed to build on these beginnings and a real 'scene' for painting never did develop in Halifax. The brave attempts of O'Brien, Valentine, and the Mechanics' Institute, with their 1848 exhibition, went for nothing. The next significant art exhibition held in Halifax, in 1863, defaulted to the garrison once again when three army captains arranged it in the armoury of the volunteers' drillroom.

In the first decades of the century there were imperial troops in Montréal, and gala social events there certainly had the required military air of the period. But the leading English families—whose fortunes were derived mainly from the fur trade and most of whom were in fact Scottish—identified themselves with the community at large, not just with the British presence. Montréal was the largest, fastest-growing city in Canada. In 1800 its population was about the same as that of Halifax: 9,000. But by 1840 it was 40,465—more than twice that of Halifax. Montréal had the earliest Mechanics' Institute in Canada, founded in 1828, and also the first YMCA in North America, which opened in 1851. Although the role of the garrison was very small in the developing art traditions of the city, the lure of the picturesque landscape appears to have been as strong there as elsewhere.

One of the earliest topographers of the region, JOSEPH BOUCHETTE (1774– 1841), was born in Montréal. His father, Jean Baptiste Bouchette, was commander of British naval forces on Lake Ontario, and young Joseph first served with the navy before going to work with his uncle, Samuel Holland, surveyor-general of Canada. In 1796 he studied painting with François Baillairgé of Québec but continued as a survey-engineer and in

Joseph Bouchette. Kilbourn's Mill, Stanstead, Lower Canada, 1827. Watercolour, 26.0 \times 40.5. McC.

1817 replaced his uncle as surveyor-general. He published topographical books on Canada in 1815 and 1832, illustrated in part by his own sketches; a lithograph of Montréal was published in 1831. Three sons also shared his love of painting: one in the army, the other two as civilians. One son succeeded his father as surveyor-general and another, a lawyer, joined the Rebellion of 1837 and was transported to Bermuda, although he later returned under the general amnesty.

Bouchette's views, such as * *Kilbourn's Mill, Stanstead, Lower Canada* (MCC) of 1827, are clear and straightforward, yet sensitive and subtle in colour and composition. They differ from the work of British-trained artists like Heriot and Cockburn chiefly in their subject matter. Where the visiting artist was attracted to great natural wonders like Montmorency Falls, or to city scenes, Bouchette singled out the farms and small communities that were opening up to the east and south of Montréal. These he depicted with attention to observed detail, yet with a sweep and scale that lend great weight of importance to them.

A community the size of Montréal offered opportunities for portraitists that were matched nowhere else in Canada, and the city benefited from a number of accomplished portrait painters at the turn of the century. Most were French-speaking and they will be discussed in the next chapter, but one in particular, WILLIAM BERCZY (1744–1813), seems to have

enjoyed a large part of the patronage of the English merchants and garrison officers. Berczy was born in Saxony. He worked in Europe as a painter, architect, and writer, was part of the German artistic colony in Italy, and later exhibited at the Royal Academy in London. He came to Canada as overseer of a group of German settlers who were destined for upstate New York. Bad faith on the part of the land company that employed him led Berczy to throw in his lot with his immigrants, who finally settled near the new capital of Upper Canada. Arriving in York in 1794, Berczy was active thereabouts in real-estate speculation for the next three years, designing and constructing some of the earliest buildings and becoming known as a gentleman-painter. Business difficulties with political overtones led him to sell his house in York in 1798 in order to pursue litigation in Québec and London. He returned to York in June 1802, where he remained another two-and-a-half years, supporting himself as best he could as a painter and builder while continuing to seek legal satisfaction for denied land claims. Finally in October 1804 he settled in Montréal with his family, having decided to live from his skill as a painter and architect, and rented lodgings and studio space from a friend, the painter Louis Dulongpré.

Berczy had painted in watercolour Joseph Brant (Séminaire de Québec), Loyalist chief of the Mohawks, at York in 1797. Later he painted an exquisite small full-length *portrait in oils (NGC) in the classical style then current in Europe. Berczy's fame spread quickly in Montréal and he received numerous portrait commissions, executed church decorations, and did some architectural work. By late 1808, when John Woolsey invited him to Québec to paint his family, he must have been the most fashionable painter of the day. He was also the best, and †*The Woolsey Family* (NGC) is one of the few exceptional Canadian paintings of the first half of the century. The complex interrelationship of the figures, the masterly treatment of the patterned floor covering, the purely pleasurable attention to the landscape seen through the open window, to the doorjamb and ceiling detail reflected in the mirror to the left, all go far beyond anything accomplished in the country before, or for some time after. It is one of the masterpieces of Canadian art.

Berczy travelled a lot in the promotion of various schemes, and it was on such a trip to New York City in 1813 that he died. His two sons, wife, and daughter-in-law also painted, and the thorough examination of his painting that needs to be carried out will have to deal with some complicated attributions and collaborations.

While portrait needs for the next fifty years were met by French-speaking artists mainly resident in Québec and by itinerant Americans, includ-

William Berczy. Joseph Brant, c.1805. Canvas, 60.9 × 46.1. NGC.

ing the famous painter and historian of Philadelphia, William Dunlap, the picturesque view-painting tradition was kept alive by a train of professionals, culminating in two who decided to stay in Montréal, ROBERT A. SPROULE (1799–1845) and James Duncan. Both were born in Ireland and both arrived in Montréal in the mid-to-late-1820s. Sproule lived there until about 1840, painting miniatures on ivory and landscape views. He is primarily known for six prints of Montréal published in 1830, and four of Québec that appeared in 1832.

JAMES DUNCAN (1806–81), the more accomplished of the two, arrived in Canada in 1825, was settled in Montréal by 1830, and lived there until his

death. He taught drawing in a number of Montréal-area schools and young ladies' academies, and found work designing coinage. He also prepared the numerous scenes engraved to illustrate the well-known *Hochelaga Depicta* of 1839, an early Montréal guide-book, and was appreciated for the numerous prints of Montréal views he issued over the years, particularly a set of six lithographs of 1849. According to a contemporary advertisement, Duncan planned to collaborate with Cornelius Krieghoff on a panorama of Canada. But today he is best known for his many scenes of the city. One of the best of these paintings is **Montréal from St Helen's Island* (MCC) of about 1850, with its rich detail and easy, rhythmical recession into distant space.

Surprisingly little is known about Duncan's painting activities in Montréal, even though he was a relatively prominent figure for fifty years. F. St. George Spendlove, a pioneer scholar of Canadian topographical art, has said that 'no artist has been more neglected by Canadians ... although he was probably for some years the best water-colourist in Canada.' He suggests that this 'conspiracy of silence' stems from the fact that Duncan ran a successful design-printing house after 1864, and as a consequence has been slighted as a painter. His best-known works, however, are often commercially anecdotal, like his view of *The Gavazzi Riot*,

James Duncan. Montreal from St Helen's Island, c.1850. Watercolour, 43.2 × 62.2. MCC.

Montréal (Séminaire de Québec) of 1853. Duncan often sketched such newsworthy events for the *Illustrated London News*. He seems to have been a painter caught in the shift of history, having arrived too late to pursue a career solely as a view painter, yet not equipped to satisfy the increasing demands for more self-conscious 'art'. The existence in numerous versions of so many of his pictures suggests that he was working under the pressure of a demanding market. But did he consider them pot-boilers, or did they represent to him significant variations on a theme? The same questions are raised by the work of Krieghoff and await the same long-overdue research for an answer.

Out of the considerable artistic activity in Montréal during the first half of the nineteenth century grew the first sustained professional art society in Canada: the Montreal Society of Artists, founded in 1847. At least it *appears* to have been a professional society, for we know little about this early organization except that it existed, and that artists such as Duncan were members. In 1860 the Art Association of Montreal was founded by a group of collectors and some members of the Montreal Society of Artists to develop a collection and a regular exhibition program. In 1939 its name was changed to The Montreal Museum of Fine Arts. It is the oldest art museum in the country.

The pattern of artistic development in Toronto follows that of the other cities in British North America, although activity was slower starting in muddy York. Founded in 1793 as the capital of an almost uninhabited Upper Canada, it had in 1830 a population of only 2,860. For the first few years the only artists of note—with the exception of the aforementioned William Berczy, and the wife of the first lieutenant-governor, Elizabeth Simcoe (an accomplished watercolourist in the picturesque tradition)were visiting army officers. As the community grew, artistic patronage fell to an educated establishment, leaders of government who achieved positions of privilege and power around the lieutenant-governor and shared the same cultural aspirations, of which Upper Canada College founded in 1829 by Lieutenant-Governor Sir John Colborne-was one manifestation. It was modelled on an English public school (what we call a private school) and drawing and watercolour painting were part of the curriculum from the beginning. An English architect and civil engineer named JOHN G. HOWARD (1803–90) arrived in York in 1832 and began teaching drawing at the college the next year. In 1834, the year York was incorporated as the city of Toronto, Howard organized the Society of Artists and Amateurs of Toronto. It was to be a permanent exhibiting society and thus pre-dates the idea of the Montreal Society of Artists by some thirteen years. Captain R.H. Bonnycastle (1791–1847) of the Royal Engineers was president, and the lieutenant-governor and Archdeacon John Strachan were the patrons. The society did not, however, outlast its first exhibition staged the year of its founding. The list of exhibitors suggests one reason for its short life: there were no real professionals then in Toronto and thus no focus for such an association. Of the exhibitors we can identify today, two—Charles Daly (1808–64) and Howard were teachers who continued to live in Toronto. The only others who might be called professionals were S.B. Waugh and G.S. Gilbert, both Yankee itinerants; John Linnen, a Scottish itinerant; and S.O. Tazewell, a lithographer. All left Toronto within a year of the exhibition. One exhibitor, however, did subsequently contribute to the development of painting in the city. This was Paul Kane (see p. 50 ff), who was then twentyfour years old. He was at that time preparing to begin his career as a professional, but in two years he would leave for the United States.

A Mechanics' Institute had been founded in 1832 where drawing lessons were given, and itinerant portrait painters continued to pass through. Most were American, and Nelson Cook (1817–92), one of the more talented, was patronized by Toronto's élite, as were upon occasion two local practitioners: Peter March (active 1842–52), and the miniaturist and print-maker, Hoppner Francis Meyer (active 1833–60). But a decade was to pass before the élite could enjoy the services of a resident portraitist of ability.

Although it has been claimed that GEORGE THEODORE BERTHON (1806–92) visited Toronto first in 1837, he did not settle in the city until late in 1844. and all his famous portraits date from after then. He was born in Vienna, where his French father-who had studied in the studio of the famous Jacques-Louis David, and was a portrait painter attached to the court of Napoleon I-was fulfilling a commission. In 1827 young Berthon immigrated to England, where he is said to have worked as French-language and drawing tutor to Sir Robert Peel's daughers. While there he absorbed that sweetly romantic style of English portraiture made famous by Franz Winterhalter, and by 1835 was exhibiting at the Royal Academy. Within a vear of his arrival in Toronto he had painted a resplendent portrait of Bishop Strachan (University of Toronto), and by the middle of the following year had executed, among other portraits, a large full-length of the mayor, William Henry Boulton (AGO), and another of the mayor's uncle, Chief Justice Sir John Beverley Robinson, the first of a series of monumental portraits of prominent judges commissioned by the Law Society of Upper Canada that all hang to this day in the offices of the Society in Osgoode Hall

Berthon's portraits often display a smooth perfection-found in its

George Theodore Berthon. *Mrs Wm Boulton as a Bride*, 1847. Canvas, 59.0 \times 44.5. AGO.

extreme in *The Three Robinson Sisters* (AGO) of 1846—and an obtrusive smugness that are disagreeable, but these qualities are sometimes overcome, as in **Mrs Wm Boulton as a Bride* (AGO) of 1847. Though the artist's obsessive attention to the detail of the intricate laces and rich silks of the bridal dress threatens to turn the sitter into a ceremonial doll, the young woman's determined expression and assured stance counteract this tendency, producing a curiously satisfying state of tension.

That Toronto was able to support a fashionable portraitist by the midforties points to a rapid acceleration of interest in painting there, and in 1847 another attempt was made to found a society, again with John Howard as the prime mover. The Toronto Society of Arts was limited to professional artists, and the organizers went far afield to invite serious contributors. Nelson Cook from upstate New York, John Linnen also of New York, and S.B. Waugh then of Philadelphia—all itinerants included in the 1834 exhibition—were again represented. Cornelius Krieghoff, recently settled in Montréal (although he had stopped briefly in Toronto

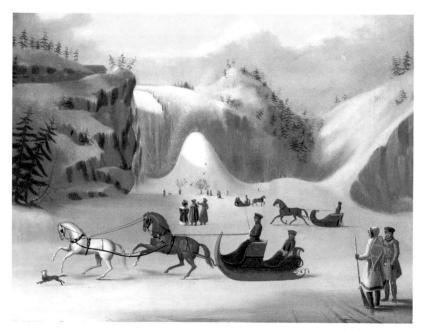

III—Robert Todd. The Ice Cone, Montmorency Falls, c.1845. Canvas, 34.2×45.6 . NGC.

 $v-John \ O'Brien, Halifax Harbour, Sunset, c.1853. Canvas, 49.5 <math display="inline">\times$ 76.0. Halifax Board of Trade.

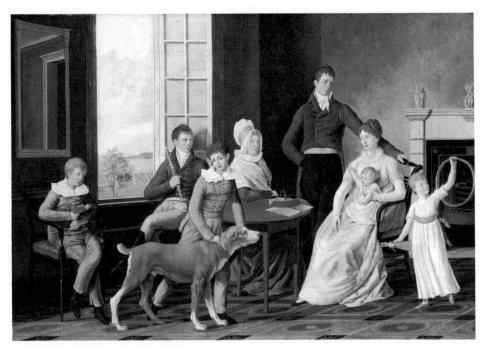

v—William Berczy. The Woolsey Family, 1809. Canvas, 65.4 × 87.5. NGC.

in 1844), also exhibited. Paul Kane showed again. Berthon and Hoppner Meyer both displayed portraits. It was an impressive exhibition for Toronto, and another was held in 1848. Kane held a one-man exhibition late in 1848, marking a new stage in the public appreciation of painting that would lead ultimately to the Ontario Society of Artists and the perpetuation of serious painting in Toronto to this day.

French-speaking Artists in Montréal 1785–1830 and Québec 1820–1860

We have seen that during the French regime the focus of all patronage for painting in Canada was the Church. After the Conquest a growing moneyed class in Québec and Montréal, both French and English, responding to the stability of peace after decades of war, began to show a new interest in painting. Portraiture became almost a fad in the 1780s and 1790s and several French-speaking artists rose to the occasion. In Montreal especially there seems to have developed what might be called a local school of portraiture. A number of portraits have survived from the two or three decades both before and after the turn of the century, but many are in a sorry state of preservation. Virtually all are half-length, or even just head-and-shoulders, and almost none are signed. They have as a group been called 'primitive' or 'naïve', although they display characteristics often found in developed provincial schools of painting. Generally shallow in modelling, they are decoratively embellished, and follow one or two simple portrait compositions. The clothes of the period, particularly the elaborately gathered head-dresses of the women, were well suited to such a schematized, decorative handling. Very little critical study has been brought to bear on this important body of material and most of the pictures extant have been attributed to the more familiar painters. Most attributions are thus suspect. There are some paintings, such as the beautiful *Mrs Charles Morrison (NGC), that might be the work of itinerant Americans. We do, however, know of three portraitists who distinguished themselves in Montréal during the last two decades of the eighteenth century.

The most prolific, by all accounts, was LOUIS DULONGPRÉ (1754–1843), a Frenchman who settled in Montréal in the mid 1780s and who, according to an obituary, is supposed to have painted over 4,200 portraits. Since he is known to have travelled throughout the province seeking church

Anonymous. *Mrs Charles Morrison*, c.1825. Canvas, 66.0 × 56.5. NGC.

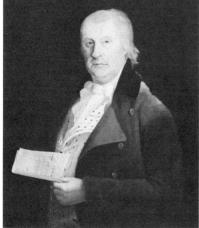

Louis Dulongpré. *James McGill*, 1806. Canvas, 84.5 × 68.0. MQ.

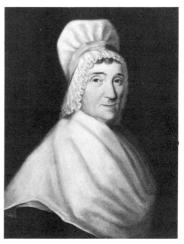

Attributed to Louis-Chrétien de Heer. *Mme Gabriel Cotté,* c.1805. Canvas, 63.5×50.0 . The Detroit Institute of Arts.

work, not all of these would have been painted in Montréal. Considering the attributed paintings, his work seems extremely uneven in quality. His best portaits, however, such as **James McGill* (MQ) of 1806, are strong, almost severe likenesses, yet decorative and—even in the depiction of male clothing—lively. Simple clothing has been exploited particularly

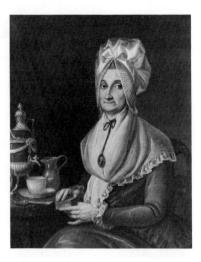

François Beaucourt. *Mme Trottier dite Desrivières*, 1793. Canvas, 80.0×64.0 . MQ.

well in the portrait of **Mme Gabriel Cotté* (Detroit Institute of Arts), attributed to another of these Montréal portraitists, LOUIS-CHRÉTIEN DE HEER (1760–before 1808), who was born in Alsace and worked in Montréal from about 1783. He opened a studio in Québec in 1787, was back in Montréal in 1789, and seems to have worked in both cities until his death.

A native Canadian, FRANÇOIS MALEPART DE BEAUCOURT (1740–94), was the best of this group of Montréal portraitists, though he worked in Canada for only the last years of his life. The son of the painter Paul Beaucour, he was born in Laprairie, outside Montréal. Not much is known of his early life. His mother was remarried to a soldier within a year of her husband's death, and it is possible that the whole family moved to France after the Conquest. We first hear of François again in 1773 in Bordeaux when he married the daughter of his painting master. Between then and 1779 there are few records, and it may be, as was later reported, that he travelled to Russia during this period. Settled back in Bordeaux as a painter, he was accepted into the local academy in 1784.

Later that year Beaucourt declared his intention to return to America. His famous *Portrait of a Black Slave* (MCC) is dated 1786, and it has been suggested that he painted it while sojourning in Guadeloupe. He next is documented in Philadelphia in January 1792 (advertising as a French portraitist and decorative painter), and finally in June of that year his advertisement appeared in the Montréal *Gazette* (presenting him as a returned Canadian). As we can see from his **Mme Trottier dite Desrivières* (MQ) of 1793, the delightfully decorative and light provincial rococo style he had learned in Bordeaux was not out of place in his home town.

Québec had its portraitists too, but there was then only one of interest, and he has been better known as an architect and a sculptor. FRANÇOIS BAILLAIRGÉ (1759–1830) was a brilliant, many-talented man. From an artistic Québec family—his father was also a sculptor and architect—Baillairgé was sent to Paris in the summer of 1778 and enrolled in the Académie Royale early the following year. After studying as well with the sculptor Jean-Baptiste Stouf and in the studio of the painter Simon Julien, he returned to Québec in the summer of 1781. Working at first with his father and a brother, he established his own studio in 1784, and his surviving account book for the period until 1800 reveals that he received numerous portrait commissions, particularly among the military. (He himself rose to the rank of major in the militia.) The few of these portraits known today are crisply decorative and colourful in the best local manner.

When examining French-speaking artists in Lower Canada during the nineteenth century, then, it is important to remember the rich precedent set by these earlier portraitists. This is most evident in the case of JEAN-BAPTISTE ROY-AUDY (1778–*c*-1848). Born at Québec, Roy-Audy received what little training he had in his home town. He was apprenticed for a short while (1799–*c*.-1802) to François Baillairgé and worked first as a carver, and gilder, but by 1818 he was describing himself as a painter. Most of his early work was for the Church.

Roy-Audy travelled quite widely following church commissions; he worked in Rochester, N.Y., from 1834 to 1837, and in Toronto in 1838. As with the painters of the generation before, the extent of his work is unclear to us at present. Only a few signed paintings have been found, and the dissimilarity of works attributed to him has led to confusion and doubt. From his **Portrait de l'Archiprêtre P. Fréchette* (NGC) of 1826, however, we can see that he continued in that wonderful tradition of portraiture we have been able to isolate at the end of the previous century. If anything he lavished even more sensitive care than did his predecessors on the repeating forms of hair and head, and managed to present the simple clothing of a priest as a decorative delight. Roy-Audy represents the end of what had become a strong native tradition by bringing the style of portraiture that flourished in the late eighteenth century to a culmination early in the nineteenth.

One reason for the flowering of a local school of portraiture just before and after the turn of the century may have been Canada's enforced separation from current French cultural forces caused by the French Revolution and the Napoleonic Wars. Following the Second Peace of Paris in November 1815, however, direct contact again became possible. Two French priests were among the first to re-establish a trade in paintings. 42 | French-speaking Artists in Montréal and Québec

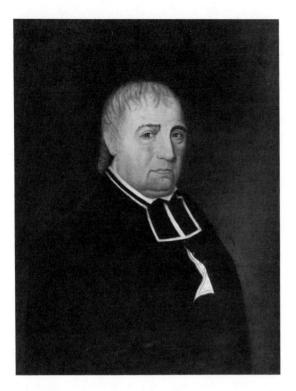

Jean-Baptiste Roy-Audy. Portrait de L'Archiprêtre P. Fréchette, 1826. Canvas, 66.6 × 51.5. NGC.

Abbé Philippe-Jean-Louis Desjardins had served in Lower Canada from 1793 to 1802. He had left France following the Revolution, and the Peace of Amiens in 1802 gave him a brief opportunity to return to Paris. There he immediately began buying works of art-paintings seized from monasteries and churches by the French government as early as 1791 that were first placed on public sale in 1798-for the churches of Lower Canada. Desjardins acquired more than a hundred of these within a year. (At least one, sold by the government in 1800, he bought from a 'ruined banker'.) Writing the following year to his brother who had stayed in Québec, he said he was 'only waiting for Peace' before shipping them out. But he would not have an opportunity until the defeat of Napoléon in 1815. A year later part of the shipment left France and arrived in Québec in the spring of 1817. His brother, Abbé Louis-Joseph Desjardins, installed them in the Hôtel-Dieu and offered them for sale. The second half of the shipment arrived three years later, and over the years until his death in 1833 Philippe continued to acquire in Paris paintings, silver, and even holy relics for sale or donation to Canadian churches. LouisJoseph, who remained in Québec until his death in 1848, continued to act as his brother's agent and generally assisted with the arts.

Most of the Desjardins Collection, as it is known, consisted of copies or the work of minor painters (though at least one major altarpiece by Philippe de Champaigne still exists). These works took on great symbolic significance in Canada as representing a legacy of French visual culture. Also, these landscapes, still lifes, religious and historical pictures represented a range in painting that Canadian artists had never to that time considered. Many of the pictures were bought by one remarkable man, JOSEPH LÉGARÉ (1795–1855), and were later exhibited in his private museum, the first art gallery in Canada.

Légaré was born in Québec and apparently harboured a great love for painting even in his early youth. When he bought some thirty of the Desjardins pictures in the summer of 1819 he immediately set about restoring and cleaning them. Apprenticed as a decorative painter in 1812, he accepted his own first apprentice in the trade five years later. As far as we know this was his only artistic training. Commissions began to arrive for copies of the pictures, and for the next few years copying was his main activity and principal source of income. He continued to build his collection—adding a large group of prints as well as more pictures and opened it to the public in 1838 and again in 1852. Twenty years after his death in 1855 a large part of it was acquired by Université Laval, and this forms the core of their present holdings.

As might be expected of someone whose skills were the result of years of copying old European pictures, much of Légaré's original work has the look of old, darkened European painting. Such is his wry comment on the British Conquest, the Paysage au monument Wolfe (MQ) of about 1840, with its romantic blasted trees (copied from a Salvator Rosa print), crumbling ruin, classic noble Indian, and dark tonality. But this look should be seen positively as an attempt to introduce a new set of premises into the art of painting in Canada-a small awareness of the value of some 350 years of accumulated visual history. As early as 1828 the Montreal Society for the Encouragement of Science and Art recognized this fact in awarding Légaré their medal, the citation of which described him as Canada's first 'historical painter': that is, a painter of epic themes from the past. Only portraits and religious pictures had been painted before. Of course Légaré painted these too. His religious pictures, again, were copies, like all those painted in Canada, and many of his portraits were also copies. There was a portrait of Lord Elgin, and one of Queen Victoria after Thomas Sully, which he raffled off. Another large portrait, copied from a copy by an English painter named Wheatley of Sir Thomas Law44 | French-speaking Artists in Montréal and Québec

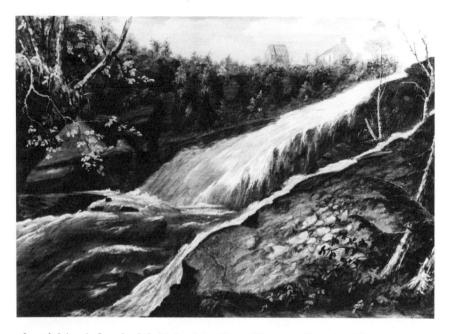

Joseph Légaré. Cascades de la Rivière Saint-Charles à Jeune-Lorette, c.1840. Canvas, 57.2×83.7 . MQ.

rence's portrait of *George IV*, was exhibited in Québec in August 1829 and was sold by Légaré to the government for the Legislative Council Chamber later that year. Légaré's version was highly praised at the time both by the governor and the garrison artist, Lieutenant-Colonel Cockburn. (Roy-Audy sold a copy *he* had made of the Wheatley copy to decorate the Legislative Assembly Chamber the following January.)

Légaré's most original contribution, however, was in the field of landscape. He is certainly one of the earliest Canadians to paint oil pictures of the local scenery. Some of these are obviously related to wild romantic visions of the Salvator Rosa variety; Légaré owned a number of prints after paintings by this famous seventeenth-century Italian. But, encouraged by the garrison artists, he also painted the Canadian landscape directly and frankly, as in his **Cascades de la Rivière Saint-Charles à Jeune-Lorette* (MQ) of about 1840. Here there is no attempt to press the experience into a European mould. His most remarkable works, however, are those that are painted in response to community crises of vast proportions. As early as the 1830s he depicted the horrors of the cholera plagues that swept through Canada, killing thousands. In 1841 a rock slide at Cap-

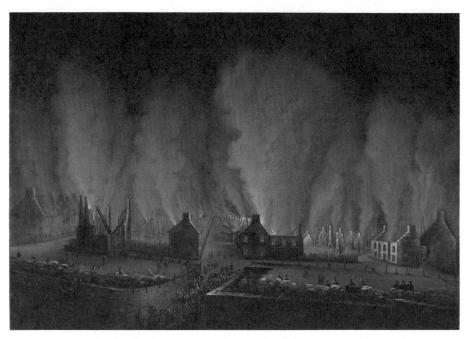

vI—Joseph Légaré. L'Incendie du quartier Saint-Jean à Québec, vue vers l'ouest, 1845. Canvas, 151.0 \times 221.0. AGO.

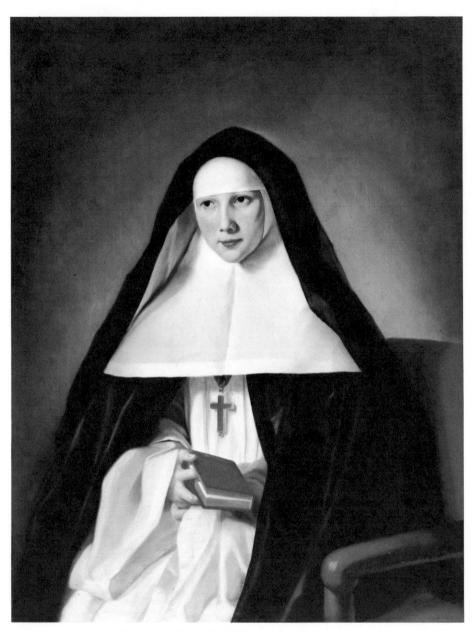

VII—Antoine Plamondon. Sœur Saint-Alphonse, 1841. Canvas, 91.5 × 72.4. NGC.

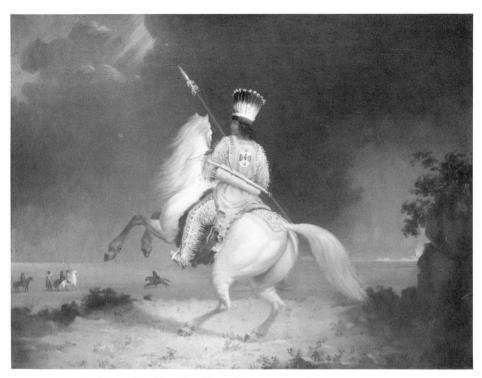

VIII—Paul Kane. The Man That Always Rides, 1849–55. Canvas, 46.3 × 61.0. ROM.

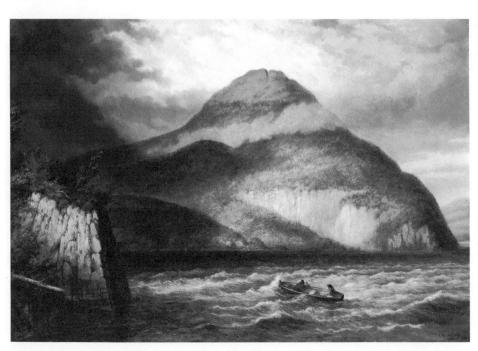

IX—Cornelius Krieghoff. Owl's Head, Lake Memphremagog, 1859. Canvas, 43.7 × 61.0. NGC.

aux-Diamants in Québec impressed him so greatly with its horror that he recorded it on canvas. And a terrible fire in the Québec suburb of Saint-Roch at the end of May 1845, which destroyed 1,650 houses and took more than 20 lives, was depicted in two huge panoramic views (MQ). Exactly one month later the more prosperous Saint-Jean suburb burned, destroying 1,302 houses and taking ten lives. This time he made a large painting of the conflagration at its height in *†L'incendie du quartier Saint-Jean à Québec, vue vers l'ouest* (AGO—a larger, more finished version than that reproduced in the First Edition), as well as a smaller one of its helllike, smouldering aftermath (AGO).

None of Légaré's apprentices appear to have emulated his interest in community concerns nor his innovations in landscape. His most famous student, in fact, marked out a successful career in the field of portraiture. ANTOINE SÉBASTIAN PLAMONDON (1804–95) was born in Ancienne-Lorette, near Québec, and at the age of fifteen was apprenticed to Joseph Légaré and set to work restoring and copying the Desjardins pictures. By 1825 he had absorbed all that Légaré and his pictures could teach and set up his own studio. The next year his work came to the attention of the vicargeneral of Québec and money was found to send him to Paris. (It had been forty-eight years since the last French-Canadian, François Baillairgé, had gone to France to study.) Plamondon enrolled with Paulin Guérin, a minor classical portraitist and friend of the Desjardins brothers.

In Paris Plamondon soon achieved the refined austerity of the classical style. He stayed in the French capital for four years, until the Louis-Philippe uprisings of 1830 when he returned to Québec. He opened a studio, advertising himself as an 'élève de l'École française', and portrait commissions began to appear almost immediately. Sitters like Thomas Paud, who was painted in 1831 (MMFA), were delighted with the severe classical treatment they received at the hands of the young portraitist. By the mid-1830s Plamondon was firmly established in Québec, and in 1836 he travelled to Montréal to expand his business. There he accepted a commission to paint fourteen pictures to form a Stations of the Cross in the church of Notre Dame. He took a larger studio back in Québec to complete them; then, much to his surprise, he found them rejected because he had not adhered to the prototypes chosen for copying by his clients but had selected his own. In Québec, however, he was succeeding so well that he began to consider the city his personal precinct and guarded his 'rights' jealously. Any itinerant painter who dared set up shop was viciously attacked in the newspapers. Some actually fled in the face of this abuse.

Plamondon reached his prime about 1841. In that year he painted a

46 | French-speaking Artists in Montréal and Québec

Antoine Plamondon. La Chasse aux tourtes, 1853. Canvas, 184.0 × 183.0. AGO.

Théophile Hamel. *L'Abbé Edouard Faucher*, 1855. Canvas, 107.0 × 81.0. Église de Saint-Louis, Lotbinière.

Théophile Hamel. *Autoportrait*, c.1840. Canvas, 122.0 × 102.0. Séminaire de Québec.

series of three young nuns of the Hôpital-Général, all daughters of prominent Québec merchant families. They are among the most beautiful and moving portraits ever painted in Canada. Each is distinguished by wonderfully balanced colour, simplicity of composition, delicate but full modelling, and a remarkable sense of psychological penetration—as in *Soeur Saint-Alphonse* (NGC). Attention to the texture of the clothing and to the space within which the carefully modelled forms are placed conveys aspects of character only hinted at in the intelligent yet impassive face.

Throughout this period Plamondon continued to fill religious commissions, and even painted scenes of everyday life. But most of these genre scenes, including the memorable **La Chasse aux tourtes* (AGO), date from after 1851 when he gave up his Québec practice and retired to the country at Neuville. There he lived as a gentleman-farmer and respected grandmaster of his art. One of his last works is an *Autoportrait* (Séminaire de Québec), painted at the age of seventy-eight. He lived for another thirteen years.

Plamondon affirmed the dominance of Québec over Montréal in the painting sphere—at least among French-speaking artists. And there was certainly no other painter in Canada who could approach him in his best years, from about 1835 to 1845. When he did choose to leave the field, his place was taken by one of his apprentices. THÉOPHILE HAMEL (1817–70) was also born in the Québec region, in the suburb of Sainte-Foy, and was apprenticed to Plamondon at the age of seventeen. An **Autoportrait* in the Séminaire de Québec was painted some six years later, probably as his 'master' piece—proof of his skill and advertisement of his standing as an independent painter as he was about to leave Plamondon in 1840. Although it has a quality of gentleness not usually found in Plamondon, its classical composure indicates the influence of the older painter. Hamel set up his own studio in Québec, but by 1841, finding it necessary to seek commissions elsewhere, he became essentially itinerant.

In 1843 Plamondon persuaded Hamel to go to Europe to further his studies. With a few copying commissions to help pay the way he left for London, went on to Rome, and after some time moved on to Naples. From there he travelled to Venice, where he again worked for a while. In 1845 a public subscription was raised in Québec to allow him to stay another year, and when the money arrived he headed north. He visited Belgium and France and finally in 1846 returned home. As attested by another *Autoportrait* (MQ) with warm colours and softly modelled forms painted following his return, he was now an accomplished, up-to-date Romantic. He was back in a Québec studio by late August, but in a little

48 | French-speaking Artists in Montréal and Québec

over a year moved to Montréal possibly to leave Plamondon alone, but certainly to locate at the new seat of government of the United Canadas, which had been established in the commercial centre of the country while he was in Europe. When the government moved to Toronto after the burning of the parliament in Montréal in 1849, Hamel followed, spending three months in the principal city of Canada West after the opening of the legislature in May 1850. When the government moved to Québec again late in 1851, so did Hamel, closing his Montréal studio for good. This may have hastened Plamondon's retirement, but for whatever reason Hamel had the field to himself after 1851. Orders flowed in. He was commissioned by the parliament of the United Canadas in 1853 to paint the present and all the past Speakers of both the legislative council and the assembly. Over the next few years, he travelled to Montréal, Ottawa, Kingston, Toronto, and Hamilton fulfilling the commission and probably finding more work at every stop. Like all Québec artists, he did church work as well, although his religious pictures appear to be particularly uninspired.

The centre of Hamel's best period seems to have been about ten or twelve years after Plamondon's—that is, about 1852–4. A portrait of **L'Abbé Edouard Faucher* (Église de Saint-Louis, Lotbinière) of 1855, still in the church it was painted for, comes closest to challenging Plamondon. The same attention to texture and substance and the expressionless yet engaging face brings us uncomfortably close to the sitter's character. Nuns and priests seem to have been the most accessible of all sitters to these painters.

Hamel had an active career until close to his death in 1870. But by 1860 his work was in decline. A portrait of *Sir Allan MacNab*, painted in 1862 and now hanging in the Senate of Canada, displays a hollow monumentality, an almost comical overscaling that nevertheless reveals the self-important politician that MacNab seems to have been.

In the same year that Hamel painted MacNab, another Canadian artist was hailed in Québec as the greatest the country had produced. This was ANTOINE-SÉBASTIEN FALARDEAU (1822–89), a curious figure whose career represents the culmination of the taste of the time—the preference for manual facility over creativity. Born near Cap-Santé, Falardeau moved to Québec about 1836 to study art: he is recorded as working with R.C. Todd and others. In 1846 a public subscription sent him to Florence, where he soon established a reputation as a copyist. He married well in Italy, and painted well too, for when he returned to Canada on a short visit in 1862 he was able to style himself *Chevalier* Falardeau on the strength of at least two Italian knighthoods. Although his entire career

as a sought-after copyist was spent in Italy, from the mid-fifties many of his paintings made their way to Canada. He also held large sales in 1862 and on his only other trip home in 1882.

Despite Falardeau's contemporary fame, a true successor to Hamel, a continuation of that dynasty of artists stretching back to Joseph Légaré in the early decades of the century, would have to be found among those who were prepared to serve their own community directly. Hamel's nephew, Eugène Hamel (1845–1932), who took over the master's Québec studio in 1870, certainly laid claim to the role, although his work is not only both slick and dull but limited in ambition. The true successor to Hamel was another of his student-apprentices, one who made his base not in Québec but in Montréal.

NAPOLÉON BOURASSA (1827–1916) was born in L'Acadie, and after receiving a classical education studied law in Montréal, 1848–50. At the same time he frequented Hamel's studio until the master returned to Québec in 1851. Bourassa left for Europe in 1852, and on his return three years later set up a studio in Montréal. He married the daughter of Louis-Joseph Papineau in 1857, and henceforth passed his time between summers on the Papineau estate at Montebello and a series of studios in Montréal. One of the prominent figures of his day, he achieved fame as a critic, a novelist, and an architect, as well as a painter. Indeed, painting was not the first among his achievements, even if it was so ranked in his aspirations.

Greatly influenced by contemporary mural painting in Italy and France, Bourassa was not content with a career as portraitist and church decorator. His one great project, a vast mural celebrating European civilization in the New World, *The Apotheosis of Christopher Columbus*, was never fully realized, however, and the easel paintings that have come down to us too often achieve a sugary perfection that is strangely morbid. Out of sympathy with the old traditions he sought to supplant, Bourassa nonetheless failed effectively to establish a new one, and by the end of the century both formal portraiture and church art in the grand tradition can be said to have run their course.

Paul Kane and Cornelius Krieghoff 1845–1865

Although PAUL KANE (1810-71) claimed to have been born in York, he actually arrived in the small capital of Upper Canada at about the age of nine. He was born in County Cork, Ireland, and crossed the ocean with his family. His father set up in York as a 'wine and spirits merchant' on the corner of present-day Yonge and Adelaide Streets. Kane was apprenticed as a 'decorative painter' to W.S. Conger, who ran a furniture factory on Front Street. Around 1830 he approached Thomas Drury (active 1825-33), the drawing master at Upper Canada College, for a critique, and Drury took Kane as a pupil. Kane was by then established on King Street as a coach, sign, and house painter. Although there was no possibility at that time of an artist's supporting himself in Toronto other than by teaching or by working as a house painter or decorator, there was a small art scene. Its clearest manifestation was the Society of Artists and Amateurs, and in the newspaper notices of the 1834 exhibition Kane was singled out for praise. As we have seen (p. 35), there were itinerant artists in Toronto in 1834. Two of them, the Americans S.B. Waugh and James Bowman, were friends of Kane. They doubtless opened Kane's eyes to the possibilities of a career as a painter.

Later in 1834 Kane moved to Cobourg, a prosperous, growing community east of Toronto on Lake Ontario. Whether he went there to follow his old employer, Conger, who had moved to Cobourg in 1829, or to pursue portrait commissions is not clear. He did not work for Conger but possibly for a man named Clench, who also made furniture. (Years later Kane married Clench's daughter Harriet.) Kane spent almost two years in Cobourg and there got his start as a portraitist. His work of this period is difficult to identify. He apparently completed at least a dozen portraits, though none are signed. Kane had kept in touch with Waugh and Bowman. In 1836 he left Cobourg for Detroit, from which the three of them had planned to leave together for Rome. But Bowman had just been married, and Waugh had apparently set out for Italy alone, so Kane decided to rent a studio in Detroit. He advertised for portrait commissions and worked there for more than a year before moving on to St Louis and then down the Mississippi to New Orleans, where he arrived late in 1838. A few more commissions got him to Mobile, Ala, where he again rented a studio. In the two-or-so years Kane spent in Mobile he achieved a reputation sufficient to be featured in the local newspaper. Finally he saved enough money for his trip to Europe, and on June 18, 1841 he sailed from New Orleans.

After a sea voyage of almost three months Kane arrived in Marseilles. He left immediately for Genoa and then for Rome, which was at that time the world centre of art study. (Hamel arrived two years later.) The winter was spent copying Old Masters. Murillo, Andrea del Sarto, and Raphael appear to have been Kane's favourites. He copied portraits primarily and was most concerned to increase his skill in the use of colour.

In March 1842, with a young artist from Edinburgh, Kane visited Naples and then headed north, hiking through northern Italy until the autumn, still copying Old Masters. These canvases were shipped to London and then the two young men crossed into Switzerland and made their way to Paris. On October 20 they sailed from Calais and were soon in London. As Russell Harper has pointed out, Kane's sojourn in London was to be the great turning-point in his career. He had worked almost exclusively as a portraitist and all of his studies in Europe seem to have been aimed at improving his ability in that field, but in London his discovery of the work of the American artist George Catlin caused his interests to shift dramatically and irrevocably.

Between 1830 and 1836 Catlin had painted among some forty-eight different Indian tribes as far west as the foothills of the Rockies. He may at first have considered the Indians simply as exotic or picturesque subject-matter, but he soon grew to understand their culture and society and became distressed by their plight. His travels on the frontier convinced him that he was witnessing the initial stages of the Indians' destruction. Catlin was not alone in realizing this, but in a romantic era the response was one of reflective pathos rather than outrage. Even Catlin accepted the inevitability of the disappearance of Indian culture, and perhaps of the Indian race. For him the most important need was to make a visual record, and he dedicated his life to that end. It was this record, displayed in a gallery in London's Piccadilly, that inspired Paul Kane.

Letters to Kane from his English friends suggest that when he left London in the spring of 1843 he was determined to return to Toronto and to set out from there to record a gallery of Canadian Indians that would surpass Catlin's record. In fact he went back to Mobile and worked there for two more years. But finally, in the spring of 1845, after nine years' absence, he returned to Toronto. Now thirty-five years old, he was ready to proceed with his great plan. On June 17, 1845 he set out on a sketching tour among the Indians, visiting first the Saugeen reservation on Lake Huron, then travelling through to Georgian Bay, northern Lake Michigan, and heading south into Wisconsin. His one artistic aim was to depict the true appearance of the Ojibwa and their environment and he was determined to paint as many portraits as possible. The portraits he sketched in oil and pencil, as well as his drawings of houses, villages, rituals, ceremonial and other tools, impress us even today as being direct, informative, and visually pleasing.

Before returning home Kane called at Sault Ste Marie, where Lake Huron joins Lake Superior, and there met John Ballenden, the local Hudson's Bay Company factor, to whom Kane described his ambitious plan. Ballenden wrote to Sir George Simpson, governor of the Hudson's Bay Company, asking him to assist Kane. Simpson was the virtual ruler of all the land we call Manitoba, Saskatchewan, Alberta, British Columbia, Washington, and Oregon, and of the vast region to the north. All fur-trading forts were owned and administered by the Company and any traveller proceeding west of Sault Ste Marie was dependent on the Company's hospitality. It was essential that Kane receive Simpson's support.

Kane returned to Toronto late in the fall of 1845 and followed up Ballenden's letter with one of his own. He then rented a studio and began to paint his first Indian canvases. **Indian Encampment on Lake Huron* (AGO) was probably painted during the winter of 1845–6. It does not retain the fresh clarity of the sketches, but from the careful composition, the richly orchestrated sky, the variety of anecdotal detail, and overall sense of refined harmony and rational order, we recognize the values Kane had absorbed in European salons and museums. His sketches were for him mere notes; he intended that his reputation as an artist—as the exponent of clear, thought-out visual experiences—should stand on his larger canvases.

Early in 1846 Kane still had received no reply from Simpson. In March he decided to call on Sir George in Montreal and on the strength of that visit was able to arrange to travel to the Lakehead with him. The party left Toronto on May 9. Everything proceeded smoothly until at one overnight stop Kane was accidentally left behind. He hired a rowboat and

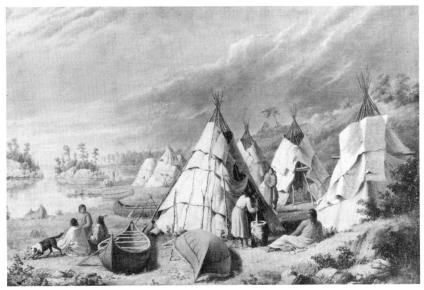

Paul Kane. Indian Encampment on Lake Huron, 1845–6. Canvas, 48.2 × 73.6. AGO.

some men and set out in full chase. When he overtook Simpson's party at Rainy River, Simpson was so impressed with Kane's determination that he supplied him with a letter giving him the right to travel with the fur brigades and free hospitality at all Company posts. Kane now began an unprecedented artistic adventure. He travelled with Simpson as far as Fort Garry. While there he was first confronted by one of his favourite subjects, the buffalo, which he sketched even while taking part in one of the last great hunts. He described the scene as 'one of intense excitement; the huge bulls thundering over the plain in headlong confusion, whilst the fearless hunters rode recklessly in their midst, keeping up an incessant fire at but a few yards' distance from their victims.' He was thrown from his horse and 'was completely stunned, but soon recovered my recollection'. On July 5 he left Lower Fort Garry in a sloop with a brigade of traders and proceeded up Lake Winnipeg. Taking the Saskatchewan River route, they headed west and arrived in Fort Edmonton towards the end of September. On October 6, despite the threat of an early winter, the traders struck out to cross the Rockies, Kane with them. After great suffering from snow and cold, they reached Fort Vancouver on the Lower Columbia River on December 8.

Kane passed the winter in the immediate area of the fort, but in February he began to explore the country, which was about to be ceded to

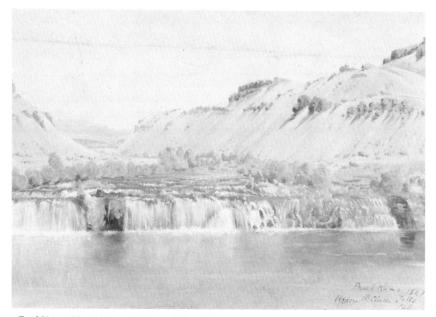

Paul Kane. The Falls on the Upper Pelouse River, 1847. Paper, 20.6 \times 33.9. Stark Foundation, Orange, Texas.

the United States. He travelled far and wide throughout the Oregon Territory and northwest to the coast, sketching such natural wonders as **The Falls on the Upper Pelouse River* (Stark Foundation). After about eight months on the coast he headed back east on July 1, 1847. Delayed frequently in the Rockies, he again found himself deep in snow and subzero weather, but he reached Fort Edmonton early in December. He spent the winter there, happily involved in the social activities of the holiday season. When the weather allowed, he ventured out on excursions. One of his favourite companions was a Métis guide named François Lucie, whom he sketched (Stark Foundation). He left the fort in April and on the first of October reached Sault Ste Marie, two-and-half years after he had visited that post on his way west. There he caught a Great Lakes steamer and returned to Toronto in some comfort. He reached home on October 13, 1848.

News of his travels spread quickly. Interest was so great that it was suggested to Kane that he hold an exhibition of his sketches in the old City Hall on Front Street, then being used as a market. Kane agreed, and the exhibition, one of the first public one-man shows held in Canada, was opened on November 9, 1848. There is a catalogue listing 240

sketches in oil and watercolour, as well as various Indian artefacts collected by Kane. The newspaper reports unanimously praised him, recognizing the qualities of objectivity and factuality that Kane himself valued. They acknowledged Catlin as a predecessor but considered the Canadian to be superior. In their view Catlin was too romantic.

Greatly impressed with the success of the Toronto showing, Sir George Simpson offered to sponsor an exhibition in Montreal. Kane declined; he wanted to get on with the canvases he planned to work up from the sketches. Then, in the spring of 1849, he accepted the invitation of a young aristocratic British adventurer who offered Kane £200 to accompany him and two others on a journey to the west coast; after a series of misadventures, however, Kane was back in Toronto by mid-September. (He appears to have done no sketching at all on this trip.) He set himself up in his King Street studio and by 1851 had completed some of the grand cycle of one hundred canvases that were to constitute a panorama of Indian life from the Great Lakes to the Pacific. Eight were exhibited that fall at the Upper Canada Provincial Exhibition in Brockville. Kane attended the opening and was treated as a celebrity. The reviews were lengthy and laudatory.

The canvases painted after the summer of 1849 show no change in style from those of 1845–6. Beginning as usual from one of his beautiful, sparkling sketches—which he still considered to be the raw material of his

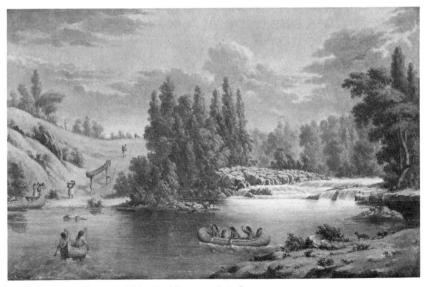

Paul Kane. White Mud Portage, 1856. Canvas, 44.4 × 72.4. NGC.

art, a record of the immediate experience-he proceeded to construct a large showpiece canvas. He took pains to introduce qualities of reflection and taste, seeing his work as part of a long tradition of European painting. The landscapes—like his *White Mud Portage (NGC)—are carefully composed and thoughtfully modelled to be harmonious and pleasing to the eye. (One of the reviewers of the 1851 exhibition in Brockville thought Kane's compositions were 'a little similar to some of Poussin's'.) *†The* Man That Always Rides (ROM), for which there is no known sketch, is a work of the imagination, in which the dramatic landscape is a fitting stage-set for the elegantly caparisoned white horse and its equally elegant rider-a natural aristocrat of the prairie. Kane would have seen such a romantic equestrian pose in European pictures. Even the individual portraits are in this same tradition of European romanticism. Intense, emotional colour in both costume and flaming sky bring highly charged associations of violence that did not exist in the original sketch to **Mah*-Min or 'The Feather' (MMFA). Nor is the brutality we see in Mah-Min's face borne out by Kane's description of meeting the Assiniboine chief, who 'permitted me to take his likeness, and after I had finished it, and it was shown to the others, who all recognized and admired it, he said to me, "You are a greater chief than I am, and I present you with this collar of grizzly bear's claws, which I have worn for twenty-three summers, and which I hope you will wear as a token of my friendship." This collar I have, of course, brought home with me.'

Kane applied for government assistance while completing his canvases. The appeal dragged on, gradually gaining support, until in August 1851 the government decided that, rather than award a grant, it would purchase twelve canvases for \pounds_{500} . These would be replicas painted by Kane of existing works in his cycle of a hundred. Content with the guarantee of that income, Kane returned to his work-and put off deliverv for almost five years. The government threatened to sue and in the spring of 1856 Kane delivered the twelve canvases. Eleven of them-one was destroyed in a fire-are now in the National Gallery of Canada. The full cycle of a hundred appears to have been finished late in 1855. Amazingly enough Kane found a buyer in Toronto-the wealthy George Allan, a collector of sorts who had befriended Kane at the time of his 1848 show. Allan paid \$20,000 for the hundred canvases and displayed them in his house until his death in 1901, when they were purchased by Sir Edmund Osler; in 1912 they were donated to the Royal Ontario Museum. So, some fifty-five years after they were completed, they finally ended up on permanent public display as a group, as Kane had wished.

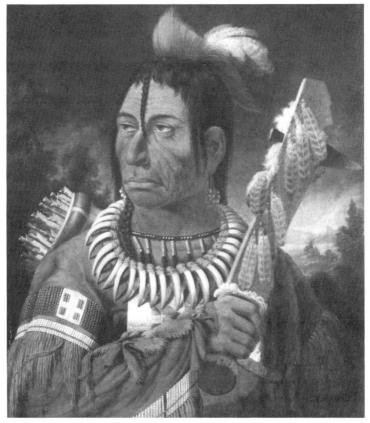

Paul Kane. Mah-Min or 'The Feather', c.1856. Canvas, 76.2 × 63.5. MMFA.

These hundred canvases, completed over about a six-year period, were the culmination of Kane's life work. He did little else afterwards. In 1853, at the age of forty-four, he had married his old sweetheart, Harriet Clench of Cobourg. They built a house on Wellesley Street in Toronto and began to raise a family. Kane's travels were over.

Only one more work of art can safely be dated to the period following the completion of Kane's canvas cycle in 1855. This is a lithograph of *The Death of Big Snake*, published in Toronto in 1856, the first large coloured lithograph produced in Canada. Kane did not witness the incident depicted—Big Snake in fact died in 1858—but he expressed it as an episode of violent nobility, played out on a stage that existed only in the romantic reveries of the artist.

This print was probably made to help advertise the second part of Kane's Indian program, the publication of an illustrated book of his travels and experiences among the Indians. From the time he completed his canvases early in 1856 until the book's publication in 1859, his energies appear to have been concentrated on this one project. The first evidence of his literary efforts appeared in March 1855 when he read a paper to the Canadian Institute on the Chinook Indians; this later appeared virtually unchanged as a chapter in his book.

In 1858 Kane went to London to find a publisher. He consulted Simpson before leaving and in London had the assistance of his Toronto patron, George Allan, who was there on business. After some delay he found a British publisher and in 1859 his Wanderings of an Artist Among the Indians of North America appeared, illustrated with thirteen wood engravings of his sketches and eight chromo-lithographs after the Allan canvases. Dedicated to George Allan,* the book was an immediate success and attracted considerable critical attention, including a lengthy and enthusiastic review in the prestigious Revue des deux mondes of Paris. The English edition sold out quickly and three foreign-language editions appeared in quick succession: in French (1861), in German (1862), and in Danish (1863). Its popularity has never seriously waned. Its interesting anecdotes, exciting incidents, and vivid descriptions of the life of Indians, Métis, white traders, and missionaries just before mid-century unfold in a measured narrative of compelling authenticity. It is a Canadian classic. A 1925 edition was reprinted in 1968; that has been superseded by a lavishly illustrated scholarly edition (1971), with a biographical introduction and notes by Russell Harper.

Kane had plans for a further publication, a selection of prints with explanatory text, but it never appeared. Partial blindness, first noticed in 1859, increased over the years and he withdrew from public life. After the publication of his book he stopped exhibiting and apparently stopped painting as well. He gave up his studio in the early 1860s. During his last years he was a familiar if somewhat aloof figure in Toronto. In the warm weather he visited Toronto Island every day and doubtless dreamed of his two-and-a-half years of adventure in the West. He died on February 20, 1871, a legend from the past in his own time.

There is no record that Paul Kane ever knew CORNELIUS KRIEGHOFF (1815-

*Simpson was deeply offended that his support was not acknowledged. This apparently led to a complete falling-out and may have had something to do with the curtailment of Kane's travels in later life. In 1861 he considered a trip to Labrador but made it clear in a letter that he no longer had Sir George Simpson's necessary support for such a venture. 72), although the rumour that they once met in Toronto is passed on by Marius Barbeau in his biography of Krieghoff (1934). It is true that both painters exhibited with the Toronto Society of Arts in 1847, but Kane's five works were submitted by an agent, for he was then on the Pacific Coast, and we have no reason to believe that Krieghoff, who was then living in Longueuil, opposite Montreal, accompanied his three canvases.

Little is known of Krieghoff's early life, although it has been established that he was born in Amsterdam of a German father and a Flemish mother. He spent most of the first seven years of his childhood in Düsseldorf and then moved with his family to Schweinfurt, Bavaria. It has been suggested that he trained as a painter, and possibly as a musician, back in Düsseldorf. There are no records to confirm this, and indeed no further trace of Krieghoff emerges until July 5, 1837, when he enlisted in the United States Army in New York City, giving his occupation as 'clerk'. He spent three years in Florida with the First Regiment of Artillery fighting in the Seminole Wars, and next appears in the records on May 5, 1840, when he was discharged at Burlington, Vermont (not far from Montreal). He then re-enlisted for five years and claimed three months' advance pay, but apparently deserted. A document of June 18 in the parish archives at Boucherville, east of Montreal on the south shore of the St Lawrence, suggests why. It is a baptismal certificate for 'Henry, né depuis cinq semaines du légitime mariage de Cornelius Krieghoff et d'Émilie Gauthier de cette paroisse.' It notes as well that the father was not present at the ceremony. The next piece of the meagre evidence concerning Krieghoff's arrival in Canada was recorded almost exactly one year later when little Henry (called Ernst in the document) was buried at Notre Dame in Montreal. Both Cornelius Krieghoff, 'peintre', and his wife, Émilie Gauthier, were described as 'de cette paroisse'. A daughter, Emily, had been born in March.

Krieghoff did not stay long in Canada. A notice in a Rochester, N.Y. newspaper in May 1843 announced that he was holding an exhibition there in part to raise money for a 'monument to his friend, Mr. Bowman, the distinguished artist, who died last year in our city'. This was James Bowman who had befriended Paul Kane in Toronto a decade earlier. He had settled in Rochester in October 1841 and died there the following May. In order to have established such a friendship, Krieghoff himself must have arrived in 1841 or very early in 1842, since Bowman had lived for a short while in Detroit and then Green Bay, Wisconsin, after leaving Toronto. A series of notices in a Toronto newspaper places Krieghoff in that city from late January to mid-February 1844. We know of two pictures painted then: attractive German-looking portraits of William Williamson,

his wife, and their two children (ROM). He would not have met Kane, who was then back in Mobile.

These two bits of evidence are perhaps enough to suggest that Krieghoff, like most of his colleagues in the Great Lakes region at the time, was an itinerant, moving from place to place in pursuit of work. We cannot be sure of this; but certainly, later that year, and probably not too long after leaving Toronto, he returned to Europe in order to improve his art. He is listed as having registered for copying at the Louvre at the end of October. Again, all traces of his movements have been lost sight of until 1846, the first year from which dated paintings of Montreal and region survive. It makes sense that on his return he would locate in the newly established capital of the United Canadas. He found there a group of supporting painters who late in 1846 formed the Montreal Society of Artists, exhibiting together publicly in January 1847. Although he appears to have opened a Montreal studio, Krieghoff lived across the river in Longueuil with his wife and daughter.

Henry Jackson, the grandfather of A.Y. Jackson of the Group of Seven, was a neighbour and friend of the artist in Longueuil, and it is known that he bought canvases from him, probably in 1847. One, a small picture of an Indian woman, *The Basket Seller*, (AGO), is unremarkable, but the other one that is known today is the highly successful **The Ice Bridge at Longueuil* (NGC). Though likely drawn from life, it is closely related to genre painting then very popular in the United States and Europe, which in turn was based on the works of Dutch seventeenth-century minor masters that Krieghoff would also have known at first hand.

The Ice Bridge and similar pieces of this period must have caused a considerable stir among artists in the Montreal region. There were no other landscape painters then working there who were able to paint in oils with Krieghoff's precision of detail, to say nothing of achieving his breadth of sky and snowy ground. The exact rendering of the distinctive sleighs and clothing of the local habitants must also have excited Krieghoff's Canadian admirers. He was certainly accepted as a man of ability by his painter colleagues, a group that included the portraitist William Sawyer (1820-89), James Duncan, and Martin Somerville (active 1839-56), who from 1847 to 1849 taught painting with Krieghoff at the Misses Plimsoll's School. Somerville's specialty was the small souvenir genre scene of an old Indian woman selling mocassins or baskets in the snow. Variations on these were popular with tourists and soldiers and Krieghoff soon caught on and turned out such 'pot-boilers' by the hundreds. Henry Jackson, as we have noted, bought an early one. Local Indians were a characteristic feature of Montreal life, and Krieghoff's first mass-pro-

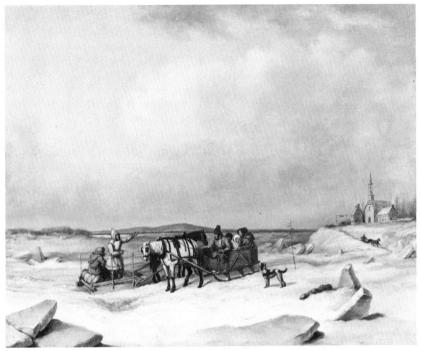

Cornelius Krieghoff. The Ice Bridge at Longueuil, c.1847. Canvas, 58.4 × 73.7. NGC.

duced print, a lithograph made in New York and offered for sale in Montreal in July 1848, depicts *Indians and Squaws of Lower Canada*. A set of four lithographs 'Illustrative of Life in Lower Canada' produced in Munich shows a 'typical' *habitant* family, an Indian settlement, Place D'Armes (the principal square in Montreal), and the splendid sleigh of the governor, Lord Elgin, on the ice of the St Lawrence. Dedicated 'with permission' to the governor, the set went on sale in November.

Krieghoff, Émilie, and their daughter moved across the river to Montreal in 1849. In that year he painted a *Winter Landscape* (NGC), one of his most ambitious canvases—it is 130 cm wide. He was unable to sell it until four years later in Quebec City, however. This was a difficult period in Krieghoff's career, but he tried the usual ways to make money from his art. Besides teaching, in July 1851 he and Duncan planned a 'panorama of Canada' for commercial viewing (this was a popular entertainment of the time), and, of course, he had his prints. His works were eminently saleable and he seems to have sold many small paintings as souvenirs. But the larger, more ambitious canvases that would support him both

creatively and financially could not be sold. Montreal businessmen were not yet ready to collect art. Finally, in 1851, Krieghoff almost stopped painting.

Shortly after arriving in Longueuil Krieghoff had met an auctioneer from Quebec City named John Budden, who bought a few pictures, and whose portrait Krieghoff painted in 1847. At some point, probably late in 1852, they met again, and shortly after, Krieghoff and his family moved into the Quebec rooming house where Budden lived.

Quebec, which is a good deal further north than Montreal, is well into the Laurentians; the land is more hilly and rugged and the autumn colour more intense and pervasive. A surprising number of new themes came off Krieghoff's easel. In the obligatory *Montmorency Falls in Winter* (MMFA) and his first pure landscapes he responded to his new surroundings with directness and freshness. He still painted the *habitant* scenes that had attracted John Budden to him. But now he increased the amount of observed local detail and generally enriched the anecdotal qualities. Indian subjects became more common. But Krieghoff was not involved in any systematic program. He simply sought out picturesque genre subjects with local flavour. Canadian peasants and Canadian aborigines fulfilled the requirement equally well.

Krieghoff's clientele in Quebec City was drawn almost exclusively from the Engish-speaking governing classes and the garrison. Some businessmen, like John Budden and James Gibb, were his closest friends and supporters. They all admired his scenes of Indian hunters and rollicking *habitants* and encouraged him to paint richer and richer images of the simple but jolly life they imagined the local folk led. The French-speaking bourgeoisie, however, did not buy his pictures.

Barbeau suggests a basic difference in the cultural aspirations of the two peoples. He claims that francophone Quebeckers insisted on the classical hierarchy in the arts in which genre scenes were the 'lowest' form of painting. While there was probably something to this, there must also have been embarrassment for educated Quebeckers in Krieghoff's patronizing view of the jolly *habitant* as the typical native of the province. In any case, Barbeau insists that friends in Quebec City talked Krieghoff into returning to Europe. They believed he needed a refresher course in the noble aims of the art of painting. Although there is no documentation to support it, Barbeau has Krieghoff and Émilie leaving for London in the spring of 1854 for a stay of probably between six months and a year. He believed that they had returned by the summer of 1855 and that they had spent most of their time at Düsseldorf, which was then enjoying a great reputation as the seat of a vigorous school of grand-scale landscape

Cornelius Krieghoff. Self-portrait, 1855. Canvas, 29.2×25.4 . NGC.

and genre painting. Krieghoff, he says, painted copies of Old Masters to sell in Canada and very soon after his return—while still on the boat, according to Barbeau—he painted the **Self-portrait* that is now in the National Gallery. Fresh from Europe, he would have wanted to demonstrate his assured grasp of the current modes, and in this painting he has presented himself as a dark, brooding figure, the very image of the romantic artist. Barbeau saw the first of Krieghoff's elaborate canvases to depict the Jolifou Inn—*After the Ball, chez Jolifou* (private collection) of 1856—as a renewed commitment to the Canadian scene and a rejection of Continental 'airs', although this type of 'stage-set' genre scene with many figures had been developed at Düsseldorf and was currently popular across Europe and in the United States.

The period from 1856 to about 1862 was Krieghoff's most fruitful, and the bulk of his finest snow scenes dates from it. The years before 1862 also saw a further exploration of the theme of autumn; he responded warmly, with rich, intense colour. During the late fifties and early sixties he drew subjects from all around the province—as far west as the Ottawa River, south to the Eastern Townships, and north up the Saint-Maurice

Cornelius Krieghoff. Coming Storm at the Portage, 1859. Canvas, 33.0 × 45.7. BAG.

River to Shawinigan Falls. In 1859 he reached a creative peak in his career. His †*Owl's Head, Lake Memphremagog* (NGC) and **Coming Storm at the Portage* (BAG) date from that year. Both are dramatic, rich in detail, thoughtfully composed, and unified in mood and emotional thrust. Technically superb, they are also works of art of considerable force. In that year as well he received an important government commission to paint a cycle of nine paintings illustrating the timber trade to decorate a reredos behind the Speaker's chair in a newly constructed Legislative Assembly.

In 1860 Krieghoff produced a painting that was the culmination of one of his most popular themes: the all-night revel at the country inn. **Merrymaking* (BAG) is not only one of his largest works—120 cm wide—but one of his most pleasing. He lavished great attention on all the tiny figures there are more in this work than in any other—and yet through a masterly use of arrangement, colour, and atmosphere he retained a unified whole. Remarkably, it comes close to marking the end of his period of creativity.

It is not clear why Krieghoff's work went into a decline. He was only forty-five in 1860, yet by 1862 his ambition seems to have dried up. There is evidence that his domestic life had become complicated and unsettled.

Cornelius Krieghoff. Merrymaking, 1860. Canvas, 87.6 × 121.9. BAG.

In August 1861 he offered his personal print collection for sale, and in December he advertised an auction of both his own and some European paintings, announcing that he intended to travel to Europe. A house he had rented in March 1861 he vacated a year later, selling many of the furnishings. Two more large auctions of his own paintings were held in 1862, and in December of that year he announced that he would dispose of his household furnishings, his library, and other collections he had assembled over a lifetime.

One reason for this dispersal of his property could have been his daughter's marriage to Lieutenant Hamilton Burnett of the 17th Regiment of Foot in March 1862, a marriage that seems to have broken up following Burnett's resignation from the army in August of the next year. At least there is no further sign of Burnett after that date. Krieghoff, curiously enough, assigned his entire property to an attorney for liquidation and the settlement of debts the day before the resignation. Later that year or early in 1864, Russell Harper argues in his extensive study of the artist, he left Quebec City for Europe.

Back in Montreal late in 1867, when the Society of Canadian Artists

was founded, he gave it his support but did not involve himself in its affairs. Then we lose sight of him again.

Krieghoff likely was staying with his daughter, who then lived in Chicago. Back in Canada again in 1870, he rented rooms in Quebec City in August. Budden was still there and, according to Barbeau, he encouraged Krieghoff to paint once more. The artist did return to his easel, with surprising success, given the circumstances. Seven paintings are known from 1871, including the accomplished *The Blacksmith Shop* (AGO). But it was a swan song. The garrison was gone, the art scene in Quebec City was by then almost non-existent, and Krieghoff, though only fifty-six, was tired. He returned to his daughter's home in Chicago and died there the next year.

English Immigrant Artists in Canada West 1850–1870

In Paul Kane's Toronto there was little awareness of artistic continuitya minor but unfortunate consequence of the unstable social fabric resulting from massive settlement between 1820 and the 1850s.* By the middle of the century, however, most of the arable portions of the present province of Ontario were settled; and out of the relative stability of the next decade there evolved what has been called a 'healthy local rural culture' that sought mainly to satisfy the physical and spiritual needs of the comfortable, independent farmer. The majority of the province's population was then rural, and the large stone and brick houses built by the more prosperous between about 1850 and 1875 (many of which still dot the countryside) are monuments to a life that was isolated yet vital, simple yet fulfilling. It was largely in this rural environment that immigrant artists settled when they came to Canada West in the fifties. Despite Berthon, Kane, and the Society of Arts, there was little in Toronto to attract them. This lack of significant artistic institutions in a main urban centre reflected a truly decentralized, or at least a precentralized, cultural milieu. For nearly twenty years the most significant evidence of artistic activity in the province was the work being done by various English painters who were scattered from the Ottawa River to Lake Huron.

The one thing that gave these English immigrants some sense of artistic community was the annual Upper Canada Provincial Exhibition, founded in 1846. Then as now, exhibitions were the artists' principal means of communicating with other artists and the general public. A painter who did not exhibit might almost not have existed. Like everything in Ontario at the time, the Provincial Exhibition was decentralized. Little more than a glorified fall fair devoted mainly to agricultural prod-

*In this period Ontario's population increased ten times: from 95,000 in 1814 (when it was called Upper Canada) to 952,000 in 1851 (when it was called Canada West).

ucts and a large stock show, it was rotated annually among the various larger communities of the province. At the first exhibition, held in Toronto, paintings were shown in the hobby and craft department. It was not until 1852 that a category was introduced for professional painters (as late as 1856 false teeth were still being included in the 'art' division); but whether it was held in Toronto, Cobourg, Hamilton, or any of the other host communities, this fair was the regular meeting-place of all the province's artists. In the late sixties and early seventies, when Toronto began to dominate the province economically and an art scene developed, these artists exhibited their work regularly there. But they were soon superseded by a vigorous new group of painters who had taken up residence in the capital (see chapter 6).

Much like the picturesque or topographical painting of the earlier years, the watercolours of these immigrant artists were primarily landscapes meant to be kept in portfolios, or if framed to be displayed in private homes. A few of these painters came to terms creatively with their new land, and the painting of W.G.R. Hind, Daniel Fowler, and Robert Whale, for instance, belongs to the history of Canadian, not British, art. But William Cresswell, Thomas Mower Martin, Marmaduke Matthews, James Griffiths, and others remained in large part transplanted Englishmen who worked in a style that was a popular variation on the great tradition of English landscape painting. For years they painted mainly to sustain a memory, and in the hope of somehow recreating in the wilderness the England of their youth.

WILLIAM NICOLL CRESSWELL (1818–88) was born at Southwark in Surrey and, like many of these immigrant painters, was trained professionally in London. He is believed to have immigrated to Canada in 1848 with his father, an uncle, three brothers, and a sister, who all settled in the Huron Tract around the town of Seaforth near Lake Huron. There is no documentation to support this view, even though Cresswell's earliest Canadian painting seems to date to 1851, and he is first recorded as a prize-winner at the Provincial Exhibition only in 1858. In 1865 Cresswell took title to land near Harpurhey, not far from Seaforth, built himself a house, and moved in with his new wife the next year. He had already made a considerable reputation among the far-flung painters of the province as an artist of ability, a reputation he sustained throughout his life while only occasionally straying far from his comfortable country home. Although his painting suggests a preference for marine subjects, he obviously worked to submit pieces in as many categories of the Provincial Exhibition as possible. Landscape with Sheep (AGO) of 1878 is typical of Cresswell's work in both oil and watercolour. It is a pastoral landscape that could have been painted almost anywhere, and suited the taste of the immigrant settlers he had chosen to live among.

THOMAS MOWER MARTIN (1838–1934) was born in London, Eng., where he became interested in an art career at an early age and briefly studied watercolour painting, though he was largely self-taught. He immigrated to Canada with his wife in 1862, first attempting to homestead in Muskoka. The farm failed and the Martins moved to another at York Mills, near Toronto, in 1863. Later he opened a studio in Toronto to which he commuted daily and where, about 1880, he painted Summer Time (NGC). Martin lived for ninety-six years and tried to keep up with painting fashion through most of his life. Summer Time is an attempt at a monumental wilderness theme and is thus current with the concerns of more vital painters–John Fraser, Lucius O'Brien, and Frederick Verner–who were then working in Toronto. But it is contrived and over-elaborate. Martin constantly strove to satisfy the art-buying public-he visited the west coast some ten times after 1886, seeking spectacular scenes and a new, less sophisticated market-but his work was then considered outof-date in the east.

MARMADUKE MATTHEWS (1837–1913) came to Toronto in 1860. Born in Barcheston, Warwickshire, he studied under T.M. Richardson at Oxford. In Toronto he became a partner in a photographic firm (1861-63), and then moved to New York, where he worked as a photo-tinter. He returned to Toronto in 1864 to marry, but left again for New York in 1866. Back in Toronto in 1869, Matthews thereafter worked primarily as a painter. In 1874 he settled on a small farm on the outskirts of the city (just north-west of Bathurst and Davenport Road). His detailed watercolour landscapes have a brittle quality, much like those of Martin. He also visited the Rockies and the west coast a number of times after 1888; some of his western pictures—like *Hermit Range*, *Rocky Mountains* (AGO) of about 1888—have a sweep that almost compensates for the obsessive detail. Matthews made his most interesting contribution to the art scene in 1891 when he developed his farm as a co-operative artists' community called Wychwood Park; many prominent painters built there, including George Reid. It is still maintained as a private co-operative housing estate in the heart of Toronto.

JAMES GRIFFITHS (1814–96) was born in Newcastle and immigrated to London, Ont., in 1854. Though a painter of china in England, he worked as a civil servant in London while in his spare time painting watercolours of still-lifes and flowers, exhibiting in the Provincial Exhibitions, later with the Ontario Society of Artists, and even with the Royal Canadian Academy of Arts. His pictures—of which **Flowers* (NGC) is a typical exam-

70 | English Immigrant Artists in Canada West

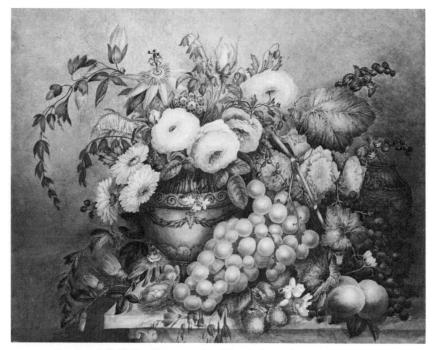

James Griffiths. Flowers, c.1865. Watercolour, 28.0 × 35.5. NGC.

ple—are, in their detailed attention to every petal and leaf, clearly dependent on his earlier experience as a china painter. This did not detract from their merit in the eyes of his Canadian patrons. The decorative vitality of his work in fact ensured him an enthusiastic response whenever he exhibited. His brother John (1826–98), also a china painter in England, immigrated with Griffiths, and at first continued to follow that line of work. He also exhibited floral still-lifes, but after 1865 showed at the Provincial Exhibition as a photographer, and seems subsequently to have followed that profession.

Some of these English immigrants, either through circumstance or creative ability, produced works that grew directly out of intense involvement with their new homeland. WILLIAM ARMSTRONG (1822–1914) was born in Dublin but in 1838 was sent to England to apprentice as a railway construction engineer. He first worked as an engineering draftsman in London in 1841, and later as an engineer on Liverpool's Birkenhead docks (1848–50). In 1851 he immigrated to Canada, and because he hoped to continue to work as an engineer, he chose to settle in Toronto. He found

William Armstrong. The Arrival of the Prince of Wales at Toronto, 1860. Watercolour, 33.5 \times 57.8. NGC.

William Armstrong. Thunder Cape, Lake Superior, 1867. Watercolour, 49.9 × 69.2. NAC.

72 | English Immigrant Artists in Canada West

work with a railway that first year and also began to exhibit watercolour paintings and drawings. By 1855 he was advertising himself as an engineer, draftsman, and photographer, and in 1857 opened a photographic business with two partners. He continued to show watercolours regularly, and about 1864 began teaching art at the Toronto Normal School, a part-time position he held for almost twenty years. His illustrations of current events—like **The Arrival of the Prince of Wales at Toronto* (NGC) of 1860—his renderings of impressive engineering feats, and his numerous loving depictions of sporting boats on the Great Lakes were greatly enjoyed in his own time and delight us today as records of early Canada. More evocative and compelling for their time as paintings and as significant expressions of Canadian aspirations are Armstrong's scenes of wilderness landscape, such as **Thunder Cape, Lake Superior* (NAC) of 1867, which was based on sketches from trips to Lake Superior and beyond (where he had mining interests) made after 1863.

WILLIAM G.R. HIND (1833–89) is in a different class. He was one of those private, intensely personal artists that Canada has been blessed with from time to time—a man *of* his time but largely overlooked by his contemporaries. Only when an exhibition of his work was organized by Russell Harper in 1967 did we become aware of Hind's accomplishment. We are still trying to put the pieces of his life together.

Hind, who was born in Nottingham, must have studied art in England, though we know nothing of his early training. His brother, Henry Youle Hind, immigrated to Toronto in 1846, working out of that city as a geologist and explorer. William followed his brother to Toronto in 1851 and taught drawing there at the Normal School until late in 1857. He returned to England, but was back in Canada in May 1861.

When Paul Kane wanted to visit Labrador in 1861 he probably intended to accompany Henry Youle Hind, who that year made a trip of exploration. Hind instead took his brother William as the official artist. William's Labrador watercolours and drawings—some of which were reproduced as chromo-lithographs and woodcuts to illustrate the official expedition report—go far beyond their documentary function. All are remarkable works of art. Harper has pointed out Pre-Raphaelite elements in Hind's work, and we can see in † *The Game of Bones* (MMFA) the simple, strong composition, the great attention to detail, and the rich colour of the thenpopular English style. Hind so involved himself in the excitement of the moment that the intense concentration of the gambling Indians appears to permeate the whole picture.

The party returned to Toronto in the fall of 1861. The restless artist had enjoyed his taste of rugged travel and the following spring went off again,

W.G.R. Hind. Self-portrait, c.1863. Watercolour, 30.5×20.3 . MCC.

this time with a party of gold-seekers, the famous 'Overlanders of '62', who intended to cross the continent to the Cariboo gold fields of British Columbia. Like Kane—who had covered much the same route sixteen years earlier—Hind kept a close pictorial record of the incidents of the journey. The party arrived at Lillooet in the Cariboo just as snow began to fall, and Hind remained only long enough to sketch scenes of the gold rush—of miners on the Fraser, panning for gold, lounging in a bar—that are as exotic in their way and yet as deeply felt as those sketched in Labrador. He arrived in Victoria in mid-October and immediately left for San Francisco. Back in Victoria by the end of January, he set up a studio and proceeded to accept commissions and to work up his prairie and Cariboo sketches into finished watercolours and even oils. A **Self-portrait* (MCC) painted then shows a man radiating a profound sense of self.

Hind left Victoria about six years later for the east, and on his way back stopped in Winnipeg for the better part of a year. (He was there during the Red River Rebellion.) His brother had moved to Windsor, N.S., and William joined him there, working for various Maritime railways (possibly as a draftsman). In 1879 he settled down in Sussex, N.B., and died there a decade later. He was buried in Windsor and promptly forgotten.

74 | English Immigrant Artists in Canada West

Daniel Fowler. The Wheelbarrow, 1871. Watercolour, 23.5 × 33.7. AGO.

Hind and DANIEL FOWLER (1810-94) were the finest watercolourists among the English immigrants. Unlike Hind, Fowler exhibited regularly at the Provincial Exhibition after 1862 and was known and respected by his peers and by the younger generation. Born in Surrey, he trained as an artist with the London topographer J.D. Harding, travelled and painted on the Continent, and worked in London as a professional from 1835 to 1843. Suffering from consumption, he immigrated to Canada West that year in search of a healthier climate. He found a farm on Amherst Island in Lake Ontario near Kingston and became a farmer. He did no painting for fifteen years. In the winter of 1857-8 Fowler visited England and when he returned to Amherst Island he set up a small studio in the back of his house and began to paint again, exhibiting at the Provincial Exhibition in the amateur class in 1863. From 1866 until the end of his life he exhibited professionally at every opportunity-though he never left his home for longer than a short trip to go to an exhibition or to visit artist friends. He was devoted to his Canadian farm where he had found a way of life suited to his temperament.

Fowler painted only in watercolour and by the early seventies had

achieved a forceful, mature style of his own, working within a limited subject range of still-lifes and landscapes. *The Wheelbarrow* (AGO) of 1871 is intimate and intense, with a clear sense that a picture must be 'alive' at every point. By the 1880s his handling had become more open, looser, but he was able to make of the whole picture surface a single integrated image. His *†Fallen Birch* (NGC) of 1886 crackles with creative energy. Working alone on Amherst Island, he had reached the point where he could touch existence itself in a single watercolour. Fowler had become what we might venture to call a great artist.

Not as good a painter, yet as interesting for his development in Canada, is ROBERT WHALE (1805-87). Born in Cornwall, he was largely self-taught as an artist, copying pictures in the National Gallery, London, then working as a portraitist in Devon and Cornwall before immigrating to Canada in 1852. He settled at Burford, a small town near Brantford. Unlike Fowler, Whale arrived with the full intention of continuing in his profession and began exhibiting at the Provincial Exhibitions immediately. Because he painted for a living, his work has all the earmarks of the journeyman; in this, and in his willingness to paint anything, he was like the Yankee itinerants who had worked in the province during the previous three decades and who still made fleeting visits to the more populous rural districts. Every year Whale and his nephew, and later two of his sons, who were also painters, would cart crates of oil paintings to the Provincial Exhibition, always submitting the maximum number of pictures allowed in each of the categories. They relied on the prize money, for there was no steady market for art. But Whale intended to benefit from such a market as did exist, and painted portraits, landscapes, and in later years a panorama of the Indian Mutiny that he exhibited as an attraction throughout Ontario. One of his first Canadian pictures-he worked almost exclusively in oils—is the *General View of Hamilton (NGC) of 1853. Likely painted for some wealthy city-father, it is in the tradition of the distant city-view that reaches back more than a hundred years to Richard Wilson in England. With its imaginative vantage point, sensitive light, and impressive breadth, it reflects a creative ambition that surpasses the merely commercial. Whale also responded to the growing interest in wilderness themes and in what was thought to be a picturesque dying race, the Indian, while trying as well to satisfy the nostalgia felt by many immigrants for an older, more settled landscape. In one canvas an Indian and a canoe seem to be sitting on the edge of an English country estate. So idyllic is the landscape that it seems to have materialized from an ancient memory that lives in the shared imagination of artist and viewer.

Whale visited England briefly in 1870, and then after the death of his

76 | English Immigrant Artists in Canada West

Robert Whale. General View of Hamilton, 1853. Canvas, 90.8 × 120.6. NGC.

Robert Whale. *The Canada Southern Railway at Niagara*, c.1875. Canvas, 58.4 × 101.6. NGC.

x–W.G.R. Hind. The Game of Bones, 1861. Watercolour, 25.4 \times 42.5. MMFA.

xI—Daniel Fowler. Fallen Birch, 1886. Watercolour, 48.2 × 69.8. NGC.

XII—Lucius O'Brien. A British Columbian Forest, 1888. Watercolour, 54.1 × 76.4. NGC.

XIII—John Fraser. Mount Baker from Stave River, at the Confluence with the Fraser on Line of CPR, 1886. Canvas, 56.0 \times 76.8. Glenbow Museum, Calgary.

wife in 1871 went back again and stayed for four years while his youngest son completed his schooling. When he returned in 1876 he moved to Brantford in semi-retirement, living with his daughter until his death ten years later. Always responsive to the market, his painting changed along with his clients' tastes, which were being moulded by the experience of life on the rapidly developing continent and were stimulated by the vibrant popular culture emerging in the United States. When railways became the symbol of everything progressive in North America, Whale painted a number of 'portraits' of trains. They are thoroughly North American-they could not have been painted in England. *The Canada Southern Railway at Niagara (NGC) dates from after 1875. Over the years Niagara Falls had become a symbol of the continent's dynamic energy. Placing the train in front of the Falls is an obvious but effective device for linking two symbols—one of progress and one of untapped energy—in praise of future potential. Less nostalgic now about what had been left behind, Whale and his patrons could be swept up in hope for the future. But the basic driving force of North American society found even more effective interpreters in the successors to these English immigrant painters of the fifties.

Landscape Painters in Montreal and Toronto 1860–1890

Although in mid-century the English immigrant painters in Ontario constituted a significant phenomenon, it was Montreal that superseded Quebec City as the principal centre of art activity in Canada during the later 1860s. Working and exhibiting there were painters who were attempting to respond to the Canadian landscape in all its splendour, in a way that reflected the eagerness then felt by politicians and entrepreneurs to encompass the vast land and to tap its mighty resources. The English painters in Ontario on the other hand, were essentially pastoral, even domestic, in their outlook. It was left to three German artists—Otto Jacobi, William Raphael, and Adolphe Vogt—to set a new direction.

OTTO JACOBI (1812-1901) was the best of these German artists who worked in Montreal during the sixties. Born in Prussia, he studied in Düsseldorf at the famous academy, and, he later reported, also taught there, likely as a private tutor. Later he was court painter to the Grand Duke of Nassau for almost twenty years. Paintings like The Splügen Pass (MMFA) of 1855 sold widely in England and the United States. At the age of forty-eight Jacobi decided to immigrate to America with his family, ending up in Montreal in 1860. Five years later the Jacobis left the city, probably moving to the Ottawa region. Back in Montreal in 1869, they left again in 1873, homesteading near the village of Ardoch in the bush north of Kingston. Jacobi's work in Canada up to this point is always specific as to site and highly naturalistic in appearance, qualities he ensured by reference to photographs. Monumental canvases like his *Falls of Ste Anne, Quebec (AGO) of 1865 are at the same time presented in the Düsseldorf fashion, with the crashing white water naturally framed within its own rock boundaries. It is a stirring image of sublime majesty. Its colour is clear and luminous, its scale is grand, and the heroic landscape is charged with a sense of importance that transcends the depicted

Otto Jacobi. Falls of Ste Anne, Quebec, 1865. Canvas, 76.2 × 58.4. AGO.

scene. In 1876 Jacobi was invited to join the Ontario Society of Artists in Toronto and moved there two years later. He moved to Philadelphia in 1881, and in 1883 joined members of his family who had homesteaded in the Dakota Territory. After returning to Ardoch in 1886, he resettled the next year in Montreal, where he lived until 1891. He spent five more years in Toronto, after the death of his wife, and then he joined a son in the Dakota Territory, where he died in 1901 in the town of Ardoch, which was named by the Jacobis after the village where they had first homesteaded in the Canadian wilderness.

WILLIAM RAPHAEL (1833–1914) was born in Prussia into a German-Jewish family. He studied in Berlin and in 1856 immigrated to New York City, where he worked as a portraitist. The next year he moved to Canada, seeking commissions in Quebec City and in Montreal, where he settled in 1858, although he continued to work for short times in other parts of the province. He visited Scotland briefly in the summer of 1865. Raphael's famous *Behind Bonsecours Market*, *Montreal* (NGC) was painted in 1866. As

80 | Landscape Painters in Montreal and Toronto

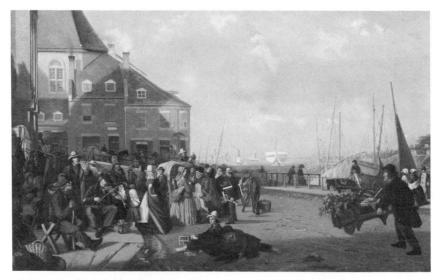

William Raphael. Behind Bonsecours Market, Montreal, 1866. Canvas, 67.3 × 109.2. NGC.

a genre scene it is more complex than Krieghoff would have painted. The careful light effects evident in the treatment of the figures and buildings and the bold symmetry—as in the profile of the woman, hands on hips, left of centre—are derived from the German Romantic painting of the early nineteenth century that is now best known from the work of Caspar David Friedrich. The luminous clarity and studied composure of Raphael's canvas are reflected in later Canadian works.

ADOLPHE VOGT (1842–71) was born at Libenstein, Duchy of Saxe-Meiningen (now Thuringia), but at the age of twelve he immigrated to Philadelphia where he immediately began to take painting lessons from other German immigrants. In 1861 he went to Munich and Zurich for further study. He was in Montreal early in 1865, but set out for Paris in the spring of the next year. By September 1867 he was back in Montreal. His beautiful **Niagara Falls* (NGC), painted in 1869, introduced a new breadth of treatment, a sense of scale, and a depth of meaning to Canadian landscape art. Vogt moved to New York in December 1870 and died there of smallpox early the next year.

There were many reasons why these artists were attracted to Montreal. The businessmen who largely controlled the city had become wealthy and sophisticated enough to found the Art Association of Montreal in 1860 for the purpose of holding exhibitions, building a collection, and generally promoting the arts. The decline of Hamel and Krieghoff by 1865 meant that Quebec City no longer had important artists. In fact there was a general decline in intellectual and artistic life among French-speaking Catholics in the 1860s, brought about by Bishop Bourget's attempts to suppress the Institut Canadien—a society that had been founded in 1844 as a forum for advanced liberal views—and by reactionary opposition to the *parti rouge*, which had been formed in 1848 by members of the Institut. The creative field was virtually left open to the new arrivals. The photographic firm of William Notman, which regularly hired skilled artists to colour photos and paint backgrounds, became the hub of the intense new activity that developed. And the Society of Canadian Artists, founded in Montreal in 1867 by a group of professional painters (Jacobi, Raphael, and Vogt were all charter members), represented the potential they then believed the city held as a centre for the arts.

ALLAN EDSON (1846–88) was a talented native-born Canadian who developed in this Montreal milieu. Born at Stanbridge Ridge in the Eastern Townships of American parents, he arrived in Montreal in 1861 to work in a wholesale house. He first took painting lessons from the black American artist Robert Duncanson (1821–72), whose father was from Montreal. Then in 1865, using his own savings and with the help of a Stanbridge banker, he was able to go to England where he studied for about a year. He returned to Montreal early in 1867, and at the end of the year became a charter member of the Society of Canadian Artists. His work of this period shows a careful attention to detail, probably reflecting the influence of Pre-Raphaelite taste that he had absorbed in England. Yet there is a concern for atmosphere and a clarity and assertion of foreground

Adolphe Vogt. Niagara Falls, 1869. Canvas, 50.8 × 99.0. NGC.

82 | Landscape Painters in Montreal and Toronto

Allan Edson. Mount Orford, Morning, 1870. Canvas, 91.4 × 152.4. NGC.

elements that suggest the style of Duncanson, his first teacher, of Otto Jacobi, and to a lesser degree of Raphael and Vogt. *Mount Orford, Morning (NGC) of 1870 first impresses the viewer with its atmosphere of lyrical quietude achieved by Edson's subtle use of tones; then one sees that every object has been picked out, almost defined, by a ring of intensely reflected light. Edson was a painter of great individuality and imagination. His vision is perhaps not as expansive as that of the other Montreal painters, but it is more penetrating, more concerned with secluded moments of quiet in nature. His Trout Stream in the Forest (NGC) of about 1875, with its mounds of soft green moss and a brightly splashing brook running between the rocks, exudes this same stillness. Edson lived in the Montreal area until 1881, when he went to Paris for about three years. He then spent a few months in London before returning to Montreal. A couple of months later he was off again on a trip to Scotland, stopping finally in London and working and exhibiting there until spring 1887. He then returned to Canada and settled in Glen Sutton in the Eastern Townships, where the following spring he died at the height of his powers, aged only forty-two.

The president of the Society of Canadian Artists was John Bell-Smith (1810–83), an Englishman who arrived in Montreal in 1866, the year before the Society was founded. Though he was an unexceptional portraitist, Bell-Smith had been secretary-treasurer of the Institute of Fine Arts,

Portland Gallery, in London, and had administrative skills to offer. His son, FREDERIC MARLETT BELL-SMITH (1846–1923), was also a member of the Society. Born in London, he had studied painting with his father and also at the South Kensington Art School, and was twenty-one when he arrived in Montreal in 1867. He worked primarily as a photographer: in Montreal until 1871, in Hamilton until 1874, and then in Toronto until 1879. Later he turned to art teaching, notably as Director of Fine Arts at Alma College, St Thomas, Ont, beginning in 1881. He lived in nearby London until 1888, when he returned to Toronto. Throughout this period after 1871 Frederic Bell-Smith also worked as an illustrator for *The Canadian Illustrated News* and other publishers. The influence of both photography and the hard line of newspaper illustration is evident in the stiff, contrived watercolours he painted before he visited Paris in 1891 and gained French experience that enabled him to achieve a looser, more expressive handling of colour and atmosphere in his later oils.

HENRY SANDHAM (1842–1910), another member of the Society who was well known in his time, was born in Montreal. He worked at Notman's, and many of his paintings are exact renditions of composite photographs manufactured there. In his oils he showed a concern for light and colour that he undoubtedly learned from his German colleagues (he took lessons from Jacobi), as in his *Beacon Light, Saint John* (NGC) of 1879. But there is a dogged literalness about much of his Canadian work that screams of the photograph. In 1877 Sandham had gone into partnership with Notman, and had also begun to produce magazine illustrations, work he would pursue for most of the rest of his life. In 1880 he travelled to England and France for the first time, and settled in Boston on his return at the end of the year. Associated with a Notman branch there (he remained a partner until 1882), he established a reputation as an illustrator. In 1901 Sandham moved to London, Eng., where he died.

The Society of Canadian Artists held its last exhibition in 1872. By 1873, with the first exhibition of the Ontario Society of Artists, the centre of art activity in Canada had moved to Toronto. Egerton Ryerson had established in Ontario an elaborate, and largely admirable, provincial educational system. It included the Canadian Educational Museum, which opened in 1857 in the Toronto Normal School. This large collection of plaster casts, oil copies (including a number by Falardeau), and prints of the great masterpieces of European visual culture was the only public display of paintings in the whole province and it attracted every young person with an interest in art.

By the late sixties and early seventies a surprising number of young people from rural Ontario had discovered such an interest, and the cen-

84 | Landscape Painters in Montreal and Toronto

tralization of provincial services accelerated with the influx of these people into the cities—primarily Toronto. A cultural environment consequently developed in the capital that enabled it to sustain an art scene in which traditions were established that have supported an active climate for art to this day. These forces were brought together in the later 1860s mainly by one man.

JOHN A. FRASER (1838–98) was born in London, Eng., where he presumably studied and is supposed to have worked as a portrait painter. His father, a tailor, was a prominent member of the left-wing Chartist movement, and probably because of his political views was forced to leave England in 1858. He took his family to the Eastern Townships of Quebec, where his son continued to paint and soon acquired a reputation as a prodigy. About 1860 John moved to Montreal and was hired by William Notman to tint photographs. Some seven years later he was one of the major figures in the establishment of the Society of Canadian Artists, and his departure from Montreal later in 1867 portended the Society's ultimate demise.

Fraser left Montreal in order to establish a photographic business in Toronto in partnership with Notman, and over the years hired, on a casual basis, many of the active artists in the city. Lucrative and only slightly demeaning, the tinting of photographs was to be worked at when sales of paintings were slow. The gallery he built for the Notman-Fraser studio was also available to the painters associated with the firm. Fraser was aggressive and self-confident, and people either liked him tremendously or hated him. All found him necessary, however. He was responsible for organizing the Ontario Society of Artists, of which he was first vice-president (the president was an honorarily appointed layman), and its first exhibition was held in the Notman-Fraser galleries in 1873.

In Montreal Fraser's reputation as an artist arose primarily from his photo-related portrait work, but in Toronto he soon became recognized as one of the leading landscape painters of the day. His **A Shot in the Dawn, Lake Scugog* (NGC) of 1873—exhibited in the first OSA exhibition—offers evidence of his considerable skill. The magnificent colour of a morning sky has become in his hands an expression of nature's sublime majesty. As in the work of Raphael and of Fraser's other German friends from Montreal, light is important in establishing figures in space.

In 1874 Fraser came into conflict with another prominent member of the OSA, LUCIUS R. O'BRIEN (1832–99). One suspects that distinctions of class underlay the disagreement. Fraser was aggressively lower middleclass and liberal. O'Brien, who aspired to the upper classes, was conservative and gentlemanly and his art reflected this sense of decorum.

John Fraser. A Shot in the Dawn, Lake Scugog, 1873. Canvas, 40.6 × 76.2. NGC.

He was born in Shanty Bay, a small community on the northwest arm of Lake Simcoe founded by his father, Colonel Edward O'Brien, a half-pay officer retired from the British army. Lucius graduated from Upper Canada College about 1847 and is supposed to have immediately entered an architect's office, though he never practised that profession. It is likely that he trained as a draftsman, for in 1852 he won two prizes at the Provincial Exhibition in the professional artist category, and over the next few years produced drawings for prints and illustrations that appeared in local magazines. He also taught drawing, and as late as 1856 he is listed in the city directory as 'artist'. In November 1858 he was given the responsibility of running one of the family businesses, situated in Orillia, just northeast of Shanty Bay. In January he was elected reeve of the township, and during the following year he married a local woman. He travelled extensively in the area immediately north of Lake Simcoe during the next decade, and in January-February 1869 visited England and the south of France. On his return he settled in Toronto, where he helped run a wine and olive oil importing business.

It was only in 1872, with the foundation of the OSA, that O'Brien decided to turn to landscape painting as a profession. He quickly rose to preeminence. The result of his disagreement with Fraser in 1874 was that Fraser and some supporters resigned from the OSA and O'Brien replaced him as vice-president, a position he held until 1880 when he became the first president of the Royal Canadian Academy. Various writers have suggested that O'Brien's social aspirations made him ideally suited for

86 | Landscape Painters in Montreal and Toronto

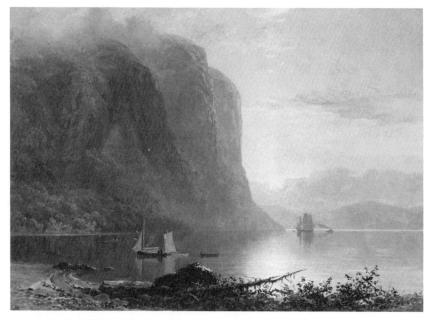

Lucius O'Brien. Sunrise on the Saguenay, 1880. Canvas, 87.6 × 125.7. NGC.

his role as president of the RCA. Required to work closely with Lord Dufferin, the governor-general, and with Dufferin's successor the Marquis of Lorne and his wife, the Princess Louise, daughter of Queen Victoria (Fraser would have been quite unsuitable for such intimate relations with royalty), O'Brien steered the RCA through its difficult first ten years with tact and discretion.

As a late beginner in the profession of landscape painting—he was forty-one in 1873—O'Brien quickly achieved great presence in his work. This is evident in his famous **Sunrise on the Saguenay* (NGC)—painted in 1880, exhibited in the first RCA exhibition, and that same year deposited in the new National Gallery of Canada as the first academy diploma piece. In its depiction of sublime grandeur in nature, in its subtle coloration and atmosphere and use of light to infuse the scene with spiritual force, it embodies a view of the Canadian landscape O'Brien clearly shared with Fraser and the German painters of Montreal. It also represents most closely in Canada a style of painting—now known as 'luminism'—that had become very popular in the United States through the work of Fitz Hugh Lane, Martin Johnson Heade, and John F. Kensett, among others. These American painters achieved a crisp but poetic land-

scape vision that reflected a moody quietude arising from a developed sense of pervasive order. Much research is required before the Canadians' links with these painters can be clarified. There are several possibilities. Fraser exhibited in New York, Boston, and Philadelphia throughout much of his career, and travelled south both as a representative of the Notman firm, and, presumably, to look at pictures. O'Brien also travelled in the United States. But what complicates a simple conclusion of direct American influence on the Canadian painters is that the Canadian 'luminist' style can be shown to have developed, at least in part, from the influence of those three German painters working in Montreal in the 1860s. (Furthermore, it also developed in the United States partly through contact with nineteenth-century German painting.) But Raphael, Vogt, and Jacobi all lived in the USA at various points in their careers, and American artists visited Canada; some, like Robert Duncanson, even lived here. There are also British painters who could be called 'luminists', and Canadians were certainly familiar with recent trends in British art.

One place the research will have to begin is with the work of the American painter Albert Bierstadt (1830–1902). Born in Germany, he was brought to the United States as an infant. He returned to Düsseldorf to study, but he then became one of the major exponents of the 'heroic' side of luminism in the United States. He was a friend of Lord Dufferin and later of the Marquis of Lorne and Princess Louise, whom he visited in Ottawa and Quebec City in the late seventies and early eighties. Paintings he did then were later exhibited in the Canadian section of the Colonial and Indian Exhibition in London in 1886. O'Brien met him and would have been familiar with his work. Encouraged by Dufferin, Bierstadt had even donated a painting to the Art Association of Montreal.

O'Brien's **Kakabeka Falls, Kamanistiquia River* (NGC) of 1882 was certainly created with some awareness of Bierstadt's work, but it is nevertheless a profound and personal response to the magnificence of the scene and to the glory of the painter's art. O'Brien continued to develop as a painter, his vision broadening to encompass the vast breadth of the nation that was, during these decades, growing literally from sea to sea. As president of the RCA he probably felt a responsibility to represent the variety of the country, and as art editor of the monumental two-volume *Picturesque Canada*, published 1882–4, he travelled over much of the central and eastern portion of it supervising his artists and making sketches for many of the illustrations himself. One of the first painters of his generation to do so, he first visited the Rockies in 1886 at the invitation of the developers of the Canadian Pacific Railway, and went out west twice more. In 1888

88 | Landscape Painters in Montreal and Toronto

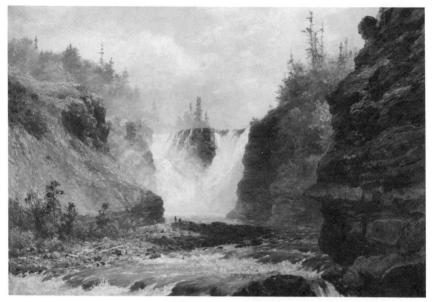

Lucius O'Brien. Kakabeka Falls, Kamanistiquia River, 1882. Canvas, 82.5 \times 121.9. NGC.

he painted his lush *A British Columbian Forest* (NGC). Factual in its depiction,* it is still pungent with the rich, fecund growth of the rain-forest. For Canadians of the time it was a fascinating new Eden-like image of their country.

John Fraser continued to paint imaginatively as well, although he was now effectively excluded from any organizational role in the Toronto art scene after his resignation from the OSA. In the summer of 1883 he travelled to the railhead at Calgary for the Chicago-based magazine, *Railway Age*, as a guest of the CPR (the directors of the company were acutely aware of the publicity they could derive from artistic visitors). Later that year he dissolved his partnership with William Notman, and early in the following year he moved to Boston. Henry Sandham, who was Fraser's brother-in-law, soon helped him find work preparing illustrations for the big American monthlies, and his brother William Lewis Fraser, who was a prominent art director with Scribner's in New York, also sent work his way. He maintained his Canadian connections, however, and when, in 1886, Sir William Van Horne of the Canadian Pacific Railway offered free passage to the Rockies, Fraser jumped at the offer. †*Mount Baker from*

*There is a famous Notman photograph of the same massive tree, taken the following year.

Stave River, at the Confluence with the Fraser on Line of CPR (Glenbow Museum, Calgary), of 1886, with its wonderfully luminous colour and its striking yet naturalistic composition, is one of the finer pictures by those artists who in the late sixties, seventies, and eighties sought to express Canada's dynamic energy and growth by depicting spectacular wilderness scenes.

This approach to painting found yet another exponent in the Torontobased painter FREDERICK ARTHUR VERNER (1836-1928). Born in Sheridan, Ont., he admired Paul Kane when he was a youth and decided to become a painter. With that intention he left for England in 1856 but soon was involved with the military. In 1860–1 he fought in the British Legion with Garibaldi's troops in the liberation of Italy. In 1862 he returned to Toronto, where he befriended Kane in his retirement. Except for a brief stay in New York during 1865–6, Verner spent the next decade in Toronto working as a photographer and painter. Following the ideas of the older artist, he specialized in Indian subjects, and by 1870 was painting large horizontal oil landscapes that were ostensibly based on Indian subjects, but were primarily concerned to express a sense of quietude, of magnificent peace. Unlike Kane, Verner did not travel extensively in search of his subject; it seems that his only documented trip west in 1873 took him just as far as Lake-of-the-Woods, although he did have relatives in Winnipeg. He may never have experienced the Prairies at first hand, but he painted them with feeling. If we compare his *Indian Encampment at Sunset (WAG) of that year with Fraser's A Shot in the Dawn, Lake Scugog-partic-

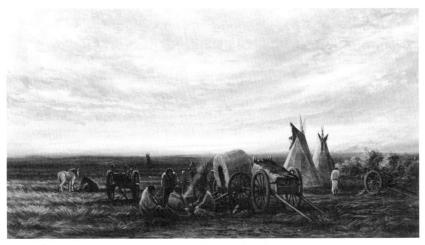

F.A. Verner. Indian Encampment at Sunset, 1873. Canvas, 51.4 × 91.4. WAG.

90 | Landscape Painters in Montreal and Toronto

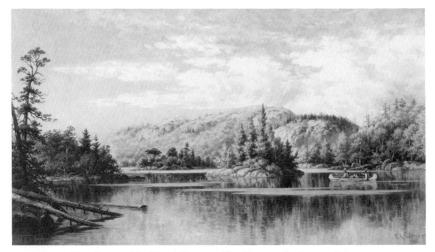

F.A. Verner. The Upper Ottawa, 1882. Canvas, 82.6 × 151.8. NGC.

ularly the sky—we see that Verner shared the other artist's understanding of the qualities of light and colour and the force of sublime natural effects. By 1880, when he moved to London, Eng., which would be his home for the rest of his life, he had totally assimilated these concerns into his particular vision of landscape. Like Fraser and O'Brien—his contemporaries in Toronto—Verner was moved by the profound sweep of the Canadian sky. **The Upper Ottawa* (NGC) of 1882, full of the crystal light of a northern lake, is breathtaking in its stillness and clarity. It is a large painting, over a metre-and-a-half wide.

Fraser, as we have seen, left Toronto in 1884. O'Brien painted until his death in 1899; but after 1890, when he retired from the presidency of the RCA, he attempted no ambitious works. Verner, seeking a larger market, moved to England. These three painters were among the first to make a concerted attempt to comprehend the Canadian experience in terms of the land itself. But they were replaced by a vigorous younger group of artists who looked outside Canada, to Paris, for the necessary equipment and approach to express their sense of themselves as Canadian artists.

7

The 'French' Period in Canadian Art 1880–1915

During the French colonial period painting in Canada was naturally derived from the mother country. After the British Conquest of 1760 this influence began to diminish, although some artistic connections persisted. But with the French Revolution in 1789, even such cultural ties as the occasional training of an artist in France were broken, and if Antoine Plamondon briefly re-established the France-Canada artistic allegiance, his pupil Théophile Hamel chose instead to follow the international current and studied in Rome and Florence. For the next thirty years other French Canadians followed his example. The strong landscape school that developed during this time in Montreal and Toronto drew primarily on English, German, and American attitudes. French painting, for Canadians, held little or no interest.

By 1875, however, young art students in Canada again began to look to Paris and by 1890 virtually every artist of note under the age of thirty aspired to study in the French capital. At that time French painting had come to be considered the most accomplished in the world. Paris was the art capital, much as New York is today, and everyone looked to Paris for standards of quality and signs of trends. Painting was taken very seriously there: it had not only a broad and passionate public following but government support that was matched nowhere else. Another attraction was the large and inexpensive art-education system that had developed. The government-supported École des Beaux-Arts was initially the most popular school, but as more and more students flocked to the capital, an informal system of private 'academies' developed. Here, for a relatively small fee, a student was supplied with plaster casts, live models, and criticism twice weekly by a renowned French painter. These academies proliferated, and by 1890 the largest and most famous, Julian's, had an enrolment of between 1,000 and 1,500 students, spread over

ten large studios. There was no prescribed course of study and no official graduation. You judged your progress from the remarks made during criticism periods and, when a certain standard had been reached, by submitting works to the official Salon.

The Salon was yet another attraction Paris held out to young artists. Established by the state in 1673 as an annual showplace of current French painting, its reputation diminished in the nineteenth century because the selection process tended to favour established artists over more experimental ones. It finally grew to be so controversial that in 1881 the running of the Salon was given to the new Sociéte des artistes français; this resulted in a larger, more open exhibition that attracted more and more foreigners who worked in the French manner. While the Salon continued to establish standards of quality for the general public, it gradually became less significant to the more experimental French painters, and during the last decades of the century became an object of derision to avant-garde figures like Gauguin and Van Gogh and their followers. These radical innovators ultimately triumphed in the struggle for critical and public approval, however, and as a consequence the great academic masters of the last years of the century were until recently relegated to the basements of our museums.

But in the eighties and nineties the names of Gérôme, Meissonier, Cabanel, and Bouguereau held a powerful attraction for young Canadian artists. All four painted in a highly finished naturalistic style that had enormous popular appeal. Their extremely detailed, yet often large canvases functioned much as epic historical films do today: they were built on extensive documentary knowledge-of animal and human anatomy, of the subtle gradations of colour and light-and imparted some psychological or emotional 'message'. They were often rich in what film-makers call 'production values'. The academic system was set up in order to train the student systematically in the skills he would need to marshall all the elements necessary to 'construct' a vast heroic image-again much as a movie director does today. (The Toronto painter George Reid, after study in Paris, actually constructed studio 'sets' of hay-lofts, country kitchens, and the like in which to pose his models.) The basis of this academic system was a thorough training in the depiction of the human figure. The kind of large finished sketch that resulted-called an 'academy' and completed probably millions of times by hundreds of thousands of students-was usually a monochromatic exercise in tone rather than a naturalistic colour rendering and was meant to develop an intimate knowledge of the form and structure of the human body, and of art.

American artists responded to this approach two decades before Cana-

William Brymner. *Two Girls Reading*, 1898. Canvas, 102.9 \times 74.3. NGC.

dians. It is therefore not surprising that the first Canadian-born painter to study in Paris in the late nineteenth century had first studied in the United States. WYATT EATON (1849–96) was really an American painter. Though born in the Eastern Townships (of American parents), he moved to New York City at the age of eighteen and never lived in Canada again. He first studied art in New York but in 1872 went to Paris and enrolled in the École des Beaux-Arts under the famous Jean-Léon Gérôme. He later came to admire the work of Jean-François Millet, the great painter of peasant subjects who died the year before Eaton returned to the United States. Eaton's mature style, as in *The Harvest Field* (MMFA) of 1884, combines Millet's subject matter with the high finish and precise composition of Gérôme.

WILLIAM BRYMNER (1855–1925)—born in Greenock, Scotland, but raised in Montreal—was the first Canadian to study in Paris who later had a wide influence in Canada. His father was the first Dominion Archivist, and as a young man William was able to study architecture with the

William Brymner. A Wreath of Flowers, 1884. Canvas, 120.0 × 139.7. NGC.

government architect in Ottawa. He already had a strong interest in painting, and early in 1878 he enrolled at the Académie Julian in Paris, where he was instructed by William Bouguereau and Tony Robert-Fleury, who were famous exponents of 'grand manner' naturalism. At the Salon he was particularly attracted to the work of Ernest Meissonier, whose highly detailed illustrative paintings were immensely popular with the French public. Although Brymner apparently never attempted a large historical subject, he did specialize in domestic figure scenes until after the turn of the century. In the best of these the drawing and the application of paint are loose and broad. The **Two Girls Reading* (NGC) of 1898 also displays a careful treatment of light and an understanding of the force of a simple emphatic composition—effects he had learned in France.

Brymner stayed in Paris on and off for almost seven years before settling in Montreal in 1886. Two years before leaving Paris (actually during a long stay at Runswick Bay, Yorkshire) he completed his masterpiece, **A Wreath of Flowers* (NGC), which proved his mastery of the rich detail and subtle tones that were then favoured in Paris. The year of his return to Montreal he was accepted as a member of the Royal Canadian Academy and deposited this picture in the National Gallery as his diploma piece. Although it was undoubtedly seen as work of an advanced order, it did not create a stunning effect because the French style had by then become almost familiar. While Brymner was still in France, the trickle of Canadian students to Paris had become a flow.

ROBERT HARRIS (1849–1919), who was born in North Wales but was raised in Charlottetown, P.E.I., arrived in Paris a year before Brymner. He received his first training in Boston and by the end of 1876, at the age of twenty-seven, had reached London with enough money to enrol in the Slade School, which was then run by a Frenchman, Alphonse Legros. Three months later, encouraged by old schoolmates from Boston and no doubt by his contact with Legros, he decided to go to Paris. In the fall of 1877 he enrolled at the studio of Léon Bonnat, who was then considered to be one of the great painters of biblical and historical subjects.

Pranks, arguments, even fighting took place almost continuously in the studios, except for two afternoons a week when the master made his criticisms. Nonetheless most of the students—from all over the world were serious in their work. Harris felt he was making great progress. After a year, when he believed he had attained a high standard of quality, he returned to Canada. Realizing that Toronto in 1879 was the principal art centre in Canada, he settled there and immediately became the object of attention with works like *The Chorister* (NGC) of 1880. George Reid, who was then a young student, remembered that Harris's arrival caused 'great excitement' in Toronto. He was asked to teach drawing at the art school and, according to Reid, 'almost at once introduced the French way of working, thereby considerably changing the teaching methods of the school.'

Harris stayed in Toronto only until the late spring of 1881 but he made a mark. He succeeded Lucius O'Brien as vice-president of the Ontario Society of Artists and encouraged young painters to look to Paris. Harris returned there in November 1881, joining an American sketch club and re-enrolling with Bonnat. He sent a picture to the Salon of 1882—which to his great surprise was hung—and he also enrolled at the Académie Julian under Jean-Paul Laurens and Alexandre Cabanel. This practice of studying with several masters appears to have been common with more experienced foreign students. It meant that their lives revolved almost totally around study, the activities of fellow students, and the annual

Salon, and that they acquired even greater facility of technique and learned to produce more dramatic 'effects' in their paintings. Like most foreigners, Harris also took the opportunity to travel. In September 1882 he left for Italy, where he self-consciously steeped himself in the values of the European cultural past. Early in 1883 he was back in Canada.

As the Canadian artist most familiar with current techniques of monumental history painting, Harris was asked by the federal government to accept the most important official commission ever to be offered in Canada: the large group composition, *The Fathers of Confederation*. Harris approached the project in correct academic fashion. He collected reams of data on the people to be portrayed, prepared monochromatic gouache studies of various possible compositions, and finally prepared an oil sketch and a full-size charcoal cartoon before proceeding with the actual painting. The whole process took him two years. His finished picture was destroyed in the great Parliament fire during the First World War and all we have now are the cartoon and the preparatory sketches. The vigour and richness of the oil sketch (reproduced) and the monumental quality of the cartoon suggest that the painting was more successful than the static, lifeless group we are accustomed to seeing in contemporary engravings and more recent copies. This commission launched Harris as one of Canada's most fashionable portraitists. His *Sir Hugh Allan (NGC) of 1885 seems to epitomize the self-confident spirit that was then welding Canada into a substantial reality. Though the painstaking naturalism and substantial 'presence' of the painting are in the French style, it has great individuality. But Harris received the warmest response from the younger artists of the day with such genre subjects as the Meeting of the *School Trustees* (NGC) of 1885, and his deeply felt and sensitively expressed 1886 picture of his wife at a harmonium, called *†Harmony* (NGC). The ease with which he captured the beauty of the moment-placing figure and instrument in a convincing space and enveloping all in an atmosphere of tranquillity-is still moving today.

PAULPEEL (1860–92), with his 'slick' technique and sentimental subjects, is the Canadian who comes closest to embodying in his art all that is popularly meant by the term 'academic' painting. Born in London, Ont., where his father was a marble cutter and drawing master, Peel first studied in 1875–77 with a local painter, William Lees Judson (1842–1928). He was a precocious student, and began studying at the Pennsylvania Academy in Philadelphia in 1877, when he was only seventeen. He worked under the Academy's famous teacher, the great Thomas Eakins, who, having studied in Paris, was causing a stir with his innovations. After graduating Peel went first to London, Eng., then in the late spring

Robert Harris. *The Fathers of Confederation (Study)*, 1883. Canvas, 33.0×57.2 . Confederation Art Gallery, Charlottetown.

Robert Harris. *Sir Hugh Allan*, 1885. Canvas, 129.6 × 106.7. NGC.

Paul Peel. *Devotion*, 1881. Canvas, 90.8×69.9 . NGC.

of 1881 crossed to France to join the American art colony that gathered each summer at Pont-Aven in Brittany. Later in the year he moved on to Paris, and the following April he enrolled in the École des Beaux-Arts in order to study under Gérôme. He later worked under Jules Lefebvre at Julian's. Both Gérôme and Lefebvre were masters of the slick brush, but we can see from Peel's **Devotion* (NGC) of 1881, which is impressive for its light and space and natural ease of modelling—good solid academic virtues—how well Eakins in Philadelphia had prepared his Canadian student to respond to the French masters.

Although Peel married a Danish art student and settled in Europe, he continued to exhibit work in Canada and was well known to the younger painters. In 1890 he held a one-man show and auction sale in Toronto, exhibiting his striking †*A Venetian Bather* (NGC), which had been painted the year before in Paris. It was probably the first nude to be publicly exhibited in Toronto. Viewers who normally would be outraged at the display of such seductive flesh were enabled by the innocence of the young subject in her exotic setting to luxuriate in the delicious curves and soft glow and to savour pleasure for its own sake. That same year Peel's *After the Bath* (AGO) won a bronze medal at the Salon. Today his

most famous picture, it was immensely appealing then too, and Sarah Bernhardt was among the collectors who wished to buy it off the Salon wall. It went to the Hungarian state collection. Peel was rapidly becoming the first Canadian artist to attract a truly international reputation. Unfortunately he died in Paris only two years later at the age of thirty-one.

Another painter who became so involved in the Paris art scene that he never returned home was WILLIAM BLAIR BRUCE (1859–1906) of Hamilton. He studied with Bouguereau at Julian's from 1881, and, like Peel, married a Scandinavian—a Swede. Bruce lived longer than Peel, and probably as a consequence attempted more ambitious canvases. His huge paintings of glistening nudes—*La Joie des néréïdes* (NGC) is almost three metres square—were never exhibited in Canada during his lifetime, however. By the end of the century Bruce had a reputation in Sweden and his home on the Island of Gotland is now a small museum housing works left by his sculptor wife and himself.

By 1890 a second wave of Canadians had begun to arrive in Paris most, it would appear, inspired by Robert Harris if they were from Toronto or by William Brymner if they were from Montreal. The only one to persist in the strict academic style of monumental figure painting so prominent among the earlier Canadians was GEORGE REID (1860–1947). Indeed, he seemed the greatest believer in the academic precepts. Peel and Bruce discovered that a comfortable living could be made from the lucrative export market that existed for fashionable French painting—for which they had to stay close to Paris—but Reid never doubted he would come home to apply newly acquired techniques to the examination of Canadian subjects and for the edification of a Canadian audience.

Reid was born on a farm near Wingham, in western Ontario. His father considered his youthful ambition to be an artist unmanly, but as the boy persisted he was apprenticed at the age of eighteen to a local architect. He enjoyed this brief experience enough to practise architecture later in a gentlemanly fashion, but he still burned to be a painter. So in the fall of 1878 he moved to Toronto and enrolled in the Ontario School of Art. The paintings in the Canadian Educational Museum there were the first he had set eyes on, except for some he had seen on a brief visit to the home of William Cresswell, who lived near Wingham.

Reid witnessed the great excitement in the fall of 1879 caused by the arrival in Toronto of Robert Harris, the first artist with an up-to-date French training. To Reid's delight Harris took over one of his classes and proceeded to teach the French method of picture making; but with one key omission.

At that time nude models were not posed in Toronto. Reid had read

an article about the Pennsylvania Academy of Fine Arts and its radical teacher, Thomas Eakins, and left for Philadelphia as soon as he could. (He worked for almost two years as a portraitist around Wingham to raise the necessary money.) Accepted by Eakins, he received an intensive training in anatomy, life drawing, and pictorial structure. He was with the famous painter from the fall of 1882 until the spring of 1885 and was among his last students at the Academy. In conflict with the reactionary forces in that institution for some time, Eakins was finally forced to resign in 1886—for daring to remove the loin-cloth from a male model in the women's life class.

After graduation Reid married a fellow student from the Pennsylvania Academy-Mary Hiester-and honeymooned on the continent, staying for ten days in the French capital; he could not yet afford to study there. In later years he remembered that this short trip, which fortuately coincided with the Salon, confirmed him in his belief that French painting presented the greatest possibilities to the modern artist. Not everyone would have agreed. In fact when John Hodgsen, Royal Academician, was asked to comment on the Canadian participation at the 1886 Colonial and Indian Exhibition, his one strong note of disapproval was for the extent of French influence evident in the Canadian paintings-the new tendency to produce broad effects and dramatically balanced tones. No one listened, of course, least of all the painters. Robert Harris commented that 'most of the old English Academicians' ideas of art rise to the level of a sort of Christmas card, and they are down on what they consider "Frenchy"!' Reid worked all the harder to raise money to return to France and in the summer of 1888 he and his wife arrived. They were met by Paul Peel, who found them a studio in the Latin Quarter. Their neighbour was Eugène Grasset, the famous French poster artist.

By the spring of 1889 Reid and his wife were fully involved in student rounds. Julian's seemed full of Canadians. Peel had signed up again. Brymner was there that spring, along with Maurice Cullen and Joseph Saint-Charles—also from Montreal—and Curtis Williamson from Toronto. Reid distinguished himself beyond all of them by tying for first place in figure competition. That same year he had two paintings accepted at the Salon, and he returned home in November convinced that he was an accomplished exponent of the most advanced painting of his day. His first painting in Toronto, **Mortgaging the Homestead*, marshalled all of his talents to a theme from his childhood. When Reid was elected a full member of the Royal Canadian Academy the next spring, the painting was deposited in the National Gallery.

Reid continued to send pictures to the Salon and to the Pennsylvania

George Reid. Mortgaging the Homestead, 1890. Canvas, 128.3 \times 212.1. NGC.

George Reid. Forbidden Fruit, 1889. Canvas, 77.8 × 122.9. AGH.

Academy, and a good proportion of them were accepted; some were even sold. His usual working procedure involved the building of a 'set' a hay-loft for his **Forbidden Fruit* (AGH) of 1889—and when his picture was completed this set was cleared away and a private studio viewing was held for the Toronto art-public. Then the picture was sent off for exhibition. His paintings were large—*Mortgaging the Homestead* is over two metres wide—and one canvas could dominate a room crowded with people. Reid's studio would likely have been crowded, for his work caught on immediately when he returned to Toronto. His striking lightand-shade effects, the dramatic placement of figures, and particularly the strong native sentiment in his large 'show-pieces', appealed to the growing public interest in art. Reid sold steadily and for good prices. When the Ontario School of Art, his Alma Mater, was reorganized during the summer of 1890 as the Central Ontario School of Art and Design, he was hired as painting instructor.

Reid's aspirations went far beyond this conventional success, however. When he was in Paris an announcement for a program to decorate the Hôtel de Ville had sparked in him a lifelong ambition to do mural work. All the great academicians were heroic muralists. Their art was unashamedly 'public' in its subject and treatment and they sought exalted public situations for its display. With high hopes Reid approached Toronto City Council in 1894 with an enterprising decorative scheme for the newly completed City Hall. His proposal was rejected for lack of funds. But Reid persisted, struggling with various committees, until finally in desperation in 1897 he offered to begin the scheme at his own expense. Council of course agreed, and two years later Reid's free contribution to the decoration of the Toronto City Hall—a group of murals, still to be seen-was installed in the entrance hall. Meanwhile he had received so many domestic mural commissions that by the turn of the century he had largely stopped making large genre pictures. And tastes in art were changing.

In 1896 Reid had revisited Paris, and for the first time looked at the Impressionists. He had been developing an interest in landscape painting, and the work of Monet encouraged him to eliminate detail, to break open his brushstrokes to let in light, and to key up his colour. After the turn of the century such 'impressionist' canvases as his *Vacant Lots* (NGC) of 1915 delighted his public almost as much as had his earlier genre scenes. But as the years progressed and Reid grew older his landscapes grew darker, more traditional in composition, and much less interesting.

Reid might have found more sympathetic patronage in Quebec City for his mural schemes than he ever did in Toronto. CHARLES HUOT (1855–

Charles Huot. La Bataille des Plaines d'Abraham, 1900. Canvas, 40.7×57.1 . Maurice Corbeil, Montreal.

1930), who was born in Quebec City, and first studied there to be a teacher, enrolled in the École des Beaux-Arts in Paris under Cabanel in 1874, and on returning to Canada in 1886 he was able to begin a career as a muralist that occupied him for the next forty years. His large historical murals were usually dull repetitions of tired formulae—*Le Premier parlement de Québec*, completed for the Salle de l'Assemblée Législative du Québec in 1913, is his most famous—but his smaller studies have always been sought by collectors. **La Bataille des Plaines d'Abraham* (Maurice Corbeil, Montreal) of 1900 is an exhilarating virtuoso performance. Such heroic themes obviously excited his creativity, but it was a long series of Church commissions that secured his livelihood.

French-Canadian painters had traditionally sought patronage and direction from the Church and, with a curious mixture of educational experimentation and practical economics, the practice took a new turn in 1890. Although the apprenticeship system continued to serve French-speaking Quebeckers seeking art instruction until well into the twentieth century, especially with regard to training in church decoration, the increasing urbanization of the Francophone community led to the establishment of an art school in Montreal in 1870. The Institut National des

Beaux-Arts, as it was known, was founded by l'Abbé Joseph Chabert (1832–94), a French priest who had studied in Paris at the École des Beaux-Arts, and was run by him in various locations until 1888. Chabert always encouraged his best students to further their studies at the École des Beaux-Arts in Paris, and in 1890 the curé of Notre-Dame in Montreal. seeking an up-to-date mural program for his new Sacré-Coeur Chapel, arranged to pay the costs for five of Chabert's past students to travel to Paris in order to prepare the program. They in turn agreed to produce the murals at no extra cost to the church. Two of Chabert's graduates who had only recently returned from two years in Paris—LUDGER LAROSE (1868–1915) and IOSEPH FRANCHERE (1866–1921)—were the first of the five to go in December 1890. JOSEPH SAINT-CHARLES (1868–1956), CHARLES GILL (1871-1918), and HENRI BEAU (1863-1949) were also involved in the program over the next four or five years. (The chapel interior and its paintings were destroyed by fire in 1978.) In later years these men continued to work as muralists, portraitists, and church decorators (except for Charles Gill, who became a noted poet), but none was ever to achieve the fame of another Chabert student, a young religious decorator from Arthabaska.

MARC-AURÈLE DE FOY SUZOR-COTÉ (1869–1937) began studying with Chabert in 1886 and a year later was apprenticed to a church decorator. Finally in 1891 he had enough money to travel to Paris (he went with Saint-Charles) and enrol in the École des Beaux-Arts under Bonnat. A guick student, he progressed to the point of inclusion in the Salon of 1894. That June he returned home, but three years later he was back in Paris and enrolled at Julian's under Robert-Fleury and Lefebvre. He also attended the Colarossi Academy, began to exhibit regularly in the Salon, and became the centre of a small French-Canadian group that met regularly at the Café Fleurus. Although Suzor-Coté had taken an early interest in landscape, academic traditions remained very strong for him and as late as 1902 he painted a historical composition, La Mort de Montcalm (MQ). By this time he had begun to assimilate other influences, and in his *LaJeunesse en plein soleil (NGC) of 1913 he shows his acceptance of the highkeyed colour and patterned brushwork he had found in Impressionism. Much like George Reid, Suzor-Coté became more conservative as he aged, and his work from before the First World War is his most adventurous.

The academies of Paris, which exerted such an overwhelming effect on virtually every young Canadian artist during the eighties and nineties, inevitably lost their relevance. After the turn of the century very few painters—if any—from Toronto found their way to Julian's or the Cola-

Marc-Aurèle de Foy Suzor-Coté. *La Jeunesse en plein soleil*, 1913. Canvas, 146.7 × 123.2. NGC.

rossi. In Montreal, where there was both a culture based on the French tongue and William Brymner, the case was slightly different.

Because Brymner taught at the Art Association of Montreal from 1886 until 1921 Paris continued to exert a pull on young Montrealers that was unknown to most other Canadians. A.Y. Jackson, for instance, went there to study in 1907 and enrolled at Julian's under Laurens. But, like James Wilson Morrice, another Montrealer who had entered Julian's sixteen years earlier, Jackson did not stay long. After six months he quit the studio to travel for two years, visiting all of the artists' spots around France and painting assiduously. He even exhibited in the Salon. But he knew, as he writes in his autobiography, that it 'catered to foreigners, handing out bushels of medals each year.' It clearly was not the Salon that attracted him, nor the academies. It was, as he discovered after returning to Montreal, the artistic climate—the great numbers of painters, the artistic quarrels, the excitement of experimentation. As soon as he had saved enough, he was back again for another year and a half. Homer Watson and Ozias Leduc 1880–1930

While most young Canadian painters of the last two decades of the nineteenth century eagerly rushed off to Paris, two who did not are among our greatest artists of the years around the turn of the century. Both Homer Watson and Ozias Leduc were born in tiny rural communities and both chose to continue living there. Both were largely self-taught and visited Europe only in their maturity.

HOMER WATSON (1855–1936) was born at Doon, Ont., now a suburb of Kitchener. His father, who owned a mill there and was an educated man with a small library, died when Homer was six, removing any pressure that might have developed for the boy to go into the family trade. By the age of fifteen Watson had already revealed a consuming interest in art fed exclusively, it would seem, by the illustrated magazines of the day. Like Horatio Walker and George Reid, he is another of the fruits of that rich rural culture that flourished in Ontario after mid-century. And, like others of his generation, he found the seedbed of his developing talents inadequate to his aspirations and was drawn to the provincial capital.

Watson first visited Toronto in 1872 and called on T. Mower Martin, who gave him a little encouragement when he saw his drawings. Two years later, when he had turned nineteen, Watson received a small inheritance from his grandfather and moved to Toronto.

'I did not know enough to have Paris or Rome in mind,' he once wrote. 'I felt Toronto had all I needed and my first look at a collection of pictures was when I visited the Normal School to see the collection of old masters there.' This was the group of oil copies assembled by Egerton Ryerson almost twenty years before—the only public art gallery in Ontario. One of the few other galleries was the commercial premises of Notman-Fraser, and young Watson soon gravitated to that focal point of art activity. There he met Henry Sandham, Lucius O'Brien, and of course John Fraser himself. He stayed in Toronto a little more than a year, working around Notman-Fraser's, sketching in the Normal School museum, and apparently receiving lessons from Fraser. It was probably Fraser who encouraged him to look further afield and in 1876 he travelled to Philadelphia to view the huge international art display at the Centennial Exposition and also visited New York City.

In New York, Watson called on the American landscape painter George Inness, several times, apparently, and in emulation of the famous painter—then at the height at his career—he sketched along the Susquehanna and Hudson Rivers and in the Adirondacks before returning home. Watson had firmly decided to become an artist. He set up a small studio in Doon and divided his time between there and Toronto, where he shared a studio with another painter.

One of the earliest of his canvases is a strange, romantic vision, *The Death of Elaine* (AGO), painted in 1877, probably at Doon, although possibly in New York. Illustrating the Tennyson poem *The Idylls of the King*, it is accomplished in treatment for a beginner; it has been suggested that it reveals knowledge of current European, most likely French, art. (The Philadelphia exhibition included the first large group of French paintings seen in America.) *The Death of Elaine* is a 'sport', however. Watson was a landscape painter, and although he periodically turned to literary themes, all of his important pictures are landscapes. His earliest—such as *Landscape with River* (AGO) of 1878 and *Coming Storm in the Adirondacks* (MMFA) of 1879—are based on his American trip and follow the late style of the Hudson River School of painting, examples of which he would have seen in New York. Dry and contrived to our eyes, they probably represented the very embodiment of art to Watson; that they depicted American scenes would only have added to their 'authenticity'.

Watson caught on quickly in Toronto. He first exhibited professionally—with the Ontario Society of Artists—in 1878, and was elected a full member the next year. In 1880, at the age of twenty-five, he was included in the first exhibition of the Royal Canadian Academy. Much to his surprise, his *The Pioneer Mill* (Her Majesty the Queen) was bought from the exhibition by the Marquis of Lorne and—even more newsworthy was bought for Queen Victoria! The story appeared in all the newspapers and Watson almost overnight became a famous Canadian painter. Other paintings were purchased from the show for the Royal collection, but they were the work of older, well-established artists.

The purchase confirmed Watson's direction as an artist and it also enabled him to marry. He and his wife bought a house in Doon and

108 | Homer Watson and Ozias Leduc

Homer Watson. The Stone Road, 1881. Canvas, 91.5 × 130.0. NGC.

settled in. For the next seven years he lived a quiet yet productive life, painting around Doon and leaving all business to his agent, a Toronto dealer he had engaged. These years resulted in Watson's strongest, and in many respects his most Canadian, canvases. With the aim of depicting his immediate environment, he spent years wandering, looking, thinking, and sketching. Intense experiences gave rise to large canvases such as **The Stone Road* (NGC) of 1881. Because Watson was finding his own way in virtual isolation from other painters, such a work has its obvious faults. Yet it has tremendous strength. The curve of the road introduces just enough tension to keep the picture taut—frozen, as in a dream, with every iron-hard detail assuming great significance.

In May 1882 Oscar Wilde visited Toronto on a North American tour and there saw Watson's work. Believing he had unexpectedly found an artist of rare talent, he exclaimed 'The Canadian Constable!' Watson, of course, had never seen a painting of Constable's; any resemblance was likely born of a similar concern with the intense, intimate expression of familiar landscape. The remark, which made an impression on Watson, was reinforced when Wilde later wrote commissioning a picture and offering support if Watson ever visited England. The painter's head

XIV—Robert Harris. *Harmony*, 1886. Board, 30.5 × 24.8. NGC.

xv—Paul Peel. A Venetian Bather, 1889. Canvas, 156.0 × 113.0. NGC.

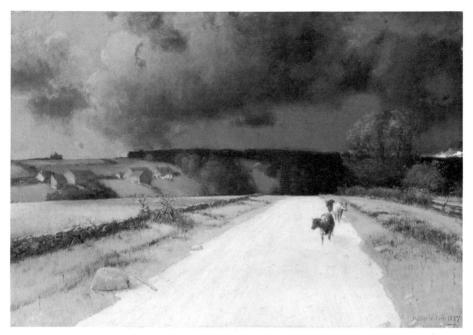

xvI—Homer Watson. Before the Storm, 1887. Canvas, 63.5 × 91.5. Art Gallery of Windsor, Ont.

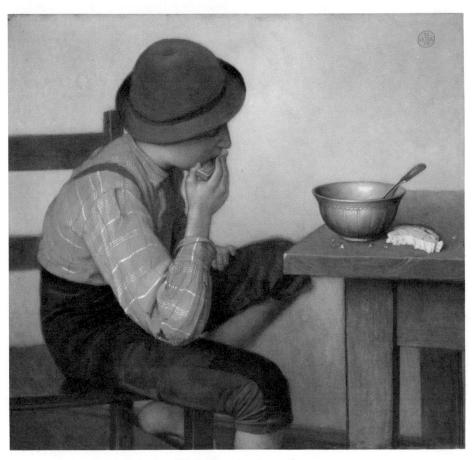

XVII—Ozias Leduc. L'Enfant au pain, 1892–9. Canvas, 50.5 × 55.9. NGC.

Homer Watson. A Ravine Farm, 1889. Canvas, 70.5 × 98.5. NGC.

remained unturned, however. Montreal collectors were beginning to buy, and a modest but steady income allowed Watson to keep working in his beloved Doon.

Watson's art was developing out of a driving need to comprehend the meaning of the familiar. His pictures are complex in their detail and have the slightly disjointed clarity of a dream vision. They are strong and individual in suggesting the strangeness of the particular when it is examined both as a concept and as a phenomenon. Many have found them a bit naïve.

When his work in the Colonial and Indian Exhibition held in London in 1886 was well received, Watson finally resolved to see what England offered. Before leaving Canada he wrote a friend in March 1887, 'Am painting like blazes. Have finished up that white road and dark sky affair and it is my best so far.' The picture—†*Before the Storm* (Art Gallery of Windsor)—is one of the best he ever painted, and suggests the route he might have followed had he stayed in Canada. In clarity and quality it is, paradoxically, the closest he came to Constable.

Watson and his wife spent three years in England. He delivered the commissioned picture to Wilde, who introduced him to Whistler. He also

110 | Homer Watson and Ozias Leduc

became interested in etching. Deciding that a print of *The Pioneer Mill* would sell well in Canada, he arranged with the Marquis of Lorne to see it again, and was flattered to find it hanging in the reception room at Windsor Castle. Lorne also helped him by recommending his work to the prestigious Goupil Gallery, and Watson was able to make some sales and arranged to have pictures shown there regularly.

*A Ravine Farm (NGC) of 1889, painted near the end of his English sojourn, shows that he had been led away from his intense concern with content, with the detailed depiction of the vision he carried of his home environment. His art was irrevocably changed. His new concern was with style as an end in itself: effect, breadth of handling, unified treatment, sweeping movement. A Ravine Farm is no longer particular, it has no magic of place. Though probably better painting, it is poorer art.

Watson returned to Doon. 'After some years of restless wandering in quest of adequate media of expression in art, a desire took possession of me to live again where I knew great quiet would blend itself luxuriously with the schemes I was developing for my painting. It came to me that among the nooks and scenes of this village nestling among the hills, I should find ample material to fix in some degree the infinite beauties that emanate from the mystery of sky and land. ... True, the place was a village, and as such would, to a certain extent, hem me in, but in such an atmosphere, undisturbed by the clamour of man's contention, I could scarcely help being in accord with nature's spirit.' Although such reasoning—as recorded by Muriel Miller in her biography of Watson—was undoubtedly the basis for his decision to return, for the next thirty years he brooded over the issue of *where* to live. He often went back to London at the prompting of his English dealers and friends and maintained steady sales there, but he always returned to Doon to paint.

Watson was never to recapture the intensity of his involvement in the landscape of his home, although he struggled with his new style and finally achieved a degree of expression that was certainly above the ordinary. His **Log-cutting in the Woods* (MMFA) of 1893 won the first prize at the Art Association of Montreal Spring Show that year and was immediately bought by Lord Strathcona. Various prominent Montreal collectors vied for similar works, and the wealthy railroad contractor James Ross in particular almost supported him. Watson's stylish treatment of such French Barbizon themes (see p. 119) appealed greatly to these collectors, who were at the same time buying real Barbizon pictures. Perhaps feeling that this work suggested some compromise, he tried to reassert a commitment to his roots through a cycle of epic canvases depicting the pioneer beginnings of Waterloo County. But he succeeded in evoking

Homer Watson. Log-cutting in the Woods, 1894. Canvas, 45.8 × 61.0. MMFA.

only an idealized nostaglia. The paint handling is often very beautiful, but there is not the biting truth, the immediacy of experience of his pre-1887 canvases.

In 1899 Watson achieved the culmination of his international reputation with a successful one-man show in London, followed by another in New York. Returning to Doon, he painted the work he later considered to be his masterpiece: **The Flood Gate* (NGC). Certainly it is the finest picture in his mature manner. He deliberately chose a Constable subject, as though finally he felt equal to challenge the painter whose name had dogged him throughout his career. Watson now strove for breadth of treatment—one big idea rather than the accumulation of a group of small effects. No longer concerned with the detailed rendering of leaf, stone, and cloud, he gives a sweep to the whole: sky, trees, water, and brute animals all move in unison. Only man leans against the combined forces of nature.

The Flood Gate was shown at the Glasgow Institute to such acclaim that Watson was tempted once more to live in Britain. As Muriel Miller has commented: 'He decided against it finally, for he felt stultified in England

112 | Homer Watson and Ozias Leduc

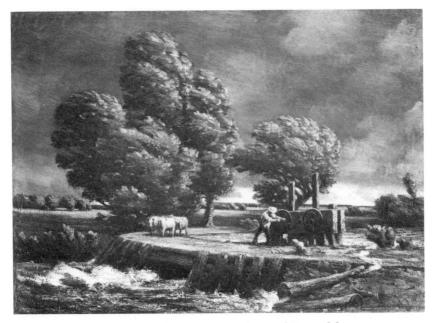

Homer Watson. The Flood Gate, 1900. Canvas, 82.5 × 118.8. NGC.

and knew that the Canadian landscape had never failed to inspire him.' Watson's career continued into the twentieth century and he became first president of the Canadian Art Club. His work of this period is often monumental and is painted in a strange reddish-brown monochrome.

Watson's wife died in 1918 and the loss shattered him. No longer able to paint, he wandered about aimlessly. One night she appeared to him, descending the stairs. The dream was so clear that he was not certain he was asleep. The experience changed his life. He adopted a notational style of painting he called 'impressionism' and returned to the artistic scene, accepting the presidency of the Royal Canadian Academy. After about 1922, however, deafness forced him almost to withdraw from public life. He had become a spiritualist and a friend of the Prime Minister (also a spiritualist), William Lyon Mackenzie King. King bought pictures from the artist and wrote to him about the trials of leadership.

In his later pictures Watson became enchanted with the problem of capturing light qualities. He has been unjustly accused of attempting to copy the Group of Seven, who had eclipsed him in the public eye. He in fact simply pursued to a logical conclusion his tendency to generalize forms and broaden his handling. In 1929 Watson visited the Rockies and the strongest of his last pictures are strange visions of mountain splendour. He died at Doon, aged eighty-one, a penniless, forgotten man. For most of his life he had struggled with the problem that has often plagued creative artists in Canada: whether to stay.

Although the career of OZIAS LEDUC (1864–1955) parallels Watson's in many respects, it does not reflect a dilemma raised by foreign acclaim. Leduc enjoyed the appreciative attention of a few admirers during his life, but it was only after his death that a retrospective exhibition revealed the beauty of his work to even a national audience. This neglect stemmed from Leduc's somewhat retiring mode of life and from having derived his livelihood mainly from the traditional work of church decoration.

Leduc was born at Saint-Hilaire, a small town nestled at the foot of a brooding steep-sided mountain east of Montreal. When he first began to paint there were no colours available except the paints used by his father, a cabinet-maker. Legend has it that he crushed stones to make pigments and that the resulting earth colours determined the range he was to prefer as a mature artist.

Leduc's simple human qualities have been so generally praised that his life has taken on a saint-like quality. Despite such mythicizing, he does appear to have been an extraordinary man. He lived his whole adult life with his wife in a house in the middle of a magnificent well-caredfor apple orchard beneath the slopes of Mont Saint-Hilaire. After he had decided to dedicate his life to painting and poetry, he built onto the house with his own hands a small stone library and a studio that became an indispensable base for a religious painter whose pursuit of church commissions often took him to distant locations for lengthy periods of time.

Leduc worked slowly on his easel painting, but he lived for ninety years and accomplished much. His rare modesty, his freedom from ambition and vanity, and his relative seclusion at Saint-Hilaire meant he had limited involvement with other artists. Nevertheless he was for many years a member of the town council, a church-warden, the founder and vice-president of the commission to arrange the decoration of his parish church of Saint-Hilaire, and a founding member and director of the regional historical society of Saint-Hyacinthe. He even wrote a history of Saint-Hilaire. His social priorities were thus centred on his immediate community.

Leduc's artistic concerns reflected this intense sense of local community as well as the traditional French-Canadian union of art and religion. He began working as an independent church decorator in 1892 and derived his livelihood from this occupation until his retirement, completing pro-

114 | Homer Watson and Ozias Leduc

grams in twenty-seven cathedrals, churches, and chapels: a total of some hundred and fifty large paintings with interconnecting ornamentation. Church decoration fell into such disrepute in the later nineteenth century (much of what survives in Quebec is the work of hacks) that this central aspect of Leduc's art has been ignored: the activity on which he spent most of his time and energy remains virtually to be discovered. On the evidence of Leduc's canvases in the cupola of the Église du Saint-Enfant-Jésus in Montreal (*c.*1916), and of his murals in the chapel of the Bishop's palace in Sherbrooke (1922–33)—considered by many to be his masterpiece—Leduc appears to have single-handedly brought integrity back to church decoration.

He received his first training in 1883 with Luigi Cappello (active 1874-92), one of the many foreign muralists to be employed by Quebec churches in the late nineteenth century. Then in 1888 he assisted a friend of Charles Huot, the jack of all trades, Adolphe Rho (1835-1905), on a decorative program at Yamachiche, just west of Trois-Rivières. Leduc's earliest known easel painting dates from the year before. Painted when he was only twenty-three, *Les Trois Pommes (Mme P.E. Borduas, Montreal) is astonishingly accomplished. The apples seem to glow in the perfection of their natural geometry. Gilles Corbeil has remarked on how Leduc 'seems at every moment to have been conscious of some moral responsibility for the way he treated his canvases and handled his brush and his colours.' Such early still-lifes-they make up the bulk of his work from before 1900-are close in certain respects to the trompe l'oeil painting then so popular in the United States. Usually assembled from objects in his studio, no two of these still-lifes have the same 'feeling'. Leduc never allowed his work to become formulaic. The intense reality of his stilllifes, their presence, becomes hallucinatory—truly mystical and religious. Like Watson's Canadian paintings between 1880 and 1886, they grew to satisfy personal needs, not to reflect an accepted idea of what 'art' should look like. He painted in order to express his deeply felt idealism, his belief in the artist's special calling: to reveal the inherent perfection of God's creation.

Leduc's remarkable *†L'Enfant au pain* (NGC), painted over a period of seven years (1892–9), reveals this same reverence for the simple appearances of life, this same intense reality. The precise colour and texture of shirt, bowl, and polished wood have been so obsessively pursued that the resulting images transcend the material. The silent musician plays in another world, at first so much like ours as to startle, but finally so ideal in its frozen moment that it represents a state of acute awareness towards which we can only aspire.

Ozias Leduc. Les Trois Pommes, 1887. Canvas, 22.5 \times 30.8. Mme P.-É. Borduas, Montreal, Que.

Two years before *L'Enfant au pain* was completed, Leduc took his one trip abroad—with Suzor-Coté. This brief visit to Paris between May and December 1897 seems not to have markedly changed his art. His charmingly titled **Mon portrait* (NGC), painted two years later, is moody and atmospheric, like some of his earlier still-lifes; a personality is formed from light out of the darkness. The current of the mainstream did not distract Leduc, unlike Watson. He accepted only what was consistent with his vision and would reinforce his art.

Leduc's retiring nature should not be stressed too much. He was involved with the poets, musicians, and architects in Montreal who published the short-lived *Le Nigog* magazine in 1918 in an attempt to bring new French ideas to Quebec culture, and with some of the regionalist writers who opposed them, and illustrated a number of books as a result of these friendships. He also exhibited regularly in the AAM Spring Show, and with the RCA and OSA from 1891 until about 1920. By the turn of the century he had a small but loyal following. Perceptive artists outside his circle appreciated his work when they were able to see it. In a letter to a

116 | Homer Watson and Ozias Leduc

Ozias Leduc. *Mon portrait*, 1899. Board, 33.0×27.0 . NGC.

Ozias Leduc. Pommes vertes, 1914–15. Canvas, 62.2 × 92.7. NGC.

friend, A.Y. Jackson singled out Leduc's *Pommes vertes* as the best painting in the 1915 Spring Show, and the National Gallery bought it later that year.

This modest public attention culminated in 1916 when Leduc was invited to hold a one-man show at the new Bibliothèque Saint-Sulpice in Montreal. It was the only such exhibition he was ever to have: he apparently felt little motivation to court public favour. He was then fiftytwo. Two or three years earlier he had turned from still-life painting to landscape, and over the next eight years a series of strange, almost abstract visions of glowing light appeared. All are set on Mont Saint-Hilaire, the brooding geological accident that dominates the region around his home. All suggest symbolic meanings. Notice, in *Fin de journée (MMFA), the rope-ladder hanging against the rock-face to the left and the wisp of smoke curling across the foreground. This work's alternative title, Les Portes de fer, only adds to the air of mystery. Jean-René Ostiguy has remarked that Leduc 'saw nature in the light of his dreams', and friends in Montreal, recognizing this 'other-worldly' quality of his vision, encouraged him to read symbolist authors like Huysmans and art historians like Émile Mâle, who in his books interpreted the symbolic meanings in the art of the great Christian eras. From 1916 Leduc's good friend, the priest Olivier Maurault, discussed with him the relevance of such symbolist painters as the Frenchman René Ménard and doubtless helped him to obtain magazines illustrating their work. And it was apparently Maurault who directed him to the important symbolist theories of Maurice Denis. Much of Leduc's late and best church work-from about 1920 through to the mid-thirties-should be studied with this French religious painter's ideas and paintings in mind.

Leduc stopped submitting to exhibitions in 1920, even though most of his important church commissions were yet to appear, but he did continue to paint, and beginning that year he began to show the occasional canvas with commercial galleries. His latest paintings—such as *Paysage de neige* (private collection) of 1939–40—show, like the later works of Homer Watson, a looser, more open quality and an absolute obsession with light. They are consistent with the vision he had pursued for almost sixty years.

Although both Watson and Leduc valued continuity, and sought it in the only way possible, by nurturing their roots, Ozias Leduc, who carried that concern almost to the point of isolation, was paradoxically the one to make a real bridge to the future. Homer Watson had been passed over by the time he had died; no one followed in his footsteps. Leduc died in full awareness of the adulation of friends and of having fostered one of

118 | Homer Watson and Ozias Leduc

Ozias Leduc. Fin de journée, 1913. Canvas, 50.8 × 34.3. MMFA.

the great geniuses and leaders of the new art, Paul-Émile Borduas (see chapters 13 and 14). Borduas, who was born at Saint-Hilaire and often worked with Leduc as a church decorator from about 1920 through to 1932, has explained the debt he owed his master. Leduc showed him 'the way from the spiritual and pictorial atmosphere of the Renaissance to the power of illusion which leads into the future. Leduc's whole life shines with this magic illusion.'

The Canadian Art Club 1907–1915

While the Parisian academies continued to attract thousands of foreign art students throughout the nineties and into the twentieth century, and while the paintings produced as a result of this training continued in their thousands to please the vast public, the academic approach to painting suffered increasingly severe criticism from the more innovative painters. Academic painters were found guilty of cold objectivity, lifeless drawing, and overly reserved colouring. Their huge 'machines' were declared to be dull, superficial, often sentimental, and totally lacking evidence of sensitive emotional commitment. In Paris such complaints had been heard for many years, but by the mid-seventies forceful alternatives to the slick narrative painting of the Salon had been found. The Impressionists began to attract foreign adherents after their first exhibition in 1874, and other alternatives also existed for students from across the Atlantic. During the 1870s a 'school' of Dutch artists gathered in The Hague. Like the Impressionists, they were influenced by a group of painters that included Corot, Théodore Rousseau, and Millet who had lived around the hamlet of Barbizon in the forest of Fontainebleau. Working in direct response to nature, these Barbizon painters had brought a moving naturalism to landscape painting, elevating it to a position of public esteem. (The academicians had thought it greatly inferior as a subject to noble themes from the past.) Unlike the Impressionists-who saw everything in terms of light (colour = refracted light) and who strove to record their sensations objectively-the Hague School consciously expressed their feelings, their mood, in 'atmospheric', almost monochromatic paintings that stressed richness of tone. Observers referred to this as 'subjective' painting.

Yet another alternative, and one particularly attractive to the Anglo-American colony in Paris, was that represented by the work of James McNeill Whistler, the American painter who by the time of his famous libel suit against the English critic Ruskin in 1878 was widely known for

his refined studies of mood. Whistler attracted a group that was vigorously opposed to the academic values of the Salon. In 1898 it formed the London-based International Society of Sculptors, Painters and 'Gravers, with Whistler as president. By the turn of the century the personal, expressive approach they advanced had superseded the academic style in the very academies themselves.

Canadians who studied in Europe-and they continued to do so in large numbers-began to reflect a tentative 'modernism'. The first evidence of changing concerns appeared in the whiter colours, looser brushwork, and studied attention to the effects of reflected light in the work of people like Brymner and Reid. But these vaguely 'impressionistic' touches were superficial, and the first shift away from academic naturalism in Canada was largely due to the influence of the Dutch painters of the late nineteenth century-notably the Hague School. By the nineties, and particularly in Toronto, the young painter seeking serious instruction thought of looking for it-at least in part-in Holland. This preference was shared and probably stimulated by a number of prominent collectors in Montreal and Toronto who, acquiring the American taste for French Barbizon pictures rather late, soon discovered the similarly pastoral paintings of the Hague School. The lugubrious nature of the Dutch work also probably appealed more to the Anglo-Saxon temperament than did the heady sensuality of recent French painting. But for whatever reasons, large amounts of money were spent on these now almost-forgotten painters, and magnificent collections were assembled. Consequently the first art books ever published in Canada were Landscape Painting and Modern Dutch Artists (1906) and The Subjective View of Landscape Painting (1914)—a study of the work of Johannes Weissenbruck both written by E.B. Greenshields, a prominent Montreal collector.

This taste began to be reflected in the exhibited work of at least two of the younger Toronto painters during the nineties, and most influentially in the paintings of the wealthy and independent young EDMUND MORRIS (1871–1913). Born in Perth, Ont., he lived in Fort Garry (Winnipeg) when his father was lieutenant-governor of Manitoba (1872–7), and then in Toronto, where he attended his first art classes. In 1891 he moved on to the Art Students League in New York where he studied with Kenyon Cox and William Merritt Chase, and then in 1893 to Paris for the usual stint with Laurens and Constant at Julian's, and with Gérôme at the École. Significantly he spent his summers painting in Holland. In 1896 he was back in Toronto and the next year exhibited his *Girls in a Poppy Field* (AGO) in the RCA and then the OSA, when it was bought by the famous local collector Byron (later Sir Edmund) Walker.

Edmund Morris. Cove Fields, Quebec, c.1905. Canvas, 75.6 × 101.6. NGC.

Morris's taste for Dutch subjects was tempered, however, by his early experiences in Manitoba, where he had developed a keen interest in the Indian people. In 1906 he accompanied a treaty commission to the James Bay region, and the following year he completed for the provincial government a large series of Indian portraits that are now in the ROM. He also painted in the West during the summer of 1907, and again in the following three years. His Indian Encampment on Prairie (AGO) of about 1911, depicting a cluster of four teepees on a low horizon, is notable for the rich and subtle modulations of the immense sky: with its dark Dutch tonalities and its avoidance of any Kane-like documentation, it must have seemed strangely modern. Its interlocking range of moody earth-tones, from blue-black through to red, is unusually successful in evoking the binding forces of nature. Morris's typical works, however, were painted in the area of Quebec City, where he worked with James Morrice, Brymner, and, more frequently, Horatio Walker. Dark, sonorous canvases like *Cove Fields, Quebec (NGC) of about 1905 seem to presage his tragic end. While visiting Walker there in August 1913, he drowned at the young age of forty-two.

CURTIS WILLIAMSON (1867–1944), who was also born in a small Ontario

Curtis Williamson. Fish Sheds, Newfoundland, 1908. Canvas, 127.0 × 96.5. NGC.

town, Brampton, is the other young painter who introduced Dutch subjects and technique to Toronto before the turn of the century. Like Morris he first studied art in Toronto—with J.W.L. Forster (1850–1938)—but in 1889 he went directly to Julian's in Paris. After only a year he left the Academy and for the next two-and-a-half years worked mainly near the village of Barbizon. There he fraternized with a group of painters that included the two Philadelphians, Edward Redfield and Robert Henri, and the Canadian naturalist and illustrator, Ernest Thompson Seton (1860–1946). He returned to Toronto in 1892.

It is likely that Williamson had also visited the Low Countries, for immediately upon his return he painted his most famous early picture, *Klaasje* (NGC). A large portrait study of a red-cheeked Dutch woman, it emulates the rich tone and colour of Rembrandt and the gusto of Hals. In 1894 Williamson was back in Europe again, and for the next ten years he travelled mainly in the Low Countries, painting dark peasant interiors lit by single golden windows or a few glowing embers in a black grill.

In 1904, finished with European travel, he returned to Toronto. During the summer of 1907 he visited Newfoundland, and back in his studio the following spring he painted the beautifully luminous and atmospheric **Fish Sheds, Newfoundland* (NGC). More than 120 cm. tall and free of anec-

dote or sentimentality, it was an ambitious, startling picture in its time. With such works as this, and his striking, uncompromising full-length portraits—like *Archibald Browne* (private collection, Kingston)—Williamson developed a considerable reputation as a difficult 'painters' painter'—a reputation he was able to prolong until after the First World War through his friendship with Dr James MacCallum, the Toronto ophthalmologist who was an early supporter of Tom Thomson and the Group of Seven. But he gradually shut himself off and in the years after the war became a cranky, impossible old man whose reputation finally passed into almost total oblivion.

By 1907, however, both Williamson and Morris were deeply disturbed by the tired, old-fashioned look of Canadian art as seen in the various annual exhibitions. They soon discovered that few shared their concern; most of those who might have been expected to do so had seen no reason to return from foreign studies and in some cases were launched on careers in New York or Paris. Change within existing structures was obviously hopeless: they must somehow lure the real talent back to Canada. During 1907, in consultation with sympathetic artists and some of Morris's collector friends, they formed the Canadian Art Club, a private exhibiting society supported by lay members. Professional membership was strictly by invitation and only modern 'subjective' work of the highest calibre was to be shown. That they meant to confront the general complacency was underlined when the Ontario members resigned *en masse* from the OSA.

D.R. Wilkie, a Toronto banker, was honorary president, chiefly responsible for soliciting the support of concerned art-lovers. (Sir Edmund Osler took over the post on Wilkie's death in 1915.) It was necessary to have a mature, successful, yet sympathetic artist as president, and the perfect choice was found in Homer Watson, the respected 'sage of Doon', who was still enjoying a certain reputation in London and New York. After a visit from Morris and Williamson, Watson agreed to serve and they began to draw up a membership list. At the top was an old friend of Watson's, Horatio Walker.

Born at Listowel, Ont., HORATIO WALKER (1858–1938) gravitated to Toronto at the age of fifteen and worked at Notman-Fraser's, where he first met Watson. Three years later, in 1876, he left Toronto for Philadelphia, perhaps still employed by Notman-Fraser, which held the official photography concession at the Centennial Exposition. Later in the year he settled in Rochester, N.Y., working there first as a photographer, then as a painter, until 1885. Walker maintained some Canadian contacts during these years, but they were centred on Quebec City, not Toronto. He

had first visited the ancient fortified city with his father as a boy, and more recently had been drawn back by the sketching possibilities of the region, notably in 1880 when, between May and November, he undertook a leisurely walking tour from near Montreal to the provincial capital. Walker first visited Europe in 1882, where he was obviously much infuenced by the famous Barbizon painter, Millet, and the contemporary Dutch artists of the Hague School, whose characteristic peasant scenes he could emulate in Quebec. In the summer of 1883 Walker first rented a studio for the season in Quebec City, and also in that year engaged the well-known Montross Gallery in New York as his dealer. He finally moved to New York in 1885.

Walker had by then established an effective working pattern, passing the summers at Quebec City (he set up a residence on the nearby Île d'Orléans in 1888), and the winter season in New York. (In 1889 he moved into the famous Studio Building on West 10th Street.) In 1902 the respected New York critic, Sadakichi Hartmann, described Walker as 'the man to whom the first place among American painters should be unanimously conceded'. Montreal collectors also valued him highly. In January 1900 his work was featured with that of the famed Maris brothers of the Hague School in an exhibition at the AAM. Seeking to expand his market, he visited Paris later that year, but settled in London where he lived until 1905, still returning annually for painting on the Île d'Orléans. When he returned to North America the village of Sainte-Pétronille on the Île d'Orléans became his principal residence, although he continued to maintain a studio in New York in order to facilitate his business there. Through mutual friends (particularly the collector Charles Porteous, who maintained a summer home on the Île-d'Orléans), he renewed his friendship with Homer Watson. By 1907 he was easily the most famous Canadian-born painter, represented in most major American collections. The Canadian Art Club hoped to bring Walker's work back to Toronto.

One of the first major cash purchases of the National Gallery of Canada was Walker's *Oxen Drinking* of 1899, which was shown in the Club's 1910 exhibition and was reserved for the Gallery by Sir Edmund Walker. The measure of Walker's reputation at that time can be taken by the price: \$10,000. The years of his association with the Club in fact coincided with the very peak of his fame. By this time his picturesque Millet-like subjects had become vehicles for virtuoso performances of paint-handling, resulting in brilliant colour feasts like the large †*Ploughing—The First Gleam at Dawn* (MQ) of 1900. Rich and varied in texture, the picture swells with the straining of the mighty oxen, forced on by the dramatic gesture of the *habitant* driver.

In 1915 Walker replaced the retiring Watson as president of the Canadian Art Club and the following year received an honorary degree from the University of Toronto. His New York dealer kept him in sales throughout the twenties, but by then he had retired to his private world on the Île d'Orléans. By the time of his death there in 1938 he was remembered simply as a chronicler of the island's peasant farming folk. His art seemed as anachronistic as their way of life.

Two other friends of Watson also joined the club at its inception. WIL-LIAM E. ATKINSON (1862-1926), who was born in Toronto, studied there under John Fraser and Robert Harris, and then with Reid under Eakins in Philadelphia before going to Paris, where he found himself drifting away from the Académie Julian to Brittany and Holland. He also worked briefly in Devonshire before returning to Toronto in 1902. His Willows, Evening (NGC) of 1908 is a typical 'tonalist' Dutch-influenced work. ARCHI-BALD BROWNE (1866-1948) was born in Liverpool of Scottish parents, but raised at Blantyre, near Glasgow. Following a move to Toronto in 1888 he decided to become an artist and returned to Scotland to study with the well-known Glasgow School painter, Macaulay Stevenson. By the time of the founding of the Club he had developed his own variation on the moody tonal landscapes of his teacher. Through the Goupil Gallery in London (Watson's dealer and later Morrice's), he had established a small but loval English clientele. His steady competence, as seen in a work like Benediction (NGC) of 1919, maintained his reputation into the twenties. He moved to Montreal in 1923 and four years later retired to Lancaster, Ont.

The Toronto orientation of the membership worried Morris and Williamson. Anxious for the club to be 'Canadian', they looked further afield for artists who shared their disaffection with the French academic hegemony. FRANKLIN BROWNELL (1857–1946), a French-trained American artist who had been teaching in Ottawa since 1886, had recently begun to paint in the Caribbean. The light and colour he found there began—as in *The Beach, St Kitts* (NGC) of 1913—to alleviate the academic routine of his earlier work. Although never approaching Impressionism, and always academic in structure, his high-keyed paintings were perfectly acceptable to the Club's membership. Brownell virtually stopped exhibiting before the end of the First World War, although he kept on teaching in Ottawa until the age of eighty and lived for another nine years.

The natural place to seek more members was Montreal, and there the Club found enthusiastic support in WILLIAM BRYMNER. He had been gradually evolving towards an atmospheric landscape style quite different from his large figure pieces of earlier years. The atmospheric and moody

William Brymner. Early Moonrise in September, 1899. Canvas, 72.4 × 100.3. NGC.

**Early Moonrise in September* (NGC) of 1899 is typically Barbizon in theme and treatment; the herd of sheep is unified by golden wisps of moonlight refracted through the trees. By 1907, with his *Evening* (NGC), he had developed this concern with atmosphere to a point of brooding moodiness, much as Atkinson had.

In 1909 Brymner, with Watson and Williamson, visited the Cape Breton home of the Montreal collector James Ross. Returning there periodically and working on the Île d'Orléans with Walker, Brymner began to develop his late style of open, light-filled, atmospheric landscapes—particularly marines—like *The Coast of Louisbourg* (NGC) of 1914. During these years Brymner was also president of the RCA (1909–18) and head of the AAM school. He held the latter post until 1921 when he retired to the south of France. Four years later he died in England.

Brymner brought to the Club a number of members from Montreal. The most brilliant was MAURICE CULLEN (1866–1934), as much a pioneer in his early years as Brymner in his, and in the same developing French tradition. Cullen was born in St John's, Nfld, and his family moved to Montreal four years later. Intended for a business career, he convinced his family that he wished to be a sculptor and probably as early as 1884 enrolled with the well-known Louis-Philippe Hébert (1850–1917). (Philippe and his son Henri (1884–1950) both later showed with the Club as

guest exhibitors.) After four years with Hébert he went to Paris and the École, where he switched to painting. Established in Paris, by 1894 he was exhibiting in the Salon, was elected an associate the next year, and had a picture purchased by the French government. *The Mill Stream, Moret* (NGC) is typical of his work then. Basically academic landscape, it has the sharp angularities in composition and the relatively intense colour and concern for light of what has been called 'second-generation Impressionism'.

Cullen returned to Canada at the end of 1895, although he was back in France by March. Late that summer he was home again, sketching at Beaupré, near Quebec City, with Brymner. He returned to this region again near the end of the year, and with another friend, James Morrice, from January to March 1897. Works completed then were the first in Canada to bring the tenets of Impressionism to the treatment of Canadian landscape. (Brymner gave a public lecture on Impressionism at the AAM in March.) What strikes one immediately in **Logging in Winter, Beaupré* (AGH), and what in fact the picture is all about, is snow—a broad expanse,

Maurice Cullen. Logging in Winter, Beaupré, 1896. Canvas, 63.9 × 79.9. AGH.

Maurice Cullen. Winter Evening, Quebec, c.1905. Canvas, 74.9 × 99.7. NGC.

but infinitely various. Newton MacTavish has explained how 'the paint is not simply swiped on with a brush, but it is built up until it attains a loose, open, vibrant texture. This textural quality in paint makes possible the absorption and radiation of light and suggests the presence of atmosphere. ...' Already at this date we can see that Cullen will have much in common with the members of the Canadian Art Club.

Cullen returned to Europe in the spring of 1900 and visited Venice with Morrice. He also visited Venice in 1901 with Edmund Morris and Morrice, and then again with Brymner and Morrice in 1902. He then settled down in Canada for good, although keeping up with his painting contacts, working at Beaupré—Canada's answer to the painters' spots of Brittany— with Morris and Morrice in the summer of 1903, and three years later building a studio at Saint-Eustache, a small town on the St Lawrence north shore west of Montreal, with Brymner. His work at this point is free of impasto, less harsh and more atmospheric. **Winter Evening, Quebec* (NGC) of about 1905 is, in fact, a paean to atmosphere. Smoke, steam, and cloudy fog all intermix in thousands of tones of bluish-grey, accented with pin-pricks of light.

During the Club years the future members of the Group of Seven always sought out Cullen's work, and his friend Morrice said that he was the man in Canada who 'gets at the guts of things'. Most Canadians were not so enthusiastic, however, and in 1920 Cullen built himself a cabin at Lac Tremblant in the Laurentians, where he painted in a more naturalistic landscape style, developing a kind of formula that found success among established collectors. In 1924 he rented his Montreal studio to his stepson, the painter Robert Pilot, and two years later moved to Chambly on the Richelieu River and into virtual retirement.

CLARENCE GAGNON (1881–1942) was born in Montreal, studied under Brymner at the AAM school from 1897 to 1900, and then worked around the area of Baie-Saint-Paul painting scenes of rural life. His *Oxen Ploughing* (MMFA) of 1903 so impressed the wealthy collector James Morgan that he sent the painter to the Académie Julian in Paris. Gagnon followed this with the usual visits to painters' spots around France and Italy. He was strongly attracted to the paintings of James Morrice, although in his *Les deux plages: Paramé et Saint Malo* (BAG) of about 1908 he still felt the need to compound naturalistic detail rather than to simplify his forms as Morrice did. It was as an etcher that he first exhibited with the Canadian Art Club.

In 1909 he returned to Montreal and Baie-Saint-Paul and for a few years painted Québec villages in a misty, atmospheric style similar to Cullen's.

Clarence Gagnon. La Croix du Chemin, l'automne, c.1915. Canvas, 51.4 × 71.7. NGC.

W.H. Clapp. Morning in Spain, 1907. Canvas, 73.6 × 92.7. NGC.

**La Croix du chemin, l'automne* (NGC) of about 1915 is one of the more successful of these 'Impressionist' works, the upper two-thirds a study in subtle tonal variations. Gagnon maintained close contact with Paris— he was there in 1912–14 and 1917–19—and in 1924 moved to the French capital, where he lived until 1936, renowned as an illustrator. His postwar paintings, such as the famous *Village dans les Laurentides* (NGC), of about 1926, are like enlarged magazine illustrations. Lacking most of the earlier atmospheric quality, they show great attention to anecdotal detail, bright clear colours, and striking, easily read forms.

Another student of Brymner's, W.H. CLAPP (1879–1954), also showed with the Club. Born in Montreal of American parents and raised in Oakland, Calif., he returned to Montreal in 1900 to study for four years with Brymner before going to Paris. There he attended the academies but exhibited in the experimental Salon d'Automne and travelled widely in Spain and Belgium. He returned to Montreal in 1908, bringing sun-filled pictures like **Morning in Spain* (NGC) of 1907, painted in a kind of decorative, pointillist style. He persisted with this technique but in 1915,

apparently discouraged by hostile reaction to his work, he visited Cuba for two years and then settled again in Oakland. In 1918 he became curator of the Oakland Art Gallery and in 1923 was one of the founders of The Society of Six, a group of painters who introduced broad, bright, post-impressionist painting to the San Francisco Bay area. He never returned to Canada.

Other painters from Quebec who studied in France also returned with a superficially Impressionistic style applied to essentially academic compositions. Of these, WILLIAM R. HOPE (1863–1931) of Montreal exhibited with the Canadian Art Club from 1912 on; H. IVAN NEILSON (1865–1931) of Quebec City showed with the Club in 1914 and 1915; and the famous Marc-Aurèle de Foy Suzor-Coté participated from 1913.

SUZOR-COTÉ, as we have seen, was a versatile and eclectic artist of great facility. By the time of his permanent return to Canada in 1907—except for a European tour in 1911—he had settled on a richly textured, Impressionist-like landscape style, as in **Settlement on the Hillside* (NGC) of 1909, that invariably contrasted an almost pastel, light-filled ground with a

Marc-Aurèle de Foy Suzor-Coté. Settlement on the Hillside, 1909. Canvas, 58.4 × 73.0. NGC.

darker, often black patterning. His compositions are always solid, though they became somewhat inflexible and even formulary as the years progressed. Never a real innovator, Suzor-Coté nonetheless was able to produce a tasteful amalgam—particularly in his sculpture—that often pleased the Club exhibitors and always pleased the less rigorous collectors. After suffering a stroke in 1927 he moved to Daytona Beach, Florida, where he died in 1937.

One of the Canadian Art Club's important contributions was the sympathetic surroundings it afforded in Toronto for the prominent Quebec artists of the time. They brought to the Toronto audience a somewhat after-the-fact and often compromised Impressionism that was nevertheless charming to the eye and that in colour provided relief from the heavy 'Dutch' tones of the Toronto-based artists like Williamson and Morris. But the Club was also intent on bringing to Canadian viewers the work of painters who had left Canada in pursuit of their careers.

Halifax-born Ernest Lawson (1873–1939) would never have exhibited in Canada without Morris's invitation to join the Club, and in later years he even claimed to be a native-born American. A. Phimister Proctor (1862–1950), the Canadian-born American sculptor, was also brought back into the Canadian cultural sphere for a few years by his membership in the Club, as was Hamilton-raised James Kerr-Lawson (1862–1939). But of the expatriate Canadians who found a forum in Canada through the Canadian Art Club the most famous and undoubtedly the most important to other Canadian artists was JAMES WILSON MORRICE (1865–1924). Cullen, Brymner, Williamson, and Morris valued his friendship; Gagnon, A.Y. Jackson, Lawren Harris, and countless other young Canadian painters sought out his work. After Walker, he was the Canadian who then had the strongest reputation abroad.

Morrice was born in Montreal, where his father, who was in the textile business, was a supporter and later a benefactor of the AAM. So even though James was educated to be a lawyer (in Toronto 1882–9), his interest in painting was accepted by the family, and they even allowed him to go to England to study early in 1890. Morrice moved to Paris in the fall of 1891, and soon after enrolled at Julian's and there met two painters who became his closest friends during these first years in the French capital. One was the American Maurice Prendergast, who was born, seven years before Cullen, in St John's, Nfld, but was raised in Boston. He arrived at Julian's in the spring of 1892, the year after an Australian named Charles Conder had enrolled. The three first visited Saint Malo, the famed painting spot on the Brittany coast from which Cartier had set out for the new world, and over the next three or four years they spent much time together, revisiting Saint Malo, Dieppe, and other painters' locales. Morrice gave direction to the retiring Prendergast, and the garrulous Conder in turn introduced Morrice to important influences.

The Australian roomed with William Rothenstein, an English painter also enrolled in Julian's. Rothenstein met Whistler in 1892, and was closely associated with him until 1897. It is likely that Prendergast and Morrice then came into contact with the famous American, although no meeting is documented. In 1898 Morrice actually had a studio just up the street from him, and the influence of Whistler is paramount in most of Morrice's work before the turn of the century. *Prow of a Gondola, Venice* (private collection, Toronto), likely painted on a trip to Venice in the late summer of 1897, is an accomplished Whistlerian tonal study, simple and reserved.

It was probably through Curtis Williamson that in October 1895 Morrice met two more Americans, the Philadelphians William Glackens and Robert Henri. (Prendergast had left for home and so did not meet them then.) Over the next year Henri, Glackens, Morrice, sometimes Williamson, and perhaps Morris (before he left for home in the spring of 1896) frequently painted together—usually staying at the village of Bois-le-Roi in the forest of Fontainebleau, made famous by the Barbizon painters. By the turn of the century, perhaps as a consequence of these new relationships, Morrice's painting had lost the washlike effect of his earlier work and begun to display a more textured 'painterly' quality. *†Return* from School (AGO) of about 1901 is based on sketches made at Beaupré where he painted with Cullen. How much more elegantly economical a picture this is than Cullen's *Logging*. Morrice's paint is never dry, never arbitrary, yet it is more natural than Cullen's somewhat contrived handling, which could never have achieved its rich mixture of streaming browns, blacks, and whites. Cullen's effect in comparison is almost confectionary; Morrice's muddy snow is of the earth, of life.

Morrice's contacts continued to change in Paris. Prendergast had left in the winter of 1894–5 and Glackens and Henri returned to the United States in 1897 (although Henri was back in Paris again in 1898 for two more years). Also in 1897 Conder moved to London; he continued to visit Paris, however, and saw much of Morrice. It was probably through him that after the turn of the century the Canadian became a regular at the *Chat blanc*, where, in the upstairs diningroom, he fraternized with a group of Englishmen, including the novelists Arnold Bennett and Somerset Maugham, the critic Clive Bell, the occultist Aleister Crowley, and the Irish painter and disciple of Gauguin, Roderic O'Conor. While regularly enjoying the company of these men, Morrice matured as an artist.

James Wilson Morrice. The Ferry, Quebec, c.1906. Canvas, 62.0 × 81.7. NGC.

As Donald Buchanan has said, he broke 'the tidy bonds of refinement which had held the art of Conder and the other men of the nineties in precious tutelage. From then on he would tend to be influenced more and more by things French.'

Quai des Grands-Augustins (NGC) of about 1903 is still atmospheric, and even painterly in part; but the paint is thin again. The period between this picture and about 1910 has been called Morrice's 'personal impressionist style'. At its centre is one of the very greatest paintings of Canadian art: **The Ferry, Quebec* (NGC). Restrained and balanced, yet lively, even vital in composition, the colour is a harmonious dream of subtle interplay and painterly speculation. The picture is cold with the living cold—the aggressive, stimulating cold of the true North we all know.

Although Morrice found his intellectual and aesthetic life in Paris, he still sought something in Canada and returned virtually every winter until the war. He usually then painted with Cullen or Brymner and Morris around Beaupré. He sent paintings regularly to W. Scott & Sons, his Montreal dealer, exhibited frequently with the RCA, and was elected an honarary non-resident member in 1913 (his friend Brymner was then

president). When the Canadian Art Club was founded in 1907 Morrice was one of the first choices for membership and he sent works loyally every year.

But his home was Paris, and his commitment to French art and his involvement in its developing progress became total. Writing to Edmund Morris about Cézanne in 1910, he said: 'His is the savage work that one would expect to come from America—but it is always France that produces anything emphatic in art.' Morrice had continued to see his American friends on his way back from Canada.* But by 1910 even such periodic contact seems to have stopped.

From 1901 Morrice exhibited with the London-based International Society of Sculptors, Painters and 'Gravers (he and Kerr-Lawson were the only Canadians to do so). It represented everything the Canadian Art Club aspired to be. Although continuing to exhibit with the International Society until 1914, in 1905 he transferred his allegiance to the more radical Salon d'Automne, where that same year the Fauves were first seen.** By 1909 Morrice had come to know Henri Matisse, one of the profound moulders of the twentieth century. He had also begun to travel south instead of north to Brittany and Normandy; in the winter of 1911–12 he followed Matisse to Tangier, and the next winter did so again. On this second trip the two painters spent much time together.

The war forced Morrice out of Paris briefly in 1914, and after a short sojourn in London he made one of his last trips to Montreal on his way to Cuba. After 1916 he no longer exhibited in Canada. The Cuban trip was just the beginning of a series of visits to the West Indies that alternated between trips to North Africa and the south of France. He was pursuing a lighter palette and the warm healing rays of the sun. (Throughout his adult life Morrice was a heavy drinker; alcohol began to ravage his body about the time of the war.) His first West Indian pictures of 1915 are not successful. Buchanan determined that 'the influence of Matisse was too directly upon him. He was still labouring to plan, with intellectual effort, a picture.' By 1921, however, and his last visit to the Caribbean, he was painting some of the finest pictures of his life.

*Prendergast joined Glackens, Henri, Lawson—who, of course, also showed with the Canadian Art Club—and four others in 1908 to exhibit in New York as 'The Eight'. For what was considered their too-harsh realism, they were dubbed 'The Ash Can School'.

**At this Salon a critic described a room full of paintings by Matisse and others that surrounded a piece of sculpture by Albert Marquet as 'Donatello parmi les fauves' ('Donatello among the beasts'). Fauvism became known as a style of painting in which an aggressive use of colour was all-important. Matisse, Derain, and Dufy were among the important members of the Fauve group.

James Wilson Morrice. Village Street, West Indies, c.1919. Canvas, 60.2 × 82.0. MMFA.

**Village Street, West Indies* (MMFA) of *c*.1919 is magnificently assured, with a pictorial space that is infinitely deep, ever expanding, yet tautly flat in breathtaking tension. The small, slightly reeling figure on the road, caught in arrested movement, seems almost to be pitched against the earth's turning.

Morrice worked with his friend Albert Marquet, the Fauve painter, in Algiers in 1922, but after that summer he stopped painting. In the fall of 1923, as his health deteriorated alarmingly, it was rumoured in Paris that he was dead and he was listed as deceased in the catalogue of the Salon d'Automne. But Morrice wintered that year in the south of France and was able to call there on his old Montreal friend, William Brymner. Then on to Sicily and finally Tunis, where in January 1924 he died and was buried. The Salon d'Automne held a memorial retrospective that fall.

The Canadian Art Club did not survive the war. In fact the last exhibition was held in 1915. The tragic death of Edmund Morris in 1913 took much of the energy, and a crucial mediator, out of the Club. Morris had resolved a disagreement between Williamson and Walker in 1910–11 over whether non-Canadians should be invited to exhibit (Walker led those who opposed such invitations), but Williamson never forgave Walker. When

Walker became president in 1915, Williamson relentlessly opposed him until he resigned. In addition, much of the lay support for the Club which had assumed very large proportions at its peak about 1913—was siphoned off by the recently organized Toronto Art Museum. And there were those, including the artists who superseded these first Canadian 'modernists' in the public eye after the war, who believed that the Canadian Art Club represented a taste and an approach to painting that was unsuitable for Canada. What could Dutch sensibility, even Dutch themes, or on the other hand watered-down French Impressionism, have to do with the Canadian experience? Tom Thomson and the Group of Seven 1913–1931

The artists who first exhibited together in Toronto as the Group of Seven in May 1920 had by that time developed a doctrine and a style of painting based on the idea that Canadian art could find sufficient sustenance in Canada alone. In 1913, however, at the peak of the public attention surrounding the activities of the Canadian Art Club, even Lawren Harris in many ways the leader of the Group—found it natural to praise the successes of the internationalists. In showing the work of painters like Morrice, Walker, and Lawson, the Canadian Art Club had after all exhibited Canadian artists who had measured themselves against the standards set in the international centres and who could be very good indeed. Slowly, though, first through the assertion of the primacy of Canadian subject matter for Canadians, then through the invention of a distinctive visual language, those who were searching for the 'essence' of Canada arrived at a position of complete opposition to the values, and even the painting technique, of most of the generation that preceded them.

LAWREN HARRIS (1885–1970) was born in Brantford and raised in a family that demonstrated the usually successful Ontario combination of Protestantism and business. Both grandfathers and two uncles were ministers, and the Harris family then owned part of the Massey-Harris farm implement firm. His upbringing followed the conventions of his social background until he began to have difficulties in his first year at the University of Toronto. Deciding that Lawren's inclinations were artistic, his family sent him to Berlin to stay with an aunt and uncle who were living there and to study painting. This was early in the fall of 1904.

After studies in Berlin, and a year-and-a-half of travel as a magazine illustrator, Harris settled into a studio in Toronto in the spring of 1909. We know little of his activities over the next two years. Near the end of

1910 he painted the first important work of his to survive: *Old Houses, Wellington Street* (private collection). A striking picture, its bold, assertive brushwork and subject matter reflect his years in Berlin, while its dark moodiness—relieved by intense, almost pure colour in the highlights suited the taste that was then reflected in Toronto in the exhibitions of the Canadian Art Club.

In November 1911 Harris made a connection that gave new direction to his life and ultimately changed the course of Canadian art. The occasion was an exhibition of sketches held at the Arts & Letters Club. It so impressed Harris that he sought out their author, J. E. H. MACDONALD (1873–1932). The immediate result was to bring Harris into confluence with a group of people and ideas that were fast approaching their moment.

MacDonald was born in Durham, Eng., but was brought to Hamilton at the age of fourteen by his Canadian father. Young MacDonald first took art lessons there, and by the time his family moved to Toronto in 1889 he had decided on a career in commercial art. He was interested in a more personal expression as well and spent a great deal of his free time taking art classes and sketching. Such concerns were relatively common in the commercial studios and a number of clubs sprang up to service the need. The oldest was the Toronto Art Students' League, founded in 1886, which organized life classes and sketching trips and in its annual illustrated calendar (published from 1893 to 1904) encouraged the treatment of Canadian subjects.

One prominent member of the League after the turn of the century when MacDonald became active in it and its various offshoots was C.W. JEFFERYS (1869–1951). He was born in Rochester, Eng., but in 1881 ended up in Toronto, where four years later he began a career in commercial art. In 1892 he moved to New York, where he worked as an illustrator on the *Herald* for seven years and familiarized himself with the brilliant magazine and newspaper renderings that were then attracting much attention to Howard Pyle and other illustrators. Jefferys kept up contact with Toronto (he participated at least twice in a summer school run by George Reid at Onteora, N.Y.) and finally moved back in 1901, whereupon he began ceaselessly to promote the depiction of subjects from Canadian history and the Canadian scene.

Another associate of MacDonald's in the clubs was WILLIAM BEATTY (1869–1941). Born in Toronto, Beatty turned to painting in 1894 and in 1900 went to Paris and Julian's. From 1906 to 1909 he travelled about Europe, particularly in the Low Countries, and when he returned home he was painting rich, dark, moody pictures of Dutch peasant life. In

140 | Tom Thomson and the Group of Seven

Toronto he frequented the sketching clubs and was soon listening to the argument from Jefferys and others that the expression of personal feelings in art was fine, but that truly meaningful expression was accomplished only when the subjects dealt with were those the viewer shared with the artist. Canadian history, and even more assuredly the land itself, were the best vehicles for such communication.

League members had been following this course for years in their graphics. As early as 1902 three members had travelled to Algonquin Park in search of Canadian landscape themes. Beatty, with the zeal of the convert, took off for the North the year of his return to Toronto. *The Evening Cloud of the Northland* (NGC), painted in 1910, is essentially a grey monochrome and was thus typical of the kind of work being shown by the Toronto members of the Canadian Art Club. But it was a Canadian subject, which for a group of painters in Toronto at that time was of overriding importance. Beatty felt this so strongly that at the time of MacDonald's 1911 exhibition he wrote to the National Gallery and insisted on sending his *Evening Cloud* in exchange for a recently purchased work of his called *A Dutch Peasant* (AGH). 'I am a Canadian,' he wrote, 'I would much rather be represented by a Canadian picture.'

Jefferys, in reviewing MacDonald's exhibition, carefully pointed out that 'in themselves ... Canadian themes do not make art, Canadian or other, but neither do Canadian themes expressed through European formulas or through European temperaments.' What was so important about MacDonald's pictures for him was that 'so deep and compelling' was the 'native inspiration' that it had 'to a very great extent found through him a method of expression in paint as native and original as itself.' That excited Lawren Harris.

We don't know what sketches MacDonald exhibited at the Arts & Letters Club in November 1911, but from Jefferys' review it is clear that the notable works were at least related to pictures like **By the River, Early Spring* (Government of Ontario) of 1911. Based on sketches done on the Humber River, near Toronto, it shows the drivers running logs along the ice-filled stream. It is dark and rich, in the Toronto taste of the time, but it is also rough and raw and taut with energy. As a consequence of the reaction to such work, Harris and his friend Dr James MacCallum talked MacDonald into leaving his commercial work (he had been a designer for twenty-two years) and becoming a professional painter. Harris and MacDonald began sketching together almost immediately, and their first large exhibition canvases appeared in the 1912 OSA. Harris's most impressive picture was his own heroic version of log drivers called *The Drive* (NGC); and MacDonald's was his famous *Tracks and Traffic* (AGO).

XVIII—Horatio Walker. *Ploughing—the First Gleam at Dawn,* 1900. Canvas, 153.0 × 193.4. MQ.

XIX—James Wilson Morrice. Return from School, c.1901. Canvas, 46.4×73.7 . AGO.

xx—A.Y. Jackson. Frozen Lake, Early Spring, Algonquin Park, 1914. Canvas, 81.3 × 99.0. NGC.

XXI—Tom Thomson. Autumn Foliage, 1916. Board, 26.7 × 21.6. NGC.

J.E.H. MacDonald. By the River, Early Spring, 1911. Canvas, 50.8×71.1 . Government of Ontario.

Although both pictures are bold and exciting, neither really went beyond the taste established by the Canadian Art Club. But the subject matter attracted viewers, and critics singled out MacDonald, Harris, and Beatty for praise. 'To a Canadian,' wrote Augustus Bridle, 'scenes in this country are of vastly more interest than all the fishing smacks and brass kettles and sea-weed sonatas of north Europe.'

Harris and MacDonald clearly had their subject. What they still lacked was a meaningful approach, a compatible technique. These were suggested to them the following January when the two travelled to Buffalo to view an exhibition of contemporary Scandinavian art. It was an afternoon they would never forget. There was a shock of recognition in the terrain of northern Europe, so similar to Canada, and there was elation in the direct expression of the exhilarating clarity and expansiveness of the lonely North. The paintings seemed to the two Torontonians, as MacDonald remembered, 'true souvenirs of that mystic north around which we all revolve'.

MacDonald had had his first taste of the North the previous summer when he spent time sketching in Georgian Bay as the guest of Dr MacCallum, a great northern enthusiast. Returning home from Buffalo,

142 | Tom Thomson and the Group of Seven

he began to work on a large canvas based on those sketches. *Fine Weather, Georgian Bay* (private collection) is dry in handling and stiff in parts, but it contains a voluminous space that almost echoes in a room. The diminutive figures perched on an outcropping of driftwood in the foreground stress the heroic scale and suggest the reverence due such magnificence in nature. In its boldness it is directly the result of the Scandinavian show.

By the spring of 1913 a small group of like-minded commercial artists had assembled around MacDonald and Harris. The eldest of these, and the least likely to have asserted himself as an artist, was TOM THOMSON (1877–1917). Born in Claremont, Ont., and raised in Leith, near Owen Sound, Thomson had in 1901 ended up in a Seattle business school run by a brother. There he studied art and shortly began to work in a commercial studio. By 1905 he was back in Canada—in Toronto—and about 1908 he was working at the same studio as MacDonald: Grip Limited, where he began to develop an interest in painting.

Other designers at Grip also painted in their spare time. In conversations there, and during lunch at the Arts & Letters Club, a number found themselves strongly attracted to the ideas of MacDonald and Harris— Thomson; FRANK CARMICHAEL (1890–1945) from Orillia; FRANK JOHNSTON (1888–1949) of Toronto; and ARTHUR LISMER (1885–1969) and FRED VARLEY (1881–1969), both recently arrived from Sheffield, Eng. They all began to share a common desire. 'We are endeavouring to knock out of us all of the preconceived ideas, emptying ourselves of everything except that nature is here in all its greatness,' Varley wrote in 1914.

The potential for really decisive action was becoming clear. But of the fledgeling 'native' group in early 1913, only MacDonald and Harris were experienced painters. There was a need for more weight. MacDonald had been corresponding with A.Y. JACKSON (1882–1974) in Montreal since late in 1910, and a number of the Toronto painters had been very impressed with his *The Edge of the Maple Wood* (NGC) when it was exhibited in the 1911 OSA. Late in March 1913 MacDonald wrote to Jackson, informing him that a friend named Lawren Harris wanted to buy *The Edge of the Maple Wood* and that the 'young' group wanted Jackson to move to Toronto. Such news could not have come at a better time.

As mentioned in chapter 7, Jackson was one of those Montreal students of Brymner who, as a matter of course, had to study in Paris. Much like the painters in the Canadian Art Club, he found it difficult to accept the bland indifference of the Montreal art community after the excitement of Europe and in 1913 had just returned from a year-and-a-half abroad. Jackson was not alone in Montreal. He was friendly with Cullen, and of

A.Y. Jackson. Terre Sauvage, 1913. Canvas, 127.0 × 152.4. NGC.

course Brymner, and among his own generation he often saw Gagnon and was particularly close to Albert Robinson (1881-1956) and Randolph Hewton (1888–1960). All felt that Montreal was moribund. It had no Canadian Art Club to set standards of excellence or to force the acceptance of modernism. Nonetheless Jackson and Hewton were determined to jar Montreal into awareness, and on their return from Europe they had held an exhibition of their recent work in the AAM galleries. There were no sales and the disappointed Jackson was contemplating the dreary necessity of returning to commercial art when he received MacDonald's letter inviting him to Toronto. There, in May 1913, he met MacDonald, Lismer, and Varley for the first time and shortly afterwards Lawren Harris. Harris described the Toronto artists' plans. He and Dr MacCallum had just decided to construct for them a 'Studio Building of Canadian Art' on the southwest edge of Toronto's Rosedale and he encouraged Jackson to stay. Jackson wanted to think it over and retreated to Georgian Bay for the summer. Harris then asked Dr MacCallum-who

144 | Tom Thomson and the Group of Seven

had a summer home there—to convince Jackson, and with a year's living guaranteed by the doctor, Jackson agreed to join the Studio Building group.* That winter in Harris's studio he painted the radical **Terre Sauvage* (NGC).

Forceful, almost crude, *Terre Sauvage* demonstrated Jackson's sympathy with the aspirations of the Toronto painters. A stirring northern theme, in its symmetry and symbolic suggestiveness it reflects his response to the enthusiastic reports of the Scandinavian show. It must as well have seemed fresh and original with its touches of pure colour, and in its audacity it became the private touchstone of the new movement. Its gradual creation in Haris's studio fascinated Tom Thomson.

As he watched Jackson paint, Thomson's admiration grew and by January 1914 the two had decided to share a studio in the new building. This pleased MacDonald and Harris, and particularly Dr MacCallum. They had been encouraging Thomson over the preceding two years, convinced of his talent. His first large canvas, *Northern Lake* (AGO), had only recently been exhibited in the 1913 OSA and had been purchased by the Ontario government. Based on sketches painted in the summer of 1912 in Algonquin Park, it is an ugly picture, but deeply moving. Its colouring derives from the current Toronto taste as exemplified by the work of the Canadian Art Club, but gone is the refined subtlety, the delicate tonal nuances of the 'European' sensibility. *Northern Lake* is raw and coarse and was seen by the Studio Building painters as the direct response of untutored genius to the inspiration of the North.

Jackson helped correct the obvious faults in Thomson's style, and the latter's *Moonlight, Early Evening* (NGC)—painted directly under Jackson's tutelage that first winter in the new studio—is more unified than the earlier canvas. But at this point Thomson seems to have had even more to teach Jackson, and in his eagerness to learn about the North the Montrealer headed for Thomson's favourite Algonquin Park sketching grounds in the depth of winter. The trip was exhilarating. Now settled in Canada, with Toronto as his new base, Jackson spent the whole year travelling and sketching: Algonquin first, then the Rockies with Bill Beatty, and back to Algonquin for the fall. Three seasons of sketching trips out of four was a pattern Jackson would follow for close to fifty years.

That October of 1914 in Algonquin was also the first 'group' sketching trip. Jackson and Thomson worked together for about six weeks and

*Jackson had a little earlier joined the Arts & Letters Club and he and his friends had been exhibiting their paintings there. He was irrevocably associated with the Toronto painters when the fledgeling group was called—half jokingly—'The Hot Mush School' in a newspaper in December 1913.

Tom Thomson. Parry Sound Harbour, 1914. Board, 21.5 \times 26.7. NGC.

were joined by Lismer and Varley for the last four. Jackson was in full form. Earlier in the year he had painted the magnificent *†Frozen Lake*, *Early Spring*, *Algonquin Park* (NGC), following the basic composition established in Thomson's *Northern Lake* but giving it a brilliance of colour that far surpassed what anyone else in Canada thought to use at that time. From sketches made in October, he painted that November *The Red Maple* (NGC), another landmark picture, amazing in colour and innovative in composition.

Arthur Lismer produced his first ambitious canvas that fall. The Guide's Home, Algonquin (NGC), which relies heavily on Impressionism, is agreeable for its high-keyed colour and open, suffusing light. Thomson, however, made the greatest strides. The sketches he produced in 1914 demonstrate a remarkable development of control. On a trip to Algonquin in May 1914 with Lismer, the Englishman taught him to isolate the essentials and to work with a conscious design in mind. A month later, while at Dr MacCallum's Georgian Bay summer home, Thomson produced sketches of admirable simplicity, responses to the sky-filled MacDonalds of two years earlier. Thanks to Lismer and Jackson, he no longer worked up a smooth surface, trying to make the brush-strokes invisible. In a work like *Parry Sound Harbour (NGC) of late May 1914certainly one of the first sketches to display the distinctive Thomson genius-the emphatic brushwork supports the natural forms of the scene depicted, but it also leaves the maker's mark all over the surface. It records the union of man and place.

Tom Thomson. Northern River, 1914–15. Canvas, 114.3 × 101.6. NGC.

In October Jackson encouraged Thomson's natural response to the intense colour of the forest to release in him the inspired use of painted colour that has since given us such pleasure. The year was then capped by the production of Thomson's first major canvas, **Northern River* (NGC). Not as good a painting as Jackson's *Frozen Lake* or *Red Maple*, and heavily influenced by reports of the Scandinavian show and by magazine illustrations of Art Nouveau design, it is nonetheless one of the great haunting images of our culture—an unforgettable view of the mysterious yet penetrable landscape of the northern bush.

During the summer of 1914 war had broken out in Europe, and by the fall it was clear that Canada was involved. The 'Algonquin School' was just reaching its moment of assertive public presence; that now had to wait more than five years to be fulfilled. Not that painting stopped; but

the group dispersed. Jackson returned to Montreal before Christmas and joined the army in June 1915. In August 1917 he was made an official war artist. In February 1918 Fred Varley was sent overseas, also as a war artist, and in June 1918 Lismer—who had moved to Halifax two years earlier to become principal of the Victoria School of Art & Design—was commissioned. Frank Johnston received his commission in August.

MacDonald and Harris might have been overwhelmed by the accomplishments of Jackson and Thomson during 1914. They worked away, however, principally lightening their palettes. MacDonald's works of 1914–15 are close in colour and paint handling to those of Suzor-Coté, Cullen, and some of the other Montreal 'impressionists' he was still seeing at the annual Toronto showings of the Canadian Art Club. Early in 1916, however, he painted *The Tangled Garden* (NGC). When it was exhibited at the OSA that March the artist was publicly accused of having thrown 'his paint pots in the face of the public.' Hector Charlesworth, the conservative art critic of *Saturday Night*, who then most strongly attacked MacDonald, and who from that time became a persistent and often vicious enemy of the Group, found the painting a crude affront. MacDonald defended himsef ably, determined to persevere in the face of such ignorant attempts at control.

The picture seems old-fashioned after all the fuss. The colours are more intense than MacDonald had employed before, but the composition, though pleasing, is tight and safe. There is an excess of detail. The painting had not reached Jackson's level of two years before. More successful as a painting, more radical in its use of paint and colour, is Harris's principal work in the OSA of 1916. *Snow II* (NGC) proved much more influential over the next three or four years in the flattening and decorative patterning of its image and in the suppression of moody atmosphere. It is also more clearly in the mainstream of the developing ideas of the Studio Building group than *The Tangled Garden*. Still dependent on the Scandinavian show, *Snow II* is very clearly a northern picture—a fresh and stimulating song to the Canadian wilds.

It was probably during the *Tangled Garden* controversy that Harris too decided to enlist in the army. Both Harris and MacDonald saw a great deal of Thomson during the early war years, at least in the winter. Thomson had established a fruitful working pattern. In Algonquin Park by April, he sketched there in the spring, worked at odd jobs for the summer, sketched again in the fall, and returned to Toronto only late in November. The sketches he produced at this time have always been widely admired. A work like †*Autumn Foliage* (NGC) of 1916 is spontaneous yet assuredly controlled. It is emphatically real both as a picture and as

148 | Tom Thomson and the Group of Seven

Tom Thomson. Petawawa Gorges, 1916. Canvas, 64.1 × 81.3. NGC.

a painting. His canvases as well as his sketches had begun to surpass the quality of Jackson and the others. In **Petawawa Gorges* (NGC), probably painted late in 1916, all extraneous compositional devices have been eliminated and colour and texture virtually carry the whole. Magnificently unified, subtle and totally free of any 'showmanship', it is, in its depiction of the annual rebirth of the river, perhaps the most profound picture painted by any of the Studio Building group until after the war. Thomson drowned in Canoe Lake in July 1917, when he was unquestionably approaching the fullness of his powers. Probably even more than *The West Wind* (AGO) and *The Jack Pine* (NGC)—the paintings for which he is best known and that have become almost sacred icons—*Petawawa Gorges* is the measure of our loss.

His drowning was a crushing blow to the Studio Building group, even though the tragedy of war had accustomed them to death. MacDonald suffered a breakdown. But with the cessation of the war a series of memorial exhibitions demonstrated that all was not lost, that Thomson had in his life achieved a very great deal, and that his hopes would be fulfilled by his comrades. Such fulfilment would not be sought in Algonquin Park, though, for after his discharge from the army in May 1918 Harris, accompanied by Dr MacCallum, first visited the Algoma region of Ontario. Excited by what he saw, Harris arranged to return in September with MacDonald and Johnston. This was the first of the famous 'box-car' trips, when they lived out of a caboose that was shunted from siding to siding along the route of the Algoma Central. The following September the same arrangements were made, but this time the recently returned Jackson replaced Dr MacCallum. Then the following May (1920), Toronto saw the first exhibition of the Group of Seven.

The Group now had clear intentions that at this point were largely social. They held 'that an Art must grow and flower in the land before the country will be a real home for its people.' They believed as well that this art, in responding to the particular nature of this country and its people, would be peculiarly Canadian. And they believed that there would be a formidable resistance to such an art. Collectors were seen to be supporters of foreign importations, and the Canadian artists who still pleased collectors were seen as 'apes' of European art. From late in 1918 A.Y. Jackson's hearty dislike of Dutch art was proclaimed, and over the next few years he took a number of opportunities to attack 'the Dutchmen'. There were doubtless members of the old Canadian Art Club included in his definition of Dutchmen. Harris referred a number of times to the years 1918-21 as the 'decorative' period—a reaction against the moody, atmospheric painting current in Toronto before the advent of the Group. The sombre canvases of the 'Dutchmen' were being replaced by the clear, forceful designs of the 'Canadians'. Harris's Shacks (NGC) of 1919 was the first emphatic declaration of the 'Group of Seven Style'. There is almost no recession in the picture, although at least two planes of depth are evident. The effect of these is diminished by the hot, aggressive colours that push up onto the surface of the canvas. The picture is almost all surface pattern, and there is certainly no moody 'atmosphere'. It is a painting that could never have been accepted by the Canadian Art Club, even though it clearly surpasses their average level in quality.

Shacks depicts a Toronto subject, but Algoma was the current region of inspiration. It was most sympathetically dealt with by MacDonald and most spectacularly in such works as *Falls, Montreal River* (AGO) of 1920, *The Solemn Land* (NGC) of 1921, and *Autumn in Algoma* (NGC) of 1922. These are MacDonald's best pictures, and among the very finest produced by the Group. All are richly decorative, profound with the blown fullness of the late autumn. And only MacDonald, it seems, had the sensibility to encompass the lush Eden growth of Algoma. Johnston found sweep in burned-over hills, Harris sought the severe monumentality of hidden

150 | Tom Thomson and the Group of Seven

J.E.H. MacDonald. The Solemn Land, 1921. Canvas, 121.9 × 152.4. NGC.

waterfalls, and Jackson came as close to 'pure' painting as he was ever to come in his breathtaking *First Snow*, *Algoma* (MCM) of 1919–20. Algoma remained 'MacDonald's country', nonetheless. Lismer found no stimulus to original work there, and Varley never visited it at all.

Lismer and Varley produced their first major canvases in 1920–1, both of which resulted from the same sketching trip to Dr MacCallum's island in Georgian Bay. These are, of course, Lismer's *A September Gale, Georgian Bay* (NGC) and Varley's *Stormy Weather, Georgian Bay* (NGC). Both are strong, elemental pictures free of atmospheric concerns. By 1920, Frank Carmichael also had found direction in the decorative, emphatic 'Group' style in such works as *Autumn Hillside* (AGO).

Men change, and as leaders grow, movements find new direction. In February 1921 Jackson returned to Québec to sketch after an absence of almost eight years. Working in the region of Cacouna on the south shore of the St Lawrence, he later painted his sensitive, delicate sketches of lonely farms and tiny villages into a number of canvases, the most famous being *Winter Road, Québec* (private collection). Delicate in colour, with forms all soft, blunted, and rounded, this canvas rolls with an easy, deep rhythm that was to become Jackson's trademark in later years. Harris also travelled east in 1921 and his dramatic canvases of the Halifax slums, particularly *Elevator Court, Halifax* (AGO), strike another new chord. The next year MacDonald also went to Nova Scotia. *Sea Shore, Nova Scotia* (NGC) of 1923, based on a 1922 sketch, is almost stark in its simplified, hard-edged forms and its dun, matte colours. A decisive turn had been taken, and the main impetus probably derived from Harris and the North Shore of Lake Superior.

In the fall of 1921, after a trip to Algoma, Harris and Jackson had pushed on north and west looking for more subjects and for the first time travelled as far as the North Shore. This new land was a profound revelation to Harris, and he returned every fall for the next three years. The vast expanse of lake and sky, the harsh yet exhilarating climate, the stark, monumental forms satisfied a developing spiritualism in him. At some point near the end of the war he had come into contact with the theosophical movement and had recently become an ardent member. Theosophy attempted to combine the best elements of the world's religions

Lawren S. Harris. Lake Superior, 1924. Canvas, 102.0 × 127.3. AGO.

152 | Tom Thomson and the Group of Seven

Lawren S. Harris. Maligne Lake, Jasper Park, 1924. Canvas, 122.0 × 152.4. NGC.

while stressing the personal development of the spirit to an elevated, highly aware level. The dramatically reduced, austere but aspiring forms of **Lake Superior* (AGO) of about 1924—among other North Shore canvases—expressed this desire for spiritual fulfilment through immersion in the vital forces of overpowering landscape.

One can almost trace the course of Harris's spiritual development in his canvases over the next few years. He sought out inspiring landscape in the Rockies from 1924 through 1928, and even in the Arctic in 1930. **Maligne Lake, Jasper Park* (NGC) of 1924 and *Mount Lefroy* (MCM) of 1930 are truly monuments to the breadth and penetration of Harris's spirit. Grave, hushed tributes to the spiritualizing force of the country, they are incentives to the spiritual capacity in us all. *Maligne Lake* is a painting of great force and staying-power. Its wonderful facetted forms, sombre yet rich colour, and imposing composition draw the viewer irresistibly to its centre and then transport him into an almost mystical realm. It was the most influential painting in Toronto prior to 1930.

MacDonald also first visited the Rockies in 1924. He was by then working full time at the Ontario College of Art and was able to sketch only during summer vacations. He returned to the mountains every summer and every winter struggled with canvases that seemed misconceived and could never become successful. Taking his lead from Harris, he tried to construct simple, heroic images, coloured in the dry, matte tones of the Nova Scotia pictures of 1923. It was only in 1932, virtually at the end of his life, that he achieved any success with his mountain canvases.* *Mountain Snowfall, Lake Oesa* (Private collection, Toronto) of that year finds the solution in moving down into the intimate detail surrounding a small mountain lake. Scale is avoided, and the locked-in force-lines of primeval rock—the simple, massive forms held in balanced tension—evoke a sense of profound equilibrium that rivals that in *Maligne Lake*.

Jackson also visited the Rockies and was the first Group member to visit the Arctic (in 1927), the area around Great Slave Lake (in 1928), and the north Pacific Coast (1926). But he returned to Quebec almost every spring, and it is from those experiences that he produced his most typical and finest canvases. *Early Spring, Quebec* (AGO) of 1926 is one of the best of these. Rich and full in colouring (though limited to tones of brown

J.E.H. MacDonald. *Mountain Snowfall, Lake Oesa*, 1932. Canvas, 61.0×66.0 . Private collection, Toronto.

154 | Tom Thomson and the Group of Seven

A.Y. Jackson. Laurentian Hills, Early Spring, 1931. Canvas, 54.0 × 66.8. AGO.

and grey), it has the easy, rolling rhythms of a mature Jackson. **Laurentian Hills, Early Spring* (AGO) of 1931 is more complex in its rhythmic structure, and even richer in earth colours. Like *Maligne Lake*, it proved to be an influential picture.

Fred Varley also first saw the Rockies in 1924 and fell as passionately in love with them as did Harris and MacDonald. He therefore took the opportunity of a job offer to move to Vancouver in 1926. It was a significant turning-point in his life. First distinguishing himself as a war artist, he had returned to Toronto determined to be a painter and was soon launched on a career as a portraitist. Suited to this work as a painter, he found it difficult as a man, although some of his portraits, notably *Vincent Massey* (HH) of 1920, are deservedly famous. With the Vancouver mountains, however, Varley finally found a piece of landscape that stirred him, just as nature had moved the other Group members for years.

By this time, however, the heroic years of creative struggle were almost over. As it turned out, their work did not meet with the resistance they

thought it would. It was on the whole accepted-though with restraint rather than enthusiasm. The Group worked hard to promote it. Between the summer of 1920 and the end of 1922 they organized more than forty small showings throughout the country. The National Gallery had encouraged them in various ways since 1913. In 1922 this support eventually drew the wrath of Hector Charlesworth upon the Gallery. The controversy that resulted lasted for some two years. Then, in 1924, with the announcement that the National Gallery would choose the Canadian representation at the British Empire Exhibition in Wembley, Eng., Charlesworth was joined by the RCA. It resented the Gallery's involvement in the organization of an international exhibition and, more importantly, was convinced that the traditional members of the Academy would be ignored. A jury eventually made a reasonably balanced choice, which included the Group. At the conclusion of the Wembley exhibition the Tate purchased one Canadian painting: Jackson's Entrance to Halifax Harbour of 1919. By 1926 the Group of Seven were the acknowledged centre of serious art activity in Toronto, which in turn was the major centre of activity in the country. Followers and disciples were gathering. And even the broad public began to become aware of the Group of Seven as the 'national' school of art. By 1931, the year of the last exhibition of the Group, their supremacy was acknowledged—both grudgingly and willingly-right across the country. But the group effort had been maintained for too many years. As Bertram Brooker explained to LeMoine FitzGerald after the 1931 show:

J.E.H. has been very ill lately, and in any case, even if he recovers full strength, will probably not do much more painting. Varley was seriously ill this past summer and is very hard up, I hear. . . . He had only one canvas in the show. . . . Casson scarcely counted at all, and Carmichael had only about two things which were very reminiscent of stuff done five years ago. Lismer's Maritime canvases were hurried and rather literal. They did not excite anyone very much. Jackson showed up best of all with a lot of things along his usual line. Lawren has done no painting for six months and very little for a year. . . . The general impression, freely voiced, seems to be that he is repeating himself and has got to the end—of a phase, at least. Holgate has had to concentrate on commercial work and consequently had only two small portraits to show, neither of them very exceptional.

Prestige and power are difficult to set aside, however, and rather than simply dissolve, the Group chose to expand. Consequently the reins of direction slipped gradually from their fingers. \mathbf{II}

Emily Carr, LeMoine FitzGerald, and David Milne 1912–1950

By the late twenties the Group of Seven had 'defined' Canadian art in their work. Their national influence was strikingly revealed by the prominence in exhibitions across the country of broadly handled, boldly coloured Canadian landscape subjects. Nevertheless during the early years of their growth a number of other artists—equally Canadian—had been developing other approaches, seeking to satisfy other needs. Largely ignored during the Group years, three of these painters each came into national prominence during the thirties.

The oldest was EMILY CARR (1871–1945). Born in Victoria of English parents, she first began to study art in San Francisco at the age of eighteen. Late in 1893, after spending three-and-a-half years there, she returned to Victoria determined to be an artist and set up a studio in the family barn where she proceeded to paint and offer children's classes. In later years she realized her naïvety then. 'As yet I had not considered the inside of myself. I was like a child printing alphabet letters. I had not begun to make words.'

There was nonetheless a desire to grow, to develop. In 1899, aged twenty-eight, she saw her first Indian village on a visit to the mission school at Ucluelet on the Pacific coast of Vancouver Island. And later that year she travelled almost halfway round the world to London to enrol in the Westminster School of Art. But her health soon began to suffer from the London climate, and she moved to the artists' colony at St Ives for about six months, followed by some weeks of recuperation in a Surrey rest home, and another attempt at art studies in Bushey, Hertfordshire, the summer of 1902. The 'city disease' that was to attack her whenever she settled in a metropolis stayed with her nonetheless, and in January 1903 she was admitted to a Suffolk sanatorium, gravely ill with what she later described as acute anaemia. Eighteen months later she was released. Late in 1905, at the age of thirty-four and with almost fifteen years of inconsequential art studies behind her, she decided to establish herself as an artist-teacher in Vancouver.

Victoria had virtually no art scene in Carr's youth. There had been visitors, like William Hind, who worked there from 1863 to 1869, but SOPHIE PEMBERTON (1869–1959) was the first native-born painter to receive even slight attention. She had gone to London to study at the South Kensington School of Art in 1890, and six years later had enrolled at Julian's. Her first exhibition in Victoria was not until 1902, and in 1904, the year of Carr's return, she exhibited at the Vancouver studio of James Blomfield (1872–1951). An uneven and often awkward painter, Pemberton achieved in her best work merely an academic competence that would have been acceptable in Toronto or Montreal ten years earlier.

The Vancouver scene was not much more lively. The first gallery had opened in 1887, primarily to sell supplies to the many eastern artists who came through by rail after 1886. These painters often made extended visits, even exhibiting in Vancouver as opportunities arose. Many returned frequently—Mower Martin almost made Vancouver his second home—and their influence had a firm hold on the taste of Vancouver's art public in the late nineteenth century. Emily Carr's early Vancouver work was nurtured in this environment. Her watercolours—she then worked exclusively in that medium—followed the taste and even the subjects of Mower Martin and the other easterners, though her compositions are often more dramatic, as in her *War Canoes* (private collection) of about 1908, and show a more sensitive concern for the strengths of Indian designs than the easterners'.

Indian culture, in fact, was becoming her creative inspiration. Carr frequently visited the reserves at Kitsilano and North Vancouver, and in the summer of 1907 she travelled to Alaska with her sister Alice, visiting a number of Indian villages along the coast on her return. Back in Vancouver she resolved—much as Paul Kane had done sixty years before to paint a programmatic series that would record the villages, and particularly the awesome totem poles, for posterity. Over the next four summers she visited many remote villages, painting hundreds of watercolours, but failed to be satisfied with the results. She realized that she was still not properly equipped to achieve her goal, so she and Alice left in July 1910 for Paris, where Carr hoped to acquire the pictorial language to express herself with force. She was then thirty-nine years old.

An English modernist working in Paris, William Phelan 'Harry' Gibb, (1870-1948), recommended that she study at the Colarossi Academy, where the women were not segregated from the male students. This she did for a few weeks, and then, also on Gibb's advice, transferred to another school, LaPalette, to study under the Scottish-born Fauve, John Duncan Fergusson (1874–1961). After about three months in the city, however, her illness returned and she was again hospitalized. In and out of a student infirmary all winter, she fled with Alice to Sweden for a month's holiday in March. Returning in the spring of 1911, Carr joined a landscape class conducted by Gibb in a small village two hours out of Paris and then spent the summer with him and his wife in Brittany. followed by six weeks of watercolour study at Concarneau with the New Zealand painter Frances Hodgkins. She was beginning to achieve good results in her painting and that fall was even accepted in the Salon d'Automne, still the showplace of 'advanced' painting. (Morrice exhibited there regularly, and did so that year; Clapp had shown there four years earlier, and John Lyman would after the war.) She returned to Victoria in November.

Early in 1912 Carr moved back to Vancouver. At the end of March she held an exhibition in her studio of her French work that likely included *Autumn in France* (NGC). A small canvas, it is vigorous in composition and strikingly brilliant in colour. Hot red-browns, oranges, and yellows are kept in lively balance by cool greens, green-blues, and blues. In its use of broad Fauve sweeps of paint and the exploitation of intense colour, it represented the most advanced and most accomplished experimental painting to be seen in Canada in 1912. Strangely enough, Vancouver welcomed the exhibition with interest as an example of the exotic contemporary culture of France.

Heartened, Carr spent the summer working, first in Kwakiutl villages on the east coast of Vancouver Island, then among the Gitksan of the Upper Skeena River, and finally with the Haida of the Queen Charlotte Islands, and that fall painted up pictures employing the intense colour and broad, expressive brushwork she had learned in France. These she exhibited in her studio in April 1913. They were, like **Potlatch Figure* (Estate of Dr Max Stern, Montreal), not as 'radical' in appearance as her French paintings. The colours do not include the hot, dry hues of the Breton countryside but tend largely towards lush blues and greens, and the atmosphere is heavy with the warm moisture of the West Coast. And the paintings all have a specific figurative concern with depicting Indian carvings. Nonetheless, Vancouver seems to have found these paintings difficult to accept. Exotic without being foreign, these innovative paint-

Emily Carr. Potlatch Figure, 1912. Canvas, 44.4 × 59.7. Estate of Dr Max Stern, Montreal.

ings held a greater threat of change than did the work she had brought back from distant France.* The result for Emily Carr was that no pictures were sold and attendance fell off at the painting classes she depended upon for her living. Retreating to Victoria, she built a four-suite apartment in the hope that as a landlord she could support her art. The load was too much. At the age of forty-two she accepted defeat and virtually ceased all serious painting.

Marius Barbeau, the world-famous ethnologist from the National Museum in Ottawa, many years later told of how early in 1915 he heard of Emily Carr from one of his Indian interpreters and visited her in Victoria. Not only did he see her paintings as priceless records of lost Indian art, but he was impressed with her artistic talent. Visiting again

*1913 was the year of the Armory Show in New York and most Canadian papers had picked up examples of the vicious assault the American popular press was mounting against the weird foreign art. The AAM spring show that year had contained a number of radical experiments that were also unequivocally attacked in the press. John Lyman's one-man show there had been ridiculed too, and the 'Hot Mush School' of Toronto was christened later that year in a similar assault.

in 1921 he brought her painting to the attention of Eric Brown, director of the National Gallery. Six years later Barbeau and Brown organized an exhibition of Canadian west-coast art that included the work of white painters as well as native art and that featured twenty-six of Emily Carr's 1912 paintings. The importance of this event in her life cannot be overestimated. But even more crucial was Brown's managing to arrange a CNR pass for her to come east for the opening. There she first met and saw the work of Lawren Harris and the other members of the Group of Seven. She wrote in her journal (*Hundreds and Thousands*, Clarke, Irwin & Company Ltd, 1966):

Oh, God, what have I seen? Where have I been? Something has spoken to the very soul of me, wonderful, mighty, not of this world. Chords way down in my being have been touched. Dumb notes have struck chords of wonderful tone. Something has called out of somewhere. Something in me is trying to answer. ... Jackson, Johnston, Varley, Lismer, Harris up-up-up-up! Lismer and Harris stir me most. Lismer is swirling, sweeping on, but Harris is rising into serene, uplifted planes, above the swirl into holy places.

Not long after her return to Victoria in December 1927 she was painting with real enthusiasm again—after fourteen years. And the next summer she made a heroic journey through the Queen Charlotte Islands, up the Skeena and Nass Rivers, and into the interior. Brown had arranged another CNR pass for the interior trip. He had plans. 'I am looking forward to the time when you and Varley and others will start a West Coast Group,' he wrote.

Her new canvases were a complete departure from the earlier work. As is evident in her **Big Raven* (VAG), they were memories of the simplified, emphatic forms of the Harris paintings she had seen in Toronto applied to the lush forest growth and dramatic totems that were her subjects (though *Big Raven* is also based on a 1912 watercolour). They are not derivative, however. They throb and sway with the vital energy of conviction. That conviction was reinforced in October 1928 when the American painter Mark Tobey, recently returned to Seattle after two years in Europe, conducted three weeks of classes in her studio. (Carr had been involved with Seattle painters since at least 1924.) His work was at this time also made up of swirling organic forms; and although more abstract then Carr's, it obviously sought the same life rhythms.

Carr exhibited with the Group of Seven in Toronto in 1930, corresponded with Harris regularly, and met him again in Toronto in 1931, but she did not seek to link herself creatively with Varley and the other painters in Vancouver. In 1930 she held an exhibition of her 'pole' paint-

Emily Carr. Big Raven, 1931. Canvas, 86.7 × 113.8. VAG.

ings in Victoria, and another at the Seattle Art Museum. After this, Indian themes were no longer her major concern. Encouraged by Harris, and led by her profound understanding of Indian art, she sought to delve deeper into the land itself to express the search for a transcendental state. In paintings like *Forest, British Columbia* (VAG) of about 1932 she portrayed the rain forest itself in the same plastic terms as she earlier had treated the Indian poles. Elaborately interlocking growth is painted sculpturally, as though it were an intricate carving, revealing glimpses of the inner life of the forms.

Emily Carr never used the small oil field-sketch made so popular by the Group of Seven. Instead in 1932 she devised a technique she described to Eric Brown: 'Oil paint used thin with gasoline on paper. I feel I have gained a lot by its use. It is inexpensive, light to carry, and allows great freedom of thought and action. Woods and skies out west are big. You can't squeeze them down.' Woods and skies were her sole concern for the next ten years. In 1933 she bought a house trailer for field sketching, and annual summer trips became the focus of her life. Her

Emily Carr. Sky, c.1935. Paper, 57.1 × 88.9. NGC.

vision, her aspirations opened up and out. No longer interested in the heavy infolding sculptural forms of the deep forest, she sought the swirling, airy images of loggers' clearings or of the seashore.

By 1937 - 8, when she painted †*Forest Landscape II* (NGC), her unique style had become perfectly attuned to every nuance of expressive feeling, her brush responding with a variety of swirls, flutters, streaks, sweeps, and dabs to the least emotive tremble resulting from her high-pitched attentiveness. *Sky* (NGC), is virtually *all* sky. Radiating a hallucinatory cool white heat, pulsating across the whole field of vision, it has transcendental qualities that rival even the best of Lawren Harris's images of the North Shore of Lake Superior or the Rockies.

By 1935, aged sixty-four, Carr had begun to feel the joy of public recognition of her now fully realized abilities. Although she still considered the art scene in Victoria to be dismal (a 'People's Art Gallery' she started there folded after two months of intense effort over the winter of 1932– 3), her eastern successes multiplied. In 1936 she had two solo exhibitions in Toronto and in 1937 the Art Gallery of Toronto gave her a one-woman show. Then in 1938 she held an exhibition at the Vancouver Art Gallery. It was a great success and eleven pictures were sold. 'What made me so pleased about it,' she wrote to Brown, 'was the fact that I had been able to make their own Western places speak to them.'

Carr had had the first of a series of heart attacks in 1937 (she had sold her troublesome boarding-house only the year before) and this curtailed travel to some degree. It also turned her with new seriousness to a longstanding interest, her writing, completing stories about her life with the Indians that she had been working on for some eleven years. These were eventually published in the first of her amazing books, Klee Wuck (1941), which won a Governor General's Award. In March 1939 she wrote to Brown that she was working on 'the story of me, or my work rather'. (This 114-page manuscript has not been published. Her autobiography, Growing Pains, was published posthumously in 1946.) But she continued to paint and her reputation grew. During the last years of her life she exhibited both on the coast and in the East at least every year; this exposure culminated in her first show in a commercial gallery in 1944. Dr Max Stern's Dominion Gallery in Montreal sold fifty-seven of the sixty works on display. Bedridden by then, she continued to paint and write until her death the following March.

In 1942—the last year of significant painting production—Carr revived a number of earlier themes of the 1930–2 period. Nostalgic yet strong full works, most depict totem poles, although one, *Cedar* (VAG), returns to the deep interior of the rain-forest. They are not—as Doris Shadbolt has pointed out—closed, heavy, foreboding, but are open, lyrical, light and sure, revealing the profound resolution achieved by a giant, striving personality.

LEMOINE FITZGERALD (1890–1956) was born in Winnipeg and, like Emily Carr, retained a fierce loyalty to and a creative dependence on his home region all his life. Unlike Carr, whose life was one of emotional extremes, buffeted by the vagaries of fortune, FitzGerald's monumental accomplishment was built slowly and steadily, never wavering; it was always internally logical. 'After leaving school,' he wrote, 'I worked in a wholesale drug office, and finding the job not quite satisfying I felt the first real urge to draw, so I got some drawing-paper, a pencil, and eraser and started work.' He was then fourteen years old.

Employed in various ways during the day, beginning in 1909 he studied nights with a Hungarian painter, A.S. Keszthelyi (b.1875), and by 1912, the year he was married, had decided to become a painter. He exhibited in the RCA that December-January—the show was held in Winnipeg to inaugurate the new art gallery— and for the next seven years he worked as a commercial designer and interior decorator, regularly sending work east for exhibit (his *Late Fall, Manitoba*, 1918, was bought by the NGC in 1918). Though hardly providing an exciting art scene, Winnipeg at least offered mutual support and camaraderie, mainly centred on Brigden's

commercial art firm established in 1913; and the arrival of W.J. Phillips (1884–1963) and of Eric Bergman (1893–1958) in 1913 did much to encourage professionalism among the local artists. The foundation of the Winnipeg School of Art, also in 1913, helped bring art to the attention of the community.

FitzGerald held his first one-man exhibition at the WAG in September 1921. It consisted principally of sketches, but there were some larger canvases, including one called *Summer Afternoon* (WAG) of 1921. Painted in a decorative impressionist style, and almost two-thirds sky, it is elegantly simple in composition and delicate in colour. Though it was likely inspired by magazine reproductions, it demonstrates a fresh inventiveness and the degree to which FitzGerald was this early responding to the visual qualities of the Prairies. He later explained that 'the prairie has many aspects, but intense light and the feeling of great space are dominating characteristics and are the major problems of the prairie artist.'

The decorative side of FitzGerald's art found support with the arrival in September 1921 of Frank Johnston of the Group of Seven to become principal of the Winnipeg School of Art. Johnston would have seen FitzGerald's show, of course, but it was FitzGerald who was impressed. Writing to Johnston from a train passing through Algoma on the way to Ottawa that October, he remarked how 'already I appreciate the truth that you have caught in your things and the big decorative values. ... To just see your interpretation and then the real thing gives me a more intimate feeling toward the work that you and the others have been doing.' Decorative landscape painting would not much longer be an enthusiasm, however, for even as he wrote the letter FitzGerald was on his way to New York City to enrol in the Art Students League.

He worked there over the winter of 1921–2 under Kenneth Hayes Miller and Boardman Robinson. It was a moment at the League when ideas were first developing that by the end of the decade would emerge as American Scene painting. The smooth sculptural modelling that later became the hallmark of that style was then being advanced. FitzGerald returned to Winnipeg and commercial art at the end of July 1922. The summer of 1924 he spent at Banff (Johnston was there in July) and that fall he began teaching at the Winnipeg School of Art.

Williamson's Garage (NGC) of 1927 is typical of FitzGerald's work of the later twenties. It has no pretensions to be a grand subject but is homely and unaffected in its loving depiction of what would have been a very familiar scene to the artist. In this regard it reflects his Art Students League experience, a part of which would have stressed indigenous values. There is evidence in it as well of the broader New York experience,

LeMoine FitzGerald. Doc Synder's House, 1931. Canvas, 74.9 × 85.1. NGC.

which would have included seeing the work of Cézanne. Consequently, its realism is emphatic, with great concern for 'plastic' qualities: a careful modelling of volumes, a precise description of space and of the placement of forms in that space. It is reverent and still.

In August 1929 FitzGerald became the principal of the school. (Johnston had left in the summer of 1924, before FitzGerald began teaching.) He was also finding his full maturity as an artist, at the age of thirty-nine. **Doc Snyder's House* (NGC) of 1931 is one of the important works of this period. It clearly maintains the 'regionalist' and 'plastic' concerns seen in *Williamson's Garage*, but it is more ambitious, larger and more complex, with an exciting play on depth through the variously placed tree-trunks. The rich texture of the earlier painting is gone. As in the work of the Precisionist painters (Charles Sheeler, Charles Demuth, *et al.*), then popular in the United States, the smooth finish stresses the sensitive inter-

relationships of the cubic forms of houses and outbuildings. The colour limited to browns, blue, and green—is delicate and moving. It is one of FitzGerald's most accomplished paintings and one of the treasures of Canadian art.

FRITZ BRANDTNER (1896–1969), who arrived in Winnipeg from Danzig in 1928, found in FitzGerald the only sympathetic ear for his theories of art. When in 1934 Winnipeg proved unequal to his eclectic modernism, FitzGerald encouraged him to move to the more cosmopolitan Montreal. In 1929 Brandtner had brought FitzGerald to the attention of another Manitoban then living in Toronto, Bertram Brooker (see p. 187 ff.), who became a lifelong friend and his greatest enthusiast. He showed Fitz-Gerald's work to Lawren Harris, arranged exhibitions in Toronto, and generally kept him linked to that centre of art activity. As a result, FitzGerald was invited to show with the Group of Seven and in 1932 was formally announced a member. The Group was by then no longer exhibiting, but when the Canadian Group of Painters was formed in 1933, FitzGerald was a charter member.

Intensely dedicated, he structured everything towards the accomplishment of his painting goals. In his characteristically measured way he once described how 'it seems impossible for the artist to attain any height without sacrificing at least a little of the ordinary necessities, not to mention the loss of ordinary social contact, that are so essential to others.' He kept his sensibility at a high pitch through constant drawing exercises. Often berated by friends and colleagues for the lack of exhibition canvases, he never made apologies. 'For some reason, I haven't been painting for quite awhile, but drawing. Result—no paintings.' In the same letter he further explained his working pace. '*Doc Snyder's House* represents two winters, including two full weeks each Christmas vacation as well as all weekends.'

During the early thirties FitzGerald, in concert with his friend Brooker, became intensely interested in the painting of still-lifes. He achieved amazing results with his painstaking technique, which by the middle of the decade included texture again. **The Jar* (WAG) of 1938 is one of the best of these still-lifes—sensual yet austerely controlled. FitzGerald once explained how 'it is necessary to get inside the object and push it out rather than merely building it up from the outer aspect.'

In 1940, feeling the increasing need to paint full time, FitzGerald applied—unsuccessfully—for a Guggenheim grant. Disappointed, but typically matter-of-fact, he explained to a friend that 'I am working along a little different line and have been doing so for the past two years, trying to broaden the previous approach, and I think the work is now showing

LeMoine FitzGerald. *The Jar*, 1938. Canvas, 41.1×36.3 . WAG.

signs of something interesting. With a year of steady work, I am sure the results would warrant the experiment.' Never accepting setbacks, he systematically continued to explore new areas in his spare time. In 1942 he wrote, 'I am still on the large watercolours with anything as subject matter and finding out quite a lot that I hadn't experimented with before. How successful they are as pictures I have not been worrying about, but the solving of certain problems has been the main issue.' Among these 'large watercolours' is a startling series of works that were first publicly exhibited only in 1963. Mainly female nude studies of great sensitivity and ruthlessly penetrating self-portraits, many, such as *Green Self-portrait* (WAG) of about 1942, combine the two subjects in rich overlays that suggest visual puns and play on the relation of model to artist in a profoundly suggestive way, although the two subjects are ostensibly unconnected on the sheet and might even have resulted from different sessions.

Systematic experimentation continued. In the summer of 1942 Fitz-Gerald first visited the West Coast; he returned the next two summers. Breathtaking large watercolours of rock formations, shoreline, and plants resulted. Like *Rocks* (private collection) of 1944, all are concerned with complex interlocking forms that manifest a delight in richly modulated surface texture. Throughout the forties almost all the major works were

LeMoine FitzGerald. *The Little Plant*, 1947. Canvas, 60.9×46.4 . MCM.

in watercolour, the result of an intense personal need to refine his experiments to an essence. In 1946 a concerted effort by friends to obtain a special government pension so that he could leave the school (he was fifty-six) failed, but it became possible for him to obtain two years' special leave beginning in September 1947. He began gingerly to work seriously in oils again.

LeMoine FitzGerald. From an Upstairs Window, Winter, c.1949. Canvas, 61.0×45.7 . NGC.

His approach was basically the same as in the late thirties, but, as in **The Little Plant* (MCM) of 1947, it displayed an even more pronounced surface texture. Each stroke is carefully placed in an effect close to mosaic, resulting in a singing, scintillating surface. The colour radiates like light itself with the clear delicacy of watercolour. That winter (1947–8) Fitz-Gerald and his wife left Winnipeg to live at Saseenos, about thirty kilo-

metres from Victoria. Painting full time for the first time in his life, he worked and reacted like a student. 'With all this continuous study, I feel a growing power in composing and in the execution, whether a drawing or a painting.' His reserved yet deeply moving reactions were transmitted to friends. 'I am more grateful than ever for this opportunity, realizing how inadequate was the time I had previously.'

The following November (1948) the FitzGeralds returned to the coast again, this time living and working in West Vancouver for six months. They saw quite a bit of Lawren Harris and of B.C. Binning, and were generally impressed with the liveliness of the Vancouver scene. They even considered moving. In September 1949 FitzGerald decided to retire rather than return to the school, and that winter they stayed at home. It was so cold he had to work inside, painting the magnificent **From an Upstairs Window, Winter* (NGC). It is a poem to the meaning of form—the distillation of a life of looking and making.

This was not the end of experimentation, however. Probably the following year FitzGerald first responded to the abstractions painted by his friend Brooker almost twenty-five years earlier. Encouraged by Brooker's continuing interest in the underlying forms of all objects, and doubtless egged on by his frequent meetings with Lawren Harris over the last decade, FitzGerald himself began to paint abstractions. They became the major concern of the last five years of his life, and he exhibited one as part of the Canadian representation at the first *Bienal do São Paulo* in Brazil in the fall of 1951. He exhibited another in the CGP exhibition in November 1952 and completed the best of the series, the beautiful *Green and Gold* (WAG), in 1954. Displaying the same delicate assuredness of colour and form as his representational works, this was his last major canvas. He continued to work, of course—mainly in chalk, ink, and watercolour principally on abstractions and still-lifes. He died in Winnipeg of a heart attack in August 1956.

DAVID MILNE (1882–1953) was born near Burgoyne, Ont., in Bruce County, near the shores of Lake Huron. He was educated there and stayed on as a country teacher. Not so tied to his region as Carr or FitzGerald, he nevertheless was seldom happy for long in cities and often sought the peace and solitude of the rural life he had known as a boy. A childhood interest in art revived while he was teaching school, and he took a correspondence course that led to his going to New York to study. That was in 1903 and Milne was twenty-one.

The first school he chose closed shortly after he had paid his hardearned fee, but he immediately enrolled in the Art Students League (eighteen years before FitzGerald attended). The first year he worked nights lettering shopkeepers' window cards to pay his way. This little business expanded, with a partner, and for the next two years he worked days and studied nights. He left the League and tried to develop a career as an illustrator, while devoting what time was left to serious painting. (He had gone to New York intending to be an illustrator.) In 1909 he began to exhibit—mainly watercolours, because the watercolour exhibitions were less rigid and allowed experimental work.

By 1913 Milne was 'known' around New York as an experimental artist and was invited to exhibit in the famous Armory Show. (The only other Canadian included was Arthur Crisp (1881-1966) from Hamilton.) The experience had little effect on his work. He later remarked that 'I already had my feet firmly set on a path of my own.' Nor did inclusion bring fame; the 'sensational Frenchmen' (Duchamp, Matisse et al.) drew all the attention. The 'path' Milne had chosen can be seen in Billboard (NGC) of 1912, possibly exhibited in the Armory Show as Columbus Circle. A striking picture, it is Post-Impressionist, almost Fauve in style, like Emily Carr's work of 1911. Milne's colours, however, are not as aggressive, and he is more concerned with the patterning of his brushstrokes. We are, in fact, primarily impressed by the sense of order this patterning brings to the lively city scene depicted. The effect is very close to watercolours by James Morrice's friend Prendergast, which Milne would have seen in an exhibition of The Eight in 1908, and could have seen, among other places, at the annual group shows at the Montross Gallery (Horatio Walker's dealer) in which Milne also participated.

By the spring of 1914 the lack of any success in the face of such an extended effort—he had been in New York ten years—began to depress Milne and he and his wife retired to the Catskills for the summer. In May 1916, tired of big-city life, they left for good and by the fall were settled at Boston Corners in the lower Berkshires of New York State. It meant the end of his intensive period of looking and exhibiting, and from then his art developed, like FitzGerald's, in a slow but steady and internally logical way. The roughly rectangular patterning of his city scenes became organic at Boston Corners, more suited to landscape forms. **The Boulder* (WAG) of 1916 is typical in its intense overall patterning in white and its harmonious closely valued hues, suggestive of the work of the Frenchman Edouard Vuillard.

War had broken out in the summer of 1914, but the United States did not enter until 1917. For reasons unknown, Milne decided then to enlist in the Canadian army (he had been a resident of the States for fourteen years). He entered the First Central Ontario Regiment in Toronto in March 1, 1918, and was shipped out in September. While still at arrival

David Milne. The Boulder, 1916. Canvas, 61.3 × 66.3. WAG.

camp in England he heard of the War Records program and was able to arrange for work to be sent to London for consideration. By May 1919 he was an official war artist with the acting rank of lance-corporal. He visited Canadian camps in Britain and theatres of action in France and Belgium (this was after the Armistice), and produced 107 works now in the NGC in Ottawa. Mainly dry-brush watercolours, they are almost oriental in their elegant delicacy. As can be seen most remarkably in *Shell Holes and Wire at the Old German Line* of June 1919, the empty spaces are more important than the lines and forms that define them.

Milne was demobilized in Toronto in October 1919 and by December was back in Boston Corners with his wife. They moved into a cabin on nearby Alander Mountain the following winter, and spent the summer at Darts Lake in the Adirondacks. (An exhibition of watercolours painted there was shown at Cornell University in Ithaca, N.Y., in 1922.) The

XXII—Emily Carr. Forest Landscape II, c.1938. Paper, 91.4 × 61.0. NGC.

XXIII—David Milne. White Poppy, 1946. Watercolour, 36.3 × 53.8. NGC.

XXIV—David Milne. Ollie Matson's House in Snow, c.1932. Canvas, 50.8 × 61.0. NGC.

xxv—Carl Schaefer. *Ontario Farmhouse*, 1934. Canvas, 106.5 × 125.1. NGC.

XXVI—Lawren S. Harris. Composition No. I, 1941. Canvas, 157.5 × 160.7. VAG.

XXVII—F.H:Varley. The Cloud, Red Mountain, 1927–8. Canvas, 86.8 × 102.2. AGO.

Milnes then spent two more winters in the region of Boston Corners, at Mount Riga, but the summers through 1923 were passed at Big Moose Lake back in the Adirondacks, where Milne built a house. In the winter of 1923–4 he returned to Canada, visiting Ottawa and Montreal. He sold six watercolours to the NGC, and was able to arrange an exhibition at the AAM. He was then painting works like **Carnival Dress, Dominion Square, Montreal* (AEAC). Open and airy, clean in colour yet suggestive of atmospheric space, it is sensitive yet in no way precious. It is totally free of sentimentality yet joyous and buoyant and above all intensely personal. Montreal was not impressed, however. There were no sales, and Milne returned to up-state New York for five more years, living at Big Moose in the summer and in Lake Placid during the winters.

Finally, late in 1928, he decided to return to Canada—he had been living in the United States for twenty-five years. The following spring he visited Ottawa and then headed north to Temagami for the summer. He had by now established his personal painting style. **Water Lilies and the Sunday Paper* (HH), painted that summer, demonstrates his remarkable abilities:

David Milne. Carnival Dress, Dominion Square, Montreal, 1924. Canvas, 45.7 × 55.8. AEAC.

David Milne. Water Lilies and the Sunday Paper, 1929. Canvas, 51.1 × 61.3. HH.

an incredible delicacy of line within a vigorous composition. The still-life is 'studied' in its arrangement yet spontaneous in treatment. Elegant, it is without pretension. The pages of newspapers spread beneath the bowls and bottles of water-lilies are taken from the Sunday coloured 'comics'. It is vibrant but harmonious in colour, vital yet tasteful.

That winter he returned to Toronto (it had been ten years since his last visit) and moved out to Longstaff's Pump Works at Weston, just northwest of the city. Early in 1930 he rented accommodation in Palgrave, also a short drive from Toronto, where he lived until May 1933. There he became an interested but detached observer of the Toronto scene. Writing to friends in Ottawa, he offered capsule evaluations of the current enthusiasms. Jackson he singled out. 'At the moment, I would say, at the top of Canadian Art and something of his own, something great. Harris I would place as your other creative man. . . . Whatever the value of the Group of Seven in art, there is no doubt about their value to Canada. Mr. Bennett [the Prime Minister] could very nicely vote the seven a

millions dollars each, and the country would still be in their debt.' But most of all he seems to have admired Thomson. 'I rather think it would have been wiser to have taken your ten most prominent Canadians and sunk them in Canoe Lake—and saved Tom Thomson.' Of all the Canadian-wilderness school only Thomson, of course, would ever have attempted a picture like *Water Lilies*.

Milne had little interest in the proselytizing efforts of the Group of Seven, and even less in their aggressive nationalism. He was interested in 'pure' painting. Subjects, he claimed, were of minor importance. 'Significant form' made a picture work. As a result of this approach his paintings have never had the wide appeal of the work of the Group of Seven. But he was nonetheless blessed with a few understanding friends. While he was living at Palgrave the NGC arranged to bring his work to the attention of Vincent Massey and his wife, and from this grew a patronage arrangement unique in Canadian art history. The Masseys purchased a large group of pictures from Milne that they then arranged to sell on consignment through the prestigious Mellors Gallery in Toronto, meeting all immediate expenses themselves and depositing all 'profits' in a fund. Milne was never happy with the arrangement. He felt it gave Mellors a guaranteed income through framing and exhibition fees while the Masseys assumed all the risks. The Masseys could afford to, of course, but Milne was still uncomfortable with the variety of interests involved in the deal. Finally, late in 1938, it was ended. Nevertheless it had given Milne five clear years of full-time painting and at least four annual exhibitions.

In May 1933, the year before the first Massey-Mellors exhibition, Milne had moved into the bush. He built himself a 'painting house in the wilderness' at Six Mile Lake on the Severn River, just north of Orillia, where he could control his contact with people. The drive from Toronto to Severn Falls then took three to four hours but the last seven miles in to Milne's tarpaper cabin added from two to five hours, depending on conditions. Friends nonetheless did visit with news of the outside world, and Milne went to Toronto regularly. He described one trip in 1938. 'The visit to Toronto—exactly a week—was, as usual, interesting and restful, except that I didn't get enough sleep.' In one typical day he met Lismer, Jackson, Barker Fairley (1887–1987), Will Ogilvie, and Carl Schaefer, among others.

The years at Six Mile Lake were not completely ideal. (Milne stayed there until the summer of 1939.) There were long periods when he was unable to work, notably the winter of 1935–6; and for almost the whole of the last two years he painted only in watercolour. But there are many

magnificent pictures. As usual, he was totally uncompromising, and such simplified, almost abstract studies in form as the *Young Poplars among Driftwood* (NGC) of 1937 are certainly among his best pictures. Almost brutal, with a gut thrill of spontaneity, it reveals the absolute precision of his touch in full maturity. Like many of his paintings, it was completed in one sitting.

During the summer of 1939 he moved to Toronto, remaining until the fall of 1940. Douglas Duncan was now his dealer. Duncan had travelled to Six Mile Lake in the summer of 1935, after having been impressed by the first Mellors show the year before. He found himself totally in sympathy with Milne's sensibility. In the fall of 1940 Milne moved to Uxbridge, a village northeast of Toronto. He spent his autumns in Haliburton, at Coboconk or Gull Foot Lake until 1946, and at Baptiste Lake just outside of Bancroft from 1947. He moved to Bancroft in 1952 and died there the day after Christmas in 1953.

Milne's works of the forties and early fifties seem very different. Mainly wash-painted watercolours, they glow with soft suffusions of colour. Like *†White Poppy* (NGC) of 1946, they usually depict subjects of intense colour. One seldom sees the dry line or aggressive forms of the twenties or thirties, and the pictures often appear, like *White Poppy*, far removed from actuality. It was in fact a period in which Milne indulged himself in numerous 'fantasy' pictures, many of a whimsically religious nature. All are rigorously beautiful, amazingly constructed works of art. They are intensely intimate and modest, with that assurance that arises only from genius.

The Canadian Group of Painters 1933–1945

As early as 1921 A.Y. Jackson had proposed that the Group of Seven expand. 'I would like to see it increased to ten or twelve members,' he wrote to a friend, 'but we do not see any original genius among the young element here. The younger set in Montreal are more promising and eventually we may merge into a Canadian group.' Eventually they did. The first substantial evidence of such a bent came in May 1926 when ten 'guests'—all clearly admirers of the Group—were included in the Group of Seven exhibition. That same year the first new member, A.J. Casson (b.1898), was added (he replaced Johnston, who had left the Group), and in 1930 the roll was brought to eight with the addition of Edwin Holgate (1892–1977) of Montreal. Since Fred Varley had moved to Vancouver in 1926, Holgate was the second member resident outside Toronto.

The Group was also beginning to assume 'national' responsibilities in other ways. Jackson's trip with Holgate to the Skeena River region of British Columbia in 1926 was followed by heroic journeys to the high eastern Arctic and the west Arctic. MacDonald and Harris both visited the Rockies at least once a year after 1924, and Harris too saw the Arctic. He was also adventuring into the most advanced art of the day. In 1927 he brought to Toronto an exhibition of the collection of the Société Anonyme.* And that same year Lismer was made Educational Supervisor of the Art Gallery: his educational and propagandizing efforts were by this time consuming virtually all of his remarkable energy.

But resentment was rising against the Group, stemming largely from

*A foundation established by Katherine Dreier—New York patron of Piet Mondrian, Marcel Duchamp, and Wassily Kandinsky, among others—to collect and promote the most advanced modern painting in the world. Lawren Harris was the only Canadian represented in its collection.

178 | The Canadian Group of Painters

its resounding public success. An anti-modernist attack from Vancouver in 1928 held a suggestion of western rancour at eastern presumption. The year before, Clarence Gagnon had chided the 'Seven Wise Men' of Canadian art for keeping others out of their house. And by 1931 there had been a number of reasonable yet fundamental complaints lodged against the Group in the press-not only about their influence but about the exclusiveness of both their vision of Canadian art and their membership. After the opening of the 1931 show Jackson announced: 'The interest in a freer form of art expression in Canada has become so general that we believe the time has arrived when the Group of Seven should expand.' As a result of a series of small meetings in Toronto early in 1933, the Canadian Group of Painters was formed, and the first exhibition of the new group was held that summer in Atlantic City, N.J. The catalogue was explicit in its nationalism. The CGP was an 'outgrowth' of the Group of Seven, it explained, and represented 'the modern movement in Canadian painting'. 'Modernism in Canada has almost no relation to the modernism of Europe', it went on. 'In Canada the main concerns have been with landscape moods and rhythms', and as modernists roamed Canada seeking the land, 'their work is strongly redolent of the Canadian soil and has a distinctively national flavour.

The statement prepared for the first Canadian audience in November was less narrow in its landscape bias, but just as clearly, if somewhat defensively, it took its position from the achievements of the Group of Seven. The CGP, although 'a direct outgrowth of the Group of Seven'. had a membership 'drawn from the whole of Canada'. Although recognizing the 'national character' of art in Canada, such an interpretation would allow 'a wide appreciation of the right of Canadian artists to find beauty and character in all things'. The CGP would encompass as well the amateur movement, as promoted by Fred Housser and Lismer, 'to extend the creative faculty beyond the professional meaning of art and to make of it a more common language of expression. ...' Although painting in Canada was seen as having been until then 'a landscape art', figures and portraits have been slowly added to the subject matter, strengthening and occupying the background of landscape. ... More modern ideas of technique and subject' would also be encouraged. It was a cautious forward step indeed.

Only four years later there were more invited contributors than members exhibiting in the annual November show. The CGP had become a regular exhibiting society like the RCA. It encouraged the young painters to exhibit, but, just like the RCA, it failed to discourage derivative work and even in the forties continued to reflect a somewhat old-fashioned landscape style that carried the distinct stamp of the Group of Seven. During the thirties, however, the CGP did focus activities in three cities— Toronto, Montreal, and Vancouver—and encouraged a number of painters of talent who might not otherwise have been seen nationally.

The principal centre of CGP activities remained Toronto, and the principal figures in Toronto during the thirties were undoubtedly ARTHUR LISMER and A.Y. Jackson. Lismer's educational work (rather than his painting) made him even more influential than Jackson. At the Art Gallery of Toronto he was able to establish the most successful childrens' art program in North America at the time. This accomplishment was recognized in the spring of 1936 when he was invited to South Africa for a year to establish a similar project. After his return he was asked to fill a visiting chair at the Teachers' College, Columbia University, New York, which he accepted for one year, commencing in the fall of 1938. Eric Brown next offered him a job at the National Gallery to initiate a national art educational program. It was a challenge uniquely suited to Lismer's abilities and would represent the culmination of his career as an art educator. But Brown died shortly after Lismer's arrival and the project caved in. Fortunately an offer came from Montreal, and in January 1941 Lismer returned to his work with children as Educational Supervisor for the Art Association of Montreal, a post he held virtually until his death almost thirty years later. His important work in art education during these years left him only weekends and summer-vacation time for his own painting; he had always laboured under such limitations, however, and he continued to develop as an artist until the end of his life. This later work—mainly intimate studies made on visits to Nova Scotia villages in the forties, and from 1951 to 1968 on annual trips to the lush west coast of Vancouver Island-was undervalued during his lifetime but is the most original, intensely personal painting of his career.

The greatest painter in Toronto during the thirties was still A.Y.JACKSON. He clung tenaciously to the old ways, living in the Studio Building until 1955, visiting various parts of the country on field trips every year, and turning out major paintings of such quality that his influence was discernible in the work of most younger painters until the mid-forties. Some have suggested that he failed to develop past 1930, that he rested on his achievement and simply repeated a successful formula. While it is true that he did not strike out on any boldly innovative course, canvases like **Algoma, November* (NGC) of about 1935 or *Alberta Foothills* (MCM) of 1937 are clearly vital, stimulating works of art, and among the most important Canadian paintings of the decade. The other members of the Group of Seven who stayed in Toronto during the thirties, A.J. CASSON and Frank

A.Y. Jackson. Algoma, November, 1935. Canvas, 79.7 × 100.0. NGC.

Carmichael, never approached the position of leadership held by Jackson and Lismer. Both remained modest, if enthusiastic, followers of the Group style as exemplified in the work of Jackson and Harris. Each achieved an individual 'look' within that style, and Casson in particular produced a number of large oils during the thirties—notably *Golden October* (HH) of 1935—that, in spite of their 'Harris' trees and 'Jackson' format, are uniquely his own in colour and mood.

The bulk of the membership of the CGP in Toronto was derived from painters roughly contemporary with Casson, most of whom were trained and encouraged by the Group of Seven during the early to mid-twenties, and most of whom, like Casson, carried the Group style into the thirties and beyond. YVONNE MCKAGUE HOUSSER (b.1898) was born in Toronto, studied at the Ontario College of Art during the First World War, and in Paris during the early twenties (1921–2 and again in 1924). Although she completed her studies before the advent of the Group of Seven at the College, she began teaching at that institution during its heyday in the mid-twenties, and clearly came under the influence of Lismer's ideas. In 1930 McKague even travelled to Vienna to study with his mentor in child art, Franz Cižek. In her painting, she was drawn to the work of Lawren Harris—both to the stark simplicity of his North Shore canvases and, as in her well-known Cobalt (NGC) of 1931, to his house paintings of some ten or more years before. Her real significance at this time, however, was in her teaching rather than in her painting. During the late twenties she was principal adviser to a unique educational experiment in Toronto, the Art Students' League. Inspired by the principles behind the famous New York school of the same name, and aware through J.E.H. MacDonald of the Toronto precursor at the turn-of-the-century, the Art Students' League was founded in the fall of 1926 as a student-administered free school to promote the relation of art to life: 'the essential idea of Art [is] a quality of human consciousness, rather than professionalism, or commercialism.' The most successful example of Fred Housser's and Lismer's ideal of 'amateurism', the League organized field sketching trips, regular visits to the studios of prominent artists, and contributed art classes to the University Settlement for underprivileged children. By the summer of 1927 the League had rented a house near the Art Gallery-The Grange Studio-that included accommodation for a number of the members, meeting and studio space for non-residents, a small gallery, and a craft shop. Harris, Jackson, Lismer, and others of similar persuasion often lectured there and, although there were no formal classes, guided students in their work. By 1930 members of the League were publishing a magazine of opinion, poetry, and art that became the voice of Toronto's first bohemian community, then growing in the old 'Greenwich Village' on Gerrard Street.

'Graduates' of the Art Students' League usually maintained an opposition to commercialism and professionalism. Some, inspired by Arthur Lismer, made great contributions to art education here and abroad. And a few were brought into the ranks of the CGP. GORDON WEBBER (1909–65) was born in Sault Ste Marie, Ont., studied at the Ontario College of Art (1924–7) during its 'Group of Seven' years, and then became active in the League. During the thirties he painted in the modest format suitable to the intentions of a League student, and, in his *Skating in the Park* (AGO) of 1933, in a style expressing the natural unity of life's activities. Not strong painting, it is honest in its presentation of a philosophy of life and art. In 1939 Webber pursued this concern with three years of study under the Bauhaus teachers Laszlo Moholy-Nagy and Gyorgy Kepes at the School of Design in Chicago, followed, upon graduation, by a distinguished career as professor of design at the McGill School of Architecture in Montreal.

Another Art Students' League member involved in the early years of the CGP-she was elected president in 1939-was ISABEL MCLAUGHLIN (b.1903), who was born in Oshawa, Ont. Her father, R.S. McLaughlinfirst president and chairman of the board of General Motors of Canadawas a prominent collector of the period. Like Gordon Webber, she studied at the Ontario College of Art with Arthur Lismer (1925-8), and joined the League. Then, like Yvonne McKague, she studied in Paris before joining McKague in Vienna in 1930. Her paintings are intensely decorative and, when she allows her rich fantasy free reign—as in the justly famous Tree (HGC) of 1935-they have the fascination of dream images. Involvement in the Art Students' League thus led some painters to follow their inclinations into areas unexplored by the Group of Seven. Other students of Group members at the college-like George Pepper (1903-62) and his wife, Kathleen Daly (b.1898)-generally accepted the limits of painting as defined by their teachers. Of the many landscape painters who developed in Toronto in the late twenties, only CARL SCHAEFER (b.1903) was able to make a consistently strong and finally unique statement

Schaefer was born in Hanover, Ont., in an area settled by Germans in the mid-nineteenth century, not far from where Milne was born. Inspired by illustrations in books and boys' magazines, he enrolled in the Ontario College of Art in 1921. There he was instructed by Lismer and Mac-Donald, among others, and through them came into contact with Jackson and Harris. He graduated in 1924 and celebrated with a small show of oil sketches in the fire-hall at Hanover. For the next three or four years he found employment around Ontario as an itinerant church decorator, as a painter of theatre sets in Toronto, and as J.E.H. MacDonald's assistant on a number of mural commissions. The summer of 1926 he first went north in the Group of Seven fashion and for the next few years painted stylized, decorative reworkings of Group themes, almost indistinguishable from the efforts of other disciples. By the Depression Schaefer was raising a family and able to find employment only as a part-time teacher; to save money, he and his family lived with his grandparents back in Hanover during every summer and winter holiday break from 1932 through 1939. This was a period of reaffirmation of traditional values and of assertive creativity, resulting in a long series of stunning canvases.

Working with J.E.H. MacDonald, Schaefer had become friendly with his son, the distinguished black-and-white illustrator, Thoreau Mac-Donald (b.1901), and had developed his own pen-and-ink work to a high level. In this medium he evolved the stark, simplified realism he was to use in his oils throughout the thirties. It was a style that in watercolour

Carl Schaefer. Storm Over the Fields, Hanover, 1937. Canvas, 69.1 × 94.0. AGO.

had already been developed to a sensitive degree by the Buffalo painter, Charles Burchfield—whose work Schaefer admired and whom he met in the later thirties—and that the American Scene painters were just then successfully applying to the depiction of regional themes.

Schaefer's first response to Hanover was nostalgia. But later the country took on a new aspect for him and familiar things began to generate a life of their own. †*Ontario Farmhouse* (NGC), painted on the Voelzing farm in 1934, represents a conjunction of the past and present, a potent image of strength in continuity. With fruitful fields pushing into its porch, the house rises like a ritualistically embellished part of the land itself. 'I felt that I was producing something of permanence,' Schaefer has said. 'I was not painting for posterity, but I painted from morning until night, and even at Christmas when there was snow. I was interested in the cycle of life.' To him the fields revealed the same evidence of man's hand as the house, the same fruitful union of past traditions and present need. The group of spreading 'field' canvases produced at Hanover—most well over a metre wide—is the most moving series of pictures painted in Canada in the thirties. They all display heroic breadth. The long rich

furrows and great golden lakes of wheat in **Storm Over the Fields, Hanover* (AGO) of 1937 are as awesome as the clouds so formidably marshalled above; they seem almost to be their man-made counterpart.

Schaefer had had his first one-man exhibition at Douglas Duncan's Picture Loan Society in Toronto in 1936 (there were to be eleven more there by 1958), and his pictures were a prominent feature of every CGP exhibition. His achievement received formal recognition in 1940 when he became the first Canadian to be awarded a Guggenheim Fellowship. Taking full advantage of a year's free painting, he moved to Norwich, Vt. It was his first long period free of teaching and proved to be one of his most productive years. The Vermont pictures, in oil and watercolour, are distinctive. He responded to the nature of the place while bringing recent tendencies in his work to culmination. February Thaw, Norwich, Vermont (NGC) is typical. Dark and moody, almost monochromatic, the paint is applied in broad swipes that suggest rather than describe the volume of forms. Objects no longer have massive individuality as in the paintings of the mid-thirties but blend into the whole, finding their depth in space through depth of tone. In these, his most 'painterly' works, subject is of the least importance and sensibility as revealed in handling carries the most meaning.

This great facility of handling found a highly charged subject during the war when Schaefer was attached to the RCAF as a war artist. Afterwards he found it difficult to return to 'normal' painting. His work remained dark—he had flown in bombers, always at night—and kept to themes of violence. *Carrion Crow* (the artist) of 1946 is a brutal image of inevitable death. He was also working exclusively in watercolour by then. 'I felt that my painting in oil was restricting and not sufficiently personal,' he has said. 'I became more and more interested in drawing and the calligraphic approach.' Schaefer has continued to find his means of expression in this intimate mode ever since.

Though landscape clearly predominated in the work of CGP painters during the thirties in Toronto, a number of figure painters were also active. None were Torontonians. WILL OGILVIE (b.1901) was from Cape Province, South Africa. He first studied in Johannesburg before immigrating to Toronto in 1925; two years later he was in New York, working at the Art Students League for three years under Kimon Nicolaides. Ogilvie's principal achievement of the thirties was the wonderfully light mural program in the chapel of Hart House, University of Toronto (1936). Buoyant, decorative, symbolic without being solemn, it is a charming reflection of its time. PARASKEVA CLARK (1898–1986) was born in Leningrad. She studied with Savely Seidenberg before the revolution, and at the

Paraskeva Clark. *Petroushka*, 1937. Canvas, 122.4 × 81.9. NGC.

Free Art Studios (formerly the Imperial Academy of Fine Arts) under Vasily Shukhayev and Kuzma Petrov-Vodkin (1918–21). She lived in Paris from 1923 until she moved to Toronto with her Canadian husband in 1931. Her painting is carefully constructed and coloured. Landscapes, like *The Pink Cloud* (NGC) of 1937, or portraits, such as the striking *Selfportrait* (NGC) of 1933, are equally rich in intricate formal relationships. (Petrov-Vodkin's paintings are deceptively simple socialist-realist pictures with a similarly complex internal relationship of forms.) Clark became active in the Committee to Aid Spanish Democracy after meeting Dr Norman Bethune in 1936, and soon after painted one of the few significant politically engaged works to survive from the period. **Petroushka* (NGC) of 1937, in which Clark employed a seemingly innocent scene of street entertainment to express her outrage at the recently reported brutal killing of five strikers by Chicago police, still has the power to move the viewer.

PEGINICOL MACLEOD (1904–49) lived in Toronto only from the fall of 1934 to early in 1938, but she left a strong impression on the local scene. Born Margaret Nichol near Ottawa, she studied painting there under Franklin Brownell (1922–3), and at the École des Beaux-Arts in Montreal (1923–4). Attractive and vivacious, she made friends wherever she went, and was involved in numerous causes. Art editor of The Canadian Forum 1935-6, Nicol also assisted in the establishment of the Picture Loan Society, and it was she who introduced Paraskeva Clark to Bethune. Her strikingly original, impulsive painting in both watercolours and oils is as exuberant as her personality is said to have been, and pictures such as Torso and Plants (RMCL), first shown early in 1936—which depicts her naked upper body as a background to a spreading bouquet of vibrant flowers-surprised and delighted both friends and critics. Nicol married Norman MacLeod late in 1937, and moved with him to New York City early the following year. She maintained her Canadian contacts, however, and taught at the University of New Brunswick in Fredericton every summer from 1940 until her sudden death from cancer in February 1949.

CHARLES COMFORT (b. 1900) was born at Cramond, near Edinburgh, but immigrated to Winnipeg with his family in 1912. Two years later, at the age of fourteen, he began working for Brigden's, a local commercial art firm. In the late fall of 1919 he moved to Toronto to work in a branch of the Brigden firm, and in May, when he saw the first exhibition of the Group of Seven, he determined to become a painter. Returning frequently to Winnipeg, he received further encouragement after September 1921 when Frank Johnston took over the Winnipeg School of Art and Art Gallery and, the next fall, gave Comfort his first exhibition. That autumn of 1922 Comfort also travelled to New York to study for a year at the Art Students League. Back in Winnipeg, he was involved in designing sets for the local theatre and became friendly with FitzGerald and W.J. Phillips. The growing art community in Winnipeg still offered too little, however, and in 1925 he and his new wife settled in Toronto.

Comfort soon became known as a young painter of promise. Works like *Prairie Road* (HH) of 1925 have a recognizable kinship with the Group of Seven in boldness of paint handling, but are more arbitrary in colour than Toronto was then accustomed to. This brash, startling quality Comfort carried even further in *The Dreamer* (AGH) of 1929, a dramatic portrait study that marshalled all of the talents he had developed as a commercial designer. It launched a series of portraits painted over the next five years that in many ways forms his most successful body of work. The best is probably the portrait of Carl Shaefer, **Young Canadian* (HH) of 1932; emphatic and admirably painted, it is notably free of the superficial illus-

Charles Comfort. Young Canadian, 1932. Watercolour, 91.4 × 106.7. HH.

trator's devices seen in *The Dreamer*. Then came a series of landscapes of similar range. The famous *Tadoussac* (NGC) of 1935 is one of the first of these. In its high point of view, delicate atmosphere and colour, and 'cutout model village' forms, it comes closer than any other Canadian picture of the thirties to the work of the famous American Scene painter Grant Wood. Comfort's other landscapes of the period are more aggressive, establishing a clear mood—as in *Lake Superior Village* (AGO) of 1937—or stating a simple theme, as in *Pioneer Survival* (NGC) of 1938. He maintained a high profile as a commercial designer in Toronto throughout the thirties, and also influenced many young artists as a teacher, first at the Ontario College of Art (1935–8), and then at the University of Toronto (1938, 1944–60). Comfort's public career culminated with a period as President of the RCA (1957–60), followed by a stint as Director of the NGC (1960–5).

Another Manitoban was an even more potent catalyst in Toronto in the late twenties and thirties. BERTRAM BROOKER (1888–1955) was born in Croydon, Eng., and immigrated to Canada with his family in 1905, settling in Portage la Prairie. For sixteen years he lived and worked around Manitoba

and in Regina as labourer, railway clerk, journalist, pioneer movie-house operator, and free-lance advertising artist. Then in 1921 he moved to Toronto to work for an advertising trade journal. About 1926 Brooker began to experiment seriously with painting (he had been drawing and dabbling in paint since about 1913), and suddenly in January 1927 he burst on the scene with an exhibition of abstract paintings at the Arts & Letters Club. They were the first abstract pictures ever exhibited by a Canadian.* Encouraged by progressive elements in Toronto, Lismer had sponsored the show and Harris lent his support.

Brooker continued to work his ideas through, and by early 1928 he had achieved the assured level of **Sounds Assembling* (WAG), which he exhibited that February with the Group of Seven. Perhaps best described as spatial geometric painting, in its use of tubular forms and its complex of interconnecting spatial pockets, it is similar in appearance to the work of the American futurist painter, Joseph Stella (particularly to his famous *Brooklyn Bridge* of 1918, then owned by the Société Anonyme), although it also reflects certain visual concepts related to the study of Theosophy. Brooker's professed intention, evident in the work's title, was to express in paint the abstract relationships that are so stimulating in the art of music. His guide in this direction was one of the key works of early twentieth-century Western culture, Wassily Kandinsky's *Concerning the Spiritual in Art*, which also arises in part from an interest in Theosophical principles.

It was doubtless Lawren Harris who interested Brooker in the writings of Kandinsky. In April 1927 (two months after Brooker's Arts & Letters Club show) Harris succeeded in displaying the collection of the Société Anonyme at the AGT. It must have been an amazing exhibition, including works by Mondrian, Kandinsky, Stella (not his *Brooklyn Bridge*, although it was shown in a slide lecture given by Katherine Dreier during the exhibition), and virtually every modernist of distinction. It was, needless

*Another early abstract painter was Rolph Scarlett (b.1889), who was born in Guelph Ont. He moved to the United States in 1918 and first became interested in abstract painting on a visit to Europe in 1923. He applied his enthusiasms as a set designer in Hollywood 1930– 4 and then as a member of Design Associates in New York, but apparently began painting non-objective canvases (greatly influenced by Kandinsky) only in the late thirties when he joined the staff of the Museum of Non-Objective Painting (now The Solomon R. Guggenheim Museum). The Guggenheim owns sixty works by him.

Jay Hambidge (1867–1924) should also be mentioned. Born in Simcoe, Ont., and raised in Ingersoll, Ont., he went to New York as a young man and enrolled in the Art Students League. He later became famous as the discoverer-inventor and chief promulgator of the principles of 'dynamic symmetry', which had a profound influence on painters, both abstract and representational, during the twenties and thirties. He was a life-long friend of C.W. Jeffreys.

Bertram Brooker. Sounds Assembling, 1928. Canvas, 113.0 × 91.4. WAG.

to say, the first time these painters had been seen in Canada. The exhibition was a success in terms of public response but it interested few of the painters in the possibilities presented. The *Canadian Forum*, a staunch supporter of the Group of Seven, had observed that 'abstraction is not a natural form of art expression in Canada', and most Torontonians, apparently, agreed. In March 1931 Brooker held the last exhibition of abstract painting—a retrospective of his early work—Toronto would see for twenty years. He was a man of incredible energy: novelist (winner of the first Governor General's Award for fiction), editor of two yearbooks of Canadian art (1929 and 1936), columnist (his syndicated column on the arts in Canada—the first of its kind—was read across the country), illustrator, and advertising executive and theoretician (he wrote two advertising manuals, 1929–30). Brooker likely would have persisted in the face of public apathy had it not been for the convincing example of a new-found friend.

In the summer of 1929 he met LeMoine FitzGerald in Winnipeg and immediately stopped painting abstractions and turned to a 'realistic'

Bertram Brooker. *Torso*, 1937. Canvas, 61.6 × 45.7. NGC.

idiom. Writing to FitzGerald that fall, he described how the effect of the visit had been to make his work 'perhaps too realistic—in a small way, I mean—but I hope to grow out of that to a bigger appreciation of form— particularly.' The first of his realistic works—*Snow Fugue* (Royal Conservatory of Music, Toronto), exhibited with the Group of Seven in April 1930—follows, as the title suggests, the concerns of the earlier abstractions in its formal patterning of snow-laden branches. By about 1934, however, he had settled on a manner of painting—detailed and somewhat dry—that perfectly suited the detached formal examination of people, places, and objects that had become his concern. The portraits, such as that of his daughter Phyllis, entitled *Piano! Piano!* (AGO) of 1937—are all penetrating in their realism, dynamic in composition, and harmonious in colour and texture. They were certainly among the most original contributions to the CGP exhibitions of the thirties.

Brooker had mentioned to FitzGerald some years before that 'after this apprenticeship to naturalistic painting has been served a little more fully I shall perhaps go back to more abstract things with a greater command of mediums and do something quite different.' Late in 1937 he did something very close to that and exhibited two of the results in the CGP exhibition that November. Neither *Blue Nude* nor *Entombment* (private collections) really is an abstraction like those of the late twenties. They are rather stylizations; plays on Cubist compositional devices; symbolic figures. Although monumental, ambitious canvases, they seem, at this remove, to lack the vitality of earlier work.

The same diminished vitality characterized the whole Toronto scene in general by 1940. After almost seventy years' dominance of painting activity in Canada, the centre had given way. A.Y. Jackson, by then the only painter in the city with the demonstrated excellence to set standards, was, in his exclusive concern for landscape, out of touch with the more interesting trends of the day. And Jackson was always a loner. Harris, the acknowledged leader, had left the city in 1933. Wyndham Lewis, the English painter and writer, trapped in Toronto from 1941 to 1943, found life in that 'sanctimonious icebox' unbearable. Two of the few stimulating personalities he did enjoy during his Canadian years (which extended to August 1945) were a young Canadian then lecturing at St Louis University, Missouri, named Marshall McLuhan, who travelled to Windsor to visit Lewis in July 1943, and the painter A.Y. Jackson. On his return to London, Lewis published an article in The Listener, 'Nature's Place in Canadian Culture⁷, which he described as having been written 'around the massive and truly typical figure of a celebrated Canadian artist . . . Alec Jackson,' who represented for Lewis the 'one very fine attempt' to creatively engage the Canadian experience.

In Montreal support for the CGP came almost exclusively from a number of artists who, in the fall of 1920, with the encouragement of Jackson, had formed the Beaver Hall Group. All had been English-speaking students of Brymner at the AAM school (as was Jackson), most had subsequently trained in Paris, they all had studio space on Beaver Hall Square, and as a group they were probably the finest figure painters in Canada in the thirties. RANDOLPH HEWTON (1888–1960), the oldest, seems to have set the direction. Born in Megantic in the Eastern Townships, he moved as a boy to Lachine near Montreal. He studied painting with Brymner (1903–7) and then spent five years in Paris. There in 1912 he met A.Y. Jackson and the two agreed to exhibit together at the AAM on their return home early in 1913. His early French pictures, like those of Jackson and Albert Robinson (1881–1956), another Canadian Hewton had met in Paris

(and who later settled in Montreal), are fresh, open, 'second-generation' impressionist landscapes of promising ability. By 1920 and the first Group of Seven exhibition (which included both Hewton and Robinson as guest exhibitors), Hewton was painting landscapes not unlike the Quebec scenes Jackson was about to begin. He was also an accomplished and recognized portraitist, working in a loose, sensitive manner. Works like his *Portrait of Audrey Buller* (NGC) of 1921 spread his reputation as a portraitist and figure painter, and it was largely as such that he later exhibited in the CGP. Hewton became Principal of the AAM school on Brymner's retirement in 1921, but in 1926 he accepted the presidency of a family manufacturing business and in 1933 moved to the small company town of Glen Miller, north of Trenton, Ont. He was by then simply a talented amateur, with little time for painting.

EDWIN HOLGATE was the only one of these Montreal painters to formalize his relations with the Group of Seven when in 1930 he became their eighth member. Born in Allandale, Ont., he studied with Brymner, and then in Paris, both before (1912–14) and after the war (from November 1920 to the early summer of 1922, part of the time with the Russian expatriate Adolf Milman). Despite his connection with the Toronto artists, he remained a figure painter. Like Hewton, he early developed a reputation as a portraitist and during the years of his involvement with the CGP exhibited a number of delightful studies of Quebec types, usually placed in landscape settings. He will be remembered, however, for his lovely series of female nudes of the thirties (also in landscape settings). The best of these, **Nude* (AGO) of 1930, is gentle and sensitive in colour, vigorous in composition, and imaginative in the relation of the figure to the landscape.

The Beaver Hall Group is most remarkable, though, for a group of Montreal-born women who dominated its membership during the twenties, and who made up the largest contingent of Montrealers in CGP exhibitions during the thirties. As Norah McCullough has pointed out, these artists were 'by no means careerists, but rather talented gentlefolk, . . . women of superior intelligence and vigorous energy.' A number of these Brymner students were, nonetheless, drawn into extended careers by their talent. LILIAS TORRANCE NEWTON (1896–1980) painted portraits in the twenties that are similar to those of Hewton. By the late twenties she had developed a relaxed informal style—perhaps best seen in the *Portrait of Eric Brown* (NGC) of about 1933—that attracted a large following, and by the mid-forties she had painted most of the famous Canadians of the time.

Of those who regularly painted landscape-including Mabel Lockerby

Edwin Holgate. Nude, 1930. Canvas, 64.8 × 73.7. AGO.

(1887–1976), Kathleen Morris (1893–1986), and the beloved teacher Annie Savage (1896–1971)—the most accomplished was probably SARAH ROBERT-SON (1891–1948). *In the Nun's Garden* (AGO) of 1933 displays many of her qualities: a lyrical charm with a touch of humour, full, rounded forms, and sensitive, harmonious colour. But the most talented of these Montreal women was PRUDENCE HEWARD (1896–1947). She studied with Brymner and had Holgate, Robertson, Savage, Morris, and Newton as classmates. Her training was thoroughly typical of her background, including a season in Paris (1925–6), and her work of the twenties reflects the English-speaking Montrealer's world as defined during that decade by the portraits of Hewton and Lilias Newton. *Girl on a Hill* (NGC) of 1928 displays more than a passing acquaintance with the subtle colours and classical compositions so dear to Parisian taste during the early years of the century. It is at the same time permeated with Anglo-Saxon reserve.

Prudence Heward. Dark Girl, 1935. Canvas, 91.5 \times 99.0. HH.

It won the Willingdon Arts Competition in 1929 and marked Prudence Heward's serious entry on the Montreal scene. That year she returned to Paris, where she met Isabel McLaughlin of Toronto, who became a lifelong friend. Through the thirties she sketched most summers at her family's vacation home near Brockville on the St Lawrence, often with her friends Sarah Robertson and A.Y. Jackson. But it was as a figure painter, and primarily as a portraitist of deep sensitivity, that Heward made her mark. *Dark Girl (HH) of 1935, although ostensibly a conventional thirties Canadian nude study with its simple seated pose and 'outdoor' studio setting, transcends the genre through its gentle revelation of character, its moving sympathetic harmonies, to become one of the most memorable of Canadian portraits. For the next ten years a slow but steady series of female portraits came off her easel, each displaying a more intense union of colour and form, reflecting personalities of vigorous individuality. One of the finest is the aggressively beautiful Farmer's Daughter (NGC) of 1945. Bold, exciting, it is almost shocking in its sugaracid colours and defiant anonymity. It was also one of Heward's last paintings. Struggling against poor health much of her life, she died suddenly while on a visit to Los Angeles in March 1947.

When FRED VARLEY arrived in Vancouver in September 1926 he found a situation not greatly changed from that familiar to Emily Carr thirteen

years before. Aged forty-five, he had for years been discontentedly managing on a bit of teaching, a bit of design, and some portrait commissions, but his creative work until then showed no central motive, no moving theme. The ten years he was to live in Vancouver provided the necessary focus. While in Toronto he had never been really taken by his friends' enthusiasm for landscape, but once away from them he became one of the most eager exponents of the Group 'method' of intense involvement in the natural environment. Challenged by the prospect of teaching in a new school (he was hired as Head of Drawing, Painting and Composition by the Vancouver School of Decorative and Applied Arts, founded the year before), he was excited by the proximity of the mountains and began weekend sketching jaunts soon after his arrival. During the first summer break, in August 1927, he went camping for about a month and a half in the magnificent Garibaldi Park, situated in the mountains north of Vancouver, and began painting bold, vigorous canvases, like *†The Cloud*, Red Mountain (AGO), immediately after returning to Vancouver. Weekend sketching trips and summer camping excursions continued, with colleagues and students invited along, and soon the Vancouver 'group' that Eric Brown had hoped to see began to develop in response to Varley's example.

Varley's arrival had happily coincided with the appearance in Vancouver of a small intellectual circle, centred on regular musical evenings at the home of a local gallery owner and accomplished, imaginative photographer, John Vanderpant. He and his friends were interested in mysticism and talked endlessly about the spiritual component in creativity. They even assisted in bringing the famous Indian poet-mystic Rabindranath Tagore to Vancouver to lecture in 1929. Varley had always been interested in such ideas. These discussions coincided with a period of intense motivation in his painting and induced bold experimentation in the use of symbolic colour to express spiritual values in his portraiture, resulting in some of the finest work of his career and, early in 1930, in a masterpiece of Canadian painting, *Vera* (NGC). As Varley doubtless recognized, *Vera* marked the peak of his abilities as a painter. It was exhibited no less than six times in the first two years, from Seattle to New York, before being purchased by Vincent Massey.

Varley's elation was somewhat dampened by the Depression, which had forced salary cuts at the school—sixty per cent in Varley's case. In May 1933 he and a colleague, Jock Macdonald, believing that all avenues of redress had been blocked, announced that in September they would found their own school, the British Columbia College of Arts. With the help of concerned friends the College lasted for two years (until June

F.H. Varley. Dhârâna, 1932. Canvas, 86.4 × 101.6. AGO.

1936)—during which time it was the effective centre of Vancouver's cultural life—before collapsing under the weight of accumulated debts. Varley's creative painting continued to flower. About 1932 he found a house in Lynn Valley, north of Vancouver. At first he spent weekends there, but during the College period he moved there and this was the time of his closet communion with nature, which he expressed in the haunting **Dhârâna* (AGO) of 1932. The title refers to the Bhuddist state of spiritual union with nature; the painting boldly asserts this union through the use of greens, blues, and purples—as first seen in *Vera*—to describe the features of both the transported girl (actually Vera again) and the enlivened land. It is a work that strikes an almost shrill pitch of intensity.

With the collapse of the College, forces that had always opposed Varley's aggressive teaching methods and free, indulgent life-style began to gain strength. Coinciding with a marital crisis and virtual destitution, the pressure became too much, and Varley left his family in Vancouver and returned to the East.

Varley's influence in Vancouver during those ten heady years had been, nonetheless, unalterably profound. Even mature painters found themselves keying up colour, working with bolder design and broader, more emphatic brush strokes. The man who brought Varley to Vancouver, CHARLES H. SCOTT (1886–1964), director of the Art School, responded eagerly to the Group of Seven type of field-sketching, often accompanying Varley on weekend hikes during the late twenties. English-born W.P. WESTON (1874–1967)—like Scott, a charter member of the CGP—was, when he first arrived in Vancouver in 1909, painting conventional academic landscapes, often even of English scenes. In the early twenties (a Group of Seven exhibition had been shown in Vancouver as early as September 1922) he began to travel into the mountains, and the freer experimentation that Varley's teaching and example later encouraged fitted the direction Weston was finding. By June 1930 a newspaper reviewer was able to remark that he 'outgrouped the Group of Seven'. Varley's most important contribution in Vancouver, however, was in awakening the painter in JOCK (J.W.G.) MACDONALD (1897–1960), his colleague at the School. Macdonald was born in Thurso, in northern Scotland. Trained in commercial design, he worked or taught in that field until coming to Canada in 1926 as head of design at the new Vancouver School of Decorative and Applied Arts. Though he had never painted in his life, he began to accompany Varley on sketching trips and developed a degree of facility with the small Group-type sketch under Varley's direction. At the age of thirty-three, in 1930, he completed the first canvas Varley had not examined in progress: Lytton Church, British Columbia (NGC). A promising work by a follower of the Group of Seven, it was purchased by the National Gallery the next year.

The decision to found the British Columbia College of Arts increased Macdonald's involvement with Varley, and the excitement growing from the College's activities stimulated him in experimental directions. *Formative Colour Activity* (NGC), his first abstract or 'automatic' work, was painted early in 1934, the first year of the College's existence, and was exhibited that year at the VAG and at the CGP show in 1936. Unlike Brooker in his abstracts of seven years earlier, Macdonald was not interested in spatial problems but purely in colour; completing the painting in one sitting, he followed natural inclinations, automatically, as the first colour led to other colours and forms. The final result suggests fantastic floral images.

Macdonald continued to experiment but did not exhibit abstractions again for seven years. The College collapsed in 1935 and that summer he moved, with his wife and little daughter, into a deserted cabin in Friendly

Cove, Nootka Sound, an isolated spot on the west coast of Vancouver Island. They remained a year and a half, and Macdonald lost himself in the land. Like Emily Carr, he began to understand the profound integration of Indian art with the natural environment and painted brooding canvases of poles and villages. Lack of money and lock's poor health finally forced them to return to Vancouver in November 1936. He had difficulty finding work, suffered a collapsed lung in April, and finally in January 1938 got a job as a high-school art teacher. Stifled by that work, he continued to seek relief in creative exploration. On his return to Vancouver from Friendly Cove he had tried a new series of abstractions. which he called modalities. All, like Fall (private collection) of 1937, are symmetrical geometric designs that bring together suggestive, often representational forms in a pyramidal arrangement. With Varley gone, it was as though Macdonald was reaching deeper into his earlier experiences as a fabric designer in England. About this time he met Emily Carr, whom he considered 'undoubtedly the first artist in the country and a genius without question'. He visited her frequently and they became dear friends. Not the mentor Varley had been, she encouraged a more certain Macdonald to persist in seeking spiritual values in the natural environment. Then, late in 1940, Lawren Harris moved to Vancouver. He and Macdonald were soon sketching together in the mountains and painting together in Harris's studio. Macdonald was, of course, greatly encouraged in his abstract experiments (Harris had by then been painting abstracts for about four years) and was utterly confirmed in his spiritual aspirations. Harris, the great Canadian proponent of such concerns, introduced Macdonald to Kandinsky's writings, as he had introduced Brooker to them more than fourteen years before.

About this time Macdonald also learned of Surrealism* through Herbert Read's *Art Now*, and by 1941 he had returned to his earliest abstract experiments in exploring again the 'automatic' method he had used in

*The Surrealists, in response to Freudian psychology and Marxian politics, understood that each man's unconscious harbours vast creative energies that are needlessly suppressed by the complex and vicious machinery of the social order. Their recognition of the natural creativity of children and of the often profound expressive qualities of the primitive or the insane—each to some degree free of the moral restrictions of society—seemed to confirm their theory. Through rigorous self-examination, often involving the analysis of dreams (those 'windows' into the unconscious), through the bold confrontation of personal and societal taboos, and through intuitive 'automatic' modes of composition that attempted to exclude conscious judgement, they sought to tap that rich creative source and make a new art of total personal freedom, heralding a new era for humanity. Hans Arp, Max Ernst, Salvador Dali, and Joan Miro were among the best-known Surrealist painters around the time the movement began in 1924, when André Breton wrote a manifesto describing Surrealism as 'pure automatism'.

painting *Formative Colour Activity*. This Surrealist approach was reinforced in 1943 when he met two friends of Herbert Read, Dr Grace Pailthorpe, a psychiatrist who was using automatic painting as a therapeutic tool, and Reuben Mednikoff, an ex-patient and enthusiastic proponent of automatic painting. Nevertheless Macdonald also still painted landscapes, culminating in the mid-forties in a series of beautiful works done in the Okanagan Valley. Of his landscapes, these last are the most transcendental in intention. In 1946 he accepted a position as director of the art department at the Provincial Institute of Technology and Art in Calgary. At the age of forty-nine he was finally, in his involvement with Surrealism, developing a visual language that would reveal his remarkable creative abilities.

Some of the painters who did not live in the three principal art centres in Canada during the thirties also found the CGP exhibitions a valuable national forum. One of these, W.J. WOOD (1877-1954), of Midland, Ont., had been a friend of Group of Seven members since before the First World War, and exhibited with them in 1928. During the Depression he put most of his effort into printmaking (he exhibited his etchings widely), but the CGP shows allowed him to present his highly personal figurative paintings to a wider audience. Several others-like Henri Masson (b.1907) of Ottawa and André Biéler (b.1896) of Kingston-were, in the late thirties, vigorous and often convincing proponents of a Canadian equivalent to the regionalist concerns that were then so prominent among the American Scene painters in the United States. One artist who might mistakenly have been called a regionalist was JACK HUMPHREY (1901-67), born and raised in Saint John, N.B., where he lived most of his life. Studying first at the Museum of Fine Arts School in Boston (1920-3), then at the National Academy of Design, New York (1924-9), with summers at Provincetown, Mass., under Charles Hawthorne, Humphrey received a good academic training. Students at Provincetown who had studied in Munich with Hans Hofmann impressed him with their innovative ideas and in the fall of 1929 he too visited Europe. There for two-and-a-half concentrated months he studied with the world-famous modernist teacher and absorbed his doctrine: that effective composition consists primarily of the judicious placement of dynamic planes of colours. Humphrey applied the lesson well on his return to Saint John. His self-portrait, *Draped Head (HH) of 1931, is monumental in scale yet infinitely rich in modelling—a living thing.

As Brooker remarked to his friend FitzGerald after the 1931 Group of Seven exhibition, it was generally known that Lawren Harris was going

Jack Humphrey. Draped Head, 1931. Panel, 40.6 × 30.5. HH.

through some kind of crisis: his painting had dried up. He continued to work sporadically—on Arctic canvases, primarily—and of course he exhibited in the 1933 CGP shows. Then in the fall of 1934 the bombshell burst. Fred Housser had decided to leave his wife, Bess, for Yvonne McKague, and Harris, in turn, had fallen in love with Bess. After much deliberation they decided to spend their lives together. To avoid embarrassing others, they would leave Toronto. Arrangements were made to move to Hanover, N.H., and later that year Harris was installed at Dartmouth College as unofficial artist-in-residence. There was no CGP exhibition that November, nor the following year, but in January 1936 Jackson and the other Toronto people were able to arrange the second local showing of the Group. Harris exhibited Arctic canvases, but at the third show in November 1937 he confirmed news that had already reached the city of a radical turn in his painting: he exhibited four abstract compositions.

Living in partial isolation in Hanover, although periodically visiting New York, Harris had begun to paint abstract pictures some time during 1935. Because he neither dated nor titled them at the time, it is difficult to determine a course of development. A rough outline can be drawn, however. *Winter Comes from the Arctic to the Temperate Zone* (LSH Holdings Ltd) is one of the first canvases begun at Hanover. Its symbolic superimposition of a snow-covered tree over an iceberg over a mountain arranged in a symmetrical, hieratic form—clearly demonstrates how the first ideas for abstraction had developed in the Arctic and later mountain canvases. But Harris soon moved away from associative images. *Poise* (private collection), completed by October 1936, employs only clear geometric forms set in an ambiguous, non-representational space. Its elegant severity and precise colour denote an impressive accuracy of expression.

Visiting Santa Fe, N.M., in March 1938, Harris became involved with a newly formed group called the Transcendental Painting Movement, and he and Bess moved there in October. Made up of artists from the Taos and Santa Fe regions-most notably Raymond Jonson and Emil Bisttram-the movement sought 'to carry painting beyond the appearance of the physical world, through new concepts of space, colour, light and design, to imaginative realms that are idealistic and spiritual.' A number of the members were adherents of Theosophy. Harris became president of the foundation established to promote the movement's aims. His painting seems not to have suddenly changed. There was no Transcendental 'style', although most of the members had been greatly influenced by the writings of Kandinsky. Harris's pictures painted in Santa Fe-Involvement 2 (NGC) is one-are more complex than those completed in Hanover. Interlocking arcs, folding in together in a complex, almost organic way, reveal the influence of the teachings of Jay Hambidge. Bisttram was a Hambidge disciple and gave classes on dynamic symmetry in Taos.

Harris, who exhibited in the American section at the New York World's Fair in 1939, although also with the CGP, rather suddenly returned to Canada in 1940 and settled in Vancouver. As is evident from the first painting completed in that city, $\dagger Composition$ No. I (VAG), he had by then achieved a level of assured accomplishment in his abstractions that perhaps surpassed even that of his representational works of the Group of Seven years. These canvases of Harris's, along with the paintings brought from Paris early that same year by Alfred Pellan, represent the first solid beginnings of abstract art in Canada.

John Lyman and the Contemporary Arts Society 1939–1948

The most eloquent critic of the Group of Seven's rugged out-of-doors nationalism was the Montreal painter JOHN LYMAN (1886–1967). Home in the fall of 1931 after almost twenty-four years of self-imposed exile, he experienced the same strong feelings for his country that stirred almost everyone in the decade after the war.* He was nonetheless disturbed by the great clamour surrounding the activities of the Group of Seven. The Group's emphasis on the adventurous exploration of the Canadian landscape—which was almost alone responsible for attracting public approbation-seemed to him to have nothing to do with the art of painting, and he knew that the national aspirations of the Group, whose members were being touted as the only truly 'Canadian' artists, precluded the acceptance of other painters who were as accomplished. 'The real adventure takes place in the sensibility and imagination of the individual,' he wrote early in 1932. 'The real trail must be blazed towards a perception of the universal relations that are present in every parcel of creation, not towards the Arctic circle.' Easily the most underrated figure in Canadian art history, Lyman addressed himself to the identification of the quintessence of Canadian culture as vigorously as did the Group of Seven. He once remarked that 'if an association of the spirit of the two races that dominate in Canada can offer any indication of what a Canadian art might theoretically become, Morrice is automatically indicated as its father.' He looked upon Morrice as his cultural father and dedicated the last thirty-five years of his life to seeking that special 'association' that he believed would lead to the achievement of a living Canadian art of unprecendented accomplishment.

*In 1927 he had written in his diary after a brief visit: 'even before the flattest Quebec landscape I feel that I have more to say than before the magnificent sites of Europe.'

Lyman's parents were Americans of old New England stock who had settled in Victoria, B.C., and become Canadian citizens. In the summer of 1886 they moved to Montreal, but their new house was not ready and Mrs Lyman withdrew to her parents' home in Biddeford, Maine, where John was born that September. Raised in Montreal, he was sent at fifteen to a Connecticut prep school (his mother died just before his second birthday) and later spent two years at McGill. At the age of twenty, perhaps encouraged by his uncle James Morgan, a well-known Montreal collector of Barbizon and Hague School pictures, Lyman decided to study art, and the spring of 1907 found him in Paris. He worked briefly under Marcel-Béronneau, once a pupil of Gustave Moreau, then spent the summer sketching in Brittany. His father had persuaded him to study architectural design at the Royal College of Art, South Kensington, so he enrolled there in the fall. But by the end of January 1908 he was in the French capital again, and was soon working under Laurens at Julian's.

At the Salon that year he was drawn to a small canvas that glowed with a soft, suffusing light. To his amazement its title was *Hiver à Québec* (now known as *Ice Bridge over the St Charles River*, MMFA), the work of a Canadian, James Wilson Morrice. Lyman called on him and they soon became friends, Morrice encouraging the student and instilling in him a love for French culture that he never lost. In the summer of 1909 Lyman sketched at Etaples and there met an agreeable young Englishman named Matthew Smith. Back in Paris in the fall, they decided in the winter to enrol in the school that had recently been opened by the great Fauve painter Henri Matisse.

A severe case of measles forced Lyman's withdrawal from the Académie Matisse in May, but the work of the master always remained his chief inspiration. In the early summer of 1910 he and Smith painted in Pont Aven, and after visiting the Englishman's home in Manchester, Lyman returned to Montreal. Later in the summer he met and wooed a young French-Canadian woman. He was back in Europe the next April with his bride and the two travelled until the winter, which was again spent in Montreal, as was most of the following year, although they went back to France again in the winter. Some time in May 1913 the Lymans returned home once again. He had been painting now for five years and felt it was time to assert himself in his home town. Four works had been hung in the AAM Spring Show in March and were roundly attacked in the press.

Lyman was probably surprised. He had been exhibiting in Montreal since 1910 with little critical reaction. The Armory Show had opened in New York only six weeks before, however, and Randolph Hewton and 204 | John Lyman and the Contemporary Arts Society

John Lyman. *Profile of Corinne*, 1913. Board, 35.0 × 26.7. Maurice Corbeil, Montreal.

A.Y. Jackson had been criticized for their French efforts exhibited at the AAM in February. In the Spring Show there was enough experimental work to suggest a trend, and the conservative critics panicked. One remarked that Lyman's A Brunette reminded him 'of the crude attempt of an amateur to depict a beauty in a signboard advertisement for cigars'. But it was Morgan-Powell of the Star who recognized the real source of the threat. 'Post Impressionism is a fad,' he announced. 'London is laughing today at the latest freak of Matisse, the Post-Impressionist leader in Paris. ... If Montreal joins hands with London and laughs, the craze will soon pass.' Lyman nonetheless proceeded with a one-man show that opened on May 21 in those same AAM galleries that had been occupied by Jackson and Hewton three months earlier. It was an intelligent, assertive exhibition, with forty-two oils divided into five groups by year of production. Montrealers probably found the titles pretentious, but Adventure in Ochre, Floral Caprice, No. 2, Nude Girl, Scherzo, or Wild Nature Impromptu, 1st State were so identified to clarify the artist's principal concern. Matisse taught that painting was an art of sensation, of

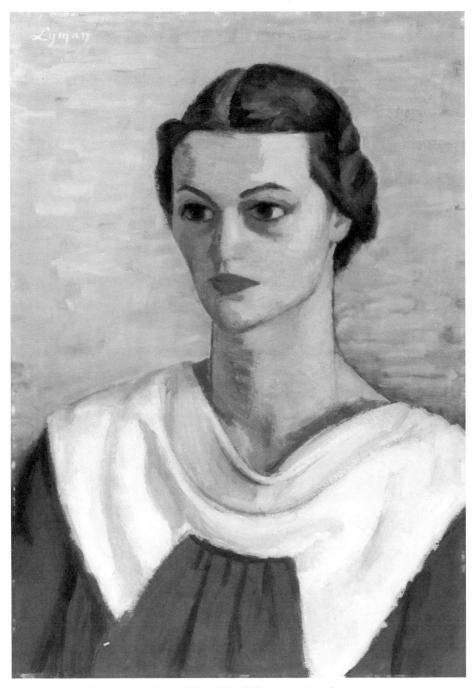

XXVIII—John Lyman. Woman With a White Collar, c.1936. Board, 61.3 \times 44.1. NGC.

xxix—Paul-Émile Borduas. Composition, 1942. Gouache, 43.2 \times 59.7. Maurice Corbeil, Montreal.

feeling response to the stimulus of colour and form, and that such sensation could be ordered to produce a rich, profound effect not unlike that of music. One strengthened the sensation by suppressing everything extraneous to it. Forms were to be simplified, made more massive, more significant; colour was to be chosen for aesthetic, not imitative reasons; and the composition was to achieve an intelligently economical fusion of these elements. The simple, unpretentious force of **Profile of Corinne* (Maurice Corbeil, Montreal), with the bold black choker effectively relating the rising shoulder to the beautifully modelled head of hair, demonstrates that Lyman learned his lesson well.

The critics did not learn theirs. Morgan-Powell again led the pack with a letter-to-the-editor in the *Star* entitled 'Extraordinary Display of Crudities and Offensive Things at the Art Gallery', in which he made it clear that he would resist any repetition of the exercise. Lyman's wife, Corinne St Pierre, nonetheless had, if not the last at least the most effective word. Her 'Avant-propos' (doubtless the first French text to appear in an AAM catalogue) ended with an almost Baudelairian impact. 'Ceux qui ne veulent trouver dans l'art qu'un narcotique pour leur procurer une douce et vague somnolence, ou qu'une friandise pour délecter leur vacuité d'esprit, ne doivent pas s'arrêter ici: ils n'y trouveront qu'un breuvage âcre des sucs corrosifs de la vie.'*

The Lymans left for France again before the end of the exhibition and, with infrequent visits to Montreal, lived abroad—chiefly in France, Spain, and North Africa, but also in Bermuda and even Los Angeles during the winter of 1918–19—for the next eighteen years. In 1922 Lyman bought a villa in Cagnes-sur-mer in the south of France and re-established contact with Matisse. He also kept in touch with Matthew Smith, who had attracted some fame in introducing Fauvism to England and later would be knighted for his contribution to British art. And he continued to see Morrice and to collect his paintings. Lyman now had much in common with the older man. Both freely indulged their love for Paris, knowing their painting was unappreciated in Montreal; both travelled constantly to sunny climates; both greatly admired the painting of Matisse; and both had independent means that allowed them to follow their inclinations.

It was probably the Depression, with the consequent loss of his income, that caused Lyman to return to Montreal in 1931. Like Morrice, he had kept up some contact with Canada (although there was a gap of eight

^{*&#}x27;Those who wish to find in art only a narcotic to induce a mild and vague drowsiness, or a confection to delight their vacuous minds, should not stop here: they will find only a draught pungent with the corrosive juices of life.'

206 | John Lyman and the Contemporary Arts Society

John Lyman. *Reading*, 1925. Canvas, 63.5 × 45.7. Anatoly Ciacka, Vancouver.

years after 1920 when he didn't even exhibit at the Spring Show), and in October 1927 he had held his second one-man show, at the Johnston Art Galleries on St Catherine Street. It had been more politely received than that of fourteen years earlier. The critics had become more familiar with experimental art in the interim, and the wonderfully calm, classical pictures Lyman was painting by the mid-twenties appealed to them more than the discordant Fauve works of before the war. **Reading* (Anatoly Ciacka, Vancouver) of 1925 is typical of his work of the twenties. There is little distortion of colour or form, a smoother application of paint, and a greater emphasis on plastic qualities, on the full modelling of forms in space.

Lyman's third exhibition was held just before his return to Montreal, in February 1931. Made up chiefly of pictures painted at Saint-Jean-de-Luz in the south of France and in Almeria, a remote Andalusian town, it was his first show with Morrice's old dealer, W. Scott & Sons, and much to Lyman's surprise he sold a number of works. Finally settling in the city in the fall, he doubtless felt mixed reactions. There had been many changes since 1913, but much remained essentially the same. Thanks to the interest of William Brymner and Maurice Cullen, and of two prominent local collectors, Impressionism had been introduced to the Montreal public in the mid-nineties. It had not, however, made much impact, and when the first exhibition devoted entirely to the French masters of the school was held at the AAM in February 1906—borrowed from the New York gallery Durand-Ruel—it was greeted with derision by the local press.

Some Brymner students essayed the style before the war-Gagnon and Jackson have been mentioned, and Helen McNicoll (1879-1915), Mabel May (1884–1971), and Emily Coonan (1885–1971) must also be cited—but, certainly, no local movement developed. As we have seen, prominent artists such as Suzor-Coté and some others associated with the Canadian Art Club introduced aspects of Impressionism into their work at about the same time, but this did not lead to significant further developments either. By 1913, when a local version of Post-Impressionism threatened to rear its head, the reaction was strong enough to drive both lackson and Lyman away from Montreal. The situation was no better in Toronto. and Emily Carr found little support for her Post-Impressionist Indian studies in Vancouver. Henry Rosenberg (1858-1947), the American-born principal of the Victoria School of Art and Design in Halifax from 1898 to 1910, found no more fertile ground there for his Impressionist and Whistler-influenced work until he began to modify it for conservative local taste.

In the decade following the war the Montreal scene was dominated by the increasingly conservative work of Suzor-Coté and Clarence Gagnon, although Ozias Leduc's Symbolist portraits and landscapes of the war years had a decided impact on a number of younger francophone painters. RODOLPHE DUGUAY (1891–1973), in particular, exploring the spiritual aspect of the land and traditional life of Quebec in his paintings, prints, and book illustrations, was able to survive despite the loss during the Depression of the church commissions that would in earlier times have supported him. ADRIEN HÉBERT (1890–1967), son of the distinguished Montreal sculptor Louis-Philippe Hébert, studied both under Brymner and in Paris, and the stolid, classicizing modernism he presented in Montreal through exhibitions and in his teaching was entirely consistent with the taste exemplified by the work of Edwin Holgate and of other leading lights in the anglophone community.

The one really innovative talent to develop in Montreal during the years of Lyman's absence was MARC-AURÈLE FORTIN (1888–1970). Born at Sainte-Rose, a northern suburb of Montreal, Fortin studied first at the Monument National (1903–6), and then with Ludger Larose (1906–8), followed by three years of working first in the Montreal post-office and

208 | John Lyman and the Contemporary Arts Society

then with a bank in far-off Edmonton, Alberta. He then spent three years travelling in the United States, ending up studying at the Art Institute of Chicago. Back in Montreal in 1914, he attracted little attention with his work until—after a short visit to France and England in 1920—he began to show large, intensely decorative watercolours and oils of the bustling activity in the port of Montreal, and phenomenal, equally decorative but serene country views dominated by the massive elm trees of his native Sainte-Rose. Almost primitive in their individualistic vitality, such major works as his *Landscape at Ahuntsic* (NGC), of *c.*1924, were certainly among the most inventive, commanding paintings to be seen in Montreal at the time. Following another trip to France and a visit to Italy in 1934, his work became more consciously colouristic and even more vividly decorative, with a sense of urgent execution that underlines its intensity.

Determined to make a place for himself in this complex, yet essentially fragmented, artistic community, John Lyman wasted no time in making friends and in devising a means to make a living. With André Biéler and two others in November 1931 he established a school, called the Atelier, in connection with the McGill University Department of Extra-Mural Relations. About a year later they moved into a building with the Montreal Repertory Company. Modelled on a Parisian academy, the school offered models, space, and the criticism of a master. Lyman ran the study classes. The Atelier intended to foster painting in the new vein, however. A brochure outlining their specific goals stated that '... the essential qualities of a work of art lie in the relationships of form to form, and colour to colour. From these the eye, and especially the trained eye, derives its pleasure and all artistic emotion.' The Atelier group attempted to foster its views through exhibitions as well as by its teaching. In the first of these exhibitions, at the Henry Morgan Galleries in April 1932, Lyman was joined by André Biéler, Marc-Aurèle Fortin, Edwin Holgate, and two others. The Atelier proved uneconomical, however, and was closed after only little more than a year. The second and final exhibition was held in May 1933, again at Morgan's. This time a young painter from Ottawa was included: GOODRIDGE ROBERTS (1904-74).

Roberts had been born in Barbados while his parents were on holiday. His father was Theodore Goodridge Roberts, the poet and novelist; his uncle and cousin were also well-known writers, Sir Charles G.D. Roberts and Bliss Carman. Goodridge lived mainly in Fredericton, N.B., as a child, but also in England, France, and for about two years after the war in Ottawa. Although surrounded by writers, by the age of twelve he had decided to be a painter, and after graduation from high school in 1923 he entered the new École des Beaux-Arts in Montreal. He studied there for two years and saw the Morrice memorial retrospective held at the AAM in January 1925. 'The pictures made a vivid impression on me,' he later remembered. 'It was my first visit to a good exhibition.'

The vear after next he went to New York, and in May he enrolled in the Art Students League where he studied under one of Morrice's old friends, John Sloan (who had earlier described Morrice in his diary as 'one of the greatest landscape painters of the time'), and with Boardman Robinson (1876–1952), who was born in Somerset, N.S., and the American cubist pioneer Max Weber. Weber encouraged Roberts to examine the French modernists, and it was in New York that he first saw the work of Cézanne, Picasso, and Matisse. After leaving the League in June 1930 he spent a brief period in Fredericton, and then in the fall moved to Ottawa, where he worked first as a Fuller Brush salesman and then as a teacher for the local art association. In the summer of 1931 he and two friends opened an art school in a farmhouse near Wakefield, Que., on the Gatineau River, and the following year he found even cheaper accommodation in a tent on a piece of Gatineau property near Kingsmere that was owned by H.O. McCurry, assistant director of the National Gallery. In November Roberts held his first one-man exhibition at the Arts Club, Montreal; it was organized by Ernst Neumann (1907-55), an old friend from the École des Beaux-Arts days. His tentative, Cézanne-influenced landscape watercolours there caught the eye of the art patron and president of Morgan's department store, Cleveland Morgan, who drew them to the attention of his cousin, John Lyman. Both agreed that Roberts should be encouraged, so Lyman wrote him, and the following year he was included in the second exhibition of the Atelier at Morgan's.

Lyman's encouragement did not help Roberts' financial situation, however, and the summer of 1933 was spent once again in a tent—this time on the Montreal Road just outside Ottawa. An offer to become the first resident artist at Queen's University in Kingston was eagerly accepted in September, and although the teaching was burdensome and his painting production fell off, he found the steady salary reason enough to stay for three years. In September 1936 he finally moved to Montreal, where he shared a studio with Neumann, and with whom he opened a school later in the fall. He was then thirty-two and responded enthusiastically to the growing Montreal scene. With his first commercial one-man show in Montreal at Scott's in January 1938 he was recognized as a strong, individual talent. The inspiration not only of Lyman but of Matisse was in his work, particularly in a series of nudes (1938–9). *Nude on a Red *Cloth* (private collection, Montreal) of 1939 draws on Matisse for its theme (an informal pose in what appears to be the painter's quarters) and its 210 | John Lyman and the Contemporary Arts Society

Goodridge Roberts. *Nude on a Red Cloth*, 1939. Board, 68.6×81.3 . Private collection, Montreal.

shallow space, but the great concern for full modelling seems more like the recent Lyman. Intense and unified in composition, it is painted within a tight range of harmonious colours and evokes admirably Roberts' unique sensibility—what Donald Buchanan has called his 'silent, solitary stubbornness'.

Roberts still had to struggle for a living, and in the fall of 1939 he joined with Will Ogilvie (who had arrived from Toronto the year before) to teach at the AAM school. Summers were free and were usually spent as a guest of the Lymans at St Jovite in the Laurentians north-west of Montreal. *Nude on a Red Cloth* was painted there, but Roberts was also drawn to the landscape. By 1940—the date of *Hills and River, Laurentians* (AGO)—he had developed a landscape style that, like his figure painting, had a family resemblance to the work of the Montreal painters who were gathering about Lyman but that nonetheless displayed a unique sensibility. These landscapes were featured in a one-man show at the AAM in April 1942 (he was still teaching there) and were largely responsible for the success

of the retrospective exhibition the critic Maurice Gagnon organized for him at the new Dominion Gallery in the spring of 1943. (Emily Carr's equally successful show would be held there the next year.) Forty-two paintings were sold and Roberts was given a salary contract against future sales that finally allowed him to quit teaching. During the early forties the chaste delicacy of his painting, as seen most notably in figure pictures like *Nude* (NGC) of 1943, inspired the respect and emulation of a number of young Montrealers, principally Jacques de Tonnancour (b.1917).

The enthusiasm with which Montreal received Roberts in the late thirties was in large part stimulated by John Lyman. The failure of the Atelier must have represented a certain setback, but three years later, in March 1936, Lyman began an art column in *The Montrealer* that over the next four years would even more effectively promote the values of pure painting as typified by the School of Paris. Lucid, intelligent, entertaining, his columns established a level of art criticism previously unknown in Canada. The great Morrice retrospective at the AAM in February 1938 (to which Lyman lent two works), and the remarkable group of exhibitions of modern French painting at W. Scott & Sons during this same period, gave Lyman ample opportunity to demonstrate the excellence against which he measured the accomplishments of the younger Montreal painters who were more and more frequently finding opportunities to exhibit.

Lyman himself was experiencing a surge of creative painting that was reflected in three one-man exhibitions: in New York at Valentine's in May 1936, at Scott's in February 1937, and at the McGill Faculty Club in April 1939. In his middle age (he turned fifty in 1936), a small devoted following had developed and his work was generally admired by those who bothered to bring a seriousness of observation to their viewing. His portrait of Mrs Leonard Marsh of about 1936, exhibited as †*Woman With a White Collar* (NGC) in the Scott's show, for instance, was praised by one young critic (Graham McInnes) for its 'austerity, its restraint which barely conceals—rather underlines—the most passionate sincerity of its conception and execution.'

Convinced that talent was developing in Montreal, Lyman was equally sure that the Toronto-based Canadian Group of Painters had failed to strike out in a vital direction that would stimulate these young artists. 'The talk of the Canadian scene has gone sour,'* he wrote in February 1938, just after the Canadian Group exhibition at the AAM. 'The real Canadian scene is in the consciousness of Canadian painters, whatever

*The CGP was never effectively to answer such complaints by Lyman. A.Y. Jackson, its acknowledged spokesman, never came up with anything stronger than that 'the chief difference between the two groups [the CGP and the Montreal painters] is that we have

212 | John Lyman and the Contemporary Arts Society

the object of their thought.' A few months later he brought together a number of painters who shared his view. There was, of course, Goodridge Roberts; and also Jack Humphrey of Saint John, N.B.; and Jori Smith, Eric Goldberg, and Aleksandre Bercovitch, all of Montreal-none of them members of the CGP. They first exhibited in December 1938 as the Eastern Group, and their common point of view was immediately recognized: a marked affiliation with the School of Paris. Yet each painter was found to be 'extremely individualistic'. 'They are not busy about being of their own time or following any line—self-conscious regionalism, formalized pattern or social comment,' one critic wrote. 'They are not racing after the band-wagon of the Canadian scene. That was once good ballyhoo to get people away from foreign stereotypes, but today it is just sentimental rhetoric.' The Eastern Group was devoted to beautiful painting for its own sake. A second exhibition was held in January 1940, but by then Lyman had devised a more effective forum—the Contemporary Arts Society-and although three more Eastern Group shows were held (May 1942, April 1945, and January 1950), by January 1940 the CAS had clearly become the hub of modern painting in Montreal.

The CAS was Lyman's most inspired creation. Suggested by the British organization of the same name, it quickly evolved into a unique body, responsive to the particular needs and trends of the most advanced painters in Montreal. Born from a meeting organized by Lyman in January 1939, its purpose was simply to promote living modern art. (The only condition for artist membership was that one not be a member of the RCA.) Its first public effort was an exhibition that May of contemporary foreign art from Montreal collections entitled 'Art of Our Day', which was described as 'the first adequate presentation in Canada of modern work by leading foreign artists'. (News of the Société Anonyme showing in Toronto eleven years earlier apparently failed to reach Montreal.) The only artist included who could be considered essential to an understanding of modern art was Kandinsky (three works of 1909–13). The general level could best be described as contemporary School of Paris-without Picasso or Matisse. Derain, Dufy, Laurencin, Modigliani, Pascin, Utrillo, and Zadkine were the high points. This first exhibition, in fact, estab-

roots in the soil and they have not; they think being Canadian is parochial.' He repeated such sentiments frequently in private—this particular time in a 1942 letter to McCurry. The NGC, also unable to forget its intimate involvement with the Group of Seven, never fully supported Lyman and his friends and almost came into direct conflict with him in 1942 over an exhibition of contemporary Canadian art chosen by an American for showing in Andover, Mass., and a subsequent tour. It stressed the vital new Montreal scene and deliberately played down Group landscape ideals.

lished one of the inherent weaknesses of the CAS: the belief that an external ultimate standard of excellence existed. The Society's other major weakness was brought to its attention in a review of its March 1941 show by Marcel Parizeau: there were too few French Canadians involved.

At the first members' exhibition in December 1939, however, such issues were not raised at all. Consisting of the twenty-one key professional members, it was rigorously selected to demonstrate the degree of local accomplishments. Various segments of Montreal's artistic community were included. Prudence Heward, Ethel Seath, and Mabel Lockerby were the only CGP members. There were two painters with developed interests in abstraction. MARIAN SCOTT (b.1906) was born and raised in Montreal, studied at the AAM school and, shortly after it opened in 1922, at the École des Beaux-Arts. She then completed her formal training with Henry Tonks at the Slade in London. Her great work of the CAS period is the mural called *Endocrinology*, completed in 1940 for the McGill University medical building. Themes suggested by that commission led to a series of fine abstract paintings-Atom, Bone and Embryo (AGO) of 1943 is probably the best-playing on a complex interrelationship of different life forms. Scott's work is much more coherent in theme and consistent in quality than that of her friend Fritz Brandtner. Arriving in Montreal from Winnipeg in 1934 (see p. 167), Brandtner was soon established as a commercial designer and experimental painter. An ardent socialist, he held his first Montreal one-man exhibition at Morgan's in February 1936 to benefit the Canadian League Against War and Fascism. Unlike many of the early members of the CAS, Brandtner saw his art as a vehicle for the expression of his various human concerns. This led to his co-operating with Dr Norman Bethune (the Canadian surgeon soon to achieve heroic distinction in Spain and China) in the establishment in 1936 of a Children's Art Centre for the underprivileged. When Bethune left Montreal that October, the burden of the centre rested on Brandtner, but with the help of Marian Scott he made it a great success and maintained its program until 1950.

The first CAS show included as well the work of three Jewish artists. ALEKSANDRE BERCOVITCH (1893–1951)—who was born near Odessa, trained in Russia, and later worked there and in Palestine—immigrated to Montreal in 1926. ERIC GOLDBERG (1890–1969) was born in Berlin, studied at the École des Beaux-Arts and Julian's in Paris (1906–10), and then taught in Berlin and Palestine and painted in the south of France, Italy, and Spain before immigrating to Chicago in 1921. He moved to Montreal in 1928. Bercovitch's work now seems quite ordinary. Goldberg's, though often over-pretty, is distinctively personal in style. *Figures* (NGC) of about

214 | John Lyman and the Contemporary Arts Society

1941 shows his delicate colours, soft lights, and wistful forms partially picked out with scratch-like lines. Bercovitch and Goldberg had participated in the first Eastern Group show, but LOUIS MUHLSTOCK (b.1904) was first associated with Lyman only in the 1939 CAS exhibition. Born in Narajow, Poland, he was brought to Montreal as a young boy of seven. He first studied art in Montreal, at the Conseil des Arts et Métiers, then at the AAM school, and finally at the École des Beaux-Arts. In Paris (1929– 31) he worked under Louis Biloul. An intensely personal artist, he was best known during the CAS years for quiet, sombre scenes of forest glades—*Sous Bois* (MMFA) of about 1941 is a good example—that evoke a sense of primeval nature, even though they were usually painted in the park on Mount Royal. His most personal work during the forties, and since, has been executed in charcoal and coloured chalk. Mainly portraits and monumental female nude studies, they have attracted a devoted following over the years.

The main identifiable 'group' within the CAS during the first years, though, was that composed of painters like Goodridge Roberts, who demonstrated particularly close ties to the School of Paris style favoured by Lyman. (It should be pointed out that, as a result of the rigorous selection procedure, the 'Parisian' qualities of painters like Heward, Muhlstock, or Goldberg were stressed, especially in the first show.) JORI SMITH (b.1907) was born in Montreal, studied under Hewton at the AAM school, then, like Muhlstock, at the Conseil des Arts et Métiers, before going abroad to complete her training in England and France. Her brusque, forceful portrait studies reveal the simplifications of a 'modernist', but as in La Petite Communiante (Maurice Corbeil, Montreal) of about 1940 their raw emotional directness suggests the work of an untrained naïve. PHILIP SURREY (b.1910) has also had his work of the CAS years likened to that of a naïve. Born near Calgary, he was raised by his foot-loose parents on a long and erratic round-the-world tour. At the age of ten he returned to Canada with his mother (she had separated from his father) and they settled in northern Manitoba. Philip was sent to high school in Winnipeg and three years later took an apprenticeship at Brigden's. He also studied nights at the Winnipeg School of Art under LeMoine FitzGerald (1926-7). In October 1929 he moved to Vancouver where he lived and worked for seven years. During this time he took lessons from Fred Varley and began to exhibit his drawings and paintings. In October 1936 Surrey left Vancouver for three months at the Art Students League in New York before settling in Montreal early in 1937. He met Lyman that first year, and when Jack Humphrey decided after the first Eastern Group exhibition that he could not afford to ship his works west so often, Surrey

Philip Surrey, The Crocodile, 1940. Canvas, 86.4 × 69.1. AGO.

replaced him in the second show. (He had already become an exhibiting member of the CAS.) Surrey's earlier Montreal paintings certainly have the charming naïvety of the primitive at first look, but closer examination of a typical canvas of the period—**The Crocodile* (AGO) of 1940 is one of the better known—reveals a well-constructed, elaborate structure. Surrey has since continued in this vein, carefully producing deeply moving images that reflect the unique urban flavour of his adopted city.

STANLEY COSGROVE (b.1911) was born in Montreal and studied at the École des Beaux-Arts (1929–33) and later (1936) under Edwin Holgate at the AAM school. By 1939 and the first CAS exhibition he had absorbed many characteristics of recent Parisian painting without leaving the city of his birth. *Madeleine* (Jules Bazin, Montreal), painted that year, shows that Cosgrove was far from being a derivative painter, however. It is gravely serious, and in the simple shallow curves of cheek, jaw, collar, and hair, it swings with the subtle rhythm of life. That same year his abilities were recognized when he was awarded a Province of Quebec

216 | John Lyman and the Contemporary Arts Society

prize, enabling him to study in France. War made such a trip impossible, so he chose New York, but early in 1940 he moved to Mexico City. There he approached the great Mexican muralist Orozco, with whom he then spent four years studying fresco technique. On returning to Montreal in October 1943, he must have felt out of touch. He exhibited with the CAS only once again (February 1946 at the AAM), although he was still on the membership roles in January 1948.

LOUISE GADBOIS (1896–1985) was also born in Montreal and also studied under Holgate at the AAM school (1932–6), but as a mature student; she was by then the mother of six. Her most accomplished works of the CAS years are her portraits. *Le Père Marie-Alain Couturier* (MQ) of 1941—subtly complex in modelling and rich in character—is among the best of the work produced by the Lyman-influenced members of the CAS. In the simple directness of its pose, however, and in the blurring of the boundaries of its forms, suggesting a soft, suffusing atmosphere, it probably borrows as well from the earlier work of another charter member of the CAS, PAUL-ÉMILE BORDUAS (1905–60).

Borduas worked as a church decorator until he was almost thirty. Born in Ozias Leduc's home town of Saint-Hilaire, east of Montreal, he apprenticed with the master at the age of sixteen and first worked on Leduc's most successful commission: the decoration of the Bishop's Chapel in Sherbrooke, east of Saint-Hilaire. With a characteristic display of intense energy Borduas occupied his evenings in further art studies at the Sherbrooke École des Arts et Métiers. In 1923 he enrolled in the new École des Beaux-Arts in Montreal (both day and evening courses) and after the first year continued as well to assist Leduc with large commissions: in Halifax in 1924 (chapel of the Sacred Heart Convent), in Saint-Hilaire in 1926 (chapel of the Couvent des Saints Noms de Jésus et de Marie), and in Montreal in 1927 (the baptistery of Notre-Dame). Upon graduation from the École in 1927 he was hired by the Montreal Catholic School Board to teach art in the high schools, and after a year of teaching was able to afford a short sightseeing trip to New York and Boston. Teaching again in September, he quit after only two weeks when his duties, and salary, were summarily cut in half. Leduc and the sympathetic curé of Notre-Dame, Olivier Maurault, saw this as an opportunity for Borduas to complete his education-he was almost twenty-threeand sent him to the Ateliers d'Art Sacré run by Maurice Denis and Georges Desvallières in Paris. Denis, the Nabis painter who had founded the Ateliers in 1919 to promote vital contemporary church decoration through the practice of his theories on the Symbolist use of colour and form, had for some years been an inspiration to Leduc. The French artist had also praised one of Leduc's church paintings to Maurault on a visit to Montreal only the year before.

Borduas arrived in France on November II and studied at the Ateliers from January until April. (Denis left on a trip to Egypt and the Holy Land in March.) Having found work in a stained-glass-window shop while still in school, he remained in Paris until at least June, when he moved to Rambucourt in the Meuse to work on some churches with a French friend, Pierre Dubois. There he helped an artist-priest from the Ateliers d'Art Sacré, Marie-Alain Couturier, who was installing windows in a nearby church. In August Borduas travelled in Brittany, but by September he was again working in Rambucourt, and the day before Christmas he was back in Paris. His money ran out in June; a ticket sent by Leduc got him home to Saint-Hilaire. By the end of September he was working again with Leduc, in the Église des Saints-Anges in Lachine.

Borduas continued to work with Leduc into 1931, picking up other small decorative or mural commissions whenever he could. Then in September he once again took a part-time teaching job, at the Collège Saint-Sulpice. The following year he received a commission for a stations of the cross for a new church at Rougemont, near Saint-Hilaire, and in July he opened a studio and advertised for more commissions. After a number of proposals were rejected by various parishes as being too 'modern', he finally in September 1933 returned to teaching for the Montreal Catholic School Board. The next summer he spent at Knowlton in the Eastern Townships, where he produced some landscape sketches, and over the next two years he completed a few small religious pictures, portraits, and lyrical, almost sentimental studies of young people. All are clearly influenced by the religious work of Denis that he had seen in Paris, but the few that have survived—particularly a tiny, stunning Autoportrait (NGC)-are subtle, hauntingly intimate colour-poems. A larger portrait, *Maurice Gagnon (NGC), was painted in 1937. At first glance it appears tentative in conception and execution, but there is assurance in the way the subtle modulation in the tones of the background and the suit reacts with those of the flesh to set up a richly harmonious, delicately coloured atmosphere. This effect is accentuated by the gently blurred edges of the forms which, with the puffing of the vest and the comfortable breadth of the lapels, have a convincing plasticity.

In September 1937 Borduas took yet another teaching job, at the École du Meuble, retaining his posts at the Collège Saint-Sulpice and with the Catholic School Board. It was an important step. His colleagues at the École—principally Maurice Gagnon, librarian and professor of art history, and Marcel Parizeau, professor of architecture—encouraged his involve218 | John Lyman and the Contemporary Arts Society

Paul-Émile Borduas. *Maurice Gagnon*, 1937. Canvas, 49.9 × 44.8. NGC.

ment in the larger art world of Montreal (he had been working as a decorator-muralist or teacher for seventeen years) and in 1938 he exhibited his first work in an AAM spring show. One of his small lyric figure pieces, *Adolescente* (Mme Jean-Marie Gauvreau, Montreal), caught the eye of John Lyman. 'It showed the influence of Maurice Denis,' he later remembered. 'It was not very strong . . . but the fact that it was expressed in true painter's language made it stand out.' Jean Palardy, Jori Smith's husband, introduced Lyman to the painter, and the next January when the CAS was formed Borduas was elected vice-president.

The choice of Borduas as vice-president of the CAS doubtless reflected Lyman's concern to encourage the assertion of a French-Canadian cultural entity. How poorly represented it was even then is difficult now to believe. Of the twenty-six artist members in May 1939, only five were French-speaking. Of the twenty-one exhibitors in the December show, Lyman and Jori Smith were married to French Canadians; Cosgrove's mother was French Canadian; but only Louise Gadbois and Borduas really represented the stirring French cultural community. Having suffered commercial domination by English-speaking Montrealers since far back in the nineteenth century, and subject as well to the control of the institutional Roman Catholic Church—which had convinced Québécois that their cultural survival in an English-speaking continent lay in unquestioning obedience to the faith—French Canadians had been virtually isolated in their own country. This isolation from the larger world was very pronounced in cultural areas, where the conservative and inevitably restrictive influence of the Church was pervasive. But a significant change took place in Quebec society in the 1940s. By January 1948, some twenty-five of the forty-six artist-members of the CAS were French, and of the seventy-one lay members listed, as many as forty-eight were of French ancestry! John Lyman's efforts helped prepare the way for the increased involvement of these artists, but the first major stimulus came from France.

Or perhaps one should say from Quebec City via France, although ALFRED PELLAN (b.1906) found many reasons to continue the expatriate tradition that had begun with Morrice. Pellan was a remarkable prodigy. Born in Quebec City, he entered the École des Beaux-Arts there at the age of fourteen, had his first work bought by the NGC at the age of seventeen, and shortly after graduation in 1925 was the first painter to win a Province of Quebec bursary, enabling him to leave for Paris in August 1926, two years before Borduas. In Paris the young Québécois enrolled in the École des Beaux-Arts under the rather traditional portraitist Lucien Simon, but he soon began making the rounds of the academies and before long was deeply involved in the frenetic, stimulating world of the Parisian art student. Such a different experience from that of Borduas! He first had a work accepted for the Salon d'Automne in 1934 (eight years after his arrival), and in 1935 won first prize in a mural exhibition, participated in a number of other group exhibitions, and held his first one-man show, at the Académie Ranson where he had recently been a student. The following year he again participated in a number of group shows, then decided to return home. His father, who had been supporting him since his bursary ran out in 1930, believed his son could find employment in the school from which he had graduated with such distinction some eleven years earlier. Pellan arrived in Quebec City, presented himself at the École, was rejected as too 'modern', and immediately returned to France. In Paris again, he associated himself with a group called the Surindépendants, contributed to numerous group shows, and in 1939 held his second one-man show, this time in the commercial Galerie Jeanne Bucher. He had become a part of the scene, to the extent that the same year he was included in an American exhibition entitled 'Paris Painters of Today'. Then the German invasion forced another return to Canada, early in 1940.

The climate in Quebec City was changing so rapidly that this time he was received as a returning hero, the very embodiment of modern art.

220 | John Lyman and the Contemporary Arts Society

Alfred Pellan. Jeune Comédien, c.1935. Canvas, 100.0 × 81.0. NGC.

'Fauve, cubist, surrealist, Pellan is much more than that,' wrote a local critic, 'he is the synthesis and the moving image of the modern era.' Almost immediately, in June 1940, he was given a large retrospective at the Musée du Québec that was then shown at the AAM in October. Its impact was tremendous. The critic Parizeau described Pellan as the first Canadian to have 'taken on international significance'. A less temperate reviewer in Quebec City went even further. Pellan was a 'European painter ... born in Quebec.' He was 'in the very first rank of those innovators who often determine the orientation of an epoch'. Of course such a description would have seemed absurd in France. Pellan was never, in his years in France, an innovator. Quite to the contrary, he was vigorously eclectic, soaking up elements of style from most of the modern masters.

Nevertheless Pellan has such a happy facility of hand and such an eager, untiring mind that there is much to enjoy in his work. And for Montreal late in 1940 there was also—simply in terms of sheer quantity of new ideas—much to learn from it. Many of his best French pictures— **Jeune Comédien* (NGC) of about 1935 comes to mind—are quite successful amalgams of cubist forms, 'classical' modelling, and ambiguous, surrealist-like space, all held together by bold, cutting brushwork and passionate colour. Pellan's colour, in fact, is uniquely his own, and it may well be that the later abstractions, free of modelling and relying almost completely on his native colour sense, will prove to be his lasting works of the French years. **La Fenêtre ouverte* (HH) of 1936—with its shallow, segmented space, vaguely anthropomorphic calligraphic shapes, brilliant colour, and emphatic spontaneity—is certainly one of the works to be singled out as having indicated the direction of the future in Montreal.

Pellan settled in Montreal early in 1941 in a studio shared with Philip Surrey and began to exhibit with the CAS people, first at the Indépendants exhibition organized by the refugee French priest Marie-Alain Couturier—whom Borduas had met in France in the summer of 1929 and who arrived in Montreal in March 1940—which was shown in Quebec City in April and at Morgan's in Montreal in May 1941. Pellan then took a long summer holiday in the Charlevoix region and returned to Montreal in the fall with a group of forcefully executed portraits of young children and startlingly realistic scenes of the villages he had visited. They would not have been out of place in a CAS exhibition, but they must have

Alfred Pellan. La Fenêtre ouverte, 1936. Canvas, 44.5 × 81.3. HH.

222 | John Lyman and the Contemporary Arts Society

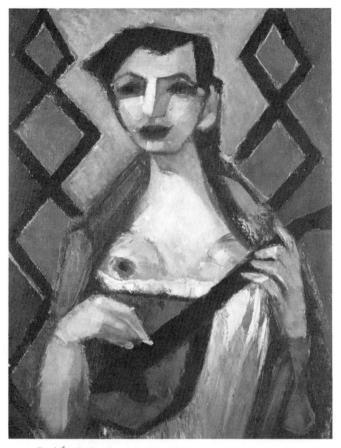

Paul-Émile Borduas. La Femme à la mandoline, 1941. Canvas, 81.3 \times 66.0. MAC.

disappointed other painters who saw in Pellan the impetus for a radically innovative art in Montreal. By 1942 he had returned to a flat image abstracted from real objects—as in *Le Couteau à pain* (private collection) made up in large part of cleverly interlocking ovoid forms. By then, however, Borduas had taken the bold step that would set him on the path of true creative innovation and, in the course of a few years, would allow him to outstrip Pellan and all other Canadian artists.

During 1939–40 Borduas appears not to have painted a great deal; in 1940 Maurice Gagnon could still describe him solely as a religious painter. He spent the summer of 1939 working with Gagnon for Gérard Morisset on the inventory of Quebec art, searching out old material in the Montreal region. And he was eagerly reading, thinking, and talking with friends from the École and the CAS. Then in 1941, as though in response to the Pellan retrospective of October 1940, his production resumed. The most ambitious work of this period is **La Femme à la mandoline* (MAC), a lusciously beautiful painting, free of compromise with sentiment or 'taste'. Borduas employs a geometric pattern in the background, as Pellan did in *Jeune Comédian*, but whereas Pellan then used heavy outlines and a deliberate modelling of the figure to set the pattern back in space, Borduas accomplishes the same end with colour alone. Boldly aggressive yet subtle, even delicate in passages, it is homogeneous in conception and execution. Beside it the Pellan seems a pastiche. About fifteen centimetres shorter and narrower than *Jeune Comédien*, it is easily twice the picture.

Borduas was painting with an awareness of the relation of act to image that few artists ever understand. He had been reading the Surrealists (see p. 198n.) for some years, and his experiences while teaching children, beginning in 1939, had doubtless corroborated the Surrealist view that the source of creation lies in the unconscious, where it has been slowly obscured by the process of 'maturation'. The strength of La Femme à la mandoline lay not in its subject, he knew, but in the naked emotion of its expression. Its beauty resulted from the successful penetration, and then projection, of the artist's self. It was a simple vet monumental step to decide to probe even deeper, and then to flow with the full springs thus released. With a rigorous discipline few could muster, Borduas accomplished such 'automatic' compositions many times over the winter of 1941-2, painting in gouache. (He had decided to experiment with the inexpensive and flexible water-based medium.) Forty-five of the paintings that resulted—which range from clearly identifiable images situated in a dream-like surrealist space, through to great looping, slightly modelled ovoids of colour-were exhibited under the title 'Peintures surréalistes' at the Hermitage Theatre of the Université de Montréal late in April 1942. The occasion was immediately recognized as historic by a number of critics. Charles Doyon was ecstatic. Borduas's exhibition was 'une preuve indubitable de son talent vigoreux, et un autre instant mémorable dans l'histoire de notre peinture'. The young painter, Jacques de Tonnancour, wrote: 'Dans l'histoire de la pensée picturale au Canada, elles constituent un apport de tout premier ordre.' Thirty-seven of the paintings were sold. Borduas's first one-man show represented a resounding confirmation of the path he had chosen to follow. He was thirty-six years old.

The gouaches were not the first abstracts Borduas exhibited. Four months earlier, in January, he had taken part in a group show in Joliette,

224 | John Lyman and the Contemporary Arts Society

sixty-five kilometres north of Montreal, and exhibited three abstract oils that he later destroyed. Harpe brune is well known from photographs. It is surprisingly close in certain respects to Pellan's La Fenêtre ouverte. Borduas used the same angular black line, darting nervously over coloured compartments of space, and even included barred, ladder-like forms that are similar to the kind of patterning one sees in Pellan. Borduas's paint appears heavier and rougher, however, and Harpe brune is more of a vigorous whole, with no consistent distinction between background and drawn forms. Pellan's Fenêtre is more like a sheet of separate drawings; it lacks the tight completeness of the Borduas. Some of Borduas's gouaches are also related to the French abstractions of Pellan in the use of heavy lines to string together forms and warp the shallow space. But the best do not resort to such an obvious solution to the structuring of a homogeneous image. *†Composition* (Maurice Corbeil, Montreal) is one of a number of gouaches in which the full swelling forms intertwine effortlessly in a solemn, endless dance of becoming. There is really no discrete image. There is just the grave, rolling breadth of the painting itself.

In April 1943 Borduas visited New York for the second time (his first visit had been in the summer of 1928) and is certain to have seen as much as he could of the work of the great Surrealist painters, most of whom were by then refugees living in New York or its environs. He would also have seen and purchased the Surrealist magazine *VVV*, which first appeared in New York the summer before. The second issue, with a striking cover by Duchamp, had just appeared in March.

As Borduas's own work and expanding interests led him through new growth, his relationships with his students at the École du Meuble were becoming more meaningful. By 1943 he had attracted a number of disciples and in early May eleven of these, and four other young friends who frequented Borduas's studio, appeared in an exhibition of twentythree painters under thirty organized by Maurice Gagnon for the Dominion Gallery. 'Les Sagittaires', as the exhibition named them, were the first real evidence of a new generation.

In June Pellan was appointed to a professorship at the École des Beaux-Arts (which produced a falling-out with Borduas, to whom the appointment was a seriously compromising decision) and during the fall he too collected a group of adherents.

Pellan may have been responding to Borduas's great gouaches in his *Le Couteau à pain*, with its flat colours and interlocking ovoid shapes, but he soon found a major new direction that led him completely away from Borduas's experiments. Late in May 1943 the great French painter Fer-

John Lyman and the Contemporary Arts Society | 225

nand Léger, a friend of the artist-priest Alain Couturier, travelled to Montreal from New York, where he was then living, to lecture and screen a Surrealist film he had made some years before in Paris. Pellan had met Léger in Paris, and perhaps in New York in 1942 when the Québécois held a one-man show at the Bignon Gallery. Léger was then painting large canvases filled with a solid mass of entwined human figures. They impressed Pellan greatly and he employed the same approach in a large canvas commissioned by the shoe manufacturer Maurice Corbeil in 1945 (*La Magie de la chaussure*). He soon turned this new idea into something uniquely his own, as in *Quatre Femmes* (MAC) of 1945, principally by overlaying the interlocked figures with intense, frenetic design patterns. Such patterning—joyous, and often compelling in the manner of folk decoration—became the distinctive feature of his work over the following years.

After the success of his gouaches, Borduas attempted the same spontaneous approach in oils. Oil is less tractable than gouache, however, and although—as we can see in *La Danseuse jaune et la Bête* (Luc Choquette, Montreal)—these experiments are often very moving, they are also awkward and are not so thoroughly homogeneous as the gouaches. An exhibition at the Dominion Gallery in October 1943 was a commercial failure. He hardly painted at all the next year. His involvement with his students now took up most of his time and he was building himself a house in Saint-Hilaire, which he moved into in 1945.

That year Borduas was re-elected vice-president of the CAS. Some of the Sagittaires had at first been grudgingly accepted into the ranks as non-voting junior members in 1943 (there were ten so listed by 1945—all French-speaking). By 1948 they had been given a voice in the administration of the Society. As most were sympathetic to the direction being pursued by Borduas, they effected his election as president, replacing Lyman. Pellan and *his* young followers, seeing this as a partisan narrowing of the objectives of the CAS, refused to co-operate and soon withdrew. Borduas, as the new president, sought the support of Lyman, who refused to take sides in what he later called a 'sectarian contention'. Borduas then felt that he had no alternative but to resign, and Lyman, with only the older members remaining, recommended to the council of the CAS that it be dissolved. At a meeting on November 18, 1948, dissolution was accomplished. Some were sad, but all realized that the CAS had reached the extent of its flexibility. It could never have hoped to contain the vigorous force that already had given a new shape to Canadian art.

Paul-Émile Borduas and Les Automatistes 1946–1960

'Enfin! La peinture canadienne existe!' exclaimed the critic Claude Gauvreau in the course of reviewing the December 1946 exhibition of the CAS, his excitement aroused by the paintings of seven Montreal artists. Marcel Barbeau, Roger Fauteux, Jean-Paul Riopelle, Pierre Gauvreau, Paul-Émile Borduas, Fernand Leduc, and Jean-Paul Mousseau were then in the midst of accomplishing a pictorial revolution, part of a widespread reaction among painters throughout the western world following the Second World War against figurative painting-even against, as the historian Bernard Teyssèdre has remarked, the great French tradition as rejuvenated by Matisse, Picasso, and Léger. Though in part nurtured by the CAS, the Montreal painters soon found it necessary to turn their backs on Lyman and the others, and even on Pellan-not so much because they felt contempt for 'l'académisme fauviste' or 'l'académisme des nouveaux Beaux-Arts' but because, like that other group of seven painters who professed to 'begin' Canadian art in Toronto a quarter of a century before, Borduas and his followers were moved by a new vision of their society to initiate a Canadian painting that would respond for the first time to the deepest needs of Canadians. The story is mainly Borduas's. Eleven years older than his eldest associate in the Automatiste group and twenty years older than the youngest, he was the teacher of them all.

The six were all born in Montreal and were students there when Borduas first brought them together. PIERRE GAUVREAU (b.1922) was encountered as an exhibitor in a show of student work Borduas judged in the fall of 1941, and he soon introduced the older man to fellow-students at the École des Beaux-Arts, including FERNAND LEDUC (b.1916). That same fall Borduas had been impressed by the work of a fourteen-year-old student of his friend Frère Jérôme at the Collège Notre-Dame, JEAN-PAUL MOUSSEAU (b.1927). Pierre Gauvreau's brother Claude, a poet, first met Borduas at the time of his famous exhibition of gouaches in April 1942, and the rest of the group—MARCEL BARBEAU (b.1925), then only sixteen, JEAN-PAUL RIOPELLE (b.1923), and ROGER FAUTEUX (b.1920)—was drawn from Borduas's own classes at the École du Meuble in the fall of 1942. The group met regularly in Borduas's studio, where they discussed things of interest to most of them: idealistic social theories, psychoanalysis, and, most enthusiastically, Surrealism (see p. 198n.)—all three subjects denounced by the Church. Intense involvement in leading these explorations into new areas would absorb much of Borduas's creative drive for the next three years.

Guy Viau (1920–71), another Borduas student at the École du Meuble, and his brother Jacques organized a series of small exhibitions and seminars in collèges around Montreal, beginning in the spring of 1943 and continuing into early 1945. To these showings, which reflected the developing ideas of the Borduas group, must be given much of the credit for a growing student interest. Student activities, in fact, were almost solely responsible for the broadening of the radical cultural movement in the Montreal area during these years. In the fall Viau took charge of the art pages in the Université de Montréal student newspaper Le Quartier Latin, beginning a tradition of support of the activities of the Borduas group that continued for years. (The Gauvreau review referred to above appeared there.) The following summer Leduc, young Mousseau, and three other students from the Beaux-Arts-the Renaud sisters-rented a house in Saint-Hilaire in order to be closer to Borduas. (Leduc and Guy Viau had often visited him there the summer before.) That fall one of the sisters, Louise, took a job in New York as governess to the children of the art dealer Pierre Matisse. Matisse's gallery was then a centre of activity for the refugee Surrealists who had fled to New York in large numbers because of the war, and Louise sent back to Montreal all the latest news of their activities. The next April, Fernand Leduc also visited New York and, on Good Friday, actually met the famous leader of the Surrealist movement, André Breton.*

Meanwhile the French artist Fernand Léger, who had visited Montreal in the spring of 1943, returned there to deliver a public address on May 10 and in the course of his lecture encouraged the audience to oppose actively the restraining influences of every conservative element in the art world. The art students of Montreal soon found an opportunity to

*Breton had been in Quebec from August 20 to October 20, 1944, at Percé in the Gaspé and at Saint-Agathe, north of Montreal, but had made no effort to contact Leduc or Borduas, both of whom had corresponded with him.

confront the forces of entrenched academicism when Pellan and Charles Maillard, the French-Algerian director of the École des Beaux-Arts, disagreed over the inclusion of certain controversial exhibits in the annual student show. The students quickly and effectively rallied to Pellan and in a series of demonstrations forced Maillard's resignation. The victory has always been seen as Pellan's, but Pierre Gauvreau was one of the student leaders, and the young 'surrealists' certainly considered the accomplishment their own.

Also in May 1945 Borduas moved into his new house in Saint-Hilaire. As they had done the summer before, a number of his young friends and students rented a house there too. By then it had become clear that the student activity—which involved poets, dramatists, and dancers as well as painters—represented a cultural movement in the widest sense. Their inspiration was generally the thought and activity of the great Surrealists. And their one common concern was becoming more and more clearly social: the struggle against personal repression and social oppression, the liberation of the creative force.

The first concrete manifestation of the Montreal 'surrealist' group was held in New York, a city that early in 1946 could still just barely lay claim to being the world centre of the Surrealist movement. A friend of Pierre Gauvreau and Fernand Leduc, Françoise Sullivan (b.1925), had studied dance there with Franciska Boas after graduating from the École des Beaux-Arts, and it was in the Boas studio in January 1946 that Borduas, Leduc, Gauvreau, Riopelle, and Mousseau first exhibited as a group.

The first Montreal exhibition was three months later (April 20-9), in an office on Amherst Street lent by the Gauvreaus' mother. Organized by Leduc, it included, as well as the five who had shown in New York, Barbeau and Fauteux. It was the first exhibition by a group of abstract painters ever held in Canada, and in its evidence of experimentation it was as bold as any then to be seen anywhere. Borduas in 1946 was clearly the most accomplished of the seven. Although the intense intellectual activity of the preceding three years had left little time for painting, a work of 1946 like *9.46 or L'Écossais redécouvrant l'Amérique (MAC) presents an intelligent solution to the awkwardness of the 1943 oils; a solution derived principally from the work of the then most-acclaimed of the New York Surrealists-the Chilean, Matta. It consisted in releasing the intertwined forms seen in his earlier paintings and letting them float individually in an infinite dream-like space. Borduas brought to the final result his rough but brilliant paint handling, his sure sense of colour and love of radiant light. The method of composition-as is obvious from the natural, flowing interrelationship of the elements-was the 'automatic'

Paul-Émile Borduas. *9.46* or *L'Écossais redécouvrant l'Amérique*, 1946. Canvas, 97.0 × 120.0. MAC.

process he had perfected over the winter of 1941-2.

The younger members of the Montreal surrealist group (some of whom were still in school) showed work more radically 'advanced' than Borduas's 'abstract figuration'. A few had no figurative tradition of their own to overcome, having painted from the first with the automatic technique of the Surrealists. Leduc achieved the most resolved image. His 1946 **Dernière Campagne de Napoléon* (the artist), although overly busy, even arbitrary in parts, is still an exciting, violent picture in its exploitation of free gesture, yet it is rigorous in its pursuit of a tight, integrated composition. In 1946 Jean-Paul Riopelle was working in inks and water-colour and he too soon commanded the easy flow of automatic composition. His admirable feeling for texture and tone and his natural sense of drama are revealed in the many untitled works of that year. Marcel Barbeau followed youthful enthusiasm even beyond the limits then comprehended by Borduas himself. **Le Tumulte à la mâchoire crispée* (MAC) is his only canvas of 1946 now extant—a frozen explosion in which every

Fernand Leduc. Dernière Campagne de Napoléon, 1946. Board, 50.8 × 66.0. The artist.

part of the surface has been vigorously assaulted. It is a dynamically spontaneous, if undisciplined, work. Barbeau was thrilled with it and with others done at the time, remarking, 'It is the first time I have painted with perfect joy.'* His young friends were delighted, but Borduas was severely critical. 'There must be an object on a ground of infinite depth,'** he had stated dogmatically. Barbeau dutifully destroyed the results of his excess! The other three participants were more faithful to the limits as then defined by Borduas.

The following year another group show was held (February 15 to March 1, 1947), this time in the Gauvreau apartment at 75 Sherbrooke Street West. The furniture was removed and the walls covered with neutral jute as a background for the pictures. There were six participants (Riopelle was missing) and it was, according to Claude Gauvreau, the most homogeneous and generally impressive of the Automatiste exhibitions.

*'C'est la première fois que je peins avec une joie parfaite.'

**'Il faut que ce soit un objet sur un fond allant jusqu'à l'infini.'

Marcel Barbeau. Le Tumulte à la mâchoire crispée, 1946. Canvas, 76.2 × 88.9. MAC.

They were first called by that name in a review of the show in *Le Quartier Latin*. Tancrède Marsil coined the term from a Borduas canvas in the exhibition, *Automatisme 1.47* (also known as *Sous le vent de l'île*). It was a name they accepted gladly, for surrealist automatic painting was then central to their whole creative stance.

Riopelle was absent from the exhibition because early in December 1946 he had left for Paris, which was once more, after the war and the return of Breton, the centre of the Surrealist movement. Leduc joined him on March 7, and by June the two had organized for the little Galerie du Luxembourg an exhibition of the work of six of the Montrealers (Gauvreau did not participate) entitled 'Automatisme'. It was a valiant statement of independence within the Surrealist milieu. Then on June 21 (the exhibition had opened only the day before), Riopelle signed the *Ruptures inaugurales*, the manifesto of the renewed world Surrealist movement. In July he was one of eighty-seven artists from twenty-four countries

included in the vast Exposition Internationale du Surréalisme organized by André Breton and Marcel Duchamp at the Galerie Maeght in Paris, the last major group show of the Surrealist movement.

Borduas had been invited by Breton to participate but had refused. He also that year refused to co-operate with Père Couturier, who wished to organize an exhibition of contemporary Canadian art for the Musée d'Art moderne de Paris. He clearly feared the absorption of the Automatistes in Breton's ambitions for a rejuvenated world movement of Surrealism, and probably mistrusted French cultural advances in general. Nevertheless the full trappings of Surrealism were brought to Montreal that December, when a Mousseau-Riopelle exhibition was installed in the Gauvreau apartment against walls covered with a dark padded material; the pictures were strikingly suspended from web-like nets strung about the rooms. Riopelle and Leduc were by then settled in Paris, however, and although they continued to support the Automatistes, they also began to associate with painters in Paris who, like the Abstract Expressionists in New York, had developed a free abstract style from the theories of Surrealism. (Their approach to painting has been called 'lyrical abstraction'.) Riopelle has never returned to Canada, save for visits; and except for occasional group shows he did not exhibit in this country again for ten years. Leduc returned only in 1953-by which time Borduas had left Montreal—then moved back to Paris in 1959.

The principal inspiration of the Montreal movement remained Surrealism. Borduas's Automatisme 1.47 or Sous le vent de l'île (NGC) of 1947 is a classic Surrealist picture, with its featherlike forms floating in an infinite, atmospheric space. Pierre Gauvreau was also painting 'dream images', as he had been virtually since his first involvement with Borduas. His Sans Titre (MAC) of 1947 is like a monstrous opening flower. Mousseau's first significantly independent works were the beautiful gouaches of 1948 that are jammed with densely packed forms, as in Bataille moyenâgeuse (MAC). In the diminishment in size of the elements towards the top of the sheet, they also suggest an infinite space. And MARCELLE FERRON (b. 1924), a new adherent from Louiseville recently graduated from the Quebec City École des Beaux-Arts, also conceived of her paintings as depicting atmospheric if indeterminate space, as in her Yba (the artist) of 1947. Riopelle, having moved physically closer to the French Surrealists, was going beyond them. His *Abstraction (Maurice Corbeil, Montreal), painted in 1947, already shows the first perception of a new kind of space, the result not of perspectival recession but of the simple juxtaposition of colour, the forms seeming to play within a shallow rectangular box. Barbeau was still the most experimental of the painters in Montreal. His

Jean-Paul Riopelle. *Abstraction*, 1947. Canvas, 76.2 × 91.4. Maurice Corbeil, Montreal.

Forêt vierge (Madeleine Arbour, Montreal) of 1948 shows that he too was aware of the possibilities of a shallow arena of space—articulated, though, with slashing string-like lines (strongly reminiscent of the string installation by Duchamp in the 'First Papers of Surrealism' exhibition held in New York late in 1942, which the Montrealers would have known from magazine illustrations).

Though hindsight now leads us to consider the younger painters more 'advanced' in their experiments with depicted space than Borduas prior to 1950, the centre still rested solidly on him. During these months of late 1947 and early 1948 he determined that his commitment to the realization of a fully free and creative life must be total. This determination resulted in what is perhaps the single most important social document in Quebec history and the most important aesthetic statement a Canadian has ever made, the *Refus global*. A hand-assembled mimeographed book, it is simply illustrated with a few halftones and is wrapped around with a reproduction of a Riopelle ink drawing. The title essay is by Borduas

and there are a number of shorter pieces by Borduas, Claude Gauvreau, Françoise Sullivan, Bruno Cormier, and Fernand Leduc. It seems impossible to overstress its importance. Because of the *Refus global*, one commentator has stated flatly, 'modern French Canada began' with Borduas! Four hundred copies were placed on sale on August 9, 1948.* They exploded like so many bombs.

Through the personal experience of one man, or at least of an amalgam of those honest intellectuals around Borduas, he records the awakening of a culture. He first describes the country that formed him, 'since 1760 a colony trapped within the slippery walls of fear, the customary refuge of the vanquished.' A colony where the Church is central, its priests the guardians of the faith, of knowledge, truth, and the national wealth. This Church extorts from society so much more than it returns in good works, however, and in fear fosters ignorance and welcomes the worst of outmoded conservative Catholicism from Europe. Nonetheless, cracks have appeared. Revolutions, foreign wars, travel, and education have stirred thoughts. Borduas describes the exhilaration of first reading 'forbidden' authors and discovering that, rather than 'des monstres', they are the ones who 'dare to express loud and clear what the most unfortunate among us have suppressed in self-hatred and terror of being buried alive'.²

The only hope for change lies in the ideal of personal liberation, and from that realization a course of action is derived.

Break permanently with the customs of society, dissociate yourself from its utilitarian values. Refuse to live knowingly beneath the level of our spiritual and physical potential. Refuse to close your eyes to the vices, the frauds perpetrated under the guise of learning, favour, or gratitude. Refuse to live in the isolation of the artistic ghetto, a place fortified but too easily shunted aside. Refuse to be silent—make of us what you please, but you must understand us—refuse glory, honours (the first compromise): stigmata of malice, unawareness, servility. Refuse to serve, to be made use of for such ends. Refuse every INTENTION, pernicious weapon of REASON. Down with them both, to second place!

> MAKE WAY FOR MAGIC! MAKE WAY FOR OBJECTIVE MYSTERIES! MAKE WAY FOR LOVE! MAKE WAY FOR NECESSITIES!³

*Since its initial appearance it has been reprinted in full or substantial part at least eleven times.

¹′Colonie précipitée dès 1760 dans les murs lisses de la peur, refuge habituel des vaincus.' ²′Osent exprimer haut et net ce que les plus malheureux d'entre nous étouffent tout bas dans la honte de soi et la terreur d'être engloutis vivants.' Balancing this utter refusal to co-operate with the controlling forces, however, must be the realization of total personal responsibility for one's actions. 'The self-seeking action remains with its author—it is stillborn. Passionate acts take wing by their own energy. We cheerfully take the entire responsibility for tomorrow . . . In the meantime, without rest or cessation, in a community of feeling with those who thirst for a better existence, without fear of a long deferment, in the face of encouragement or persecution, we will pursue in joy our desperate need for liberation.'⁴

Some think the *Refus global* has nothing to do with aesthetics. But for Borduas and his followers the creative act could be realized to its fullest potential only in a liberated individual; therefore politics, personal security, and joyful fulfilment were essential concerns of the artist.

A few months before the actual appearance of the *Refus global*, just about the time Borduas was elected president of the CAS in February 1948, Pellan rallied 'the anti-Automatiste' faction among Montreal painters with a manifesto (prepared with the help of Jacques de Tonnancour) establishing the 'Prisme d'yeux' group. *Canadian Art* magazine reported its manifesto as having stated: 'We seek a painting freed from all contingencies of time and place, of restrictive ideology, conceived without any literary, political, philosophical or other meddling which could dilute its expression or compromise its purity.' In its first exhibition that year, held in space provided by the Montreal Museum of Fine Arts, the group attracted fourteen participants. They included disciples of Pellan like Léon Bellefleur (b.1910) and Albert Dumouchel (1916–71), and more conservative members of the CAS like Jacques de Tonnancour, Goodridge Roberts, and Gordon Webber. It lasted as a group for less than a year

³Rompre définitivement avec toutes les habitudes de la société, se désolidariser de son esprit utilitaire. Refus d'être sciemment au-dessous de nos possibilités psychiques et physiques. Refus de fermer les yeux sur les vices, les duperies perpétrées sous le couvert du savoir, du service rendu, de la reconnaissance due. Refus d'un cantonnement dans la seule bourgade plastique, place fortifiée mais trop facile d'évitement. Refus de se taire—faites de nous ce qu'il vous plaira mais vous devez nous entendre—refus de la gloire, des honneurs (le premier consenti): stigmates de la nuisance, de l'inconscience, de la servilité. Refus de servir, d'être utilisables pour de telles fins. Refus de toute INTENTION, arme néfaste de la RAISON. A bas toutes deux, au second rang!

> PLACE À LA MAGIE! PLACE AUX MYSTÈRES OBJECTIFS! PLACE A L'AMOUR! PLACE AUX NÉCESSITÉS!

⁴ 'L'action intéressée reste attachée à son auteur, elle est mort-née. Les actes passionnels nous fuient en raison de leur propre dynamisme. Nous prenons allègrement l'entière responsabilité de demain. . . . D'ici là, sans repos ni halte, en communauté de sentiment avec les assoiffés d'un mieux être, sans crainte des longues échéances, dans l'encouragement ou la persécution, nous poursuivrons dans la joie notre sauvage besoin de libération.'

and a half. The real opposition to the *Refus global* came not from the artistic community, however—the critic Charles Doyon explained it as merely 'a cry of anguish aroused by the disillusionment of the young confronted with a generation of establishment fogies and sycophants'⁵— but from those who at least partially felt the correctness of Borduas's statements and sensed his threat to their position: the politicians and the clergy.

Borduas received a letter on September 2, 1948, less than a month after the first appearance of the *Refus global*, informing him that the minister of social welfare and youth of the province, Paul Sauvé, had ordered that he be dismissed immediately from his post at the École du Meuble, 'because the writings and manifestos he has published, as well as his general attitude, are not of a kind to favour the teaching we wish to provide for our students.'⁶ Borduas of course informed the newspapers, and some people reacted with shock. But most remained silent. It was the directness of Borduas's attack on the Church, it seems, that had paralysed them with fear.* Only twelve of his former students condemned the government and upheld Borduas's views in a letter in *Le Clairon* (October 15). Then, at the end of October in *Le Clairon*, Pierre Gauvreau, Riopelle, and Maurice Perron, another Automatiste, tried unsuccessfully to shame the intellectual community into supporting Borduas.

In an editorial in the prestigious *Le Devoir* (November 13), Gérard Pelletier, doubtless expressing the point of view of the liberal Catholic intellectual, openly rejected Borduas's position. He was opposed to Surrealism. 'We do not accept the rule of instinct because we believe in sin,' he explained. He was equally unable to accept the *Refus global* because 'we have faith in God, whose name does not once appear and whose Presence is nowhere alluded to in your manifesto.^{'7} Borduas had described how 'beyond Christianity we reach the fervent human brotherhood to whom it has become a closed door.'⁸

⁵'Un cri de détresse suscité par l'écoeurement des jeunes devant une génération d'assis et d'encenseurs.'

⁶'Parce que les écrits et les manifestes qu'il publie, ainsi que son état d'esprit no sont pas de nature à favoriser l'enseignement que nous voulons donner à nos élèves.'

*As early as 1946 a book by René Bergeron, *Art et Bolchevisme*, condemned the recent modern trends in Quebec. The 'surrealists' were there presented as demons, followers of Marx and Freud (both anathema to good Catholics), and violently anti-Christian.

^{7'}Nous n'acceptons pas la règle de l'instinct parce que nous croyons au péché . . . nous avons foi en Dieu, dont le nom n'apparaître pas une seule fois et dont la Présence n'est pas évoquée dans votre manifeste. . . .'

⁸'Par delà le christianisme nous touchons la brûlante fraternité humaine dont il est devenu la porte fermée.'

xxx—Paul-Émile Borduas. Fence and Defence, 1958. Canvas, 49.5 \times 61.0. Martha Jackson Gallery, New York.

xxx1—William Ronald. *Gypsy*, 1959. Canvas, 177.8 × 152.4. Dr and Mrs Sydney Wax, Toronto.

Such strong feelings did not soon subside. As late as February 1950 two young students of the Jesuit Collège Sainte-Marie were expelled for attending the opening of a Mousseau-Ferron exhibition. And even in the later fifties there were disconcerting reminders of 1948. Marcelle Ferron, then living in France, was questioned by the police for Algerian sympathies and was greatly surprised to discover that her interrogators had been supplied with a personal dossier that, unknown to her, had been assembled by the RCMP at the time of the appearance of the *Refus global*!

The fall of 1948 was excruciating for Borduas: little money for his family (he had three children), no possibility of employment as a teacher, few painting sales, and society turned against him as at the least emotionally unstable and at the worst a dangerous, violent criminal. (One Jesuit had claimed in print that Borduas was insane.) There were, fortunately, a few friends who stood by him and, most important, Borduas sustained his courage. His probing self-explorations had resulted in more brilliant accomplishments in his painting over the last five years than in the whole twelve years of his career as a church painter. At the age of forty-three he knew he would be able to continue to find strength in his creativity, and so he pressed on. His entry in the MMFA spring show won first prize in April 1949, and his supporters took strength in interpreting this as a criticism of Sauvé's action. In the second half of May he held a one-man exhibition in the studio of the Viau brothers, and that summer he taught painting to children in Saint-Hilaire. He also led the Automatistes in a demonstration to protest police violence during the famous Asbestos strike.

Then in July, almost one year after the appearance of the *Refus global*, he published his *Projections libérantes*. In it he confirms the reading of Quebec society as set out in the *Refus global* with a simple description of his own development as a painter and teacher up to the point of his dismissal. Intensely personal and nobly impassioned, it tells how his brutal treatment at the hands of the established order moved him just that much closer to the freedom to seek his own destiny: 'Enfin libre de peindre.'

Borduas was hospitalized during August and September 1949 for an appendectomy and an ulcer operation; he spent the fall again teaching children in his home. He exhibited at every opportunity and was rewarded with a few sales. Two canvases were bought by the Musée du Québec that fall. The winter found him working hard on watercolours. 'Ma peinture est en pleine transformation ou mutation,' he wrote to Leduc at the end of January. But then his painting had always developed through evolutionary change—through 'mutation'. The fluid ease of the

watercolour medium was leading him towards a single integrated image. His intention was still ambiguous, however. In *Au paradis des châteaux en ruines* (Jean McEwen, Montreal), for instance, he floats castle-like forms in an indefinite space. The few paintings that do almost obliterate deep space, like *Bleu* (MQ), are tense and taut, rippling with strength across the whole surface. Subsequent oils, nonetheless—*Floraison massive* (AGO) of 1951 is one of the most gloriously beautiful—returned to an object-like shape centred in atmospheric space. His watercolours often thus led him on excursions that could predate a definite 'advance' by as much as two years.

Although Borduas continued to exhibit frequently, there were few sales and his financial situation remained desperate. He held an exhibition of the new watercolours in his house in late November 1950 (it had been specially designed for such a purpose), and the following February his friend Robert Elie hung a showing in his home and encouraged friends and associates to buy, with some success. Then in April 1951 he had his first serious exposure in Toronto when he was rather insensitively linked with the Prisme d'yeux supporter, Jacques de Tonnancour, in a two-man exhibition at the Art Gallery of Toronto. Early in June he held another exhibition in his house that included some remarkable wood sculpture he had recently completed, and then in mid-October he travelled to Toronto for his first one-man show there-an exhibition of 'Colour Ink Paintings' at Douglas Duncan's Picture Loan Society. Returning to Saint-Hilaire, he was distressed to find his family gone. He had pridefully refused to allow his wife to work even in the face of poverty, and she had finally been driven to leave Borduas to support their children herself.

The MMFA asked him for an exhibition in January and he showed ten of his own paintings (a mini-retrospective of the last nine years) with the work of ten followers, only three of whom had been among the original Automatistes. The Automatistes themselves had arranged a group exhibition in May 1951—the first in four years—called 'Les Étapes du Vivant' that included the work of thirteen artists, but not Borduas. The older 'youngsters' were clearly going their own way. At the end of April 1952 Borduas exhibited recent works in his home once again—for the last time. He was forced to sell the house he had built himself and went to live temporarily with his brother. He had decided to move to New York. Long delays with his visa caused worry (McCarthyism was then rampant; 'godless communists' were as feared there as in Canada), but finally on March 31, 1953 he set off for New York City. The National Gallery of Canada bought *Sous le vent de l'île* just before he left.

Why New York instead of Paris? He was possibly still concerned to

keep out of the Breton sphere of influence; and even though New York, because he didn't speak English, was much more foreign than Paris, Borduas did have some familiarity with the American metropolis. He had visited it in 1943 and his friends had associations with it. Francoise Sullivan had lived there for two years and Barbeau had had a small exhibition at Wittenborn and Shultz the year before. But Borduas was probably most influenced by the knowledge that the French Surrealists, before their return to Paris, had stimulated a group of young American painters. In January 1950 an exhibition of contemporary art from Great Britain, France, and the United States, organized by the AGT, was shown in Montreal. The works included by the Americans de Kooning, Gorky, Motherwell, Rothko, and Tomlin-with their abstract object-shapes variously related to ambiguous Surrealist space-were then very close to Borduas's own concerns. And Jackson Pollock, whose breathtaking Cathedral was one of the largest pictures in the show, must have impressed him greatly. Pollock had achieved the most profound statement of all the Americans with an automatic 'drip' technique that was seemingly even more abandoned than that used by the younger Montreal painters.

Arriving in New York, Borduas soon discovered that little could be accomplished before the fall, so in May he left for Provincetown, Mass., a resort town well known to painters as the location of Hans Hofmann's summer school. 'I have passed a magnificent and unique summer,' he wrote to a friend, '40 new canvases. That is greater than my production during five years in Canada." In September he returned to New York and settled into a studio at 119 East 17th Street. In January 1954 he had his first one-man exhibition there at the Passedoit Gallery, showing works painted during the fall and, we can assume, some of the Provincetown canvases. Two basic types of pictures are identifiable; both tend towards an active engagement at so many points that the whole surface of the canvas seems enlivened. As in his late Montreal works, the distinction between object and ground is diminished. In *Les Signes s'envolent (MMFA) 'object' forms cover about one third of the surface, but the 'ground' itself, worked up in texture with a palette knife, presses forward on the objects, as though seeking to integrate with them. The other approach in these 1953 canvases can be seen in Figure aux oiseaux (AEAC). Here a neutral-coloured background is clearly visible, but the 'objects' explode all over in a burst of brown, white, red, and gold; the colour is slashed

^{9′}J'ai passé un été magnifique et unique ... 40 tableaux nouveaux. C'est plus que ma production de cinq ans au Canada.'

Paul-Émile Borduas. Les Signes s'envolent, 1953. Canvas, 114.3 × 147.3. MMFA.

on with a palette knife, but with innate precision. Though neither type of picture presented a radical change—they showed rather a logical development out of earlier work—as the first examples of a consistent concern for the 'all-over' integrated image, they mark an important turning-point.

Borduas would have seen such expanded all-over images soon after his arrival in New York in late March and early April 1953 when Willem de Kooning held the first exhibition devoted to his violent, slashing *Woman* canvases at the Sidney Janis Gallery. There was also the magnificent example of Jackson Pollock, and the memory of works by Barbeau, Leduc, and Riopelle. All would have been brought into sharp focus at the time of his Passedoit showing by a glittering and highly successful Riopelle exhibition then on view at the famous Pierre Matisse Gallery. The NGC, responding to the prestige of the event, bought two paintings. The larger *Knight Watch*, is brilliantly decorative. Swatches of colour are laid on with a palette knife to a thickness of almost one and a half centimetres, built up to a dense but faceted surface that completely covers the canvas. At first appearance it is similar to Pollock's work, its shallow but dynamic space articulated with darting lines, suggesting a grid ordering the multiform accidental effects of facture.

Borduas's opening at the Passedoit Gallery was attended by Robert Motherwell, one of the leading American painters to evolve out of the Surrealist milieu in wartime New York. And the Montrealer later came into contact with some others of the American Abstract Expressionist persuasion. But Borduas still did not speak English well and so found communication difficult. Besides, he was primarily concerned to digest the great resources of information about him, and so during the spring of 1954 he turned again to watercolours, a medium that allowed him to work out new ideas rapidly. The resulting series was as fine as that of early 1950. Some of these watercolours, like Forces étrangères (NGC), are in fact similar to those earlier ones in their structuring of shallow space. Others, like Les Baguettes joyeuses (MQ), are much closer to Pollock, even to the extent that the paint is splashed, perhaps even dripped in a controlled 'accident' to produce an open but full image. In these 1954 watercolours Borduas for the first time seems thoroughly free of his old concern with the infinite space of Surrealism. He is no longer making dreamimages but has learned from the American Abstract Expressionists how to produce an image of 'actuality'—an image that is not of anything but itself-in which the 'making' and the 'being' have become one, and everything.

The degree of Borduas's involvement with Abstract Expressionism could subsequently have been seen in Montreal at the end of June 1954 when he held an exhibition of his recent watercolours at the Lycée Pierre Corneille.* The next January he exhibited them again in New York at Passedoit. 'The American response was warmer, more eager,'¹⁰ he wrote to a friend. The Museum of Modern Art and the Carnegie Institute each purchased one. He was by then working hard on canvases and was pleased with the results. 'My painting becomes more and more ''transparent'', perhaps? More crystalline, in any case. Let's hope it can tell us more about what none of us knows about ourselves.'¹¹ These were the first canvases in which he sought to refine the new 'all-over' composi-

¹⁰'La réponse américaine se fait plus chaud, plus pressante.'

¹¹'Ma peinture devient de plus en plus 'transparente', peut-être?, plus cristaline, en tout cas. Puisse-t-elle nous renseigner davantage sur ce que nous ignorons tous de nousmêmes.'

^{*}He had in April revealed this new interest in a prepared statement circulated while he was in Montreal jurying the exhibition 'La Matière Chante', which Claude Gauvreau had arranged at Antoine's Art Gallery. The relationship of Surrealism to Asbtract Expressionism would then have been a topic of animated discussion.

Paul-Émile Borduas. Pulsation, 1955. Canvas, 96.5 × 119.4. NGC.

tional format. The whole surface is worked over in thick paint, often methodically applied with a palette knife as in the paintings of Riopelle. Some works, like **Pulsation* (NGC), emphatically reveal the 'gesture' of application, as though the paint had been 'whipped up'. The transparent or crystalline quality Borduas mentioned is due to the illusion of seeing through small broken planes: a jumble of facets trapped within a shallow space. An effect of dynamism is achieved without disruption of the homogenous texture of the surface.

Borduas had always intended to move to Paris after New York, and then to Japan. (His dream was to settle in Tahiti!) He passed August 1955 in Montreal preparing for this next stage of his journeys, and on the twenty-first he left for the French capital. He was in the highest spirits. That spring three Montreal collectors had together purchased eighteen pictures to help him finance the trip, and in July the well-known Martha Jackson Gallery became his New York dealer, agreeing to purchase a regular portion of his production. Montreal's Dominion Gallery made a similar arrangement. He arrived in France on September 27 and soon found a studio in Paris at 11 rue Rousselet. By December he was terribly homesick. 'I would give at this moment Paris and everything good in the world for a cozy little corner, if it were in Canada,' he wrote home to a friend. By the end of May 1956 he was beginning to despair. 'Never have I felt such loneliness. ...'¹² While in New York he had been able to return to Montreal every two or three months. Hoping that travel would break his despair he bought a car, and from September through to November 1956 he visited Italy. Then in November he received a further boost when Martha Jackson bought everything he had painted since July.

Although homesick, he had painted feverishly during the spring and summer of 1956, anxious to work through new developments. He was mainly concerned to order and substantiate the shallow space he had developed in the works of 1954–5. He appears to have begun, as in the accomplished **Fond blanc* (NGC), by smoothing out large contiguous areas of white with a long palette knife loaded with pure colour, leaving streaks of whitened colour across their surfaces as well as curled-over accretions of coloured paint along their borders. The coloured 'objects' of his earlier work have here become the residue of process, an actual part of the ground. The overall appearance is of a crude grid of rectangles. Borduas was certainly aware of Mondrian in New York, and the first major monograph on that artist who had himself so successfully ordered shallow space with a rectangular grid was published that year.

In *Goéland* (NGC)—painted before the beginning of August 1956—the solution is even more effectively economical. Virtually all colour has been suppressed except for delicate tints left by the sweep of the knife; then, embedded in the 'ground', are large areas of solid black, like rocks in a Japanese sand-garden. These 'black-and-whites' continued into 1957, culminating in L'Étoile noire (MMFA). Here the surface has been caressed with the long blade to a pearly, slightly flushed hue, leaving delicate ridges where the knife has stopped. The rectangles thus formed into a loose pattern glow with a soft light, reflected through the translucent surface as through fine marble. Embedded in this sensitive 'flesh' are five roughly rectangular shapes of black and dark brown, like malignant growths frozen in perfect, living balance with the sustaining host. Ominous, sombre, it is more majestic than baleful.

In March and April 1957 Borduas was given his first one-man show at the Martha Jackson Gallery; there was another, also that April, at the Gallery of Contemporary Art in Toronto. That spring his painting activity declined—he was by then close to collapse from fatigue and rapidly

¹²'Je donnerais en ce moment Paris et tous les biens de la terre, pour un petit coin douillet, fut-il au Canada.... Jamais je n'ai eu le sentiment d'une telle solitude.'

Paul-Émile Borduas. Fond blanc, 1956. Canvas, 147.3 × 114.3. NGC.

deteriorating health. In July he left for Spain and Portugal, returning in October. The next two years he followed much the same pattern. There were important shows at Lefort in Montreal (May 1958), Schmela in Düsseldorf (July), Tooth in London (Oct.), Martha Jackson (April 1959), and he had his first one-man show in Paris at the Galerie Saint-Germain (May). He continued to travel as relief from his feverish working schedule: to Switzerland and Italy (March 1958), Brussels (June), Düsseldorf (July), and Greece (June-Oct. 1959). Nevertheless he still thought of home. That April in a letter to a childhood friend he described plans to build a studio on the Richelieu River near Saint-Hilaire.

A European reputation was developing. In November 1959 Borduas described how 'growing friendships in the European critical world are bringing me moral and intellectual consolation. They are interested above all here in the last canvases, in comparison with which 'L'Etoile noire' seems pleasing.'¹³ It is in the promise of these 'last' canvases that the

^{13′}... des amitiés naissantes, dans le monde de la critique Européenne, apportent réconfort

Paul-Émile Borduas. L'Étoile noire, 1957. Canvas, 161.9 × 130.2. MMFA.

measure of his genius can be taken. Refining and eliminating everything except the simplest elements of form and structure, he applied himself during his last two years with punishing rigour, seeking a severe statement, free of sentiment or prettiness. Much less 'pleasing' even than the sombre majesty of *L'Étoile noire*, *†Fence and Defence* (Martha Jackson Gallery, New York) of 1958 certainly avoids even the slight congeniality of the earlier canvas. The conceptual simplicity of the composition—much as in the paintings of Mondrian—allows infinitely exact attention to the sensitive placement of each element to create an image of total unity. It is so full of interrelationships that close examination produces a feeling of profound fulfilment. It is a complex, living thing.

The rich fecundity of these last two years found release in a large number of small canvases equally rigorous in their economical statement of the profound force of simply related forms. Any one could, and did,

moral et intellectuel. On s'intéresse surtout, ici, aux dernières toiles en comparaison desquelles ''L'Etoile noire'' semble gracieuse.'

trigger numerous exploratory variations in which Borduas tested the extent of his potence. His spirit spumed fruit even as his body failed. 'La vie devient dure,' he wrote Gérard Lortie in Montreal late in January 1960. Less than a month later he died of a heart attack. In December of the same year Amsterdam's Stedelijk Museum presented a projected 'mid-career' retrospective as the first tribute to one of the great courageous spirits of the mid-twentieth century.

Painters Eleven 1953–1960

In comparison with the brilliant activity in Montreal, the painting scene in Toronto during the forties was moribund. The war weighed more heavily there than in Montreal—Borduas's followers had been almost all under military age—and many of the local artists were involved overseas in the war-art program. There was also in Toronto no informed interest in the European modernist tradition, as had developed around Lyman in Montreal during the later thirties. In fact, after the departure of Lawren Harris, the only sophisticated stimulation came from the Picture Loan Society, and even there the lines ran as much to the past as to the future. Remarkably, A.Y. Jackson still represented the heart and soul of vital painting in the city—in fact in most of English-speaking Canada.* And memories of the Group of Seven, which his presence so readily called up, were intensified after 1945 with the return to Toronto that year of Fred Varley.**

John Lyman's assault on the hegemony of the Group of Seven following his return to Montreal in 1931 was echoed a few years later in Toronto, most notably by the Group's old supporter, Barker Fairley, and by Paraskeva Clark. This militant call for figurative painting seemed to take an organized form with the establishment of the Studio Group on Hayden Street, near Bloor and Yonge, in 1938. Largely made up of amateurs looking for inexpensive shared studio space, the group was Fairley's

*Jackson's opinions were kept very clearly before the public in a column he wrote for the weekly *Toronto News* from 1942 through into 1946.

**In 1936 Varley had left Vancouver for Ottawa, where he taught at the local art association and completed some portrait commissions arranged by the NGC. The Gallery also arranged for him to accompany a government ship, the *Nascopie*, to the eastern Arctic in 1938. The sketches he brought back are among the most beautiful works of art ever produced by a visitor to that region. In 1940 he moved to Montreal, where he lived for four years, probably the most desperate years of his life. Alone and virtually penniless, he drank heavily and painted little. He was welcomed generously on his return to Toronto, however, and soon was reinvigorated.

idea. Although it never attracted a great deal of attention, a group show was held in Hart House in 1941, and there was a series of shows by single members two years later. As well, the group offered support for painters who felt that art should reflect a social consciousness, a position much admired at the time in the work of the Mexican muralists Orozco and Rivera. There was no Studio Group 'style', although the more serious among them, such as Aba Bayefsky (b.1923)—one of the few to pursue a successful career as a professional artist—developed an assertive form of expressionist figuration.

There were some other promising new faces. JACK NICHOLS (b.1921) first arrived from Montreal in 1939, and his beautiful oil-in-turpentine washes soon attracted the attention of Douglas Duncan, who by then was running the Picture Loan Society pretty much by himself. Most of Nichols's work of the forties—*Sick Boy with Glass* (AGO) of 1942 is particularly fine is, in its full modelling and stark simplicity, reminiscent of Louis Muhlstock (with whom he studied in Montreal) and, in its soulful humanity, not unlike Varley's portrait sketches (Nichols had close contact with Varley too). Nichols joined the navy as an official war artist in 1944. The year after his discharge in 1946 he was awarded a Guggenheim Fellowship that enabled him to study in California until 1948. Thus, at a time when he might have made an impact in Toronto he was occupied abroad.

The influence of another Duncan 'discovery' was also lost on Toronto during the forties. ROBERT 'SCOTTIE' WILSON (1890–1972) was born in Glasgow. After a stint in the army, he worked throughout Britain as a junk dealer. He first came to Canada during the twenties, staying only briefly; but he returned about 1931. Finally in 1938 he set up a junk shop on Yonge Street in Toronto, and between bouts of sorting scrap metal he began to draw pictures of particularly vivid dreams. Wilson left Toronto in 1942, settling briefly in Vancouver, but was back within the year. He then met Douglas Duncan, who was immediately taken with his madly intense ink drawings of dream-creatures. Carefully composed of simple forms, each element is painstakingly cross-hatched with straight, evenly spaced lines, and brightly coloured in with crayons. The staring-eyed monster of *The Bird Head-Dress* (NGC) of about 1943 wears a radiating halo made up of bird-shapes, exquisitely spaced with an exact sense of placement usually associated only with the Orient.

Duncan gave Scottie Wilson a show at the Picture Loan Society in April 1943, and in June and July the artist himself staged another in a Vancouver store-front and charged admission. There was a second Duncan show in February 1944, and Scottie arranged another one himself in St Catharines, Ont., in June. Later that year he returned to Britain and settled in London. Exhibiting there at the Arcade Gallery in 1945, he was presented as a proto-Surrealist painter of hallucinations and was subsequently included in the same 1947 Parisian Surrealist exhibition that Riopelle took part in. Two years later Wilson's drawings were shown at the Passedoit Gallery where, in 1954, Borduas was to have his first New York show.

Although Duncan was the first to show Scottie Wilson's drawings, he exhibited them as those of a primitive or naïve. The connections London and Paris later made between his work and Surrealism would not then have been possible in Toronto.* During the forties, in fact, Toronto painters were seemingly detached from most currents of international thought and were no longer motivated by the nationalist-landscape movement. When the famous Massey Commisssion (the Royal Commission on National Development in the Arts, Letters and Sciences) convened at the end of the decade, Charles Comfort, representing the English-speaking painters of the country, delivered a paper on the contemporary international scene and its impact on Canadian art. 'By far the most stable expression in the visual arts today is emanating from the United Kingdom,' he observed, 'the most eclectic and experimental from the United States. ... It would be of great value to Canadian painters and sculptors if a closer relationship were maintained with the United Kingdom and with France. Such a policy would be in line with those sympathies and loyalties which are part of our cultural heritage.' But when new forces finally gathered in Toronto, they came looking for experimental new directions, not stability.

As in Montreal some ten years before, these forces were engendered by the affiliation between a mature teacher and the largely undisciplined energies of ambitious youth. In Toronto the teacher was JOCK MACDONALD; youth, however, was represented principally by one man: William Ronald.

Although he painted his first abstract in 1934, Macdonald began serious experiments with automatic painting in watercolour and inks in Vancouver in 1941 (see pp. 196–8), around the time of Borduas's experiments. He continued to experiment with his 'automatics' in watercolour throughout the forties—in Vancouver and then in Calgary, first exhibiting them in a one-man show at the VAG in September 1946. The following August, at the end of his year in Calgary, he exhibited thirty-six of them at the San Francisco Museum of Art. All, like **Russian Fantasy* (AGO) of 1946, are similar to Borduas's 1942 gouaches in the sense that fortuitous

^{*}Unlike Montreal, which had its own 'Baie Saint-Paul'primitives: Yvonne Bolduc (b.1905), Mary Bouchard (1912–45), and Robert Cauchon (1914–69). They, however, were of the 'Grandma Moses' rather than the 'psychedelic' variety.

Jock Macdonald. Russian Fantasy, 1946. Watercolour and ink, 25.1 × 35.9. AGO.

shapes are sometimes allowed to develop into recognizable forms (fish, birds, etc.) and at other times are simply left as non-objective elements. For both artists an expanding, rich field of imagery was the desired result. Macdonald, however, tends to 'doodle' (he used a pen as well as washes). He had developed more of an interest in the 'fantasy' aspect of Surrealism than had Borduas and his followers in Montreal, and it was this vein he would explore, mainly in watercolours, during his first years in Toronto.

In September 1947 Macdonald settled in Toronto, where he had taken a position teaching drawing and painting at the Ontario College of Art. He found the size of the city stimulating and was excited by the relatively large number of painters. The first year or so he was absorbed in organizing his heavy class load: he taught four full days a week throughout his career at the College. But the next year he became interested in a third-year drawing and painting student, WILLIAM RONALD (b.1926). Born William Ronald Smith in Stratford, Ont., he was raised at Fergus, some eighty kilometres due west of Toronto, where his father was a market gardener. After making some money by working in an airplane assembly plant at the end of the war, he enrolled in the Ontario College of Art. An aggressive, independent young man, Ronald was frustrated by the conservative nature of the college, became rebellious, and was failed. Macdonald encouraged him to return. Coaching him almost as if he were an athlete, he saw him graduate in the spring of 1951 with honours and a scholarship. Ronald then took a job as a display artist with the Robert Simpson Co., a Toronto department store.

The next year, Macdonald—who by then had developed an engrossing personal involvement in Ronald's career—persuaded him to take six weeks off and visit New York City to attend Hans Hofmann's painting school. Macdonald had spent two brief periods with Hofmann at Provincetown in the summers of 1948 and 1949 and he greatly admired the spiritual basis in the theories of the great teacher. For Ronald, the sojourn provided his first extended contact with the work of the New York Abstract Expressionist painters.

Back in Toronto, Ronald left Simpson's, now convinced that commercial art represented a serious drain on his creativity. Supported by sporadic teaching, free-lance designing, and some tour lecturing at the Art Gallery of Toronto, he painted with a driving ambition, inspired by his lessons from Hofmann and by gallery-viewing in New York. **In Dawn the Heart* (AGO) of 1954 is one of the best of these pictures, reflecting Ronald's intense interest in Abstract Expressionism. It is also reminiscent of Borduas's canvases of the last four years in Montreal (1949–52), although in its vigorous handling it is an 'action' painting of the sort that Borduas would approach only the next year.

Even by the time of his short visit to New York in 1952, Ronald was hardly alone in Toronto in having such interests. Every society exhibition was beginning to include one or two works revealing some awareness of current abstract painting in New York or Montreal.* And in 1950 the Dutch-born painter Albert Franck (1889–1973) organized, with R.F. Valkenberg of the Eaton's Art Gallery, an Exhibition of Unaffiliated Artists that was held at Eaton's again in 1951, and at the AGT in May 1952. These shows attracted many of the experimental painters in the city, none of whom were known other than by isolated works, except for two or three who had had shows at the Picture Loan Society or at Hart House—those

*An exhibition of contemporary art from Great Britain, France, and the United States at the Art Gallery of Toronto in November-December 1949 included work by Pollock, de Kooning, Tomlin, Rothko, and Motherwell, who were among the artists that developed out of the Surrealist years in New York during the war and were by then beginning to attract considerable attention. The work of Borduas was certainly known in Toronto. He first showed there in a five-man show at the AGT in 1942, and virtually every year thereafter in CGP or other group shows. In April 1951 he was seen in a two-man show with de Tonnancour at the AGT, and in his first one-man show in October 1951 at the Picture Loan Society.

William Ronald. In Dawn the Heart, 1954. Canvas, $18_{3.2} \times 101.3$. AGO.

unique show-places of experimental art of the day. Ronald, however, noted these sporadic appearances.

Early in the fall of 1953—frustrated by the lack of any attention, commercial or critical—Ronald approached his old employers at Simpson's and to his delight they agreed to feature local abstract pictures in a display of contemporary furniture interiors. Publicized as 'Abstracts at Home', this unusual exhibition was mounted that October with a full-page promotion in the newspapers. Of the seven painters assembled by Ronald, only two apart from himself were not then full-time advertising artists. One was KAZUO NAKAMURA (b.1926), who was the same age as Ronald. Born in Vancouver, he was interned with his Japanese parents during the war and settled with them in Hamilton, Ont., in 1947. He began studying art at the Hamilton Technical School in the evenings and the next year enrolled full-time at Central Tech in Toronto, graduating in 1951. Like Ronald, he took what commercial work he had to in order to live but spent most of his time making delicate drawings, watercolours, and small oils—mainly stylized landscapes. He had his first one-man show at the Picture Loan Society in 1952 and another at Hart House in 1953.

ALEXANDRA LUKE (1901–67) was twenty-five years older than Ronald and Nakamura and had married into the wealthy McLaughlin family of Oshawa, so she did not need to waste painting time with commercial work. Born in Montreal, she moved to Oshawa (fifty kilometres east of Toronto on the lakeshore) at thirteen. She studied with lock Macdonald at Banff in the summer of 1946, and from 1947 through 1954 spent her summers at Hofmann's Provincetown school. She had her first onewoman show at the Picture Loan Society in late March 1952, but her bold Hofmann-influenced canvases were received with almost total bewilderment. Realizing that the viewers had probably never before encountered abstractions, she sought to educate them and organized the Canadian Abstract Exhibition, which opened in the Oshawa YWCA in October 1952 and then toured the southern-Ontario gallery circuit. It was shown at Hart House in Toronto. Including most artists who had experimented with abstracts in Canada, she rather surprisingly left out most of the Ouebeckers; only Léon Bellefleur, Louis Muhlstock, and Marian Scott from that province were shown. Luke did include everyone in the later Abstracts at Home exhibition (except Nakamura), including two commercial artists who had only recently settled in Toronto: Ray Mead and Oscar Cahén.

RAY MEAD (b.1921) was born in Watford, Hertfordshire, Eng., and had studied at the Slade. An RAF pilot during the war, he was stationed in Hamilton in 1946 and chose to stay in Canada. He moved to Toronto to become art director of an important advertising firm in the late forties and there, with Nakamura, was soon involved with a group of young artists that met at the Gerrard Street home of Albert Franck and Florence Vale, and showed in the Unaffiliated Artists exhibitions. OSCAR CAHÉN (1916–56) was also brought to Canada by the war. The son of a German diplomat, he was born in Copenhagen, and studied art at the Dresden Academy and in other schools around Europe. A teacher of illustration and design in Prague when war broke out and an anti-Nazi, he made his way to England in 1938 but was taken into custody as an enemy alien the

next year. In 1940 he was moved to an internment camp in Canada, near Sherbrooke in the Eastern Townships of Quebec. Thanks to a chance article on the camp in a Montreal newspaper, Cahén was soon working as an illustrator again, at first through correspondence for about a year, and then in his own studio in Montreal after being released in 1942 under the sponsorship of a local businessman. He married in 1943, and the next year moved to Toronto, where in 1946 he became a Canadian citizen. Always in demand as an illustrator, he began to take a great interest in painting, and was soon involved with the group of artists around Albert Franck. His earliest extant paintings are of somewhat expressionist figures, or of more formal, abstracted still-lifes, painted in a highly finished style developed out of both Cubism and Surrealism. Some, such as *Vegetation* (estate of the artist) of 1951, are reminiscent of the spiky, angular forms of the contemporary British artist Graham Sutherland, two of whose works were acquired by the AGT that same year.

The last two of the painters Ronald assembled in October 1953 were Toronto-born. JACK BUSH (1909-77), however, had been raised in Montreal, and first studied there in 1926–8 with the longtime secretary of the RCA, the Frenchman Edmond Dyonnet (1859-1954) and the Scottish muralist Adam Sherriff Scott (1887-1980). Sent back to Toronto at nineteen to work in the main office of the commercial art firm whose Montreal branch was run by his father, Bush continued his studies evenings at the College of Art, notably with Charles Comfort. He later married and settled in Toronto to pursue a career as a commercial designer. In his spare time Bush sketched and painted with his designer friends (a longstanding tradition in Toronto), and first exhibited publicly in a two-man show with R. York Wilson (1907–84) at the Women's Art Association in 1944. The next year he began exhibiting with the CGP and also held his second two-man show. This 1945 exhibition, with his partner in a small advertising firm, William Winter (b.1909), was at Hart House. Bush was then working in the Group of Seven landscape tradition, with strong elements of the 'regionalist' style that had been popular in the United States and with some Canadians during the thirties. The intense and emphatically presented sentiment of paintings like Village Procession (AGO) of 1946 began to attract attention, and in 1949 Bush was given his first one-man show, at the Gavin Henderson Galleries in Toronto. Everyone remarked on the dramatic change in the work he exhibited then. No longer based on landscape field-sketches (like Village Procession and most of the work before), these new paintings seemed to be deeply felt allegories that touched upon spiritual matters. They are powerful pictures, and they generated interest in his work. Three years later he was taken on contract by the Roberts Gallery. By then he was stressing simple, expressive shapes in his painting. *The Old Tree* (AGO), exhibited in a one-man show at the Roberts Gallery in 1952, is made up of stylized, angular forms derived from Cubism, clearly modelled in space.

At the same time Bush was discovering an interest in the kind of abstract art that had developed out of Surrealism—some of his gallery work even suggested dream imagery. The first time he met Jock Macdonald (soon after Macdonald's arrived in Toronto) he was impressed with the westerner's ideas. 'He believed strongly in intuition; painting how you feel,' is how Bush later put it. He himself had recently been inspired by the example of Borduas, and had privately begun to experiment with automatic composition. In 1952 (the same year as Ronald) Bush paid his first visit to New York.

¹ The other Toronto-born exhibitor in Abstracts at Home was raised on Toronto Island. TOM HODGSON (b.1924) first attended Central Technical School and then the Ontario College of Art. He first exhibited with the OSA the year of his graduation in 1946 but then took a job as an advertising designer and stopped painting. He resumed about 1951, dividing his spare time between his art and paddling. A serious athlete since highschool days, he was a member of Canada's Olympic paddling team in 1952 and again in 1956. He took his painting just as seriously and had his first two one-man shows in 1953, at the Picture Loan Society and Hart House. Decorative stylizations of recognizable objects, his work at this point was related most closely to Cubism.

If Abstracts at Home had simply assembled these beginners at abstraction, it would long ago have been forgotten. But the seven participants were called together one night for publicity shots (they were not all friends, and some had never even met before), and afterwards everyone but Bush-who had another engagement-ended up at Ronald's studio at Bloor and Spadina. Out of conversation grew the idea of a 'real' group exhibition, co-operatively financed, and an agreement to meet later at Alexandra Luke's cottage-studio near Oshawa to discuss the possibilities further. To this now-historic meeting Ronald brought Jock Macdonald (he was to have been included in Abstracts at Home but had no work ready). Ray Mead brought HORTENSE GORDON (1887-1961), a Hamiltonborn-and-raised painter he had met while posted there with the RAF. Gordon, who taught design at the Hamilton Technical School, had, like Alexandra Luke, spent the summer of 1947 with Hans Hofmann. She had had a one-woman exhibition in New York at the tiny Creative Gallery in January 1952, and at sixty-six was the oldest painter at the meeting. And Oscar Cahén brought two more advertising artists, friends from the

Franck-Vale circle: Walter Yarwood (b.1917), born in Toronto and a graduate of Western Technical School, and HAROLD TOWN (b.1924), also of Toronto and a graduate of Western Tech and (in 1944) of the Ontario College of Art. During the latter half of the forties, Town worked at painting in his spare time, developing an angular, spiky style of abstracting figuration that, like the work of Cahén, seems to have been inspired by the Cubist-Surrealist amalgams of Graham Sutherland. Town first exhibited, with the OSA, in 1949.

That first meeting was stormy (as each of the subsequent meetings were to be), but out of the clash of personalities came the decision to finance an exhibition jointly. The group soon also determined on a name—Painters Eleven—that avoided committing the membership to any one position. Bush, the only one with a dealer, approached the Roberts Gallery, which agreed that if all expenses were met, space could be made available. The exhibition was set for February 1954, with plans to send it later to Ottawa and Montreal.

The crowd at the opening was unlike any the staid Roberts Gallery had ever seen. There was a charge of excitement, the sense of an event. But Toronto generally ignored the paintings and there were only one or two sales. Reviewers, at a loss to evaluate the art, resigned themselves to remarking on the aggressive nature of the work and on the variety of approaches to abstraction it revealed. Pearl McCarthy of the *Globe and Mail*, however, observed that it reflected a positive desire to 'disagree harmoniously'. It was shown at Ottawa's Robertson Gallery in March, but the planned Montreal exposure fell through.

The painters themselves were delighted to see their work hung together and believed that there was indeed strength in numbers—particularly in the struggle against indifference. So they returned to the Roberts Gallery in February of the following year. By this time they apparently had been considered in relation to the Montreal movement of some eight years before. At the exhibition a statement was presented—suggesting one eye cocked on the *Refus global* and the other on Pearl McCarthy's review of the previous year—that read: 'There is no manifesto here for the time. There is no jury but time. By now there is little harmony in the noticeable disagreement. But there is a profound regard for the consequences of our complete freedom.' The exhibition was then again sent to a small Ontario centre—Oshawa this time.

The following year the Roberts Gallery, concerned by the lack of sales, and unconvinced that any appreciable public was developing, showed only 'Small Pictures by Painters 11'. But Painters Eleven had indeed begun to attract interest, if not support, and that year from late in Feb-

Oscar Cahén. Painting on Olive Ground, 1956. Canvas, 152.4 \times 132.1. John and Mable Ringling Museum of Art, Sarasota, Fla.

ruary 1956 through to December an exhibition toured the western-Ontario circuit. The real turning-point was reached not in western Ontario, however, but in New York. From April 8 to May 20 Painters Eleven were guest exhibitors with the American Abstract Artists* at the Riverside Museum. The Canadians were generously received by the American critics and of course back home news of the exhibition drew more attention than had any of their previous activities. It really marked the acceptance among the informed public of the existence in Toronto of contemporary 'modern' artists. Painters Eleven had to that degree achieved their aim. What, though, of their individual progress during these two years? There was certainly no Painters Eleven style in the sense that there was an Automatiste style.

*An association founded in 1936 in New York to exhibit abstract painting.

Oscar Cahén—who was tragically killed in an automobile crash late in November 1956—had distanced himself in his painting from the illustration that brought him his livelihood until his death, and in his last two years he accomplished a series of compelling pictures. **Painting on Olive Ground* (John and Mable Ringling Museum of Art, Sarasota, Fla) of 1956, with its threatening, jaggedly angular forms and dense concentrations of frenetic scribblings, hung on a simple grid partitioning the olive background, is a provoking image of arrested violence. During the last three years of his life, Cahén pulled some of the younger painters away from their stylized figuration with his intense, concentrated brush drawing and his method of composing in cell-like, often individually coloured, compartments.

Harold Town held his first one-man show in February 1954, at the Picture Loan Society. ('Any real interest in my work begins precisely with the moment I first met Douglas Duncan,' he once said.) He did not exhibit paintings but his unique 'single autographic prints'-which he had begun producing the year before-and drawings. The next year, in October, he showed 'colour print collages' at another gallery, and in November 1956 he held another exhibition of his prints at the Picture Loan Society. (He exhibited paintings only in group shows during these years.) In his drawings, and particularly in his prints and collages, he developed a great formal facility, a highly refined sense of design, and this growing ability began to appear in his paintings. By 1956 he was capable of an assured painting like Dead Boat Pond (NGC), which he exhibited with the American Abstract Artists that year. It reveals a familiarity with Abstract Expressionism (Town had stayed in New York for some months in 1948) in the boldly blocked-in black forms and slashing 'gestural' brushwork. In its cellular composition and dense drawing it recalls Cahén. But it is nonetheless uniquely Town's in its commanding unification of a large, complex image.

Late in 1956 or early in 1957 Town resigned from the executive of the Toronto Art Directors' Club. Tom Hodgson had already quit his job as a commercial artist in 1955, although he free-lanced until 1957 when he once again took a position as an art director. He had continued to paint angular figurative pictures until 1955—*Red Lanterns* (NGC) was made that year. Then, drawing heavily on Cahén and to a lesser degree on Town, he turned to full abstractions like *This is a Forest* (Owens Art Museum, Mount Allison University, Sackville, N.B.).

Both Alexandra Luke and Hortense Gordon continued to find inspiration in the theories and painting of Hans Hofmann. Although they experimented continuously and thrilled their colleagues with their bold

Kazuo Nakamura. Waves, 1957. Masonite, 68.6 × 85.1. NMAG.

enthusiasms, even their most successful work carries a strong mark of derivation.

WALTER YARWOOD continued to work as an advertising artist and had his first exhibition—with Ray Mead—only in 1957. His work of this period shows the same spiky, angular quality as that of Cahén and Town, but contains more massive forms, clearly set in space. As in *The Lost Place* (AGO) of 1956, it is usually very sculptural. Yarwood in fact totally abandoned his painting in 1960 and turned to sculpture. Ray Mead also continued as a successful advertising artist, painting very reserved, almost geometric pictures in his spare time. Mead moved to Montreal the year of his show with Yarwood.

Kazuo Nakamura, working in his quiet, very personal way, organized his painting ideas into a number of overlapping 'series'. He continued with his stylized landscapes, dwelling particularly on the phenomenon of water reflections. There is also a well-known series of strange, brooding pictures depicting monolithic structures set in otherwise empty land-

scapes. But the most beautifully profound are his 'string' paintings. Among the most radically simple works produced in Canada at the time, all—like **Waves* (NMAG) of 1957—are expansive, infinitely subtle pictures. They are without scale, and are equally without limit to their meaning.

Jack Bush was exhibiting figurative pieces as late as 1956, but he was also displaying abstractions with Painters Eleven, of course, and even in some CGP and OSA exhibitions. These early non-objective paintings-like Holiday (AGO) of 1954—had developed out of his earlier interest in Borduas and his subsequent experiments with automatic painting. They already reveal some of the simple forms and distinctive, luminous colour that Bush was later to exploit so profoundly. (Bush's characteristic colours in fact appear in his work in the 1930s.) By the middle of the decade, however, he had settled on a New York type of Abstract Expressionism (he had returned to that city a number of times since 1952). Reflection (RMCL) of 1955—which was exhibited with the American Abstract Artists in 1956—seeks, in its strong tonal contrast, to achieve a deep moodiness. The sooty-grey 'swipes' in the upper portion of the picture-strange objects flying in close formation from dark into an area of most intense light—are suggestive of elements in Borduas's paintings of some two or three years before. They also are a common mannerism of developed Abstract Expressionism. Dramatically striking, they function as a successful device rather than as an inspired creation.

During these earlier Painters Eleven years Jock Macdonald was having even more difficulty than Bush in finding a moving expression of his ideas about form and about the 'natural forces' that supported form. His initial enthusiasm for the Ontario College of Art had soon subsided and by 1951 he found himself in a constant struggle to advance his ideas. While Macdonald coaxed and encouraged his students to find personal freedom in their decisions, most of the faculty resented both his spontaneous enthusiasms and the questioning spirit he brought out in the students. Early in 1954 he even considered leaving the College to teach on his own, like Hans Hofmann, but the decision was postponed when he received a government fellowship for one year of study in Europe. He was ecstatic. 'It will give me the chance to find out at last what I am capable of doing in art,' he wrote.

The Macdonalds left in the fall of 1954, and after a visit to Scotland and a brief stopover in London (Jock was unimpressed with what he saw of current British art), they installed themselves on November 19 in the ground floor of a furnished villa in Vence in the south of France. They stayed there until April 1955. The most important event of the sojourn

Jock Macdonald. *Obelisk*, 1956. Canvas, 101.6 × 61.6. Dr and Mrs Barry Woods, Oshawa, Ont.

was meeting the French painter Jean Dubuffet, who moved to Vence with his wife at the end of January. Macdonald was deeply impressed with Dubuffet, whom he described as a 'sensitive and delicate looking fellow with a friendly disposition and a deep awareness of spiritual values in art.' They visited many times and Dubuffet encouraged the Canadian. Most impressed with Macdonald's watercolours, he suggested that he thin his oil paints to more closely approximate the fluidity of watercolour. 'Start experiments of technique immediately,' he advised; 'it is only a

technique discovery you have to find, everything else you have already.'

Back in Toronto Macdonald had a sense of imminent breakthrough and applied himself determinedly to bringing it about. 'I just feel I want to work, to experiment, to find my next pathway. I believe in myself that my work is saying things and will say more ere long-so my direction seems to be to continue striving and forget about exhibiting for the immediate future.' Consequently the works of 1955–6 are experimental, revealing a great variation in style, format, and medium. * Obelisk (Dr and Mrs Barry Woods, Oshawa) of 1956 has sand embedded in its plastic enamel. In its raw texture, and in the suggestion of a primitive human form, it is of all of Macdonald's work the closest to that of Dubuffet. And in the shallow modelling of its forms, one sliding ambiguously either over or into another, it sets the direction Macdonald would pursue. But early in 1956 he was still unsure of his new work and so exhibited two pre-Vence paintings of 1954 with the American Abstract Artists in New York. Both were painted in a studio he then had in the same building where Bill Ronald worked. One of them, White Bark (Private collection), was painted in the summer of 1954 partly in consultation with Ronald, who encouraged Macdonald in a developing interest in a larger, more prominent single image, a departure from the elaborate and somewhat diffused results of his earlier automatic style.

That summer of 1954 Ronald was more aggressively self-assured than ever. Out of school only three years, he had been painting almost fulltime for two, producing pictures like *In Dawn the Heart* and the Pollockinspired *A Nearness and a Clearness* (NGC), also of 1954. As individual works of art these paintings were unmatched at the time in Toronto in their coherent, direct impact. Ronald knew what he was after and was singleminded in its pursuit. 'Nothing saps your creativity and your energy the way commercial work does,' he has said, and he would occasionally forgo eating rather than put aside his painting for a paying job. At this time all of the other members of Painters Eleven except for Nakamura, Luke, Gordon, and Macdonald were employed as advertising artists, and the latter two were full-time teachers. (Macdonald even had to add some evenings to his four full days at the college in order to afford to rent a studio.)

Ronald held his first one-man show in January 1955, at Hart House. Later that year he moved to New York City. He was convinced that if he was to make his mark as an Abstract-Expressionist painter—and that style certainly seemed to be the only viable language of visual expression in 1955—it would have to be in the birthplace, and still the spiritual home, of the movement. Most of the members of Painters Eleven watched

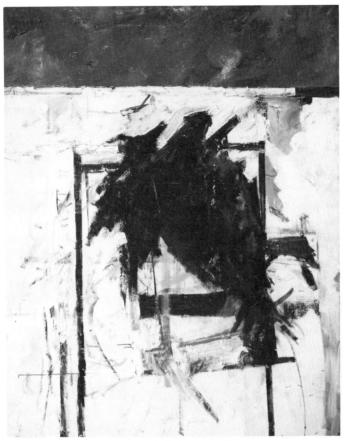

William Ronald. *Central Black*, 1955–6. Canvas, 214.0 × 165.7. RMCL.

Ronald's departure with excited anticipation. He did not disappoint them.

Shortly after his arrival in New York, Ronald began to meet painters associated with the American Abstract Artists group. Primarily through Henry Botkin he learned that they sometimes invited foreign groups as guest exhibitors. Ronald told them about Painters Eleven and to his delight—and not a little amazement—the Toronto group was invited to participate in the twentieth annual exhibition the next April. The show opened on April 8, 1956, and Macdonald, Luke, and Bush flew down to join Ronald for the opening.

It was a most important recognition of Painters Eleven, and Macdonald

was particularly pleased by the generous welcome they received. 'The Americans were superb to us. We have the best room, more space per painting . . . and they used a large canvas by Ronald to place over the main stairway entrance to the Exhibition rooms.' This was Ronald's *Central Black (RMCL), painted that first winter in New York. It is the first landmark Painters Eleven picture. Boldly aggressive, and very much a 'New York' painting in scale and slashing brush work—its central black image on a whitish ground suggests Franz Kline, though it is more organic in shape and less calligraphic than the work of the American-it is still deeply personal in expression. It impressed American viewers with its control. The crudely emphatic centering of the almost chaotic black form presents a satisfying image of dominant will. As a painting it clearly marks a divergence from the free, almost abandoned approach to abstraction earlier espoused by the Montrealers and the first generation of American Abstract Expressionists. Interestingly enough, it coincides almost exactly with Borduas's turn to a new interest in structure in his art

The American Abstract Artists exhibition was Ronald's first public display in New York. It brought him some attention, and one collector-the Countess Ingeborg de Beausac-introduced him to Samuel Kootz, an important dealer who handled some of the major Abstract Expressionists. Ronald was given his first show (his first commercial exhibition ever) at the Kootz Gallery in April 1957. Parker Tyler, a well-known New York critic, wrote in the introduction to the catalogue of his amazement at how, after only two years in New York, Ronald had been able to 'clairvoyantly appropriate its milieu of paint'. Like a conqueror, Tyler observed, the Canadian 'bows to take over'. It was doubtless this ability to command the New York idiom with such seeming effortlessness that led to Ronald's amazingly rapid rise. This first show was a great success, and it was followed by another in 1958, and four more by 1963. Already by 1959 Ronald had become such a 'star' in the Kootz stable that it was his one-man show that opened a new Madison Avenue location that October.

Ronald's first New York success in 1957 also had immediate and farreaching consequences for Painters Eleven back in Toronto. Realizing the importance of the occasion for Macdonald ('It was everything Jock and I had talked about coming true,' said Ronald), a Toronto university professor and his wife—collectors and supporters of Painters Eleven—paid Macdonald's air passage to the opening. It was a brilliant New York affair. Macdonald was 'as proud and happy as if it was his own show'. Hofmann, Franz Kline, and Mark Rothko were all there, and Clement

Greenberg, an influential critic, talked with Macdonald about Painters Eleven. He was impressed by Ronald and curious about the kind of scene that produced him. The upshot was that Greenberg said he would be pleased to be invited to Toronto to see these painters. Jock later related the incident to Ronald, who believed that it represented a wonderful opportunity for Painters Eleven-perhaps a crucial break. Later, back in Toronto, a meeting was held to discuss the proposal. Ronald was so convinced of its worth that he flew up from New York to encourage an affirmative decision. The meeting, however, resulted in the first serious division in Painters Eleven when Town and Yarwood strongly opposed paying the way of an American critic to view their work. The others were so enthusiastic, however, and Ronald pressed so firmly, that the dissenters finally decided to opt out rather than block the project. Greenberg came up in June 1957 and spent half a day in the studio of each cooperating painter. None ever later discussed with others in the group these strangely intimate communions with one of the principal theoreticians of modern American painting. Jock, however, wrote to a friend in Calgary: 'At long last I am really on the road-so says Clement Greenberg. He arrived here after I had two of the new things done so he told me that my new work was a tremendous step forward, in the right direction, completely my own and could stand up with anything in New York. The step forward is through my being able to completely free myself from the canvas limitations—or what he called "the box" '.

Which were these first two new canvases—done after viewing Ronald's New York show—we don't know. But they were followed by a summer of intense production. Writing to his friend in Calgary again early in August, Macdonald reported: 'I have twenty-two new things done since the college closed in the middle of May and I am still at it with increased enthusiasm.' These would have included a number that were very clearly painted in response to Ronald's exhibition. *Airy Journey* (HH), in fact, is limited to the black, white, and red-yellow of *Central Black*, although its centred black shape is closer to Franz Kline's calligraphy than is Ronald's. Others, like *North Wind* (Mr and Mrs William Nurse, Whitby, Ont.), grew directly out of *Obelisk*. The modelled form has now completely broken down, though, and the shimmering planes float effortlessly over or through one another.* They are altogether different from anything I have ever done and in our opinion far superior. I am really surprised. ... Greenberg gave me such a boost in confidence that I cannot remember

*Town had introduced Macdonald to Lucite 44 in the summer of 1956. Fluid and quickdrying, it has many of the characteristics of watercolour in handling, while finishing like oil. It assisted Macdonald in achieving this easy interpenetration of transluscent forms. ever knowing such a sudden development taking place before. The only parallel was when I concentrated for five months producing automatic watercolours every day. This work is also automatic.' That November 1957 at Hart House he had his first one-man exhibition after ten years in Toronto.

Jack Bush is the other member of Painters Eleven who was demonstrably affected by Greenberg's visit. Looking at paintings like *Reflection*, Greenberg was apparently much more critical of Bush's accomplishment than of Macdonald's. He immediately questioned the Abstract-Expressionist mannerisms; he called the facile brush effects 'hot licks'. Bush considered the use of such hard-learned devices an accomplishment, and this criticism totally destroyed the confidence he had built in his work over the past years. Greenberg did have suggestions, though. He believed that Bush possessed real promise, and in some watercolours in particular—likely similar to the beautifully constructed and sensitively coloured *Theme Variation No. 2* (AGO) of 1955—he found a simplicity that allowed the most essential characteristics of Bush's sensibility to shine through. Greenberg suggested that Bush strive to achieve a similar quality in his oils. He also invited Bush to call on him when he next visited New York.

Bush decided to try a couple of canvases that were simple in composition and straightforward in handling. They turned out so simple and unembellished that he was hesitant to consider them complete. He turned them to the wall and went back to his Abstract-Expressionist style. But he kept turning them around, beginning to feel that they were indeed more 'full' as paintings, and they began to influence his exhibited work. By January 1958, when he held a one-man show at the new Park Gallery his first since that initial visit to New York six years before—a very distinct change was evident. **Painting with Red* (RMCL) of 1957 was in that show. Its simple structure is largely responsible for the picture's compelling interest. The forms, which had formerly been almost facile, now have a moving awkwardness, and the colour—limited to mustard-brown, brown, red, grey, and white—is unaffectedly direct. Bush had achieved a profoundly human statement with simple, uncontrived means.

The Park Gallery, which opened at the end of the summer of 1957 across from the Park Plaza on Avenue Road, was run by two men who were connected with one of Toronto's leading advertising firms and were friends of most of the commercial artists in Painters Eleven, and by a local critic, Paul Duval. The Roberts Gallery had failed to follow up its 'Small Picture' show—which had proven no more successful commercially than had the previous two—so when plans were announced for

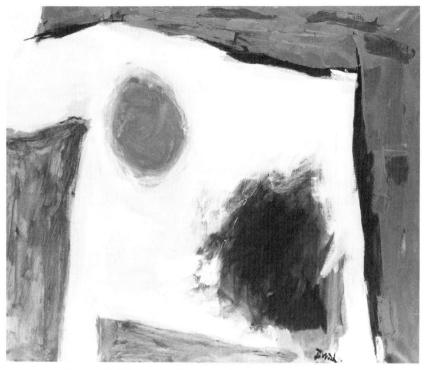

Jack Bush. Painting with Red, 1957. Canvas, 121.7 × 152.1. RMCL.

the Park Gallery, it seemed natural that Painters Eleven should find a new Toronto showplace there. Ronald expected this commercial gallery to pay for shipment of his works (owned by his New York dealer) from New York. Other members, and particularly Town, felt that Ronald should, like the others, bear the expense of transporting his own work. Ronald also disliked the idea of associating publicly with the critic-dealer Duval. In the argument that ensued, Town and Ronald squared off (Town felt Ronald had become 'inflated' by his New York success), and Ronald resigned from Painters Eleven on August 17, 1957. The Park Gallery show, with a sixteen-page illustrated catalogue, went on without him that November and received the most enthusiastic local reaction to date. In spite of Ronald's absence, the international ambitions of the group were stressed in the catalogue statement. 'What might seem novel here in Ontario is an accepted fact everywhere else. Painting is now a universal language; what in us is provincial will provide the colour and accent; the grammar, however, is a part of the world."

In May 1958 the Park Gallery show was displayed at the École des Beaux-Arts in Montreal, thanks to the efforts of Jacques de Tonnancour. And from that showing Richard Simmins of the National Gallery selected thirty works to circulate across Canada. Also in 1958 Painters Eleven prepared a statement for a 'confrontation' show organized by the London Art Museum that placed their work opposite that of the conservative Ontario Institute of Painters. This statement claimed that Painters Eleven had received 'more individual honours and collective acclaim than any other group in Canada. In so doing, we have secured recognition for the vital, creative painting being done in this province. In this sense, our work will soon be accomplished, and no doubt we will return to the singular ways that are best for painters, anywhere, anytime.' The last Toronto exhibition was held shortly thereafter, at the Park Gallery in November 1958, with ten of the Montreal hosts of May as guests. The group accepted invitations to show later—in April 1960 at the MMFA and in December 1960 at the Kitchener-Waterloo Art Gallery—but these exhibitions were a belated recognition of a phenomenon that was already over. In October 1960, in fact, they met at Tom Hodgson's studio and formally disbanded. All present agreed that the adventure begun some seven years before had ended in success.

'Painting contemporary with its time' had been brought to Toronto, and by the late fifties a vital scene had once again developed in that city, a scene that went far beyond the activities of Painters Eleven. But probably even more important as an accomplishment than this general enlivening—for surely something would have forced the issue during the decade if Painters Eleven had not existed—was the individual achievement of virtually every member of the group.

Ronald's New York success had become legendary in Toronto by the end of the fifties, and he was probably then the single most influential painter in the city, even though he continued to live in New York. He had exhibited at Av Isaacs' Greenwich Gallery in November after his first Kootz show in 1957. And his New York exhibitions were even reviewed in the Toronto papers. In October 1959 Robert Fulford covered the Kootz show of that year, noting Ronald's increasing concern for 'structure' in his still basically Abstract-Expressionist canvases. All presented large, roughly circular images against patterned backgrounds (since *Central Black*, he had made the centred image his own particular concern). Fulford singled out *The Visitor* as 'the most striking and memorable work', interpreting it as 'a huge head which explodes off the canvas in a dozen directions, filling the room with its presence'.

In April 1960 Ronald had an exhibition at Toronto's Laing Galleries. It

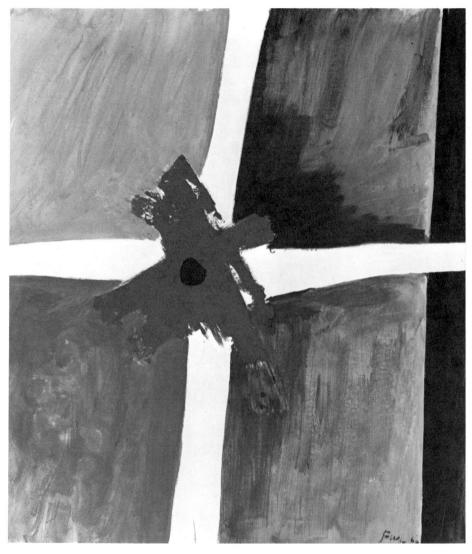

XXXII—Jack Bush. The White Cross, 1960. Canvas, 203.2 \times 177.8. AEAC.

xxxIII—Guido Molinari. Mutation rythmique No. 9, 1965. Canvas, 203.2 × 152.4. NGC.

was to many of the local artists the 'return of the conquering hero'. This show, displaying his most recent refinements on the 'central image' works, included $\dagger Gypsy$ (Dr and Mrs Sydney Wax, Toronto), which had developed directly out of *The Visitor*. It is rather an *implosion*, though; the pinkish red and almost electric blue are in direct juxtaposition, building to an intense level of inward-concentrating energy. The central form in *Gypsy* is almost spherical, floating freely against rough dark and white stripes—free of the pattern where *The Visitor* had been held by it. It is a consummate work, almost magical in its effortless levitation; a featureless Veronica's veil.

The Toronto buyer of *Gypsy* waited until it was shown at Kootz in November before purchasing it, however, and Ronald realized that his great success in New York—his work was owned by over twenty American museums and was part of every important collection in that country—tied him to that scene. Comfortably settled in Kingston, N.J., just two hours from New York, he took out American citizenship in September 1963.

Harold Town's first one-man show to include paintings was held at the new Gallery of Contemporary Art in Toronto in 1957, the year Town gave up full-time commercial art, though this exhibition also included examples of his famous 'single autographic prints' (it was only in 1962 that he exhibited canvases alone). His prints and collages are obviously central to his art. Both the collages and Town's unique method of printmaking entail judicious deliberation in the placement of each of the discrete elements—his is an art of carefully interrelated components. The problem is to achieve a sense of natural wholeness with such an 'additive' technique. Like most of the other members of Painters Eleven, Town usually found unity in the broad sweeping gestures of Abstract Expressionism, as is evident in *Dead Boat Pond*.

His most ambitious essay in 'action painting', and probably his most successful, is a huge (3 × 11 metre) mural he painted between early May and late July 1958 for the Robert H. Saunders Generating Station on the St Lawrence Seaway. The paintings Town exhibited later that October in a two-man show with Borduas at Arthur Tooth & Sons in London, Eng.—are closer to his delicate large collages (which made up two-thirds of this showing) than to the bolder approach seen in the mural; but an aggressive, broad paint-handling began slowly to dominate in his canvases during the next year. He continued to show mainly his collages and graphics, however, and to great acclaim. Alan Jarvis, then Director of the National Gallery, referred in his introduction to the catalogue of the Tooth show to Town's drawing as 'Picasso-esque in its fluency, its authority and its range'. And Robert Fulford in January 1959 contributed a note to the catalogue of a Town collage exhibition at the Jordan Gallery in Toronto, and an introduction to a catalogue for a drawing show at Laing Galleries the following September. 'As a draughtsman,' he said then, Town 'is unequalled by any member of the present generation in Toronto or anywhere else in Canada.'

In March 1961 the Laing Galleries exhibited collages, prints, and-for only the second time in Toronto in a one-man show—paintings by Town. Robert Fulford, again, was particularly moved. 'Town's search is not necessarily for beauty-though he achieves that, even formal beauty, in some of his best work; nor for power, though that too is a vital characteristic of his larger canvases. His real search, though, is for the heroic gesture.' Among the canvases in this show, like *Side Light* (AEAC) of 1960, were some of the most freely 'gestural' Toronto had ever seen. They are consistent with earlier paintings in their intricately busy detail and in displaying Town's usual assured design sense, but they still represent a vivid new departure in their dashing, almost calligraphic images. Even though they convey a fascination with the central-image format—which is most pronounced in Landscape (AEAC)-they are fresh and inventive variations on Abstract Expressionism and are in no essential way dependent on Ronald. (Many Toronto painters had been moved to work with that format after Ronald's April 1960 exhibition in those same Laing Galleries.)

Jack Bush never really looked back after his first Park Gallery show in 1958, although he once asserted that he was not thoroughly used to his new direction until 1960. He showed at the Park Gallery in 1959 and again in 1961, and continued to visit New York on a more-or-less regular basis. He became a good friend of Clement Greenberg's and through him met a number of American artists who were concerned in the same way as he was to emphasize colour and basic structure through ruthless simplification. These contacts gave Bush that last bit of assurance he needed. *†The White Cross* (AEAC) of 1960—which Bush called *Spot on Red*—is certainly assured. The harmonious, and apparently effortless, conjoining of its quarters—each somewhat eccentrically coloured in a different, shaded hue—with the black-spotted mark of intense red is a brilliant achievement.

Jock Macdonald too moved from strength to strength after Greenberg's visit. He believed that he was very close to the culmination of his life's search and struggled almost desperately to find time to paint. In 1958 he sent works to exhibit everywhere he could, but the expenses only increased the financial difficulties that plagued him. In the summer he

Jock Macdonald. Nature Evolving. 1960. Canvas, 111.8 × 137.2. AGO.

took on yet another teaching load when he accepted a position at the Doon School of Fine Arts. It meant the loss of at least three weeks of his valuable summer-vacation period, and probably more, because such breaks from the intense concentration of his painting routine threw him off stride. Nonetheless he moved into a new phase that year, featuring large slabs of radiant colour sliding one into the other, which culminated early in 1959 in the monumental *Heroic Mould* (AGO). The largest canvas he would ever paint (over 180 centimetres tall), it is still breathtakingly delicate in its colouring, and complex and involving in spite of its boldly simple form.

In April 1959, after more than ten years, Macdonald was able to give up his evening classes—sales were gradually occurring. He was painting during every free minute. Over that year and into the next he seems to have worked through a number of series of paintings, each a variation on a different colour combination or image. The pictures that culminated each series are of astounding quality. All—like *Fleeting Breath* (AGO) and *Earth Awakening* (Mrs John David Eaton, Toronto) of 1959 or *Nature

Evolving (AGO) of 1960—are complex yet emphatically unified descriptions of a profound world-view. They celebrate states of change with the grace of natural inevitability. By early 1960 Macdonald was working full-out, racing with the pounding excitement of a man suddenly articulate after a lifetime of struggling to speak.

Dorothy Cameron gave Macdonald a one-man show in January 1960 at her Here and Now Gallery, and at about the same time the Art Gallery of Toronto approached him for a retrospective exhibition. He was very pleased. Everyone knew he would be the first living Canadian, other than members of the Group of Seven, to have been afforded such an honour. Then in the midst of the preparations he heard that the Ontario College of Art had changed its policy and would insist on retirement at sixty-five. Macdonald was crushed by the news. It meant that he would have to retire after the following year on a monthly pension of only \$100; and he had no savings. The work on the retrospective rushed him along, however, and it opened on April 29 to an enthusiastic reception. Sales increased markedly and the Roberts Gallery signed him on. That summer his pace slackened and his painting became softer, even more spiritual. As is evident in All Things Prevail (NGC), he was blending his colours, building up rich moving combinations of green, blue, red, and white, at times rubbing the lucite into his canvas to produce an intense stain. All Things Prevail was his last completed canvas. He died of a heart attack on December 3, 1960, less than two months after Painters Eleven had been formally dissolved. The magnificent creative flowering of Macdonald's last three years is their greatest testament.

A Continuing Tradition 1955–1965

The continuing Canadian tradition in painting naturally flourished most vigorously on its two principal stalks: those nurtured in Toronto for some hundred and thirty years and in Montreal for almost two hundred and sixty-five years. By the mid-sixties of the twentieth century, however, it seemed clear that painting had found a sympathetic and sustaining response in other parts of the country as well. Vancouver had seen at least four consecutive generations of creative artists. London, Ont., became one of the places in Canada where it was possible to see art of consequence. And in numerous other communities across the nation there were serious, committed painters contributing principally to their region but often rising to national, and at times even international, significance.

Outside the metropolitan centres the incentive for excellence derived mainly from university art departments. The oldest such department in Canada was at Mount Allison University in Sackville, a small town in New Brunswick near the Nova Scotia border. Since 1893 its art school has been centred on the Owens Art Gallery, a charming late-nineteenthcentury structure housing a small but interesting permanent collection.*

The first director to pull the Mount Allison school fully into the twentieth century arrived only in 1946. LAWREN P. HARRIS (b.1910), the son of Lawren Harris of the Group of Seven, was born and raised in Toronto. He received his formal training at the school of the Boston Museum of

*John Owens, a ship-builder and merchant of Saint John, left a sum of money on his death to be spent on the religious and artistic education of the youth of his city. The Owens Art Institution was consequently founded in 1885 in Saint John with a local painter of some national prominence, John Hammond (1843–1939), as its principal. Hammond, in between extensive travels, ran the school in Saint John until local interest fell off in the early nineties. Both he and the school were moved to Mount Allison Ladies College in Sackville in 1893 and the gallery was that same year built to house the collection Hammond had helped to assemble on his travels. He continued to travel widely in America, Europe, and the Orient until 1901, when he decided he would be content to settle in Sackville. He ran the school until 1919 when he retired, and continued to live in Sackville until his death in 1939.

274 | A Continuing Tradition

Fine Arts (1931-2) but learned much more from the intense artistic activity surrounding his father in Toronto in the late twenties. Harris began teaching at Northern Vocational School in Toronto in 1936, then in 1939 switched to Trinity College School in Port Hope, Ont. He joined the army in 1940—first serving as a lieutenant in a tank regiment—and in 1943 was made an official war artist. With an eye for a striking image, he produced a number of canvases for the war-art program depicting the strange nightmare world of mechanized warfare. Tank Advance, Italy (Canadian War Museum, Ottawa) of 1944 shows a pack of heavily camouflaged tanks speeding across a plain like so many armoured hillocks churning up great obscuring clouds of dust. Such highly finished paintings, in a style we would today call 'magic realism', were the works by which he was known when he assumed the directorship of the Mount Allison University School of Art in September 1946. Harris soon moved on to geometric abstraction, inspired—as is evident in the beautifully serene *Project* (the artist) of 1947—principally by Kandinsky and the work of his own father. Such explorations in fundamental colour and form have occupied him since.

Harris was joined in Sackville in September 1946 by a young local man also just returned from service as a war artist. ALEX COLVILLE (b.1920) was born in Toronto. When he was seven his family moved to St Catharines, Ont., and two years later to Amherst, N.S., near the head of Chignecto Bay, the northeastern arm of the Bay of Fundy. In 1938 Colville enrolled in the Fine Art Department of Mount Allison University in Sackville, a few kilometres northwest of Amherst. He graduated in 1942 and joined the army; two years later he was commissioned as an official war artist. Upon his discharge in 1946 he took a position teaching art at Mount Allison. Colville's war paintings are realistic, like those of Harris, but his forms are not so smoothly modelled nor are the subjects chosen so strikingly horrific. He often, in fact, seeks out the most ordinary of moments, as in *Infantry Near Nijmegen, Holland* (Canadian War Museum, Ottawa) of 1946, where a long line of tired soldiers tramps towards us through muddy snow, away from battle, each man lost in his own thoughts.

In Sackville, Colville became involved in his teaching duties and painted little before 1950, the year of his haunting *Nude and Dummy* (New Brunswick Museum, Saint John, N.B.). In it a nude woman stands at the window of a bare attic room, looking back over her shoulder towards us at her dressmaker's dummy in the foreground. The picture is precisely organized, with the architectural lines of the room dividing it exactly down the middle, the woman small in her space, the dummy looming large in its. The colour is gentle, almost pastel, and the paint is applied

Alex Colville. Couple on Beach, 1957. Board, 68.5 × 91.4. NGC.

in small separate strokes. Shading is accomplished by cross-hatching.

All of Colville's subsequent paintings reflect a similar interest in the precise, geometric articulation of space. Most of them show figuresusually in juxtaposition with inanimate objects, animals, or other human beings-carefully placed at the most concentrated point in that space, drawing substance from the charged atmosphere. This precision suggests arrested action, the 'magic' moment. But the way the invariably passive subjects often contemplate their co-inhabitants-the woman her dressmaker's dummy, or the child a Black Labrador in Child and Dog (NGC) of 1952—suggests self-reflection as well. Such an interpretation leads us to reflect on their self-contemplation (their bodies are often nude or only partially clothed), and gives rise-as much as Colville's precise rendition of texture does-to an acute tactile sensation. It is the unfulfilled desire to touch and become involved in the painting, half realized in anticipation but discouraged by the 'distant' quality of his pictures, that gives his work its poignant ambiguity. This is unusual in painting; one more often senses it in films. Colville's images are in fact much closer to those of the best film-makers of the British-American popular tradition-particularly

276 | A Continuing Tradition

Alfred Hitchcock—than to those of other painters. There is the same concern for precise composition and the arrested moment, the same understanding of the body as being somehow the focus of the space through which it moves. And like Hitchcock, Colville is often unashamedly contriving, fully aware that the exact configuration of his scene can—as in *Woman, Man and Boat* (NGC) of 1952—make of his usual sensuality an overt yet far from explicit sexuality, or, as in **Couple on Beach* (NGC) of 1957, an ambiguous primal image of the conjoining of two seemingly detached beings.

Colville's painting is collected avidly both in Canada and abroad and in 1963 he was able to quit teaching, though he continued to live in Sackville for another ten years. He now lives near Wolfville, N.S. Before leaving Mount Allison, however, he had a great influence on a number of his students who, like him, have chosen to stay in the Atlantic region. CHRISTOPHER PRATT (b.1935) of St John's, Nfld, graduated from Mount Allison in 1961 and has since worked in his native province. His painting is more generalized in form, more austere than Colville's, but his interest in evocative images of isolation—always in a Newfoundland setting—is clearly derived from his teacher. Another student of Colville's, TOM FOR-RESTAL (b.1936), was born in Middleton, N.S., and studied at Mount Allison from 1954 to 1958. He too has stayed close to home, working in Fredericton, N.B., following graduation, although his realistic pictures diverge from Colville's in theme more clearly than do those of Pratt.

If a continuing tradition does develop in the Atlantic provinces it could grow from the work of these 'magic realist' painters. The only other promising beginning was in Saint John, N.B., where Jack Humphrey (see pp. 198–9) and MILLER BRITTAIN (1912–68) both worked for some thirty-five years. But that start seems to have ended with their deaths. Brittain, like Humphrey, was born and raised in Saint John. He then studied drawing in New York at the Art Students League (1930–2). Back in Saint John, he worked as an artist for the rest of his life—except for four years in the Air Force (one as an official war artist)—responding to an increasingly more personal vision. *Man and Woman* (BAG) of 1957 is typical of his mature, visionary art. Awkward, strident, but with serenely beautiful passages, it and many of his other paintings will doubtless find a secure corner in the history of Canadian painting as they become better known outside the Maritimes.

The Prairie West—a region, like the Atlantic Provinces, of rigorous climate, relatively sparse population, and limited economic development (mainly of resources)—is in artistic matters similar to the Maritimes area in that the most important sustained activity historically has centred on art-educational institutions, primarily at Banff, Alberta, and, most importantly, at the University of Regina, Saskatchewan. The Banff School of Fine Arts-until recently mainly a summer school for hobbyists-has served as a place of meeting and a source of income for the more serious artists in the West. An outgrowth of an art camp first held in 1935 by the English mountain-painter A.C. Leighton (1901-65), it has since employed most of the artists of local importance and has annually attracted an increasing number of painters from elsewhere in the country. A.Y. Jackson, who had relatives in southern Alberta, taught for six summers beginning in 1943, and Jock Macdonald also taught there in the summers of 1945 and 1946. Macdonald then stayed on in Alberta as head of the art department at the Provincial Institute of Technology and Art in Calgary (renamed the Alberta College of Art in 1961). The Provincial Institute first began to give classes in art in 1926, conducted by a Norwegian 'impressionist', Lars Haukaness (1862-1929). After his death, classes were run by that same Leighton who was later to start the summer school at Banff, and he in turn was replaced in 1935 by the Englishman H.G. Glyde (b.1906), who also, from 1936, headed the painting department at Banff. When Jock Macdonald taught in Calgary for one year in 1946-7, he was most impressed with two painters: another teacher at the institute, Marion Nicoll (1909–85), and a local architect-painter, MAXWELL BATES (1906– 80).

Bates was the first Albertan artist to achieve national prominence. Born in Calgary, he began to work in the office of his architect father at the age of eighteen. Two years later he enrolled in the new painting class in the Provincial Institute under Lars Haukaness and was soon drawing and painting in an expressionist figurative style derived from art books and magazines; in 1928 he even tried his hand at an abstraction. Bates's efforts were met with bewilderment, even hostility, and in 1931 he decided to move to England. In London he worked in an architectural office and continued to paint until 1939, when he joined the British army. Captured by the Germans in 1940, he spent the rest of the war in a POW camp, returning to Calgary in January 1946. He had been abroad for fifteen years.

Jock Macdonald arrived in September, and, with Marion Nicoll and one or two others who were also interested in personal expression, formed a loose-knit 'Calgary group' around Maxwell Bates. Macdonald left the following summer, but for the next fifteen years (with a year out in 1949–50 to study with the German Expressionist painter Max Beckmann at the Brooklyn Museum Art School) Bates continued to make his

278 | A Continuing Tradition

living in Calgary—primarily as an architect—and acted as the centre of a group of painters made up mainly of teachers in the Provincial Institute. Each pursued personal experiments in expressionist figuration, and by the later fifties in abstraction, but no one in the group focused its activities. In 1961 a partial stroke caused Bates to give up his architectural practice and the next year he moved to Victoria, B.C., where he continued to paint cynical but brightly coloured, highly expressive comments on the human condition.

What has proven to be the most important concentration of creative activity on the Prairies developed in Regina. Interest in art first appeared there just before the First World War with the arrival of two British artists, Inglis Sheldon-Williams (1870–1940), who taught at Regina College from 1913 to 1917, and James Henderson (1871–1951), who worked in the city from 1911 to 1916. It was only in 1936, however, that the potential for the growth of an active climate for the arts was first recognized. That year Augustus Kenderdine (1870–1947)—another British-born-and-trained painter who had been teaching at the University of Saskatchewan in Saskatoon since the early twenties-moved to the provincial capital to start an art department at Regina College and arranged for the university to take over and develop some property he owned on Emma Lake, in the wilderness north of Prince Albert, as a summer school for the arts. Established at about the same time as Banff, it grew into an annual sixweek summer course, administered by the School of Art at Regina College. Nineteen years later, in 1955, two young painters connected with the School of Art-Kenneth Lochhead and Arthur McKay-persuaded the university to extend this summer camp by two weeks so that a workshop could be held for professional artists.

KENNETH LOCHHEAD (b. 1926) of Ottawa, who had been named the director of the Regina College School of Art in 1950 at the age of twenty-four, had studied at the Pennsylvania Academy at Philadelphia and at the Barnes Foundation, Merion, Pa (1945–9). ARTHUR MCKAY (b. 1926) from Nipawin, Sask., east of Prince Albert, who had joined the art school as an instructor in 1952, had studied at the Provincial Institute of Technology and Art in Calgary (1946–8), where he came into contact with Jock Macdonald, and then in Paris (1949–50). The first artist they invited to lead the workshop at Emma Lake was Jack Shadbolt from Vancouver; then, in the summer of 1956, they invited Joe Plaskett (b. 1918), also from Vancouver, though resident in Paris (as he is now). The following year they had their first American guest: Will Barnett from the Art Students League in New York. The most far-reaching impact, however, resulted from the visit in the summer of 1959 of Barnett Newman. Now seen to be one of the giants of the post-war generation of American painters (he died in 1970), Newman was then almost unknown outside the New York painters' world, although an exhibition that March at the new French & Co. galleries (his first in New York since 1951) had been recognized in some reviews as a landmark. Newman had developed out of that same wartime milieu that produced Abstract Expressionism, but he rejected many of the elements of that style. His usually very large paintings seem radically simple, with vast, unmodulated areas of colour articulated by one or more vertical stripes. They are radiant, and in their monumental presence unique. By 1959 it was clear that Newman's work was pointing in a new direction, away from Abstract Expressionism. Indeed, the 'action' painters would be replaced by more reflective, contemplative spirits.

Newman was invited to Emma Lake by McKay and two others then connected with the art school, Roy Kiyooka and Ronald Bloore. Each found himself ready to consider the direction the American proposed. A Canada Council grant had allowed McKay to take a year off (1956–7) to study at Columbia University and at the Barnes Foundation (where Lochhead had studied ten years before). He has described his work then as 'an abstract version of English landscape painting'. In New York he saw the memorial retrospective of the work of Jackson Pollock, who had died in an automobile crash in August 1956. McKay was interested in the effects of hallucinogenic drugs such as mescaline, and later volunteered to participate in the pioneering controlled experiments with LSD then being conducted at the University of Saskatchewan.* His drug experiences intensified an interest in contemplative art and opened for him the expanding yet effortlessly contained 'all-over' cosmic images of Jackson Pollock.

ROY KIYOOKA (b.1925)—born in Moose Jaw, about eighty kilometres west of Regina, although raised in Calgary (where, because of his Japanese ancestry, he was registered as an 'enemy alien' during the war)—first studied art at the Provincial Institute in Calgary (1946–9) with McKay, and like him came into contact there with Jock Macdonald. He then worked in Calgary as a display artist, teaching an evening class at the Institute and associating with the small Calgary group around Maxwell Bates. In 1954 he worked on a display job in Nelson, B.C., but the next year a scholarship allowed him to study for a year at the Instituto Allende in Mexico. There he too was introduced to hallucinogens and, as he has recorded, 'did my first real paintings'. In September 1956 he took a position as an instructor at Regina College. His paintings of that period—

*It was Dr H. Osmond, then superintendent of the Saskatchewan Hospital, who in 1957 suggested the term 'psychedelic' to describe LSD and related drugs.

280 | A Continuing Tradition

'controlled' Abstract-Expressionist works, with an expanding, often centred image—reveal interests not unlike McKay's.

The third painter involved in inviting Barnett Newman was not a westerner and had moved to Regina only the summer before. RONALD BLOORE (b.1925) was born in Brampton, west of Toronto. He studied art history at the University of Toronto, graduating in 1949, and then spent two years at the Institute of Fine Arts at New York University and a year at Washington University, St Louis, Mo., where he received an M.A. After two years of lecturing at Washington U., he studied for two more years at the Courtauld Institute of the University of London (1955–7) and then lectured for a year back at the University of Toronto. In the summer of 1958 he became the director of the Norman Mackenzie Art Gallery at Regina College.* With a thorough academic training in art history and a developed, broad interest in aesthetic theory, Bloore brought an intellectual rigour and assertive purposefulness to the Regina group.

At the college a definite 'group' was forming for whom Barnett Newman would act as an amazing catalyst. Newman did no painting at Emma Lake in the summer of 1959, but his intense commitment and his unquestionable seriousness in the exploration of new areas of human experience moved the Regina painters deeply. McKay seems to have responded directly to Newman's own painting practices. He stopped making oil paintings and proceeded to experiment with flat black paint on paper. (Newman had the year before painted the first two of his famous Stations of the Cross, using only black paint, and there is a well-known series of black ink-on-paper works of 1960.) McKay's results do not resemble Newman's work, however; as Terry Fenton has pointed out, they are much closer to Pollock in their 'all-over' interlocking forms. None of the other painters began producing 'Newmans' either, although many were inspired to attempt solemn paintings of vast scale, simplified in form and colour. Four of the people involved in the workshop, and Kenneth Lochhead—in Italy on a year's leave during Newman's visit—were by the next year painting distinctively new work, and beginning late in 1961 an exhibition of this 'Regina Five' was given a cross-country tour by the National Gallery. McKay and Bloore were among the 'Five'-Kiyooka had left Regina to take up a position at the Vancouver School of Art in 1959. The two other members were Douglas Morton (b.1926) from Winnipeg, who had moved to Regina in 1954, and Ted Godwin (b.1933) from Calgary, the youngest of the group (all the rest were born within a year of one another), who had arrived in Regina in 1958.

*Opened in 1953, the Norman Mackenzie Art Gallery houses the collection (since extensively augmented) left in 1936 by the Regina lawyer after whom it is named.

Ronald Bloore. Painting, June 1960, 1960. Board, 121.9 × 121.9. NGC.

Of the 'Five', Bloore and McKay were in the early 1960s the most accomplished, the most resolved, and they have since continued to develop the basic approach they were able to establish then. Two early pictures by Bloore, *Painting No. 1* of 1959 (NMAG) and *The Establishment* of 1960 (Mr and Mrs A.W. Johnson, Regina), are without pictorial 'image'. Both are four-feet-square (1.22 m.) masonite panels covered with a homogeneous coat of paint—freely impastoed in the latter; carefully laid on in even, broken stripes in the former, giving the appearance of the stratification of a bed of slate. Then Bloore painted a number of centred circular image paintings on similar $4' \times 4'$ masonite. The most impressive is **Painting, June 1960* (NGC). Made with slightly tinted paint on a white ground, the circular image is worked up in a delicate relief of radiating

Arthur McKay. Effulgent Image, 1961. Board, 121.9 \times 121.9. Mr and Mrs Clifford Wiens, Regina.

lines, broken in a whorl that extends out to about halfway along the radius. Resembling the underside of a mushroom, the minimal differentiation between the radiating image and the ground induces a concentrated examination that draws the eyes inexorably to the centre. The fine lines then stand out like taut wires, running in and out at invisible speed. The effect is almost hypnotic.

Bloore, unlike many of his colleagues in Regina, never became involved in creative experimentation with hallucinogens, although an interest in oriental thought and expression gave him common ground with the others. And his mandala-like, contemplation-inducing pictures of 1960 certainly helped point a direction for McKay. The westerner had attempted to translate his paper works of 1959 into a larger format by employing-at the suggestion of Bloore-enamel on masonite. Experimenting later in 1960, he devised a method of 'skimming' freshly applied enamel that left a heightened negative pattern of the irregularities in the surface of the masonite as the enamel darkened in the depressions where it was thickest and was left thin and transparent on the ridges. By preparing the masonite surface a range of effects is possible, all of them ambiguous because the enamelled surface appears textured when it is in fact as smooth as glass. Employing this technique, McKay began in 1961 to paint circular shapes on $4' \times 4'$ sheets of masonite. *Effulgent Image (Mr and Mrs Clifford Wiens, Regina) is one of the best of these first mandala pieces. It is radiant, and with extended contemplation it begins to 'breathe', to become an organic, ever-changing enlivened space. Magically complex, it nonetheless has a simple, bell-like clarity. It reflects a view of the world immediately and profoundly real to those who have exercised the discipline of meditation or have experienced a union with their environment through the medium of hallucinogens.

Bloore turned to more 'painterly' concerns in 1961, completing a group of pictures of crosses, spoked wheels, and other 'centred' devices, all of them painted with warm colours freely brushed. Then in 1962 he received a Canada Council grant that allowed him to spend a year on the Greek Island of Lesbos. When he returned to Regina he destroyed most of his earlier pictures and proceeded to work exclusively in white-on-white relief on masonite. He discovered that many of his colleagues had also gone through a change over the last year, induced primarily by the visit of another influential American to Emma Lake in 1962. The workshop that summer had been conducted by Clement Greenberg, the New York critic who had been involved with Painters Eleven in Toronto five years before. Surprised to discover on the Canadian Prairies painters of the calibre of the Regina Five, he encouraged them-as he had the Toronto painters in 1957-to abandon even the last vestiges of Abstract-Expressionist mannerisms evident in their work in order to seek a more direct expression through the configuration of simple forms of colour. Lochhead responded most readily, abandoning the calligraphic, black-greyand-white 'action' paintings he had been making in favour of large, simple 'colour' paintings like Dark Green Centre (AGO) of 1963. When Greenberg in 1964 organized his 'Post Painterly Abstraction' exhibition for the Los Angeles County Museum of Art-to define the new generation of 'colour' painters he believed had supplanted Abstract Expressionism-Lochhead, McKay, and Jack Bush were each included.

Greenberg discovered on his visit a number of landscape painters working out of Saskatoon that he considered to be as accomplished in

their own way as the Regina Five. They included the watercolourist Robert Newton Hurley (1894-1980), born in London, England, who retired to Victoria in 1963, and Reta Cowley (b.1910), from Moose Jaw, a sessional lecturer at the University of Saskatchewan who also worked in watercolours. The best of the watercolourists, however, was DOROTHY KNOWLES (b.1929). Born in Unity, Sask., she first studied biology and then gradually came to art through summers at Banff and Emma Lake. It was only during Greenberg's session in the summer of 1962, however, that she felt confirmed in the naturalistic landscapes she had been inclined to pursue. Subsequent workshops led by Kenneth Noland, Jules Olitski, and other American colour painters led her to concentrate on her colour and paint handling, and since about 1964 she has been painting large, highly individual, beautiful landscapes in oils and (during the seventies) acrylics, full of the light and atmosphere of Saskatchewan. They are surpassed, perhaps, only in the contemporary work of ERNEST LINDNER (b.1897).

Lindner-who was born in Vienna-immigrated to Saskatchewan in 1926 and by 1931 was teaching night classes at Saskatoon's Technical Collegiate Institute. By 1936 he was head of the art department and teaching full time; he retired in 1962. Throughout these years of teaching Lindner was an essential force in the artistic life of Saskatoon, and even of the province. He and his wife (from Prince Albert) established a summer home at Emma Lake the year before the summer school began, and although his involvement with the painters and students there was usually informal, it was constant. The bush around Emma Lake has been his chief inspiration and it was the naturalness of his response to this environment that drew Clement Greenberg's attention. His encouragement, and that of the colour painter Jules Ölitski-who led the workshop in 1964—stimulated a wonderful flowering of Lindner's art since his retirement from teaching. He no longer had to think about anything but his painting, and his beautiful watercolour studies of tree stumps-Decay and Growth (NMAG) of 1964 is very fine—and more recently his profoundly moving acrylics reveal a lifetime of experience focused sharply on the phenomenon of generation.

The painting of abstractions has an even longer history in Vancouver than in Montreal, although the number of years of continuous production is about the same, following the arrival of LAWREN HARRIS and the painting of *Composition No. 1* (see p. 201) in 1941. Nature is always present in Vancouver—spilling lush growth into every empty space, looming over the city in the form of mountains, pushing long inlets of the ocean right

into its heart—and it inevitably creeps into painting. By 1945, in smaller works like *Mountain Spirit* (University of British Columbia, Vancouver), Lawren Harris was again considering landscape forms, atmospheric space, and looser, more 'subjective' brush work. By 1950 landscape was supplying the vocabulary for his abstractions: *Nature Rhythm* (NGC) is a powerful evocation of the force-forms of ocean and mountains.*

But not all artists working in Vancouver succumbed to the encroaching landscape. B.C. BINNING (1909-76) consistently proclaimed the virtues of formal abstraction. Born in Medicine Hat, Alta, Binning was brought to Vancouver at the age of four. After studying at the Vancouver School of Art under Varley and Macdonald (1927-32), he became an instructor there in 1934. In 1938 he visited London, studying at various schools, including the Ozenfant Academy under the French abstract painter Amédée Ozenfant and the British sculptor Henry Moore, and spent the following year at New York's Art Students League. Returning to Vancouver, he continued teaching at the School of Art for nine years, attracting a reputation with witty, beautifully full line drawings. Then in 1948, during a year's leave of absence, Binning painted his first oils. Ships in Classical Calm (NGC) of that year is a tightly constructed yet impressively light and open abstraction made of simple geometric shapes-all based on the forms of ships' hulls-overlapped, interlaced, but always inter-related in a flat, dynamic pattern. It is clearly derived from the work of Ozenfant, his teacher of ten years before. The next year Binning took a teaching post at the University of British Columbia, where he worked until 1974. His lucid formal abstractions were an essential part of the Vancouver scene for more than twenty years.

The dominant concern among Vancouver's painters during the fifties, however, was pervasive nature, which found its principal interpreter in JACK SHADBOLT (b.1909). The same age as Binning, he too was forty years old before he began to find his way as a painter. Born in Shoeburyness, Eng., Shadbolt was brought to Victoria at the age of three and was raised there. Studying to be a teacher, he moved in local cultural circles and knew Emily Carr before taking a job as a high-school teacher in Vancouver in 1931. On a trip east in 1933 Shadbolt resolved to become an artist, and the next year he began night classes with Varley at the Vancouver School of Art. After graduation in 1936 he studied for a year in London and Paris, and on his return in 1938 became an instructor at the Vancouver

*Harris continued to pursue nature rhythms in his work throughout the fifties in paintings he called 'abstract-expressionist'. Only in his last great mystical paintings of the early 1960s did he once again return to geometric forms, although these are painted with unusual 'feathered' strokes, and glow with the white light of pure spirit.

school. In 1942 he joined the army and was appointed a war artist in 1944. He returned to the school once again the next year as head of the drawing and painting section. Then in the fall of 1947 he followed Binning's lead of some seven years earlier and spent a term at the Art Students League in New York. At this point his strong work begins to appear. The first notable pictures are surrealistic images based on northwest-coast Indian themes, followed—while he was building himself a house on a wooded suburban lot (1948–51)—by a lengthy series of surreal landscapes filled with strange plant forms. Shadbolt moved into his new house in 1952 and continued to explore the cycles of nature—painting, as he had before, in casein, gouache, watercolour and ink, always on paper. Some of these works—like *Presences after Fire* (NGC) of 1953—are surreal abstractions from seed and leaf forms, but many are free representations of such disparate things as bones, insects, bouquets of flowers, birds.

Shadbolt began painting canvases in 1957 while on a trip to the Mediterranean, an experience that revealed to him a new world of colour. (Most of his earlier works on paper are in dark earthy hues.) His subjects hardly changed, though, and the works of the late fifties and early sixties are usually based on landscape experiences. Some are quite literal, but many—and the best—are ambiguous in scale and point-of-view. **Winter Theme No.* 7 (NGC) of 1961 grew initially from the memory of boats clustered around a jetty; but passing through numerous configurations, it has emerged as a rich, many-levelled painting representing for the artist 'the evocation of growing nature—of insect-larvae-boat-root-cutbank. All these welded into a dark poetry of sleeping cocoons harbouring in the shelter of roots during the winter, waiting like boats behind a winterbound pier.'

A surprisingly large number of painters with a similar persuasion appeared in Vancouver during the fifties. GORDON SMITH (b.1919), who was born in England, arrived in Winnipeg at the age of fifteen and first studied art there with LeMoine FitzGerald. He later moved to Vancouver and graduated from the Vancouver School of Art at the end of the war. He joined the staff in 1946 and in 1957 moved to the Fine Art Department of the University of British Columbia. In his work of the fifties he is concerned to recreate an actual experience or mood rather than, like Shadbolt, to create a new multi-levelled reality. But, as is clear in *Orchard* (AGO) of 1954, he employs stylized natural forms within an abstract structure, much as Shadbolt did. Most other painters in Vancouver at the time, like Takao Tanabe (b.1926) and Donald Jarvis (b.1923), were even more lyrical than Shadbolt or Smith in their interpretation of the landscape and were often more freely abstract. (Tanabe and Jarvis both stud-

Jack Shadbolt. Winter Theme No 7, 1961. Canvas, 108.0 × 128.9. NGC.

ied with Hofmann in New York). Seven of these lyric-abstract landscape painters (including the four mentioned here) were grouped in an exhibition by Ian McNairn that was shown across the country in 1959. The seven painters 'are not interested in the visual recording of nature alone,' McNairn pointed out in his introduction to the catalogue. 'They don't escape into the hills for inspiration. Each in his own way expresses the environment of nature, of society and the excitement of growth. This is not an art form of direct observation but is the result of contemplation, self-analysis. It is a reflective art form.'

These painters, exploring their subjective reactions to nature, dominated the art scene in Vancouver into the sixties, and (partly as a result of the McNairn show) were then seen nationally as the most coherent 'group' working outside of Montreal. This local movement was bolstered in 1958 by the appearance on the Vancouver scene of Toni Onley (b.1938) from the Isle of Man, as well as by the expressive, painterly landscapes Bruno Bobak (b.1923) produced in between his extensive travels after

Roy Kiyooka. *Barometer No 2,* 1964. Canvas, 246.4 × 175.3. AGO.

retiring as Head of Design at the Vancouver School of Art in 1957. But a powerful stimulus for change appeared in 1959 in the person of ROY KIYOOKA.

Kiyooka brought from Regina pictures with broad areas of freely brushed colour that in their contemplative, reflective nature were not entirely foreign to the Vancouver painters; but in scale, and in their quality of brooding presence, they introduced a new factor. Vancouver related these paintings to current New York art and, as Doris Shadbolt has remarked, they soon 'brought bigger issues into local focus'. Over the next years Kiyooka developed a lyrical 'hard-edge' style of large-scale colour painting of wonderful economy and beauty. **Barometer No. 2* (AGO) of 1964 is awesome, primal, seemingly not man-made. Compelling yet 'cool', it—and his earlier Vancouver paintings—set the sensibility for a phenomenal 'rush' of painting in Vancouver in the mid-sixties. Most of the young artists who later effected that flowering had come into contact with Kiyooka as a teacher at the Vancouver School of Art and virtually all would have known him as a key figure in the thriving cultural subcommunity that began to grow on the lush western edge of the country during the early sixties. To many people, in fact, Kiyooka personifies the most convincing strengths of that peculiarly distinctive 'coast' mentality, even though he lived in Vancouver for only five years.*

The continued dominance of Montreal over the artistic activity of Quebec City has been offset only slightly by the presence in the capital city of a few painters who have been concerned to reflect their unique heritage. The most important of these is JEAN-PAULLEMIEUX (b.1904). Born in Quebec City, he was taken to Berkeley, California, by his mother at the age of twelve and the following year was brought back to Canada to settle in Montreal. Interested in art from an early age, he enrolled in the new École des Beaux-Arts in 1926, but withdrew three years later and then travelled in Europe with his mother. Back in Montreal, Lemieux established early in 1930 a commercial art studio with two friends from the École des Beaux-Arts, Jean Palardy and Jori Smith, but this venture lasted only a few months. After a return visit to California (his sister had settled there), he enrolled again in the École in September 1931, graduating finally in 1934. He accepted a teaching position at the École, but in 1935 left to become a professor at the École du Meuble.

Lemieux's painting of these years reflects something of the landscapes of the Group of Seven, introduced to him through the friendship of Edwin Holgate. But the principal direction in his art stemmed from summers he spent with Palardy and Smith investigating Quebec folkways in rural Charlevoix County. In 1937 Lemieux returned to Quebec City (Borduas replaced him at the École du Meuble) to become a professor at the École des Beaux-Arts there. (This was presumably the appointment Pellan had been too 'modern' to be given a few months earlier.) The ancient capital reinforced his interest in the traditional values of his people, which he explored in a series of consciously naïve allegorical paintings—Lazarus of 1941 (AGO), is the best-known—that are richly anecdotal cross-sections of Quebec society. He remained at the École until 1965, when he retired to the Île-aux-Coudres on the St Lawrence River. The stylized portraits of French-Canadian types for which Lemieux is so well known today first began to appear after a trip to Europe in 1954, made possible by a Royal Society grant. Moody, simplified studies of strong sentiment, they confront the solitude the Québécois has traditionally felt in his struggle with a harsh climate and an isolating social environment. By implication they celebrate 'la survivance' of the basic values of the true Quebec.

^{*}He left for Montreal in 1965, but returned to Vancouver in 1970, where, except for a year in Halifax (1971–2), he has lived since—not painting, however, but working with photography, and writing.

Such an interpretation of 'folk' values in a stylized figurative idiom has found other adherents. JEAN DALLAIRE (1916–65), who was born in Hull, taught with Lemieux in Quebec City from 1946 to 1952. There he developed his personal vision, drawing on modernist techniques as transmitted by Pellan and on the folk imagery of his province. From 1952 to 1957 he worked for the National Film Board in Ottawa and Montreal, illustrating educational films on local history and folklore.

These painters mean much to Québécois who were born before the Second World War. ALFRED PELLAN (b.1906) also derived his following primarily from this group, and most commentators have seen indigenous 'folk' values in his brightly coloured, exuberantly decorative paintings of the fifties and sixties. Pellan continued to teach at the École des Beaux-Arts in Montreal until 1952, when a research bursary from the Royal Society of Canada allowed him to spend three years in Paris, a sojourn that culminated in a full retrospective at the prestigious Musée national d'art moderne in February-March 1955. He returned to Montreal a few months before Borduas set out for the French capital.

While Pellan was in Paris, though, a new moving spirit stirred to life in Montreal. This was first announced by four young painters in an exhibition staged in February 1955 at l'Échourie coffee-bar: LOUIS BELZILE (b.1929) from Rimouski (he studied at the Ontario College of Art in Toronto from 1948 to 1952 and then with André Lhote in France, 1952–3); RODOLPHE DE REPENTIGNY (1926–59), a mathematician and philosopher from Montreal (Université de Montréal and the Sorbonne) who was art critic for *La Presse* and who painted as 'Jauran'; and the two Montrealers JEAN-PAUL JÉROME (b.1928) and FERNAND TOUPIN (b.1930), both of whom had studied at the École des Beaux-Arts under Stanley Cosgrove (1949–53). These painters first began to work out their ideas during the summer of 1954 in a series of exhibitions at the Librarie Tranquille.* By the time of their February show they had developed a clear position, proclaimed as had by then become traditional in Montreal—in a manifesto that they signed simply *Les Plasticiens*.

'The Plasticiens', the manifesto reads, 'are drawn, above all else in their work, to the "plastic" facts: tone, texture, form, line, the ultimate unity of these in the painting, and the relationships between these elements The significance of the work of the Plasticiens lies in the continual refinement of the plastic elements and of their order; their destiny lies typically in the revelation of perfect forms in a perfect order The Plasticiens are totally indifferent, at least consciously so, to any

*A Montreal bookstore that had acted as distributor of the Refus global.

possible meanings in their paintings.'* Diametrically opposed to the spontaneous expression of the unconscious—replete with associative meaning—as was earlier sought by the Automatistes, the Plasticiens hoped to achieve a precise, uncomplicated response to the painted object. To create such a refined vehicle of pure aesthetic pleasure, they restricted themselves to composing coloured geometric forms, much like the De Stijl group that had grown around Mondrian and Theo Van Doesburg in Holland after the First World War.

The Plasticiens were just the leading edge of a new sensibility, however, and by February 1955 even some of the Automatistes were revealed to be seeking a more ordered form of expression in an exhibition entitled 'Espace 55' that was shown that month at the MMFA. Both FERNAND LEDUC (b.1916), who had returned from Paris in 1953, and Jean-Paul Mousseau showed pictures composed of roughly rectangular forms of juxtaposed colour.** Leduc began to associate with the Plasticiens the following year, by which time he was painting hard-edged geometric compositions. Works like *Nœud papillon* (NGC) of 1956—with its gently arcing forms producing a delicate internal rhythm—quickly set the measure within the group.

The Plasticiens, however, failed to generate any systematic exploration of the formal problems they presented. They diminished their impact as well through involvement in a larger group of abstract painters, the Nonfigurative Artists' Association of Montreal, founded in February 1956 with Leduc as president and de Repentigny as secretary. Its membership was made up of the Plasticiens and most of the people who had shown in the 'Espace 55' exhibition, including those who were still working in the Automatiste tradition: Léon Bellefleur (earlier associated with Pellan in the Prisme d'yeux group, he became interested in Borduas's Automatisme in the early fifties); Rita Letendre (b.1929) from Drummondville, Que.; and the Montrealers Jean McEwen (b.1923) and Paterson Ewen (b.1925). A non-juried exhibition association, it presumed to be no more

*'Les Plasticiens s'attachent avant tout, dans leur travail, aux faits plastiques: ton, texture, formes, lignes, unité finale qu'est le tableau, et les rapports entre ces éléments. . . . La portée du travail des Plasticiens est dans l'épurement incessant des éléments plastiques et de leur ordre; leur destin est typiquement la révélation de formes parfaites dans un ordre parfait. . . . Les Plasticiens ne se préoccupent en rien, du moins consciemment, des significations possibles de leurs peintures.'

**Borduas came up from New York to see this exhibition and publicly expressed his disappointment at the evidence of both a new group of late arrivals to Automatisme and the revival of an 'archaic' form of geometric painting (thinking of the Dutch of the twenties) in the work of Leduc and Mousseau. In the argument that ensued, Leduc broke with Borduas.

than a free forum for serious abstract painters in Montreal.* The members had in common, apart from their general interest in abstraction, the fact that they frequented the Galerie l'Actuelle, a small avant-garde show-place dedicated exclusively to the exhibition of non-figurative art. Opened in June 1955, it was energetically directed by GUIDO MOLINARI (b.1933), a twenty-two-year-old painter who was even then wholeheart-edly committed to aesthetic exploration with the rigorous seriousness introduced to Montreal by Borduas some dozen years earlier.

Molinari was born in Montreal, and while still in high school at the age of fifteen he enrolled in night classes at the École des Beaux-Arts. He followed the course for three years; then in the spring of 1951 he studied under Marian Scott at the MMFA school and that fall enrolled full-time in the second-year course under Scott and Gordon Webber. Both his teachers were abstract painters committed to formal statement rather than to the Automatiste type of intuitive expression. Molinari quit, following the spring term, and began exhibiting about a year later—mainly drawings in which he explored the formal possibilities of the automatic technique. He was also painting, notably a group of small pictures—*Emergence* (private collection) of 1955 survives—in which the paint is generously applied with a palette knife in long, crude rectangles of intense, harmonizing colour. Though similar in configuration to the canvases of Mousseau and Leduc of that year, there is no evidence at all of the concern for 'atmosphere' they reveal.

During 1955 Molinari's energies were absorbed in running Galerie l'Actuelle, but in May 1956 he held his first one-man exhibition of paintings. All displayed simple arrangements of black straight-edged forms on white. All—like **Angle noir* (NGC)—are so composed that after a moment the white assumes form, the black becoming the intervening space; finally an exquisite resolution is achieved in which neither black nor white is form and yet neither is space or ground. As paintings they are limited to the plastic 'facts', but are much more economical and finally more emotionally satisfying than anything the Plasticiens were ever able to achieve.

The following month (June 1956) an even more radical exhibition was staged at L'Actuelle. Devoted to the work of another young Montrealer, CLAUDE TOUSIGNANT (b.1932), it consisted of a series of nine rigorously simplified colour 'panels' painted with shiny automobile paint. One, covered completely with unvarying orange, presented a pure colour experience. Tousignant studied at the MMFA school (1948–51) under *It was much like Painters Eleven of Toronto in that respect. Ray Mead in fact became a member after he moved to Montreal in 1957.

Guido Molinari. Angle noir, 1956. Canvas, 152.4 × 182.9. NGC.

Jacques de Tonnancour and—like Molinari—Gordon Webber, so he was also introduced to formal abstract painting almost from the outset. In October 1952 he went to Paris to further his studies, but he was unimpressed with current French painting and returned to Montreal the following May. There he was soon swept up in the group of young painters who met at L'Échourie. He held his first one-man show there in March 1955, a month after the Plasticiens. (Molinari had shown drawings there in December 1954.) Employing intense, clear colours—which also appealed to Molinari at the same time—Tousignant, in works like *Les Asperges* (NGC), applied the paint in long, asparagus-like forms, densely packed but never crossing. The result is an excited 'all-over' effect of dynamic colour. Tousignant had by this time met Molinari, and in fact joined with the architect-painter Robert Blair (b.1928) early in 1955 to assist in the launching of Galerie l'Actuelle.

In January 1959 Tousignant and Molinari took part in an exhibition entitled 'Art abstrait' at the École des Beaux-Arts that brought together

the two tendencies of geometric painting developing in Montreal.* Belzile, and Toupin of the Plasticiens, were revealed as basically Europeanoriented painters of small-scale pictures. Diffused in intention, they seemed to be involved simply in the manipulation of decorative forms. Tousignant, Molinari, Jean Goguen (b.1928), and Denis Juneau (b.1925) formed the by-then clearly identifiable 'nouveaux plasticiens'—exponents of large-scale, American-oriented colour paintings. The Plasticiens would soon disappear from the scene. The new group—which, with Luigi Perciballi replacing Jean Goguen, showed together at the Galerie Denyse Delrue in October 1960 under the banner of 'Espace dynamique'—would be recognized as the leading painters in Montreal, and Molinari and Tousignant as among the greatest artists in the country.

Tousignant's representation in the 'Art abstrait' exhibition included *Verticales jaunes* (the artist) of 1958, a tall (nearly 2.5 metres), narrow painting made up of six sloping or trapezoid vertical planes of red, yellow, and green. In the catalogue the painter wrote: 'What I wish to do is to make painting objective, to bring it back to its source—where only painting remains, emptied of all extraneous matter—to the point at which painting is pure sensation.' Molinari that year was making paintings just slightly wider than tall, composed of a series of vertical bands of uniform width, some of which, however, were divided horizontally into two colours or widened by the juxtaposition of a band or bands of identical colour. *Equivalence* (private collection) of 1959 is yellow, red, black, and white. Not so 'sensational' as Tousignant's paintings, there is a deeper, more 'classical' rhythmic interrelationship of the coloured forms as the eye runs over the surface, unable to find a static point of rest. Both artists were clearly establishing a dynamic integration of colour with structure.

Over the next two years Tousignant also turned to the almost-square format, but employed distinct rectangles and horizontal bars to structure his colour. Then in 1962, on a trip to New York, he first saw the work of Barnett Newman. It recalled the pure colour experience of his own 1956 works, and the desire then 'to say as much as possible with as few elements as possible'. He soon began to re-examine this concern in a series of simple compositions involving the placement of large, austere rectangular and circular shapes. This led finally in 1963 to the isolation of the circle as the most satisfying motif, and the following year, in **O*Eil

*After their 1956 shows at L'Actuelle—which met with little understanding even from the Plasticiens—Molinari and Tousignant had continued their experiments, but in more modest format. Tousignant worked mainly in watercolour for two years; Molinari drew with pencil or pen and painted with gouache. Then in 1958 the two began again to make large canvases with colours. L'Actuelle folded in 1957.

Claude Tousignant. Œil de boeuf, 1964. Canvas, 181.0 × 88.9. NGC.

de boeuf (NGC), to the use of a 'target' form of concentric circles, whose inexorable radiation broke the rectangular format. In 1965 Tousignant logically moved on to a circular canvas and, in the *Transformateur chromatique* group of that year, to working in thematic series. He had successfully achieved a profound, rhythmically pulsating surface of colour. Free of any associative image (no longer even resembling a target), and

without compositional 'tension', his pictures had finally arrived at the desired 'pure sensation'.

Molinari first came close to abandoning the composition of varioussized elements in 1961 in Hommage à Jauran (VAG), a canvas made up only of vertical bars of colour. But it was not until 1963 that he consistently made the bars of uniform width. This was found to be as ideally suited to his intention as the circular format later was to Tousignant's. It removes completely any need to devise an 'image' from variable forms. The emphasis is solely on colour structure. In works like †Mutation rythmique No 9 (NGC) of 1965, Molinari was able to present a complex experience with the most simple means. Although there are only four colours (green, red, blue, and orange), each seems different every time it is repeated because different colours surround it. The longer one looks at it, the more amazing are the changes the painting accomplishes. The peculiar property of colour-that it derives its nature in part from its relation to other colours, and is consequently never stable-makes possible what Molinari calls 'the continuous perceptive restructuring of the painting'. Although Molinari and Tousignant made colour painting the most important concern among serious artists in Montreal during the first half of the sixties, at least three other painters of strong individuality should also be cited. JACQUES HURTUBISE (b.1939), who held his first one-man show at the MMFA in 1961, soon became a prominent figure on the Montreal scene. He attracted attention nationally only with his scintillating 'optical' works produced after 1965, but his earlier canvases-in which the controlled 'accident' of splashed paint is formalized, isolating the immediate impact of colour on our senses—nonetheless represented an important variation on the dynamic colour-space experiments of Molinari and Tousignant.

Two other painters of commanding presence in Montreal during the early sixties worked largely outside such pure colour concerns, however. JEAN MCEWEN (b.1923) first studied to be a pharmacist at the Université de Montréal, but just before he graduated in 1949 he met some of the Automatistes and decided to become a painter. A year in Paris (1951–2) in contact with some of the lyrical abstractionists around Riopelle encouraged him, when he returned to Montreal, to work through surrealistderived abstract expression. By 1956 and the foundation of the Nonfigurative Artists' Association (McEwen later replaced Leduc as its president), he had arrived at a statement of unique force. Amorphous, floating forms, virtually filling the whole canvas (often resulting in images reminiscent of the American Mark Rothko), later came to display a surface burnished to the texture of old leather. By the early sixties his distinctive, ominously brooding canvases, such as the *Meurtrière traversant le bleu* (MMFA) of 1962, were widely admired by those with a developed taste for refined experience.

CHARLES GAGNON (b.1934), born and raised in Montreal like Hurtubise and McEwen, studied graphic art and interior design at the Parsons School of Design in New York from 1956 to 1959. He returned to Montreal in 1960. During his four years in New York he became familiar with the brilliant activity and the ideas on randomness and chance developed by the composer John Cage and his associates, the dancer Merce Cunningham, and the painter Robert Rauschenberg. Taking his lead from these important figures, Gagnon by the early sixties had developed a cool but seemingly spontaneous style of painting. The primal lushness of his *Hommage à John Cage* (Department of External Affairs, Ottawa) of 1963 derives from the imaginative exploration of various ways of applying paint. A natural order arises from the methodical execution of a precisely defined though ostensibly 'free' activity.

Although it is unlikely that art activity in Canada will ever again be so centralized as it was in Toronto between the wars, the Ontario capital has nevertheless once again become the main focus for the nation. And although this is largely because Toronto is the principal art market-place (virtually every artist in the country of more than local interest exhibits there regularly), its current status could not have been attained without the large number of painters of quality who assembled there during the late fifties and early sixties.

At least three members of Painters Eleven remained prominent within this expanded scene: WILLIAM RONALD—in a tragically reversed role—Harold Town, and Jack Bush. Although Ronald was at first the inspiring example of local success at the centre of world art, he came to be a moving example of the cruel vagaries of the 'international league'. Only three months after he finally decided that he would make his home in the New York area, he was given his last exhibition at the Kootz Gallery (December 1963). By this time Abstract Expressionism had been superseded by more rationally 'cool', un-'expressive' forms, and the so-called second generation of Abstract-Expressionist painters was, in a body, out! Ronald struggled to accommodate the new sensibility, but with work that was at the time generally rejected. A 1965 show at the new David Mirvish Gallery in Toronto was interpreted as an attention-seeking gimmick (movable painted panels allowed the viewer to re-compose the picture). Ronald stopped painting shortly after, and the following year undertook what appeared to be a new career as a television and radio performer.

HAROLD TOWN held his first one-man show in New York just about a

year before Ronald staged his last show there. At the Andrew Morris Gallery from November 2, 1962, Town displayed works from his 'Tyranny of the Corner' series. Most of the pictures—like *Tyranny of the Corner*—*Glass of Fashion Set* (the artist)—reveal a concern for surface: they are covered with a uniformly textured paint that suggests an industrial product. Limited in colour to black, silver, and white, the consequent 'high-contrast' effect causes an optical vibration that stresses the silhouette of the forms. But the main concern in these pictures has been explained by Town himself. 'Painting is still to a great extent dominated by a central image; corners in most paintings are like uninvited guests at a party, uneasy and unattended. In my series I have invited the corners to come early to the party and tried, if anything, to make all the elements of the painting that arrived later a trifle uncomfortable.' Town, like everyone in Toronto, was acutely aware of Ronald.

The early sixties was the period of Town's real prominence in Toronto as a painter, culminating in a pair of large exhibitions of paintings held simultaneously at the Jerrold Morris and Mazelow galleries in February 1966. The well-known *Great Divide* (AGO), in the Morris portion of that show, has generally been held to be his finest picture. The critic Harry Malcolmson saw in it evidence of Town's 'deep affection for Canada'. In his introduction to the show's catalogue he described how 'The entire canvas is suffused with the unshadowed golden light that floods the Northern landscape prior to sunset.'

Many would now argue that the *Great Divide* in fact presaged the 'setting' of Town's brief sun-like presence on the Toronto scene. Like Ronald, he has since largely existed in the eyes of younger artists as a controversial 'personality' rather than as a painter. JACK BUSH (1909–77), to the contrary, over the same period assumed more and more relevance for the younger painters in the city. This local importance derived, at least in part, from Bush's rise to a position of international eminence seldom achieved by a Canadian.

Bush had his first New York show in 1962, the same year as Town. Robert Elkon had consulted with Clement Greenberg before opening a new gallery, and the critic recommended Bush. The 1962 show was reasonably successful, and was followed by two more in 1963–4 and a steadily growing reputation. Bush then signed a contract with the prestigious André Emmerich Gallery, the New York showplace for a number of the so-called 'post-painterly' abstractionists. These painters proposed a 'cool', rational abstraction that, like the work of the Montreal colour painters, sought to integrate colour with structure. They differed from the Montrealers in that their substantial colour images were typically achieved by staining paint into raw canvas. Of this group—which includes Kenneth Noland and Frank Stella—Bush is the most openly lyrical, the most 'emotional', the least cerebral. In his great works of the sixties—*Dazzle Red* (AGO) of 1965 is one of the most monumentally beautiful paintings of the decade—there is a boldness that is in no way brash. It is a huge great living banner of colour in which Bush even managed to infuse naturally cool blue and green with vital human warmth. It reflects the open joy of personal fulfilment.

The succession in Toronto was very different from that in Montreal, where there was a distinct group who broke clearly with the position of the Automatistes. In Toronto it was rather individuals finding their way out from the example set by Painters Eleven. In fact to some of the older members of the second 'generation' Painters Eleven must have seemed a parallel, rather than a preceding development. Michael Snow and Graham Coughtry held their first exhibition less than a year after the inaugural Painters Eleven show.

GRAHAM COUGHTRY (b.1931) was born and raised in St Lambert, east of Montreal across the river, where his father was a commercial sculptor. He first studied art at the MMFA school (1948–9) under de Tonnancour and Webber, and then moved on to the drawing and painting course at the Ontario College of Art in Toronto. Through a common interest in jazz he there met MICHAEL SNOW (b.1929), a design-course student a year ahead of Coughtry. Snow was born in Toronto, but was raised in a number of cities—particularly Montreal and Chicoutimi, the home of his French-Canadian mother—as his engineer father followed his work. He entered the Ontario College of Art in 1948 with an already highly developed interest in jazz, fed in his second yēar—with a forthrightness that was to become typical—by trips to Chicago, where he played in the home of the great boogie-woogie pianist Jimmy Yancey. Snow soon became an accomplished jazz musician himself.

Coughtry, upon graduation, won a scholarship that allowed him to travel to Europe, and he and a school friend, Richard Williams (b.1933), left in the fall of 1953. First visiting Barcelona, they soon ended up on the island of Ibiza, where they stayed for about six months. In the spring they spent a few months in Paris, where they ran into Snow, who had over the past year been working his way as a musician around holiday resorts in Italy and France. Back in Toronto, all three found work in a small film-animation company recently launched by George Dunning. Graphic Associates, as it was called, supported a concentration of nascent

talent then unmatched in Canada outside the National Film Board, and virtually all of the staff went on to do impressive work in film after the business folded in 1956.*

At Graphic, Snow met the woman he would later marry. JOYCE WIELAND (b.1931), a Torontonian who had joined the company—like Snow, Coughtry, and Williams-after returning from European travels, studied commercial art at Central Technical School but in Europe had decided to become a painter. Snow and Coughtry of course were also then determined to be painters, and they held their first exhibition-a joint venture—at Hart House in January 1955. The works they exhibited reflect interests fostered in school and on their European trips. Coughtry's Figure on a Bed (AGO) of 1954 shows the influence of the American socialrealist Ben Shahn in its severe line, though it is virtually overwhelmed by Bonnard-like vibrating colour. (He had seen the sensual paintings of the French artist in Paris.) Snow's A Man with a Line (Mrs O.D. Vaughan, Toronto) of 1954 also combines a clean line with rich surface. His witty, ambiguous play on the nature of the 'line' the man holds suggests an interest in the work of the great Swiss artist, Paul Klee. Sensuous, expressive colour became the dominant characteristic of Coughtry's later work, while rigorously intelligent 'play' is at the heart of everything Snow does. These nearly polar sensibilities mark the extremes between which painting developed in Toronto over the next decade. That first exhibition also inadvertently revealed the relationship their generation would hold to the local establishment when some gentle nude drawings curiously outraged the mayor of Toronto, Nathan Phillips. And these two artists as well soon found the base from which the new Toronto painters would most effectively operate. In the spring of 1956 they joined with three others-William Ronald and two figurative painters of some strength, Gerald Scott (b.1926) and Robert Varvarande (b.1922)—in the inaugural exhibition of Avrom Isaacs' new Greenwich Gallery. Coughtry held his first one-man show there soon after, and Snow his first that October.

The Greenwich Gallery was located in the old 'Greenwich Village' area around Bay and Gerrard, which after the twenties was the centre of Toronto's small contribution to Bohemia (and has disappeared through

*Dunning then went to England where he later directed the landmark animation success, *Yellow Submarine*. Richard Williams also moved to England, where he has followed a successful career inventing animated film credits, most remarkably in *What's New Pussycat*? and *The Charge of the Light Brigade*. At Graphic also was Sidney J. Furie, who subsequently made two feature films in Toronto (1957 and 1958) before he too went to England. He is now best known as director of *The Ipcress File*. Graham Coughtry moved over to the CBC to establish its animation section. His award-winning work there set the standard for years.

xxxiv—Michael Snow. Beach—hcaeb, 1963. Canvas, 155.9 \times 105.4. University of Western Ontario, London, Alumni Collection.

xxxv—Greg Curnoe. Camouflaged Piano or French Roundels, 1966. Panel, 183.0 × 301.5. NGC.

XXXVI—Gershon Iskowitz. Uplands H, 1972. Canvas, 182.9 × 241.3. AGO

redevelopment). During the second half of the fifties it blossomed. A number of galleries joined the Greenwich Gallery, specialty shops and coffee houses opened, and the House of Hambourg began to attract devotees of avant-garde jazz, poetry, and drama. DENNIS BURTON (b.1933), a young painter just out of art school, ran a small gallery in the House of Hambourg over the winter of 1956–7.

Born in Lethbridge, Alberta, Burton came east to complete high school and enrolled in the Ontario College of Art in 1952. At the time of his graduation in 1956 he was living in a rooming house with several friends, including GORDON RAYNER (b.1935). Rayner was born in Toronto, where both his father and uncle were commercial artists. When the time came to work, with no school training in art at all, Rayner was sent out by his father to find an apprenticeship in commercial art and was hired in 1953 by a small firm that included Jack Bush among its partners. Rayner observed some of the early Painters Eleven meetings but was then unimpressed with 'fine' art. He left Bush late in 1954 for a trip to Europe. Back in Toronto the next year, an interest in jazz brought him into contact with Burton, who soon involved him in painting. The two travelled to Buffalo to see a de Kooning that had been recently purchased by the Albright-Knox Gallery. Rayner soon began to appreciate Painters Eleven.

Because of Painters Eleven, Abstract Expressionism had, by 1958, become the current local idiom in Toronto-almost as much as in New York itself. Dennis Burton remembers that 'the knowledge that in the forefront of American Abstract-Expressionist painting there was a Toronto artist, William Ronald, assured us that there was a direct line of communication to the source.' The major Ronald shows in Toronto-at Av Isaacs' Greenwich Gallery in 1957, at Laing in 1960, and at the Isaacs Gallery in 1961-kept that line wide open. Jock Macdonald's teaching at the Ontario College of Art also assured an interest in New York painting among many of the graduating students. (Burton had studied with him.) And some one hundred and sixty kilometres away, across the American border, Buffalo's Albright-Knox Gallery began to acquire important examples of Abstract Expressionism. Many artists who matured in Toronto at this time could even today describe de Kooning's brilliant Gotham News of 1955 almost stroke by stroke. Dennis Burton, of all the younger painters, then most enthusiastically embraced the example of de Kooning. His Intimately Close-in (NGC) of 1958-9 is an audacious, vigorous variation on the passionate work of the American.

Coughtry had received his first significant attention with a sensitive series of interior studies. The carefully worked paint surface of *Interior Twilight* (WAG) of 1957 results in shimmering colour effects that dissolve

Michael Snow. Secret Shout, 1960. Canvas, 132.1 × 190.5. Graham Coughtry, Toronto.

the depicted chair and table in atmosphere. The intense local interest in post-war New York painting encouraged him to follow a more freely expressive bent in subsequent paintings. In a group of 'imaginary' portraits, delicately modelled heads grow out of paint thickly congealed at the centre of the canvas.

The rapid evolution of Michael Snow, however, was the most amazing of all of the Toronto artists. In 1955 he made a group of full yet wonderfully controlled collages, gently tinted with photo dyes. During the next two years he, like Coughtry, followed an obsessive interest in crowded interiors, splayed tables and chairs, the furniture of the mind. Then about 1958 Snow addressed himself to some of the problems raised by recent New York painting, working through pictures like **Secret Shout* (Graham Coughtry, Toronto) of 1959, which, with their carefully positioned but roughly blocked-in forms, resulted in a clear but open structure, much like that of jazz. (Snow had been supporting himself working as a jazz musician since Graphic folded in 1956.) Improvisational options were then reduced in a series of works over 1960. *Lac Clair* (NGC), the most lusciously beautiful of these, is a large square canvas, completely and evenly covered with generous blue strokes. Brown paper tape is pasted a bit less than halfway along the edge of each side starting in the lower right corner, placing the canvas in a tension, anticipating spinning. Suggesting pervasive order underlying the variation of stroking, the whole painting swells out imperceptibly and serenely, with the great placid force of a northern lake.

By 1961 there was unmistakably a 'new' Toronto scene and the Isaacs Gallery was at its centre. (The Greenwich took the name of its proprietor early in 1959.) Joyce Wieland first exhibited there in February 1959 with Gord Rayner (their first commercial exposure), but then showed briefly at Dorothy Cameron's Here and Now Gallery before settling with Isaacs in 1961. Her husband, Michael Snow, had been with Av Isaacs from the beginning, as had Graham Coughtry. Dennis Burton's work had been noticed at the House of Hambourg by Barry Kernerman, who gave the young painter a show at his new Gallery of Contemporary Art in May 1957.* There he met Robert Hedrick (b.1930), a young artist from Windsor, Ont., who was then beginning to attract appreciative reviews of his painting. Kernerman's gallery survived only about two years, and Burton then had a show at the Park Gallery early in 1959. But in 1960 both he and Hedrick moved to the Isaacs Gallery, and Rayner too held his first one-man show there that year.

Although the scene was no longer geographically situated in the Gerrard Street 'village' (the Isaacs Gallery moved to Yonge Street above Bloor in the fall of 1959), it soon found a spiritual centre in a new quarterly magazine, Evidence, which first appeared in 1960. With photostories on Rayner and Snow, and with written or drawn contributions fromamong others-Leonard Cohen, Snow, Gwendolyn MacEwen, William Ronald, Wieland, Burton, and Austin C. Clarke, it helped to define that Toronto scene. Jazz continued to be the most important unifying force, and by the time of the appearance of *Evidence*, marihuana and other mood-altering drugs traditionally associated with jazz had also become a regular part of the lives of most of the painters. Spontaneous, free creativity was celebrated in regular 'jam-sessions' held on off-nights at the First Floor Club, then the local outlet for live jazz. As many as fifteen or twenty would gather to play, and out of this grew the Artists' Jazz Band, an institution that was to survive almost twenty years around a hardcore made up of Coughtry, Rayner, Robert Markle (b.1936) from Hamilton—who graduated from the Ontario College of Art in 1959 and soon became involved with the Isaacs group-and Nobuo Kubota (b.1932), a Vancouver-born architect-sculptor.

*The month after Borduas's one-man show there. Burton and a number of the younger Toronto painters greatly admired the work Borduas exhibited.

Joyce Wieland. Time Machine Series, 1961. Canvas, 203.2 × 269.9. AGO.

In retrospect Joyce Wieland appears, in a series of vast paintings shown at the Isaacs Gallery in February 1962, to have exploited most successfully the liberating energies of this moment. One of the largest and most beautiful of these is **Time Machine Series* (AGO) of 1961, in which a great round shape—suggestive of an open vagina as well as of a fleshy clock floats in a sea of ethereal blue. She pursued the theme of female sexuality in a number of subsequent works of equally vast scale and consuming, timeless space. *Heart-on* (NGC) of later in 1961 is a large piece of draped linen with cut-out and drawn hearts scattered across its surface and red ink poured and splashed on it: blood on the sheet.

The fall 1961 issue of *Evidence* carried a photo of Marcel Duchamp, the great living master of the Dada movement,* on the cover and a short

*Dada was a nihilistic movement that initially developed in Zurich during the First World War. Deliberately anti-'high' art, Dada artists revealed aesthetic significance in chaotic, random, or fortuitous acts. Duchamp's 'ready-mades'—everyday objects that he 'chose' to be art—are the most famous artefacts of the movement. Dada thought and activity were currently enjoying a resurgence in New York in the light of Robert Rauschenberg's painting and the informal theatre-pieces called 'happenings'. Pop art would soon grow out of this interest. interview inside. The extent of local interest in Dada ideas was then revealed that winter in a 'Neo-Dada' show at the Isaacs Gallery (from December 20, 1961 through to January 9, 1962), to which most of the Isaacs artists contributed works assembled from various objects they had found. The show was humorous, imaginative, and unpretentious, working beyond 'taste' and 'style' and encouraging personal expression with the means immediately at hand. A number of the artists—Gord Rayner with the most consistent success—continued to employ 'assemblage' techniques: Rayner's *Homage to the French Revolution* (AGO) of 1963, is a witty, suggestive work of art made from an old extended table top.

The very *direct* attitude revealed by such assemblage work is also a characteristic of much of the painting that was done in Toronto in the early sixties. In 1960 Dennis Burton, in his **The Game of Life* (NGC), painted a huge game board with each square containing a mouth or a breast or male or female genitals—the 'pieces' in the game. Burton, with Snow, was one of the first to discard as well the essentially Abstract-Expressionist notion that a statement requires the support of a personal 'style' in order to achieve credibility. Burton felt that the weight of a work must lie in its essential content, and he placed most of his emphasis on the meaningful ordering of the information he was able to gather on the

Dennis Burton. The Game of Life, 1960. Canvas 137.2 × 198.0. NGC.

subjects that interested him. His most famous extended exercise of this sort was his examination of the idea of contemporary woman as revealed by her underclothing in his 'Garterbeltmania' series (1964–8).

Lyrical abstraction remained popular as well, though always of a 'post'-Abstract-Expressionist sort that was also very personal. Robert Hedrick's work was notable. And Gordon Rayner explored a lyric 'northern landscape' theme on summer trips to the Magnetawan River west of Algonquin Park. *Magnetawan No. 2 (NGC) of 1965 is a charged, expanding evocation of the North. Spontaneously new and fresh, it is lodged securely in a rich Canadian tradition.

RICHARD GORMAN (b.1935) of Ottawa, who studied with Macdonald and graduated from the Ontario College of Art in 1958, had his first exhibition at Isaacs in 1959. A year later he was exhibiting original work that already had gone beyond Abstract Expressionism. Like others in Toronto, he had derived from that style a sense of scale and presence, seeking evocative, primal abstract images that touched the fundamental human concerns of creation, life, and death. Gorman achieved his greatest success in large canvases he exhibited in 1964. *Kiss Good-Bye* (AGO) of 1963, with its great opening red-and-orange striped form on a yellow field, is ominous in spite of the bright colours. Like much of the painting of the period in Toronto, it seems to be dealing with perception at the outer edges of consciousness.

Travel has been important to the painters of Toronto, and Spain, particularly Ibiza, has exercised a continuing fascination for many. Graham Coughtry made a second home there. After he left the CBC graphics department in 1959 he returned to Europe; he married in Paris and he and his wife moved to Ibiza. He returned to Toronto for an exhibition in 1961. One of the amazing canvases he brought with him was *Corner Figure* (Larisa Pavlychenko Coughtry) of 1960. Dependent to a degree on the tortured figuration of the Englishman Francis Bacon and on the attenuated sculptural masses of the Swiss Alberto Giacometti, it is nonetheless profoundly personal and moving. Coughtry returned to Ibiza and continued to create figures emerging from thick muscle-like concentrations of paint. He sought a quality of presence, to establish a 'living' space between the figure and the viewer.

In 1962 he was back in Toronto, to execute the commission of a mural for the Toronto airport, and took a studio at the corner of Yorkville and Yonge.* Coughtry had just separated from his wife; he was hurt and confused and couldn't get the mural started. He began painting pictures of two figures in sexual confrontation, working off his own frustrated energies in explosive, expressionistic paint handling. Gradually, as he worked through one canvas after another, he released his anxieties and frustrations and the figures seemed no longer so specifically locked in sexual struggle but became rather the vehicle for more gentle feelings concerning the nature of sexual union, as in **Two Figure Series XII* (AGO). With the completion of the mural early in 1964 he returned to Ibiza, and alone there continued to paint his two-figure series. Changes accelerated over the nine months he spent there, with the paint becoming thinner and the images more balanced, more resolved. As is evident in Two Figure Series XIX (Private collection), he became concerned principally with the harmony of the shapes and the pleasure in the colours. The upper portion of xix is a hot red-orange, the bottom a warm yellow-green. The figures are a dripping magenta-purple fusion of the two. The series was exhibited in October 1964 at the Isaacs Gallery and was immediately recognized as one of the most beautiful shows ever mounted there. It is

*According to Coughtry and friends, it was haunted by Curtis Williamson, who had occupied it during his final years as a total recluse and had died there.

Graham Coughtry. Two Figure Series XII, 1964. Canvas, 213.4 × 182.9. AGO.

one of the great accomplishments of Canadian art.

The giant figure of painting in Toronto, however, is Michael Snow. He and Joyce Wieland moved to New York City in the fall of 1962 (to stay for ten years and become an important part of the New York scene*), but

*Particularly in their film work. Both began making personal films in 1963. Wieland's La Raison avant la passion and Snow's La Région centrale will doubtless be seen as among the finest films made anywhere in the world during the decade; and a number of informed

Joyce Wieland. Nature Mixes, 1963. Canvas, 30.5 × 40.6. Catherine Hindson, Hamilton

they still continued to exhibit and visit regularly in Toronto. In October 1960 Snow had invented 'The Walking Woman', a simple cutout silhouette of a typical young woman of the sixties. In the next seven years she became the 'subject' of every one of his paintings. Such fidelity freed him to try anything. Because the 'subject' never varied, everything else could change, and any one painting would still remain a coherent part of the whole. For in a sense the Walking Woman Works are one: a massive dispersed monument that explores in imaginative re-creation virtually the whole of western man's aesthetic possibilities. Though they are usually separately perceived, each piece stands on its own, creating a specific experience and raising specific questions about creating and about viewing art; about how we make and how we perceive.

†Beach-hcaeb (University of Western Ontario, London, Alumni Collection) of 1963 is spontaneously radiant. The paint was applied half to one side, half to the other; the lower space behind the right-hand figure, for instance, was left blank, and on the other side it was painted in. While

observers look upon Snow as one of the greatest innovative geniuses film has ever attracted. Their accomplishment can hardly be overstressed.

the paint was still wet, the canvas was folded down the middle and the two halves were pressed firmly face-to-face. Pulled apart, they reveal an 'accidental' image of subtly perfect symmetry.

Joyce Wieland's work is also richly allusive. Where Snow meets you at mid-point in some incredible structure out of his mind, Wieland draws you in with the wonder of her woman's work. She leads you to see in feeling, as Snow leads you to feel in seeing. The poetry of **Nature Mixes* (Catherine Hindson, Hamilton, Ont.)—a story-board series of frames in which a hand turns gradually into a flower and then into a penis—surpasses logic and beggars description. It is the colour of wild-strawberry plants in the grass.

Two painters who began exhibiting in Toronto in the late fifties began to make an impact on the scene only near the end of this period, an impact that subsequently revealed the merit of their earlier work as well. GERSHON ISKOWITZ (1921–88), who was born at Kielce, Poland, was an art student when he was imprisoned by the Germans. He miraculously survived six years in Buchenwald and Auschwitz and continued his studies after the war at the Munich Academy and privately with Oscar Kokoschka. He arrived in Canada in 1949. Always a landscape painter, his magnificent colour-field paintings of the mid-sixties—*Summer Sound* (AGO) of 1965 is gloriously expansive—evoke the sky, trees, earth, and water in a great amalgam of joy.

JOHN MEREDITH (b.1933), the brother of William Ronald, was born in Fergus, Ont., but raised in Brampton. He commuted to the Ontario College of Art (1950–3) and maintained a studio in his parents' basement until 1964. Although he began exhibiting in 1958 with a one-man show at the Gallery of Contemporary Art, his residence in Brampton made him an elusive figure in Toronto. His strange, highly personal paintings, with their suggestions of Eastern magical forms, simply added to his mystery. When the huge triptych *Seeker* (AGO) was exhibited in 1966, a steadily growing reputation leaped suddenly to bring him to the forefront in Toronto. Eccentrically intense in colour, it is a weighty but joyful object of veneration, dedicated to the celebration of a religion whose dogma will forever be hidden in the cryptic symbols the painting so triumphantly displays.

Although only a bit more than one hundred and sixty kilometres southwest of Toronto, London, Ont., a city with a population of about a quarter of a million, spawned one of the more active groups of artists in the country in the mid-sixties. London had produced artists before—notably Paul Peel in the nineteenth century—but had never been able to keep

Jack Chambers. Messengers Juggling Seed, 1962. Board, 138.4 × 115.6. NGC.

them. That there is now a relatively large and active second group that has responded to the efforts of the pioneers suggests that London will continue to be one of the major places in Canada to see art. That promise is almost entirely due to the activities during the first half of the sixties of three painters: Jack Chambers, Tony Urguhart, and Greg Curnoe.

JACK CHAMBERS (1931–78) was the oldest. Born in London, he studied art there at Beal Technical School and then worked sporadically at painting. In the fall of 1953 he left for Europe, travelling in Italy and Austria

and then, in January 1954, visiting Spain, settling in Madrid in February. There he enrolled in the Royal Academy of Fine Arts where he stayed distinguishing himself in rigorous academic exercises—until 1959. He then moved to the small village of Chinchon near Madrid, where he painted and taught until 1961. Returning to London after eight years' absence, he was soon struck by the degree to which the local environment seemed to take hold of his life.

In Spain he had painted stylized figurative pictures that were not unlike American regionalist art of the thirties. But in London he set that approach aside in a desire to explore memories, to bring together associations that moved him greatly. In paintings like **Messengers Juggling Seed* (NGC) of 1962 he assembled images of smiling faces, each presumably recalling an occasion of importance. These disparate and disembodied presences he floated in a hilly landscape, popping with mad seeds flowers exploding like brightly coloured mould sperm.

Chambers continued to explore his familiar environment, creating many-layered images of precious moments. Such evocative nostalgia reached an exquisite level with his *Olga and Mary Visiting* (London Public Library and Art Museum) of 1964–5. An accumulation of sensory associations, this painting shows how every new moment, in adding to the remembered experience, thus alters it. With its muted colours and fragmented forms it reveals the gentle pain of time.

TONY URQUHART (b.1934), who was born in Niagara Falls, Ont., studied at the Albright School of Art in Buffalo, graduating in 1956. He then enrolled in the University of Buffalo and graduated with a BFA in 1958. Already, though, he had had a successful one-man show at the Greenwich Gallery in 1957. In 1960 he became artist-in-residence at the University of Western Ontario in London and settled in for a five-year stretch—with a one-year break—in that community. He is an artist of many parts, but at the time he was probably most admired for his 'allegorical' landscapes. *In Hiding* (NGC) of 1961 is a particularly strong example. Beautiful in its rich and subtle brush-work, there is a strong sense of the earth in it: germination, growth, and decay. Its ominous swellings and gill-like infoldings evoke the ambiguity of the natural order. Nature gone wrong is still right. Urquhart too is concerned to reach deep, to touch some common stream, to bring us into closer contact with the forces that make life.

GREG CURNOE (b.1936) was, like Chambers, born in London and also studied art first at Beal Tech. During his year there (1954–5) under Herb Ariss (b.1918), he was introduced to an intelligent sampling of virtually the whole development of modern aesthetic thought: Cubism, Dada,

Greg Curnoe. Family Painting No i—In Labour, 1966. Board, 123.0 × 123.0. Mr M. Winberg, Toronto.

Surrealism, and Jackson Pollock. He remembers seeing the work of Borduas in a four-man show with that of Bush, Cahén, and de Tonnancour at the London Art Museum in the spring of 1955.* In the summer of 1956 Curnoe attended the Doon School of Fine Arts in Kitchener, and then in the fall he enrolled in the Ontario College of Art in Toronto. This was, in spite of Jock Macdonald's presence there, an unsatisfying experience, and he came away thoroughly disillusioned with 'fine' art. It seemed to him to have no relevance to his life. In 1960 he returned to London and

*The London Public Library and Art Museum began collecting in 1940, but it was only from 1953 that the addition of suitable galleries allowed a full exhibition program.

the next year rented studio space. He and some friends began to explore their own cultural roots, and out of a consideration of the meaning that popular heroes, music, and art (comic books, etc.) held for them, they affirmed a sense of place and of their location in that place. *Region* magazine was founded in 1961 as a forum for their investigations. Their questioning, and finally their massive rejection of much of established 'culture', led to the foundation of the Nihilist Party in 1962, followed shortly by the appearance of the Nihilist Spasm Band, a kazoo free-music group.

Curnoe—realizing the degree to which his position found historical precedent in the Dada movement of the earlier twentieth century—participated in the 'Neo-Dada' exhibition at the Isaacs Gallery in the winter of 1961–2. He was spending time in Toronto, visiting with Graham Coughtry and Mike Snow, and had met there as well Michel Sanouillet prominent authority on the history of the Dada movement—who was then teaching French literature at the University of Toronto. In February 1962 Curnoe arranged a 'happening' at the London Art Museum, a vigorous audience-participation piece called *The Celebration*. Wieland, Snow, and Sanouillet were among those from Toronto who went to London for the event.

The Celebration in a way sets the tone for all of Curnoe's work, which is, before anything else, a celebration. For him the 'ordinary' hardly exists. The world can open out from a single observation or reflection made in his home or studio. In his painting, Curnoe usually focuses on an event of deep personal significance, as in **Family Painting No. I—In Labour* (Mr M. Winberg, Toronto) of 1966. Depicting his wife in labour it is a direct and powerful image. As we try to see her unpainted face, we constantly focus on the hard line of the chrome bedside. The floor is a rushing hallucination of rainbow tiles. The low point-of-view puts us on our knees, and although we are incessantly drawn to feel the tender anxiousness in his wife's arms, our eyes are snapped to the centre, where a block of letters, in a fragment of matter-of-fact prose, describes not birth but a death. It is a work of intense concentration.

As the centenary of Confederation approached in 1967, every aspect of Canadian culture enjoyed unprecedented financial support. The magnitude of the celebrations, highlighted by the spectacular world's fair held in Montreal that summer, instilled a confidence in Canadians about their place in the world that was reflected in an upsurge in cultural activity. Facilities were increased, new support programs were launched, and communication was encouraged across the country. Artists flourished, and their numbers increased tremendously. It seems now that the impetus of that moment will never subside. Yet, shortly after the Centennial, in the midst of a remarkable cultural boom, it was widely held among artists, critics, and their followers that painting was dead. It was not that art was failing, but that painting, after centuries of pre-eminence in the visual arts, was exhausted and no longer viable.

This opinion did not originate in Canada, but arose throughout the western cultural sphere. We have seen how in the late fifties and early sixties a new interest in the Dada movement of the second decade of the century led some Canadian artists to stage 'happenings' and other forms of multi-media performance or display. The rise of virtually self-sufficient artistic subcultures during this period—centred on popular bars, restaurants, and even particular neighbourhoods—tended both to blur the traditional borders between the arts and to pervade individuals' life-styles with artistic consciousness. To a degree unknown before in Canada it was understood among artists that art was primarily about stance, ideas, and vision, not craft.

Changing technology also played a role. Film, and then video, attracted many visual artists. Other forms of electronic gadgetry began to proliferate, and each innovation seemed to offer exciting new creative possibilities. But more important was the emergence in the sixties of a huge new generation born towards the end of the Second World War. Raised

in the belief that the war had been fought to win individual freedom and social equality for all, they assumed those idealistic goals as a birthright. Their sense of personal freedom extended to a general tolerance of drug use and the pursuit of sexual liberation. Their concern for the environment and their openness to a wide range of mystical religious concepts and leftist political ideas resulted in widespread social experimentation that to many heralded a new age. First civil-rights activism and then organized opposition to the United States' involvement in the Vietnam war marked out the new battlefields for freedom. The pervasive American film, recording, and television industries ensured the involvement of the Canadian post-war generation in the basic issues of the decade. Popular music gave the sense of a broadly based social movement to the tendencies of the day. As the Vietnam struggle threatened to initiate a kind of civil war in the United States, thousands sought refuge in Canada from military conscription, adding impetus to the demands for change. Painting—especially the abstract painting that had gained the vanguard just as the decade dawned-seemed suddenly insufficient. Addressing only one sense, it seemed unable to encompass social issues. Messy, cumbersome, and tied to a system of property value based on the charade of rarity, paintings were hopelessly anachronistic.

Most remarkable about the widespread belief that painting had died is the speed with which the news was conveyed, and the artists' haste to adapt to the new order. The growth of specialized communications media played a major role. Exciting new British and American art magazines were for the first time easily available on news-stands in the larger Canadian cities, and Canadian Art magazine was transformed into the 'hotter' and more widely distributed artscanada. Throughout the sixties their pages chronicled a dizzying sequence of international painting styles: Pop Art, Post-Painterly Abstraction, Optical Art, Minimal Art, Colour-Field Painting, and the New Realism, to name only the most prominent. The debates that raged among the contending ideologies were reflected in a stream of popular anthologies pumped out at the end of the decade by the New York critics Gregory Battcock and Nicolas Calas: collections including The New Art (1966), Minimal Art (1968), Art in the Age of Risk (1968), Icons and Images of the Sixties (1971), and Idea Art (1973), which heralded the attitudes of the new decade. Major exhibitions in Canadian public galleries-Post Painterly Abstraction (AGO, 1964), London: The New Scene (VAG, AGO, NGC, 1965–66), Dine, Oldenburg and Segal (AGO, 1967), James Rosenquist (NGC, 1968), Los Angeles 6 (VAG, 1968), New York 13 (VAG, 1969), The New Alchemy (AGO, 1969), which attested to a major turn of affairs-heightened the sense of a clamorous rush towards some sort of apocalyptic resolution, a stance that could meet the demands of the age.

By the end of the decade alternative modes—sculpture, photography, film, video, conceptual art, performance, installation work—predominated among the younger artists in Canada. By the mid-seventies, with the proliferation in most larger centres of artist-run 'parallel' galleries (funded by the Canada Council and linked together by the Association of National Non-Profit Artists Centres—ANNPAC—incorporated in February 1976), it appeared that painting *had* become irrelevant to the vanguard. Commercial galleries, and even large public institutions, also managed to adapt, helped along by those artists who had achieved prominence as painters in their early maturity a decade or more before, but who were now involved with the possibilities of the new media.

It is a tribute to the complexity and adaptability of the painter's art that, in spite of these prevailing tendencies, most of the important painters in the preceeding chapter devised strategies for sustaining their own attention and for capturing that of a significant number of viewers during the period, and that some young artists still found painting exciting and relevant. In the major artistic centres of Canada, and throughout the Western world, at the close of the seventies those who had kept the faith were joined by numerous others who turned to painting again. Critics, dealers, collectors, and curators soon followed in the wake of these enthusiastic young proponents of this most vital and adaptable form of the visual arts.

LONDON

In the last chapter we noted that by mid-twentieth century Toronto and Montreal, the principal artistic centres, had been joined not only by Vancouver but by a string of communities across the Prairies and in the Maritimes, where university art departments had attracted painters of ability. London, however, presented a unique phenomenon. This small, well-off city in southwestern Ontario (its major industry the insurance business) had inexplicably spawned a community of artists of uncommon vitality and originality. Their accomplishments were celebrated in an exhibition circulated by the NGC in 1968–9, 'The Heart of London', which documented the growth and continuing development of the London scene, a scene that like any other was subject to the artistic currents of the day. Of the three pioneer painters cited in the previous chapter, one, Tony Urquhart, had abandoned the easel by 1965 for sculpture.

JACK CHAMBERS (see p. 311 ff.), confronting limitations in his painting, also found himself drawn to other media. His first Canadian exhibition in 1963, at the Isaacs Gallery in Toronto (his very first one-man show was

at the Lorca Gallery in Madrid in 1961), was enthusiastically received and he was able to arrange shows in New York (the Forum Gallery in 1965), and Montreal (Galerie Agnes Lefort, 1966) in close succession. Nevertheless he feared that people liked the 'realism' of his paintings but did not appreciate the complex investigation of the nature of experience that lay behind them. In 1964 he had begun working with film. His R_{34} of 1967, about his friend Greg Curnoe, was called by Stan Brakhage, the pre-eminent American 'personal' film-maker, 'the greatest film on the creative process I've yet seen'. In 1968 Chambers founded the London Film Makers Co-op.

All of Chambers' earlier paintings have a cinematic quality in their simultaneous presentation of a sequence of actions. But in 1966 he made a series of large pictures on plywood that juxtapose usually three or four discrete images created entirely in a few layers of aluminum paint. Chambers called these silver paintings 'instant movies'. The flat images flash between positive and negative as you move in front of them. The rejection of illusionary space in favour of a temporal dimension seemed to him to address the nature of perception as revealed in film. Further experiments in assembling separate, delicately tinted drawings, laminated at different depths in a complex 'sandwich' of wood, paper, and plastic, continued through 1968 (although some were not completed until three or four years later). One of the most impressive, *The Hart of London* (1968, NGC), is intimately related in subject to a film of the same name that Chambers finished in 1970.*

Essentially these film-related pictures are assemblages of fragments of experience, and their making resembled the editing process by which films are assembled. But Chambers did not entirely abandon more traditional painting, and in 1968 he began work on two huge wooden panels (one almost 2×2.5 metres, the other almost three metres wide), highly naturalistic panoramic views of Highway 401 near London. One was never finished, but the slightly smaller one, *401 Towards London No. 1 (AGO), was completed late in 1969. It is breathtaking: expansive, full of the light, air, and space of actual experience. At first glance it seems to reflect the anonymity of modern highway construction but soon reveals a particularity of place and time that, in an unexpected way, is deeply moving.

*The title *The Hart of London* is both a reference to the pursuit by police of a deer that once strayed into London, Ontario, and a pun on a quotation Greg Curnoe included in his mural for Dorval Airport (see pp. 321–2) recording a German officer's declaration, in the First World War, that the very heart of London, England, 'must be hit'. The name of the travelling exhibition of work by London artists mentioned on p. 317—'The Heart of London'—was therefore richly allusive.

Jack Chambers. 401 Towards London No. 1, 1969. Panel, 183.0 × 243.5. AGO.

401 Towards London No. 1 represented a momentous turn for Chambers, and thereafter he was committed to creating similarly singular, relentless visions, capable of stirring deep emotions in the viewer. His determination to reveal the emotive underpinnings of visual perception seems especially remarkable when one considers that in July 1969, as he pressed towards completion of his huge painting, Chambers learned that he had leukemia-and was not expected to survive more than a few months. But he fought the disease relentlessly for almost a decade, travelling repeatedly to clinics and hospitals in Texas, England, New York, Mexico, and Germany. Most of 1975 was spent on such journeys, and in hospital in London, Ont. Early that year he also visited India, returning again in 1977. A religious man (he had converted to Catholicism while living in Spain), Chambers was certain that his struggle with the debilitating disease would be resolved in keeping with his faith. This conviction clarified the essentially spiritual nature of his concerns as a painter and filmmaker, which he had made evident in a personal manifesto and description of his artistic credo that he completed in the momentous summer of 1969 and published in artscanada in October as 'Perceptual Realism'. From 1969 through 1974, working from his own photographs of carefully cho-

sen subjects, he completed a series of monumental paintings (the last large one actually completed two years later). These landscapes and domestic interiors—including a remarkable painting of a female model in his studio—all address the nature of being, which Chambers understood as an integrated continuum, revealed in the condition of love for all creation. This sense of continuity is as manifest in *Sunday Morning No.* 2 (1968–70, Private collection, Toronto)—a radiant image of his sons watching television in the family livingroom—as it is in a series of transcendental images of Lake Huron and its skies begun late in 1970, or in a profoundly moving group of drawings made in India early in 1975. His view of all of existence as essentially one living organism is equally evident in *Circle* (1968–9), a 36-minute time-lapse film of the passing of a year in his backyard in which the light and space is seen to breathe to a slow, subtly shifting rhythm. Chambers died in London in April 1978.

Although Chambers' paintings of 1969 to 1975-each a lucid epiphany illuminating the meaning of life-and his films represent the most substantial part of his considerable legacy, his political activity was also important. Galvanized in the summer of 1967 by a presumptuous letter from the NGC regarding the inclusion of a slide of one of his paintings in an educational kit, he insisted that copyright be respected and royalties be paid. The NGC refused. In response to a poll of as many artists across the country as he could contact, Chambers later that year established Canadian Artists' Representation (CAR), with himself as president, Tony Urguhart as secretary, and Kim Ondaatje, another London painter, as treasurer. On the basis of 'fair exchange-payment for services', particularly for the reproduction and exhibition of works, CAR attracted the interest of many artists, and when Chambers arranged a session in Ottawa in June 1968 to discuss artists' copyright, representatives came not only from London but from Vancouver, Winnipeg, Toronto, Montreal, and St John's to meet with those from the NGC, the Canada Council, the Professional Art Dealers' Association of Canada, and the Canadian Art Museum Directors' Association. Rental fees for the exhibition of works of art proved to be the sticking point, but CAR was determined to see justice done.

By 1971 CAR locals were established by virtually every artistic community of any size in the country. Becoming Past President in 1974, Chambers remained active in CAR nearly to the end of his life. He was proud of its accomplishments in asserting artists' rights and in broadening their sources of financial support; it was important to him that these had been realized entirely on the basis of organization through free association.

GREG CURNOE (see p. 312 ff.), like Chambers, was convinced that art had

to be firmly grounded in life experience. This led to the determined regionalism that had been the hallmark of the nascent London scene in the early sixties and that, as its proponents often pointed out, was the only safeguard against provincialism, which—because it represented an attempt to imitate the attitudes and concerns of a metropolitan centre necessarily ignored or rejected the true source of authenticity, of originality, in art. Nevertheless Curnoe and the other London artists did not turn their backs on the world. He, in particular, has a voracious appetite for new ideas and information, but he always shapes them according to the reality of his immediate experience.

Curnoe's deep interest in Dada is a case in point. He had no desire for his art to look like, or otherwise attempt to appropriate, the historical Dada precedent, but the contempt for conventional fine-art values shared by most of the Dada movement, and their fascination with the aesthetic possibilities of the commonplace, supported Curnoe's own feelings and encouraged his personal investigations. This background separates him most clearly from Chambers; of the painters who reached maturity in Canada by the mid-sixties (with the possible exception of Michael Snow), Curnoe was the least dependent on traditional views of painting. Nonetheless he did make paintings—bright and shiny on heavy plywood—as well as write, perform, film, agitate, and generally serve as a creative focus for the growing artistic community in London.

Curnoe's most ambitious painting of the period, *†The Camouflaged Piano* or French Roundels (NGC) of 1966, is certainly his largest to that date (almost two metres by over three). It contains, in addition to pictures of two of his London friends playing jazz (one at the piano), pictures of the sculptor Robert Murray, of the British dirigible the R-34, numerous texts, and an old hotel sign, richly encrusted with pigeon droppings and supporting a row of electric lights. Curnoe's bright, graphic paintings, particularly The Camouflaged Piano, led directly to his receiving a major commission to devise a mural for the international-arrivals corridor at Dorval Airport in Montreal—a long tunnel through which a moving sidewalk connects two wings of the building. Almost as long—some 170 metres—the mural is made up of twenty-six shaped panels representing the passenger gondola, engines, and other lower parts of the R-34, which in 1919 was the first aircraft to cross the Atlantic non-stop; in addition there are texts and images reflecting Curnoe's immediate concerns at the time-his family, friends, historical and contemporary figures. And weaving through it all is the theme of air travel in peace and war. Curnoe began to install the completed mural in March 1968, but was stopped by transport officials because of complaints that it contained anti-American elements (appar-

ently a reference to the boxer Mohammed Ali, who had publicly opposed American involvement in Vietnam, and a figure who resembled then-President Lyndon Johnson). Curnoe refused to make changes, and the partly installed mural was later removed and transferred to the NGC in Ottawa.

It must have been a crushing disappointment, but there was little time to brood over it. The mural commission had made it possible for Curnoe and his wife to acquire an old furniture factory on Weston Street in south London that they turned into a spacious studio and comfortable home. And, in the midst of the fallout over the 'Dorval affair', the Nihilist Spasm Band cut its first record. In August, Curnoe was again subject to public censorship when three elements of a piece entitled *24 Hourly Notes* (Mr Avrom Isaacs, Toronto) were removed by officials from a Canadian exhibition at the Edinburgh International Festival. A kind of 'round-the-clock diary', the work consists of twenty-four small sheets of galvanized metal (twenty-three painted, each a different colour) on which, for a full twenty-four hours once an hour, Curnoe recorded in rubber-stamped text his thoughts or actions at the time of making. Some of the wording was deemed offensive.

24 Hourly Notes was made on 15 December 1966. Earlier that year Curnoe had produced a similarly programmatic Weekly Notes and a Daily Notes, also rubber-stamped, but on pieces of prepared wood. An early interest in comic books led him to associate texts with pictures, and virtually all of his paintings bear some text. But in May 1961 he rubber-stamped a verbal description of the view from his third-floor studio on Richmond Street on to a piece of drafting linen. This work, Cityscape (Mr David Silcox, Toronto), was the first to consist of text only. Soon after, he acquired more rubber stamps from Michael Snow and continued to experiment with descriptions and lists. A reading of Alain Robbe-Grillet's novel The Voyeur confirmed his belief in the force of simple, unadorned description, and as he acquired more and larger rubber stamps his lettered work became more ambitious. Then in April 1967 he was given a number of primed and stretched canvases by another artist, and used them as the supports for his first 'paintings' made entirely of rubberstamped texts: descriptions, again, of the view from his studio, now located on the third floor of a building on King Street.

In August 1968, soon after settling into the new studio on Weston Street, Curnoe began work on his most ambitious lettered paintings. Unlike the previous lettered canvases, these were carefully prepared in advance, as had been his textual 'diary' pieces such as the 24 Hourly Notes. He commissioned especially large rubber-stamp letters from a local

firm, and ordered oversize canvas, which he primed with white latex paint and stapled to a standing sheet of heavy plywood that was covered with rubber carpet padding. His north studio windows offer a clear view across a broad river valley to Victoria Hospital, where he and his children were born; he stretched a string across one of the windows, and systematically scanned the scene from left to right, describing in notes everything crossed by the string and a few things that popped into his head. Using printing ink he transferred the notes to the prepared canvas with his large rubber stamps. The effort was greater than he had anticipated, and by the time he finished in January 1969 he was thoroughly fed up with the process.

View of Victoria Hospital, First Series (NGC), as he called it, consists of six huge canvases (each almost three metres high by over two wide), and is visually stunning, with the words close together and broken arbitrarily by the edge of the canvas. But, as Curnoe pointed out in a later catalogue note, 'they don't work if not read. The varying tones of the surface are completely accidental. To remark on the subtlety of the surface, as some have done, is like admiring the shape of a cloud of dust made by a car and attributing that shape to the driver's ability.' 'ARE YOUREADING ORJUST LOOKING?', he asks in one of the asides. To read the pictures takes considerable concentration, but it is the only way to participate in this highly focused and individualistic landscape experience.

Although Curnoe has almost always worked programmatically, and usually in series, some series freely overlap. As soon as he finished View of Victoria Hospital, First Series (which was chosen to be part of the Canadian representation at the X Bienal de São Paulo, Brazil, in the summer of 1969), he began a huge painting of the window view of the hospital in the stylized representational mode he had used for the Dorval mural and The Camouflaged Piano. But View of Victoria Hospital, Second Series (NGC) is not a straightforward landscape view. One hundred and twenty small numbered circles are scattered across its broad surface $(2.5 \times 5 \text{ m.})_{r}$ relating to an eight-page notebook that describes various brief incidents that occurred while he was recording the scene; a small tape deck sits in front of the plywood picture playing back sounds Curnoe recorded at the window. The complex layering of the experience does not end there, for he undertook the project in tandem with Jack Chambers, who was going to paint the hospital-a significant institutional structure in his life too-in his 'perceptual realist' style alongside Curnoe in the latter's studio. But Chambers photographed the view and worked on his Victoria Hospital (Private collection, Toronto) in his own studio. Almost exactly half the size of Curnoe's painting, it was finished in less than half the

time. Curnoe finally completed his in March 1971.

By then Chambers was working on his series of ethereal Lake Huron landscapes (the first was finished). Although he had sketched out-ofdoors before, this work perhaps stimulated Curnoe to take watercolours with him on a trip to Frobisher Bay in the summer of 1971. He has painted watercolour landscapes on summer trips every year since, usually on lightly squared or ruled sheets from a coil-bound school-size notebook. These intense, sensitively coloured scenes are naturalistic, in the sense that they arise in part from a topographical concern, but they are also highly personal, often idiosyncratic. They resemble nothing else in Canadian art as much as those remarkable oil sketches Tom Thomson painted in Algonquin Park during the last four years of his life.

A gifted watercolourist, Curnoe maintains a lucid clarity while employing saturated hues that are almost as bright and forceful as the shiny paint he applies to plywood. Because of the nature of the medium his watercolours are more painterly than his oils. Surprisingly, he embraced this new medium at precisely the moment when many other artists were questioning the very validity of painting. In January 1972 he began work on the first of a series of life-size cut-outs of his favourite racing bicycle (he is an avid road-racer) that are almost sculpture. But a year later he switched to watercolour treatments, first of the whole bicycle in small scale, then of full-size single wheels. Reminiscent of Marcel Duchamp's famous bicycle wheel 'readymade'—one of the icons of Dada—these are paradoxically the most lusciously painterly works Curnoe had made to that date. By 1975 he was painting life-size bicycles, carefully measured and precisely drawn, and bearing many notations, but exquisitely finished in open, radiant watercolour.

Other decisions also seem to have been setting the direction of Curnoe's work against the general artistic trends. He continued to pursue his interest in the Nihilist Spasm Band, in film and video work (his first video piece was shown in 1974), in critical writing and publishing, in illustration (notably his large group of pen-and-ink drawings for David McFadden's *The Great Canadian Sonnet* of 1970), in CAR, and in the formation and support of galleries responsive to the needs of London's artists. (Only Curnoe has served on the founding boards of all three of London's successive artists' co-operative galleries: Region Gallery, November 1962—December 1963; 20/20 Gallery, 1966–71; and Forest City Gallery, formed in 1973.) But increasingly he investigated further possibilities in painting.

Curnoe accepted the position of artist-in-residence for a year at the University of Western Ontario in July 1975, and that fall or early winter he began to sit in on the life classes. He had not worked from a nude model since his student days at the Ontario College of Art. Chambers had begun drawing from a model about two years earlier in preparation for his wonderfully disarming painting of a model in his studio, *Nude No. 4* (Estate of the artist), which was nearing completion that fall. But Curnoe's investigations took their own particular, unexpected turns. He re-examined the work of Matisse and others who had been able to sustain the female nude as a viable subject in modern art, and fastened on a minor Fauve painter, the Dutch Kees van Dongen, whose work from between the wars retained certain characteristics of fauvist colour within a more conservative but eccentrically interpreted pictorial tradition. Curnoe entitled a number of wonderfully fluid pen-and-ink nude studies of the winter of 1974–5 *Homage to van Dongen*.

In the summer of 1976 Curnoe was chosen to represent Canada at the *XXXVII Biennale di Venezia* with *View of Victoria Hospital, Second Series* and seven more large painted plywood pieces (all but one also equipped with sound) depicting the views from the other windows of his studio. These were done during work on the *Victoria Hospital* series (although the last one was begun in August 1971 and completed in January 1973). Each panel is highly individual in shape, although all but one are rectangular, and the speakers through which the soundtracks are broadcast are attached each to its panel in a distinctive way that enhances visual interest. After Venice the works were shown at the Canada House Gallery in London, England (December 1976), along with seven of Curnoe's life-size watercolour paintings of bicycles.

Watercolour now dominated his concerns as a painter, as painting dominated his concerns as an artist. A monumental watercolour painted between January 1975 and April 1976 shows the position this most painterly of media held in his life. One-and-a-half by over three-and-a-half metres in size, **Corner* (NGC) is a steady, detailed view of the northwest corner of his studio, revealing in its bright, richly coloured breadth the range of the artist's interests. Filling most of the right-hand portion is a large unfinished painting, a constant ironic reminder of the new primacy for him of watercolour. (This acrylic on plywood painting, *I Iron, First Hole, Thames Valley G.C., with Delaunay Sky* (the artist), was begun in July 1971 and not finished until 1978.) The unfinished painting also announces that this is an artist's studio, thereby connecting *Corner* to that grand tradition of studio interiors exemplified by Courbet in the last century and Matisse in this.

A devotion to watercolour and an awareness of his own work's relation to the history of painting marked Curnoe's efforts for the rest of the

Greg Curnoe. Corner, 1976. Watercolour, 149.2 × 364.5. NGC.

decade, and beyond. While visiting Toronto regularly during the school year 1976–7 to teach a class at the Ontario College of Art, he painted a series of views of the CN Tower, many of them related to the Parisian Robert Delaunay's studies of the Eiffel Tower made early in this century. Curnoe also shares with Delaunay an interest in depicting dirigibles, sport, and roundels of saturated colour. At Emma Lake in Saskatchewan in July 1973 he painted a self-portrait in watercolour (Ron Longstaffe, Vancouver), and picked up the theme again in 1977 in a continuing series of often highly coloured and painterly self-studies.

In June 1978 Curnoe began work on another very large watercolour $(1.5 \times 2.5 \text{ m.})$, *Homage to van Dongen (Sheila) No. 1* (HH). Finished late in 1979 (by which time he had begun studies for No. 2 in the series, started in 1980), it is a brilliantly accomplished watercolour, clear, bright, and equally intense over its entire vast surface. The composition is based on a pose from van Dongen, but Curnoe asked his wife to model for him, establishing a relationship that he knew would bring authenticity to the finished work. Vibrantly alive, it is the first of his paintings to be entirely free of text (although a discreet message to his wife is pencilled into the upper-left background). After twenty years as an artist, Curnoe was confidently pushing watercolour, that most unfashionable of painting traditions, to a previously unheard-of scale, and to new heights of inspired emotion and visual force.

Through the late sixties and a good part of the seventies Curnoe and Chambers shared the role of senior artist on the London scene, a position arising as much from the inspiring example of their respective bodies of work as from their active leadership both in artists' organizations and in *ad hoc* responses to broader community issues. During these years London was, in relation to its size, the most active artistic scene in Canada, where painting—as elsewhere—was but one of a number of artistic options. This attitude was encouraged in part by Chambers' work in film, and by Curnoe's—along with his ongoing musical concerns, and the fundamentally nihilistic, yet programmatic, nature of his wide-ranging artistic activities.

Among artists whose early development was nurtured within this openly enquiring and tolerant environment are a number of sculptors, most notably the twins, Royden and David Rabinowitch (b.1943). The important, innovative sculpture-installation work of Murray Favro (b.1940), who studied art at Beal Technical School (1958–62, 1963–4), must also be cited. But despite the importance of three-dimensional art in London in the seventies, painting persisted, clearly nurtured by the example of Chambers and Curnoe. The work of most of the younger or newly serious painters can be situated within the orbit of one or the other. Among those interested in imagery that falls somewhere between photographic naturalism and a kind of precise, geometric realism, the work of Jack Chambers was important to Toronto-born Kim Ondaatje (b.1928), who lived in London 1967-73; Bernice Vincent (b.1934), from Woodstock, Ont.; Gilbert Moll (b.1948), London-born and trained, at Beal Tech and Fanshawe College; and Brian Jones (b.1950), who was born in Chatham, Ont., but studied art at Beal. Associated with the work of Greg Curnoe are some mid-seventies pictures by Robert Bozak (b.1944), who was born at Hudson Bay Junction, Saskatchewan, and studied at the Alberta College of Art in Calgary before moving to London. Another artist whose iconographic concerns, style, and technique at times resembled Curnoe's is London-born Dave Gordon (b.1944).

But the painter who most fervently embraced both Curnoe's regionalism and the colourfully painted plywood constructions that he focused on in the mid-sixties has also achieved the most distinctive voice in the long run. JOHN BOYLE (b.1941) was born and raised in London, but after high school and a stint at Teacher's College, he took a job teaching elementary school in St Catharines, Ont. Spurred by a Van Gogh exhibition he happened to see in Detroit, Boyle had tried painting in his last year at high school, an interest he continued to pursue in St Catharines. On a visit to London the following year he met Greg Curnoe, who showed an interest in what Boyle was doing, and later visited him in St Catharines. In the fall of 1964 Boyle took a leave from teaching to attend university in London. He later described it as 'a pivotal year' in his life. Though he just scraped through his university courses he met many artists, began to exhibit his art, and became an integral part of the bur-

geoning London scene. Returning to St Catharines, he kept in touch with his London friends (he helped form the Nihilist Spasm Band in the fall of 1965, and the following May, when his *Seated Nude* was removed from the annual Western Ontario Exhibition by the London Public Library and Art Museum, Greg Curnoe, Murray Favro, and Bernice Vincent withdrew their works in protest), and in addition to teaching, worked assidously at his art.

Boyle's painting of the late sixties and early seventies is aggressively vulgar. Although inspired by Curnoe's painted constructions, it displays a distinctive handling. Boyle agreed with Curnoe that authenticity in art derives from working with what is most immediate in one's life. His heavily painted free-standing plywood structures are covered on all of their (usually) many-faceted surfaces with large images of cultural heroes mixed in with friends and familiar places. The best of these is *Midnight Oil: Ode to Tom Thomson* (London Regional Art Gallery) of 1969. One of a series of pieces devoted to Thomson—another largely untrained painter who depicted what he loved and knew best—it renders in thick primary colours high-contrast images based on photos, some of them set against backgrounds derived from Thomson's famous paintings. This intense, celebratory object—both sculpture and painting—transcends the constraints of medium to proclaim its cultural identity.

Two more painters of importance emerged from the stimulating London artistic environment of the late sixties: Ron Martin and Patterson Ewen belong to the small handful of painters of extraordinary talent working in Canada today.

RON MARTIN (b.1943) was born in London, where he attended Beal Tech (1960–4), emerging 'at a moment of high energy', as Curnoe would remark almost twenty years later, 'moving into a community where the pressure was on to rent a downtown studio and do original, serious things.' Martin found a studio early that summer that he shared with his friend Murray Favro for about two years. (He met Favro during their final year at Beal.)

Martin has said that the 'magical charm' of Greg Curnoe's paintings influenced him. So did Curnoe's collages, and some of his ideas; his sense of historical context, his great interest in Duchamp, and his consciously programmatic manner of working all helped Martin isolate his own concerns. A retrospective of the great German collagist Kurt Schwitters at the AGO in September 1965 was also crucial to Martin's developing sense of himself as an artist, and he had his first one-man show—of 'Pop Collages—at Toronto's Pollock Gallery in February 1966.

The philosophical and theoretical nature of Martin's approach to art is

apparent as early as 1967 when he began working on a series of pieces he called Conclusions and Transfers. In response to a remark of Marcel Duchamp's about the 'gap' in representational painting between the subject (the thing painted) and the object (the painting itself), Martin sought to bridge this by making an abstract painting (always in homage to an artist he admired), creating an exact copy, and hanging the two together as a single work. The series continued through 1969, stimulating experiments in watercolour that began to reveal to him that the reality of a painting resided entirely in its material nature. Seeking to investigate that nature more closely, he developed a conceptual system of paintingdividing a canvas of fixed dimensions (all but one are 213.4×152.4 cm.) into one-inch squares, and filling each with three simple strokes of acrvlic paint in the shape of an N, alternating the direction of the strokes between horizontal and vertical (N Z N), and choosing the colour of each stroke from eight basic hues (the spectrum and brown and black), according to a predetermined pattern. The 'meaning' of these World Paintings, as he called them, resides in the viewer's experience of the perceptual phenomena they display. Each is a highly individualistic shimmer of optically blended colour that relaxes and contracts, shifts and ripples as we attempt to isolate parts or absorb larger areas.

A group of the *World Paintings* was shown at the Carmen Lamanna Gallery in January 1971 (the first of his annual shows there). Martin then added two more to the series, but used a thicker and more opaque paint than formerly. Roald Nasgaard has pointed out that in these new works 'perception of colour as something immaterial becomes transformed into perception of colour as coextensive with body ..., the perception of the body of the paint as articulated through physical movement'.

Subsequent experiments led in August 1971 to the One-Colour Paintings, a series in which Martin continued to explore the implications of the unity of colour and paint. Slightly wider at 182.8 cm. than the World Paintings, the format of the One-Colour Paintings reflects exactly Martin's reach. Although in reproduction they look something like children's finger painting (the white primed canvas is bare in places and lightens the more thinly spread paint-colour), in life the marks left by every move that went into their making evoke the painter's presence. It induces an acute self-awareness of both body and perceiving mind that is associated inextricably with the reality of colour as substance.

Beginning in May 1972 Martin began to concentrate on just one colour through a series in his *Bright Red Paintings*, fourteen of which were featured in a six-man show at the NGC in the summer of 1973. By then he had virtually stopped painting. During August and September, however,

Ron Martin. Lovedeath Deathlove, 1975. Canvas, 213.3 × 167.6. NGC.

he made a series of pictures with a brush in clear water on cheap poster paper. The ethereal, constantly shifting images created by the shrinking of the paper in the track of the water are remarkably compelling and moving reflections on the role of personal expression in painting. These *Water on Paper* works were exhibited at the Carmen Lamanna Gallery in January 1974. Martin meanwhile had returned to paint, increasingly larger quantities of mars black iron oxide—first one gallon per canvas, then two, then three, and finally twenty-five gallons per canvas. Abandoning his brushes, he worked on a flat table easel and moved and shaped the paint with his hands. These Black Paintings are remarkably various in character. (Martin represented Canada at the XXXVIII Biennale di Venezia in 1978 with a group of nine of them.) The earliest show both the white ground in places and the tracks of his fingers as they kneaded and scraped the paint; in some a variety of hand techniques resulted in contrasting textures and densities; others reveal a steady, purposeful application in a single regular motion. By January 1975, with *Lovedeath Deathlove, No. 15 (NGC), Martin was working with a substantial amount of black paint, arranging it in magisterial movements. In the spring of 1976 he reached the maximum amount of paint that could be expected to remain fixed to the canvas. Muscular, fleshy, organic embodiments of natural growth, these sculptural pieces are nevertheless palpably of paint-in such excessive, eruptive quantities as to suggest disastrous chemical accidents.

During the summer of 1976 Martin responded to a recently heightened awareness of the sense 'that the material takes on its own character apart from anything I might have done', as he put it in the catalogue for his Venice show. 'It alters, it changes ... through the drying process as through the doing process.' This underlined for him that 'painting is reality in itself instead of just a vehicle to imitate reality', and he devised a conceptual mode within which his actions would reveal more about the essential nature of his medium. A short series, In Pursuit of the World, arose from stretching the canvas before working, propping it against the easel, then applying the black paint in layers and allowing a skin to form between coats. The paint sagged, and in some cases actually slipped before congealing. Martin has since pressed the drying paint in a methodical fashion, or rubbed it, producing a burnish, or allowed it to 'curdle' before manipulating it, or, once having applied it, scraped it back to the ground—all actions that reduced the making of the painting to a simple physical process. The regular yet still seemingly 'natural' surfaces that resulted are visually compelling. But more important is the fundamental certainty of being that they embody; this situates them among the most moving paintings of the decade.

A similarly fundamental certainty is declared in the London work of PATERSON EWEN (b.1925), who was born and raised in Montreal. In February 1948 he enrolled in the school of the Montreal Museum of Fine Arts under Arthur Lismer and Goodridge Roberts. That spring he met the

dancer Françoise Sullivan, a member of the Automatiste group (and a contributor to the Refus Global, see p. 233 ff.), and through her became involved with Claude Gauvreau, Jean-Paul Mousseau, and most of the rest of the group. Ewen and Sullivan married in December 1949, and the next April he graduated from the Museum school—a year early—because Lismer felt there was nothing more he could learn there. Working first at odd jobs to support a growing family (he and Sullivan eventually had four sons), in 1956 he became personnel manager at Bathurst Containers, a position he held for ten years. Still an integral part of the francophone avant-garde artistic scene in Montreal, Ewen contributed to most of the important group shows, and in February 1956 and again in January 1958 he held one-man exhibitions at the Parma Gallery in New York. He was by then involved with Guido Molinari, Claude Tousignant, and some of the others around the Galerie l'Actuelle. His pictures of the late fifties particularly a long series of relatively formal abstract colour paintings he called *Lifestream*—evoke landscape, or perhaps geological strata.

By the mid-sixties Ewen was using Molinari's and Tousignant's shared studio in the evenings (the only time, other than weekends, that he was able to paint), and had adopted their masking-tape technique to produce hard-edge pictures, featured in a one-man exhibition at the Galerie du Siècle in May 1966. Early that fall he moved into Molinari's new studio on Visitation St, and in November formally separated from Sullivan. He spent the winter of 1966-7 in a small house in the St Henri section of Montreal; then early in the new year he was admitted to the Royal Victoria Hospital, to receive treatment for acute depression. (An intense personality, Ewen had suffered from chronic St Vitus's Dance as an adolescent.) After his release he moved to Kitchener, Ont., to stay with his sister, subsequently entering Westminster Veterans Hospital near London, Ont., for further treatment and rest. (He had served in the army during the war.) On weekend leaves, and later for more extended periods, he stayed in London. When Ewen was discharged, he lived in the York Hotel, and then rented the space at 523 Richmond St that earlier had housed the Region Gallery, and Curnoe gave him a stencilled 'sign' painting-made both to commemorate the earlier tenancy and to identify the new one.

During the stressful period from late 1966 through the first months of 1967, Ewen managed to produce some paintings. At the time of his breakup with Sullivan he was working on large hard-edge canvases—divided into twelve equal portions, each containing a variation of a simple linear theme—called *Diagram of a Multiple Personality*. Early in 1967 he produced a series entitled *Close Up* that presented one portion of a picture of the preceding series. He also began working on the *Lifestream* theme again, but using tape—applied quickly by running up to the canvas—to achieve crisp edges to the slightly wavering lines of unmodulated colour that continued to be his subject. Five *Close Up* and *Lifestream* works were featured in the *Seventh Biennial of Canadian Painting* at the NGC in the summer of 1968.

Welcomed warmly in London, Ewen was soon deeply involved in the local scene. In September 1969 he began teaching at Beal Tech and also joined the Rabinowitch brothers in a three-man show at the London Art Gallery. In October he showed recent *Lifestream* pictures—still hard-edge, but more dynamic in configuration—at the Carmen Lamanna Gallery in Toronto (this began a sustaining relationship with that important dealer). A retrospective at the 20/20 Gallery in January 1970 reflected London's esteem for Ewen's earlier career, especially paintings from the late fifties and early sixties. (Ron Martin owns a small single-colour picture, *Untitled* (*Blue Monochrome*), of 1963.)

Shortly after the London retrospective Ewen moved into a new studio in a warehouse at 19 King St. This coincided roughly with another crisis, one centered almost entirely on his unhappiness with the static, 'precious' appearance of his hard-edge paintings; but this time he did not slip into despair. Supported by the artists around him (Dave Gordon, the Rabinowitch brothers, and Murray Favro, among others, had space in the building at different times), Ewen 'really felt just like playing', 'making an anti-art gesture', as he said later. Taking a roughly primed canvas, and using a piece of felt instead of a brush, he dabbed on it an ambling line of dots. Traces Through Space (the artist) seems to parody the clean, carefully executed Lifestream pictures. But it also suggested to him that the earlier paintings were not entirely abstract, that their dominant 'streams' could be seen as the traces of an object moving through deep space. More 'playing around' soon resulted in Rain Triptych (the artist). At almost two-and-a-half metres tall, it is his first really monumental work. Using the technique he had devised for Traces Through Space, he increased the number and variety of 'traces' to describe three different patterns of rainfall. The diagrammatic, quasi-scientific nature of the pieces fascinated him—an interest that was supported by a growing collection of popular illustrated science books that portrayed complex natural phenomena through simple, direct drawing.

Subsequent works of early 1971 are essentially blow-ups—some as large as the triptych—of several of these diagrams. *Artesian Well* (Canada Council Art Bank) or *Thundercloud as Generator I* (London Regional Art Gallery), for instance, describe in linear terms the cyclical process that underlies

common phenomena. But they are impressive phenomena, celebrated by the scale and power of Ewen's paint-handling.

In the spring of 1971 Ewen was awarded a Canada Council Senior Fellowship, which enabled him to quit teaching at Beal. He decided to try a year in Toronto. Although pleased with the abrupt turn his work had taken, Ewen was still troubled by the 'fine art' implications of paint on stretched canvas. (He later reported that his revulsion to canvas reached the point that it made him ill.) He began to experiment with different materials, which later in 1971 culminated in three large wood and metal constructions, Thunder Chain (the artist), How Lightning Worked in 1925 (the artist), and Rocks Moving in the Current of a Stream (AGO). He then turned to a standard sheet of plywood intending to make a huge woodcut print; but after gouging out an image, and while rolling on paint with a printer's roller, he realized that he had completed something that satisfied him. The result was Solar Eclipse (the artist), soon followed by Eruptive Prominence (the artist), and a continuing sequence of plywood pieces gouged with an energy that echoes the natural forces they illustrate, the images strengthened with metal or linoleum cut-outs, and often heightened with chain or other pieces of hardware. Though still often diagrammatic in nature, they were executed roughly, which gives them an urgent, natural quality.

In the fall of 1972 Ewen gained a new position teaching drawing and painting at the University of Western Ontario. The numerous pieces of 1973 and 1974 generally pursue the concerns he set out in 1971, with three exceptions. Two are figure paintings. *Bandaged Man* (NGC) of 1973 is a larger-than-life-size figure of a man wearing every sort of first-aid bandaging imaginable. It was based on an illustration Ewen found in a book, but by the time it was finished he thought of it as a self-portrait. *Portrait of Vincent* (VAG) of 1974 is based on a slide of his eldest son, a gifted, precocious writer, who is emotionally disturbed and has been handicapped by this condition for most of his life.

The third departure from what Ewen calls his 'phenomascapes' based on natural phenomena is a large panel created in homage to an earlier student of natural phenomena, the renowned Japanese woodcut artist Katsushika Hokusai (1760–1849). **The Great Wave: Homage to Hokusai* (Art Gallery of Windsor), of 1974, is Ewen's version of one of the Japanese master's most famous prints. Ewen had been using an industrial router to gouge the wood, propping the sheet against a wall in an approximation of easel painting, but a near-accident in 1973 led him to lay the sheet flat across saw-horses and work at it both from the edges and while kneeling on all fours on top. This enabled him to achieve greater intensity, partic-

Paterson Ewen. The Great Wave: Homage to Hokusai, 1976. Panel, 243.9 × 243.9. AGW.

ularly at the centre, a characteristic particularly well exploited in *The Great Wave*. The wonderful variety of routed 'lines' results both from the variety of bits he has for his router and his highly developed facility in using it, and he has coloured *The Great Wave* with white, green, and a range of earth pigments that suggests the saturated hues of a pulled print as well as the deep, polished stains of a rubbed woodblock.

Like Ewen's other works of the early seventies, this elephantine woodcut strains the definition of painting to its limit, and Ewen stopped working on his prodigious series of 'phenomascapes' some time late in 1974, turning to watercolour on heavy, rich paper that he made himself. (Curnoe was then working on his monumental watercolour *Corner*.) As redolent of their own physical materials as his gouged panels, these smaller works are naturally more painterly. When he returned to plywood more

than a year later he showed—as in *Moon Over Water* (Canada Council Art Bank) of 1977, or *Cloud Over Water* (AGO) of 1979—an even greater consciousness than before of the force of colour, of tonal contrast; and achieved a more painterly, palpable atmosphere, an overpowering sublimity that is darkly romantic. He had begun to look again at the work of a favourite painter of his youth, the late nineteenth-century American visionary Albert Pinkham Ryder, best known for his small but stupendous nocturnal marines. This new expressionist moodiness hardly changed Ewen's basic concerns, however. The magnificently serene *Gibbous Moon* (NGC) of 1980 conveys a sense of the force of a complex phenomenon presented as the material essence of what can be known.

A somewhat isolated figure who achieved recognition only near the end of a long career was CLARK MCDOUGALL (1921–80). Born and raised in St Thomas, near London, he was largely self-taught (an early inspiration was the Buffalo watercolourist Charles Burchfield), and except for the war years, which he spent in Toronto, he lived and worked his whole life in St Thomas. Partly owing to the enthusiasm of Greg Curnoe, McDougall's work came to national attention in the early seventies, when he had been painting in a highly personal manner for about ten years. His pictures, typically scenes of the St Thomas and London region, are composed of areas of usually unmodulated, saturated colour, separated by heavy lines and areas of black enamel.

At about the same time another painter with a highly personal style emerged from a remote Ontario background. NORVAL MORRISSEAU (b.1932), an Ojibwa, was born on the Sand Point Reserve on Lake Nipigon in northwestern Ontario, and raised in the nearby town of Beardmore. Instructed in shamanistic beliefs by his grandfather, he recorded the legends by adapting traditional pictographic techniques to pencil or pen on paper, or paint on birch bark. Morrisseau moved to Red Lake in 1959 to work in the gold mines, and there was encouraged in his art-making by a doctor friend. (The consequences of poverty and alcholism have frequently brought him into contact with the medical profession.) There in 1960 he also met Selwyn Dewdney (1909–79). From 1947 Dewdney worked as a pioneering psychiatric art therapist at Westminster Hospital while pursuing a career as a writer (his novel Wind without Rain was published in 1946) and artist in London. Always fond of travelling in the northern bush, he began systematically to search for and study Ojibwa rock paintings (pictographs) and carvings (pictoglyphs) in 1957. Uniquely prepared to respond to Morrisseau's special talent, Dewdney encouraged him, and helped him prepare an illustrated book, Legends of My People, The Great Ojibway (1965).

Meanwhile, Morrisseau had arranged for an exhibition of paintings at Toronto's Pollock Gallery in 1962. Consisting primarily of 'legend pictures' in oil or tempera on paper, it caused a sensation. Although a show the following year was virtually ignored, Morrisseau persisted, working in a distinctive personal style that owed something to Ojibwa pictorial traditions, West-Coast native art, and European painting practices. His subject matter-which expanded to encompass his conversion to Apostolic Christianity in 1972, and a few years later his interest in Eckankar, a holistic religion combining Asian and Christian concepts-has remained resolutely spiritual in nature. Although Morrisseau's workas is evident in Warrior with Thunderbirds (Helen E. Band, Toronto) of 1973-shares with Clark McDougall's the deployment of areas of flat, saturated colour, outlined in thick black lines, it is more monumental in scale than McDougall's and usually features one or two figures isolated in silhouette rather than a scene rendered in perspective. The work of both artists in some instances strongly recalls the effect of a stained-glass window.

Morrisseau has attracted a substantial following among both white collectors and other Indian artists, and by the mid-seventies a 'school' of Ojibwa and Cree artists working in the manner of Morrisseau had been identified. These younger painters were inspired by attendance at the Manitou Arts Foundation camp, first staged on Schreiber Island, northeast of Manitoulin Island in the summer of 1971; by contact with Morrisseau or CARL RAY (1943–78, a Cree follower of Morrisseau whose work displays a highly developed graphic character) on their tour of northern communities in 1971–2 sponsored by the Department of Indian Affairs; and by the native-run Ojibwa Cultural Foundation established in West Bay, Manitoulin Island, in 1973. They included a few distinct personalities who by the late seventies were beginning to add breadth to this so-called 'Woodland' school. Nevertheless Norval Morrisseau was still almost entirely responsible for the credibility the movement had by then achieved.

One other group of Ontario painters rose to a position of some prominence during the sixties. So-called 'Magic' or 'High Realists', they do not constitute a group as such but, like the painters of the Woodland School, they live mainly outside Toronto, and in their work they have disregarded the major artistic concerns of the avant garde. The most prominent among them is KEN DANBY (b.1940). Born in Sault Ste Marie, Ont., he studied briefly at OCA (1958–9), and held his first exhibition, of abstract painting, at the Pollock Gallery in 1961. Three years later he made his début as a realist at Toronto's Gallery Moos, showing works

such as *Fur and Bricks* (Private collection, Toronto) of 1963. This picture in egg tempera of a cat crouched on the parapet of a roof is a detailed treatment of texture in the manner of the contemporary American realist Andrew Wyeth (Danby viewed a retrospective of his work in Buffalo late in 1962). Subsequent paintings, always in the dry and precise egg tempera (although he sketches in watercolour), have included sports subjects—his *At the Crease* (Private collection) of 1972 has been much reproduced—and show a growing openness of composition and breadth of light. They increasingly reflect a nostalgia for the values of rural youth. (Danby's studio is in an old mill near Guelph.)

A shortcoming of many of the realist practitioners is that their determined pursuit of visual detail often leaves their work intellectually flat and conceptually one-dimensional. BRUCE ST CLAIR (b.1945)—who was born in Galt, studied at OCA (1965–7), and lives near North Bay—seeks to invest more interest in his small oil-on-panel pieces by assuming a tightly intimate and yet casually off-balanced point-of-view. D.P. BROWN (b.1939)—who was born Daniel Price Erichsen-Brown in Forestville, Ont.—studied art at Mount Allison University in Sackville, N.B., graduating in 1961. As a consequence of being taught there by Alex Colville, he conveys a visual sophistication in his egg-tempera paintings greater than that shown by most of his Ontario coevals, although the content is at times uncomfortably self-conscious. Brown has lived in Collingwood, Ont., since 1966.

The most accomplished and most interesting of these Ontario realists is HUGH MacKENZIE (b.1928). Born in Toronto, but raised in London, Ont., he too studied at Mount Allison (1952–4), after a stint at OCA (he graduated in 1949). At first a commercial artist in Toronto, he returned to London in 1960 to teach life-drawing at Beal Tech, and resettled in Toronto in 1967. His meticulous egg-tempera panels of the early sixties display a special regard for the form-revealing quality of light, but his painterly love of light really became manifest in the watercolour studies of female nudes and city scenes that he began to show in the early seventies. MacKenzie continued to work in tempera on panel as well; but, while still concentrating on the female nude in an urban setting, he brought a looser, more sensual aspect of the medium to the fore.

THE ATLANTIC PROVINCES

In 1973 it seemed that the art of Alex Colville would set the direction of artistic development in the Atlantic provinces for at least a generation. But by 1980 it was clear that the focus had shifted from Mount Allison University in Sackville, N.B., to the Nova Scotia College of Art and Design in Halifax, and from the charged realism that Colville espouses to the highly theoretical, concept-based artistic activity that was then calling the very act of painting into question. In the eastern provinces, as in Ontario, this period is marked by an increase in the number of artists, and by a diversity of approaches.

This was encouraged not only by the international proliferation of contending theories and styles, but by an increase in opportunities to exhibit in the region. Memorial University in St John's, Nfld, opened an art gallery in 1961. In Charlottetown, PEI, the Confederation Art Gallery, a large public facility, opened its doors in 1964. The sculptor Claude Roussel (b.1930), who had established a visual-arts department at the Université de Moncton in 1963, opened an art gallery there in 1965, which for the first time brought a focus to Acadian artistic activity. And artistrun spaces were helped into existence during the seventies by the Canada Council. By 1980 there were two alternative galleries in Halifax (one specializing in video art), another in Moncton, and one in Charlottetown.

BRUNO BOBAK (see pp. 287–8) and his wife, Molly Lamb Bobak (b.1922), who hailed from Vancouver, arrived in Fredericton in 1960 when Bruno accepted the position of artist-in-residence at the University of New Brunswick. They returned to settle in 1962 when he was made Director of the Art Centre there. Bobak's large expressionist figure paintings are now seen as a substantial accomplishment, but during the later sixties and the seventies they were not widely shown and had a limited effect on the course of events in the area.

ALEX COLVILLE (see p. 274 ff.) remained the most prominent painter of the region. He represented Canada at the XXXIII Biennale di Venezia in 1966, designed the official Canadian centennial coinage, and among numerous other forms of recognition held highly successful one-man exhibitions in Hanover, West Germany (1969), at Marlborough Fine Art in London, England (1970), at the Künsthalle in Düsseldorf, West Germany, and then at Fischer Fine Art in London (1977), and at both the Montreal and Toronto galleries of Mira Godard (1978). In 1981 he was appointed Chancellor of Acadia University in Wolfville, N.S., his home since 1973. By then he had also collected seven honorary degrees and the Order of Canada, and was the one contemporary Canadian artist that was widely known and appreciated by the general public.

The only painter from the Atlantic region to approach Colville's national prominence during these years was CHRISTOPHER PRATT, a student of Colville's at Mount Allison. (His other best-known pupil, TOM FORRE-STALL, who left Fredericton for Dartmouth in 1972, and who has for many

years presented his Wyeth-influenced realist paintings in unusually shaped formats, has not gained such wide recognition outside the Maritimes.) When Pratt and his wife Mary first met at Mount Allison, they were both studying art. The Newfoundland-born Christopher Pratt's sense of vocation came early in life and persisted against considerable odds (his prominent St John's family would have liked him to follow in the family business, or at least some business). Because of delays arising from initial confusion, he graduated as a mature student (BFA at age 26), but his work at that time still came under the spell of the ideas and images of Alex Colville. This is evident in his senior student canvas, Euclid Working (Private collection), of 1961, whose title refers both to the subject of the painting, a 'Euclid' truck hauling earth or gravel, and to the Euclidian geometry that underlies the composition. (A stab at studying engineering at Memorial University in the fall of 1952 gave Pratt an early taste of such compass-and-rule work.) His graduation piece, a brooding Selfportrait (Owens Art Gallery, Mount Allison University, Sackville, N.B.), while still located within the Colville orbit, projects a heightened, complex, personal mood, and reveals the start of his consuming interest in architectural detailing.

Back in St John's late in the spring of 1961, Pratt was offered a job teaching night classes at Memorial University and running the new Art Gallery. He found little time for painting while working at Memorial University, and in the spring of 1963 he and Mary (they married in 1959) took a bold step. He quit his job and they moved into the Pratt family cottage near the mouth of the Salmonier River on St Mary's Bay, about ninety kilometres southwest of St John's. This experiment in full-time painting, attempted on a trial basis, worked: they have lived there since, expanding the structure as needed to accommodate four growing children and two working artists. (Mary returned to her own painting in the late sixties.)

Christopher Pratt sent pictures off at every opportunity to such showcases of the day as the NGC biennials, the London Art Gallery *Young Contemporaries*, and the WAG annuals, and sold many of them. But, as Newfoundland's only professional painter at the time, he did not want to become simply representative of his province on the national scene; and to avoid being labelled a picturesque regionalist, he eschewed the 'typically Newfoundland' paintings of the sea and bleak landscape that had formed the basis of his painting income till then, and turned resolutely to one of the classic themes of western European art, the female nude. At first friends sat for him in their underwear, and then he found a local girl who would model regularly. Over the next three years he produced five figure paintings from the numerous drawings that arose from the modelling sessions.

Like Woman at a Dresser (CIL Art Collection) of 1964, the first one, all are medium-size oils on masonite, depicting partially clothed women alone in domestic settings, their faces turned from the viewer as they make their toilet, dress, or engage in some simple, personal activity. As much care is taken with the description of the room as with the women's bodies or underwear. Each plank of the floor, every detail of the moulding, the repeated pattern of wallpaper—all are carefully laid out within a geometrically predetermined format, creating the sense of a lovingly crafted environment that is closed, private, and thoroughly supportive.

Although Pratt continued to draw from the model when he could arrange sessions, he completed no figure paintings between 1967 and 1973. He was inhibited by the suggestion of exploitation in the display of anonymous female bodies, but was also drawn to the evocative particularity to be found in examining a small part of the built environment. His paintings-still oil on masonite-became much larger over the next few years, and more simplified. Pratt's pictures of the very late sixties and early seventies reveal an indebtedness to the abstract work of his other Mount Allison teacher, the head of the department, Lawren P. Harris. These evocative interiors also indicate that he was thinking at times of the images of the American realist Edward Hopper, and a series of riveting pictures of windows painted from 1969 through 1971 evokes the imagery of the American 'Precisionist' Charles Sheeler. They are uniquely Pratt's, however; exquisitely coloured in shades of a dominant hue, each glows with a particular and remarkable quality of light revealed through the window. Like *Night Window (York University, Toronto), of 1971, they are stripped of all hardware or other extraneous material, but every aspect of their design and construction is detailed. Night Window, which lacks the radiant light of the others in the series, offers the added delight of reflection, revealing the interior wall opposite. We see a fireplace, and over it a circular object, a mirror or perhaps the reproduction of a Botticelli tondo that hangs over the mantel in the Pratts' living-room. Missing, of course, is the painter/viewer, whose image ought to be reflected in the black glass of the night window, and whose unseen presence fills every one of Pratt's 'empty' interiors.

The shallow space and clear symmetrical geometry of works like *Night Window* underlines their 'objectness', the way in which the subject and the format/material are fused into a simple, holistic experience. We are not conscious of looking at a picture *of* something, just *at* something that in itself defines the experience. This entirely contemporary concept is

Christopher Pratt. *Night Window*, 1971. Masonite, 115.6 \times 75.6. York University, Toronto.

explored further in Pratt's paintings of the later seventies (he calls them his 'objects'), which grew larger and larger while becoming ever simpler in form. *March Night* (AGO), of 1976, is a wide (some 230 cm.) view of a wall of meticulously described, pristine clapboard that fills the painting's surface, except for a small grey margin of foundation at the bottom and a wide stripe of infinite night on the right.

Pratt's largest painting (113 \times 273 cm.), *Me and Bride* (Private collection), went through many changes between 1977 and 1980. He had returned to the figure in 1973 with *French Door* (Private collection), a painting, for the first time, of a particular model, shown reflected nude

in a glass-paned door as she looks back at the painter/viewer. *Me and Bride* carries the theme further. The wide panel is divided into five equal sections, each of which is twice as high as it is wide (a golden section). The separations between the sections could be the mullions between the continuous row of windows across the front of Pratt's studio. We look through into the screened porch beyond. It is a dark night, but the porch is lit, so there is no reflection. Pratt, in his first self-portrait since 1961, sits in the second section from the right, his back extending into the first. He is bent over his drawing board, absorbed in his line. In the far left section, separated from the artist by two empty sections, stands the model, Bride, in radiant pink underpants, her arms raised to display small tight breasts, her dark gaze turned inward/outward to the viewer. Charged with sexuality, the painting is at the same time heavy with control.

No other painter in the Atlantic provinces, and very few elsewhere in Canada during the period, were capable of accomplishing such a grandly public image that addresses vital human issues and that is also unflinchingly honest in its presentation of a specific set of personal circumstances. Pratt stands apart-from his teachers, and from other painters who came out of Mount Allison, although his wife, MARY PRATT (b. 1935), deserves to be singled out as well. Born in Fredericton, she devoted most of her considerable energy since meeting her husband to helping him realize his potential as an artist, and to creating a comfortable home and raising four children. It was only in the mid-sixties-while noticing the momentary effect of light on certain objects-that she felt she wanted to paint. Because of the transitory nature of these effects (and her busy schedule as a homemaker) she was frustrated until she began to keep a camera to hand, taking coloured slides of those little visual feasts that appeared occasionally in the course of her day. When she had the time she worked them up into small oil paintings. By 1970 she had mastered the depiction of surface effects, relishing the apparent unseriousness of being caught up in appearances. But such kitchen still-lifes as Eviscerated Chickens (Memorial University Art Gallery, St John's) of 1971, or Cod Fillets on Tinfoil (Dr and Mrs Angus Bruneau, St John's) of 1974, are little celebrations of the very stuff of life-intense, concentrated, and visually engrossing.

The Nova Scotia College of Art and Design (NSCAD) was established in Halifax in 1887 as the Victoria School of Art and Design, a name it bore until 1925. Meant only to serve the needs of the region, it ran a conventional art-training program for much of its history, turning out students with a good knowledge of the materials and techniques of the various

artistic crafts. After GARRY NEILL KENNEDY (b.1935) was appointed principal in April 1967, however, it was radically transformed. Born in Port Dalhousie, Ont., he studied at OCA in Toronto (1956-60), then went on to the University of Buffalo (BFA 1963) and to Ohio State University (MFA 1965). By the time Kennedy took on NSCAD he, like many of his contemporaries, was questioning the basic tenets of art. Painting, as an endeavour, no longer held any interest for him. From the beginning he intended to throw NSCAD open to the contending ideologies of the day and create a kind of institute of living art: students would be immersed not in acquiring manual facility but in the wellsprings of creativity. In 1969, when NSCAD was given university status by the province, making it Canada's only degree-granting art college, it became well placed to attract both students and the artists Kennedy wanted as teachers. Of key importance was David Askevold (on faculty 1968-75), an American who brought in many prominent conceptual artists over the next decade for short teaching stints. Among the important painters were Art Green (1969–71), from Chicago; Bruce Parsons (1969–77), who as a colour painter had attended three Emma Lake workshops but soon began working in video and with concept-based photo pieces as well as with informal, programmatic paintings on sheets of plastic; Eric Fischl (1974-8) of New York; Yorkshire-born and trained John Clark (1978–); and Ron Shuebrook (1974, 1979—), an American-born painter who had been teaching at Canadian universities since 1972.

Despite NSCAD's reputation during the seventies of being concerned mainly with conceptual art-which, it was often claimed, had flowered in American university art departments and was sustained by NSCAD's American teachers-there was nevertheless an underlying commitment to painting, as could be seen in the work of Garry Kennedy himself, and in that of his friend and closest associate at the College, Cincinnati-born GERALD FERGUSON (b.1937), a graduate of Ohio State University (MFA 1965) who joined the faculty in 1968. An eclectic, deliberate artist, Ferguson briefly turned away from painting in the early seventies to explore concept-based activity. He returned in September 1972 to create severely reduced-what we would call minimal-objects in felt pen and acrylic on unprimed canvas, art that is neither illusionistic nor emotionally contrived but that is self-evidently about its own particular and specific objectness. His paintings, untitled, are accompanied when displayed by a statement about the nature of the art work and how it came into being. A four-foot-square $(1.2 \times 1.2 \text{ m})$ painting of July 1974 has the following description:

Template 1 (a one foot square, 1/4" aluminum plate, subdivided into 1" squares

with ½" holes drilled in the approximate centre of each 1" square: the centre being judged by eye) was registered in the upper left with circles drawn throughout the template. With the drawing completed, the canvas was stretched. Using a No. 4 brush and white acrylic paint, the canvas was then painted outside the circles, with care taken not to overpaint the drawn lines.

Garry Kennedy, who occupied himself—apart from administration entirely with conceptual art until 1975, also proceeded in a minimalist, deliberate way when he returned to painting, attempting to re-establish its integrity from a zero-point. Working, in cautious steps, through basic procedures that are unidealistic and free of artifice or embellishment, he produced works that, like Ferguson's, are entirely self-referential, displaying only the evidence of their unique objectness. Like Ferguson, Kennedy accompanies these paintings with a description. An untitled acrylic on canvas over masonite of 1977 (80.6 \times 80.6 \times 4.8 cm.—Kennedy always gives the depth measurement, thereby reinforcing the objectness) is described as follows:

The brush strokes follow the horizontal condition of the structure of the canvas. The brush strokes on both sides are continuous with those on the front. The brush strokes on the top and bottom, while following the horizontal direction of the weave, indicate the distinct break in the fabric as it folds over to cover the top and bottom edges. The painting is grey and is completed when enough coats of paint have been applied to cover all evidence of the canvas.

Through the work of its teachers and students NSCAD introduced a vast amount of art-making to Halifax, and in the realm of art made the city a centre of national, and even international, significance. While it is too early to assess its impact on future artistic activity there, or across the nation, it is evident that NSCAD graduates will become a potent force in the development of Canadian art. By 1980, however, there were relatively few painters of promise among graduates, although these were very promising indeed. The work of TIM ZUCK (b.1947), for instance, closely reflects the character of the College during the seventies, while also manifesting an impressive personal resolution and individuality.

Zuck was born in Erie, Pennsylvania, and after studies at Wilmington College in Ohio (where Ferguson took some of his undergraduate courses), and at Madras Christian College in India, came to NSCAD in 1969, graduating with a BFA in 1971. After taking an MFA at the California Institute of the Arts (1972), he was engaged as an assistant professor at NSCAD, a position he held until 1979. While teaching there Zuck turned to programmatic process pieces (such as those Kennedy, Ferguson, and

Tim Zuck. Boat at Anchor, 1980. Canvas, 76.2×76.2 . Private collection.

others were exploring), covering small squares of plexiglas with strips of tape laid carefully side by side. Later he applied the tape in such a way that the most simple of images would be produced: a rectangle 'drawn' in tape in the centre of the square, but visually attached to the corners by more strips of tape. He next painted the same rectangular image in thick, tape-like lines, on a thirty-inch square (76.2×76.2 cm.) of canvas, joined to the corners or edges by similar lines. Then in 1976 he made the central shape a simple house or barn (with roof, walls, double doors, but no windows), sitting on a tremulous horizon line that bisects the canvas, and connected to the lower-right-hand corner by a tape-like curving path. A series of untitled paintings that year explore similarly flat, entirely two-

dimensional relationships of house to canvas edge. Then a map-like landform was introduced, and simple docks, trees, etc., began to appear. In 1980 Zuck began to name the paintings.

Such a tentative, step-by-step evolution of procedure—constantly testing the method of picture-making in order to guard against the numerous assumptions that had brought painting into such disrepute—was expected at NSCAD. But unlike others who were gingerly warming up to painting activity again, Zuck—who had no formal training in drawing or painting; his art education had been based entirely on conceptual art found it virtually a new experience. He literally was learning how to paint pictures as he went along. The strong resemblance to folk art in his work is not emulative (as is the work that Fischl, Parsons, or some of the others made at NSCAD) but is a genuine result of the conjunction of intense will with limited method.

This is not to suggest that Zuck is naïve or unsophisticated. *Boat at Anchor (Private collection), for instance, is a thoroughly considered, elegantly crafted object that reveals a highly developed consciousness of both pictorial conventions and perceptual psychology. It is like a simple diagram of countervailing forces held in balance. The minimal, entirely unembellished forms are actually linked-a cable from the boat on the water/horizon is connected to the buoy, another cable connects this to the anchor on the bottom of the sea—and their many simple relationships of colour and form also bind the piece together. The crucial buov is a small, intense red circle, the anchor a black square; light grey sky, mauve water, and slate-grey sea-bottom are conveyed in progressively more saturated colours, increasingly darker in tone. The carefully applied oil paint covers evenly but does not disguise the canvas support. While we see that these elements relate to one another within a closed formal structure, we also see a jaunty boat on the still surface of the sea. It relates a Nova Scotian experience that tugs gently at the heart.

Before moving on, it must be noted that had NSCAD not existed there still would have been art in Halifax during the late sixtes and seventies. Two painters who settled there for other reasons very likely would have drawn attention to the city; JULIA SCHMITT HEALY (b.1974), who arrived from Chicago in 1973 and helped enliven the scene for five years with her own version of Chicago-style imagery, and CAROL FRASER (b.1930), who left a teaching position at the University of Minnesota for Halifax in 1961, and whose complex, fantastic landscapes on psycho-sexual themes have added diversity to the local fare in art. One local artist of stature, JOHN GREER (b.1944), would certainly have attracted attention. Born in Amherst, N.S., Greer studied at NSCAD (1962–4) before the change, and

then at the school of the Montreal Museum of Fine Arts (sculpture, 1966) and at the Vancouver School of Art (painting, 1967). He has left his mark as a maker of witty, punning conceptual pieces and highly personal, profoundly humorous sculptural objects.

REGINA

During the late sixties and seventies art activity in the West, as in Nova Scotia, revolved around post-secondary art departments. Regina no longer dominated the art scene as it had during the preceding decade, however. (See pp. 278 ff.) Of the prominent Regina artists mentioned in the preceding chapter, only Roy Kiyooka and Arthur McKay were born in the province and they were trained, like the Calgary-born Ted Godwin, in Calgary. (Douglas Morton, originally from Winnipeg, was curator of the Calgary Allied Arts Centre before arriving in Regina.) Kiyooka, Lochhead, and Ron Bloore had all left by 1966; and McKay, who followed Lochhead as director of the Regina College School of Art, also quit in 1967 to teach at NSCAD in Halifax, where he stayed until late in 1968. After a visit to England in the spring, he settled again in Regina. By nature a sporadic painter, he maintained a low profile until 1979, when he reemerged nationally with a touring show of new work that relates closely to his famous mandala-like paintings of the early sixties.

Douglas Morton took over from McKay as head of the Regina College School of Art in 1967 but left two years later to teach, like Bloore, at Toronto's York University. Godwin was appointed to a teaching position at Regina College in 1964 and stayed. He and his work—during the late sixties and early seventies colour paintings he calls 'tartans', made by staining the canvas with elaborately overlaid grids, and large, closely viewed landscapes in the later seventies—were the only constant link to those brave beginnings of experimental painting in Regina in the late fifties.

The new generation of artists in Regina consequently had little interest in painting, although it was not conceptual art or performance that presented an attractive alternative but ceramics, usually developed as a sculptural form. This interest—sparked by the arrival from San Francisco of Ric Gomez (b.1942), who joined the faculty in 1964—was consolidated by Jack Sures (b.1934), from Winnipeg, who established a ceramics department in 1965, and peaked with the arrival in 1969 of David Gilhooly (b.1943), who had studied in California with the well-known ceramic sculptor Robert Arneson. Of their students, Don Chester (b.1940) in the seventies made heavily worked colour-field paintings that reveal a ceramicist's sense of colour and texture, and David Thauberger (b.1948) by the end of the decade had begun to make a name for himself with paintings inspired by both popular imagery and local folk traditions.

SASKATOON

During the seventies there was a more active painting scene in Saskatoon. The high standard of quality there was due primarily to the continuing contributions of Ernest Lindner and Dorothy Knowles, but was also helped by the Saskatoon Arts Centre, launched in 1944, which for many years was the only place one could stage exhibitions, and the Saskatchewan Arts Board, established in 1948 by the new CCF government, which assisted the province's artists with annual purchases and travelling exhibitions.

In 1950 a painter/sculptor from Milwaukee, Wisconsin, Eli Bornstein (b.1922), was hired to start an art department at the University of Saskatchewan. A few years later he became utterly committed to an art based on the construction of three-dimensional painted geometric reliefs, and since 1960 has published *The Structurist* in support of his theoretical position. The university's art program has grown and broadened, and with the opening of the Mendel Art Gallery in 1964, built with the help of local businessman and art collector Fred Mendel, Saskatoon could boast of a diverse and developing art scene. The founding of the Photographers Gallery in 1968, the only artists-run alternative space in the province, reinforced that diversity.

But the prominent painters of the period, like Lindner and Knowles, are usually seen in their mature work to be the products of the Emma Lake workshops. That is certainly true of WILLIAM PEREHUDOFF (b.1919). Born in Langham, Sask., he studied at the Colorado Springs Fine Arts Center in Nevada in 1948–9, and then at the Ozenfant School in New York. He has since worked as a commercial artist in Saskatoon (he married Dorothy Knowles in 1952), while painting seriously in his free time. He attended several Emma Lake workshops—with Will Barnet in 1957, with Herman Cherry in 1961, the controversial Clement Greenberg session of 1962, with the American painter Kenneth Noland in 1963, and with the American minimalist sculptor Donald Judd in 1968. Because he and his wife have a cottage at Emma Lake, they have benefited at least indirectly from the whole range of visitors over the years.

Perehudoff emerged as a painter of more than local ambition in the mid-sixties with big paintings—simple configurations of large rectangles and circles of colour stained into untreated canvas. Directly inspired by the technique of Noland and other Post-Painterly colour painters who stained their canvases with simple, iconic images of pure colour, he

would also have been aware of work being done by other Canadians employing the same techniques and similar imagery-notably Ken Lochhead, then in Winnipeg, and Jack Bush in Toronto. Over the next decadeand-a-half Perehudoff explored the developing implications of carefully ordered stained colour-floating vertical stripes against translucent fieldlike bands, as in *Prairie No.* 4 (EAG) of 1972. This work then evolved into horizontal stripes centred on wide canvases (often over three metres) with the background colour lighter at top and bottom in a manner that strongly evokes the prairie landscape. By the end of the decade his work was changing rapidly (he had more time for painting after he retired from his job as art director with a local printing company in May 1978). A more painterly manipulation of medium that related colour to texture as well as to a more organic sense of form nevertheless adhered to the evolving concerns of the American colour painters and their followers. Because this work of the late seventies is less formal, it seems more personal-it is the most affecting work of his long career.

OTTO ROGERS (b.1935) did not participate in the influential Emma Lake workshops of the early sixties, but still his work relates strongly to American colour painting of the period. Raised, like Perehudoff, on a prairie farm (he was born at Kerrobert, Sask.), Rogers was introduced to art by his instructor at Saskatoon Teachers' College (1952–3), Wynona Mulcaster (b.1915). An inspired teacher who hailed from Prince Albert, Sask., she revealed to him the energy in art, and he went on to acquire a B.Sc. in Art Education and an M.Sc. in Fine Art from the University of Wisconsin at Madison (1953–9), Bornstein's Alma Mater. Hired by the art department of the University of Saskatchewan, Rogers has taught there since, serving as head of the department, 1973–7.

In 1954 Rogers saw an exhibition of the work of Mark Rothko at the Art Institute of Chicago. Though this American master's great floating rectangles of atmospheric colour may have impressed him greatly, their intensely spiritual nature and evocations of high-skied landscape did not influence him at the time. It was only in Saskatoon, after embracing the Baha'i faith in 1960, that both the landscape environment and his spiritual concerns began to engage his interest as an artist. His first fully mature, commanding work is a series of twenty-five five-foot-square (152.4 \times 152.4 cm.) paintings made in the mid-sixties. Painted in oil on primed canvas, each features a puffy, rounded tree form (called by some a 'lollipop') that is related to a horizon line, and usually to another element above—a circled sun, or a cloud, round and puffy like the tree—the whole surrounded by roughly painted framing lines that suggest a view through a window. The colours, as in the muted earth hues of **Sunset Stillness*

Otto Rogers. Sunset Stillness, 1966. Canvas, 152.4 × 152.4. MAG.

(MAG), have been worked up gradually so that, as in a Rothko, they glow and tend to emphasize tonal contrast as much as hue relationships. Again like a Rothko, these image/objects are still, spiritual, and utterly selfconfident.

In 1968 Rogers began using acrylic paint, which presented a greater range of paint/colour effects, although he continued to work on canvas primed with gesso throughout the seventies. By the early seventies he had perfected an impressive range of painterly effects, from wash-like glazes to thick, sensuous scumblings that, while still revealing a rudimentary—often minimal—landscape image, had acquired a commanding presence that was autonomous enough to attract the interest of those who admired the work of the American colour painter Jules Olitski. We know from Rogers' writings that these paintings embody an understanding of the unity of spirit and matter, the essential continuity of all experience, that is at the centre of the Baha'i faith. *Mondrian and the Prairie Landscape* (EAG, 1978) demonstrates that this metaphysical dimension is entirely consistent with the aesthetic concerns of the high formalism of developed colour-field painting. Rogers' delicate and lovingly worked balance of light and dark, form and space, containment and openness, roughness and smoothness, is a profoundly harmonious expression of apprehended unity.

EDMONTON

As a direct consequence of institutional development and the influence of the Emma Lake workshops, Edmonton began to figure as a place of significant artistic production in the seventies. A Division of Fine Arts had been established in the University of Alberta by H.G. Glyde in 1946. Along with the summer program at Banff, he ran it for the next twenty years. After his retirement in 1966 the department was reorganized and expanded and by the early seventies a number of painters who brought an awareness of current artistic issues to Edmonton had joined the staff: among them Ann Clarke Darrah (b.1944) from Norwich, England, a graduate of the Slade (1966), arrived in Edmonton in 1968; Graham Peacock (b.1945) arrived from London in 1969; Doug Haynes (b.1936), of Regina, began teaching there in 1970; and Richard Chenier (b.1945), born and raised in Edmonton and trained in the art department of the University of Alberta (BFA 1969, MVA 1972), was engaged upon graduation. By the mid-seventies they were all working in a more-or-less advanced form of colour-field painting that revealed a surprisingly intimate understanding of the current issues in the work of Olitski, or of some of the younger American and Canadian advocates of 'pushing paint'-the active manipulation of the medium to a maximum range of colour/paint effects. DOUG HAYNES has most successfully established a confident, personal voice within the idiom, particularly with a series of pictures based on a splitdiamond format that he began in 1977. Open to a variety of colour relationships and painterly treatments, works such as Banzo's Last Stand (AEAC) of 1978 are nonetheless always recognizably his own.

The dominance of this particular approach to painting in Edmonton during the seventies was not only due to the lingering influence of the Emma Lake workshops. Although colour-field painting was then being challenged as much as any other approach (it was painting's mannered, decadent last gasp, according to some detractors), it was still covered in the art magazines, and was displayed in the galleries of the major cities of the United States, and at the David Mirvish Gallery in Toronto. The 'ripple effect' of Emma Lake did add to its credibility throughout most of western Canada, which brought added confidence to the local practitioners, and the Edmonton Art Gallery took up the banner early in the decade after its new building opened in the heart of the city in 1969. Following the appointment of Terry Fenton as director in 1971, the Gallery launched a determined, coherent program meant to establish a critical framework for the appreciation and production of advanced formalist art of the sort encouraged by Clement Greenberg.

Fenton was born in Regina and studied there during the heady days of the Regina Five (1959–60), before taking his BA in literature in Saskatoon (1962). He attended three of the Emma Lake workshops in the late sixties after he had been appointed assistant to the director of the Norman Mackenzie Art Gallery in 1965, a position he held until his move to Edmonton. Fenton was convinced that the true course of painting followed a modernist line from Matisse through to Olitski-the only course, as Clement Greenberg argued on the basis of formal analysis, that revealed the specific nature of painting, free of narrative concerns or other 'borrowings' from the sister arts. Fenton found a curator in Edmonton, New York-born Karen Wilkin, who shared his basic views concerning recent art history, and together they set out to put the city on the map. Masters of the Sixties, an exhibition organized with the David Mirvish Gallery and shown in Edmonton in the late spring of 1972, laid the groundwork, and a series of one-man shows subsequently filled in the details. Their efforts raised the level of critical discussion in Edmonton and drove many local painters to reach further than they otherwise would, putting Edmonton on the international 'circuit' of most of the proponents of that particular approach to painting. Consequently, and despite the efforts of the artists featured in the Hairy Hill Exhibition at the Edmonton Art Gallery in 1971, who were opposed to formalism, and the activities around the local alternative gallery Latitude 53, there was little support in the community for other approaches to art.

CALGARY

During most of the seventies it must have seemed as though Edmonton was merely part of an art scene that could reach a level of diversity common elsewhere only by encompassing activities in Calgary, where there was an active alternative scene. The English-born performance artist Clive Robertson helped launch the first artist-run centre in 1972, and the Calgary-born correspondence artist Don Mabie, and Wendy Too-

good from Bristol-who graduated from the Alberta College of Art (ACA) with Mabie in 1969 and with him ran Chuck Stake Enterprizes, devoted to correspondence art and publication-made important contributions. Painting of some significance has been produced in Calgary since the late forties when Jock Macdonald taught at the Provincial Institute of Technology and Art (see p. 277). Under the able direction of Illingworth Kerr (b. 1905) that institution remained for the next twenty years one of the most important in the West. It was the largest art school in the country, when, as the ACA, it moved into its own building in 1973. The new facility included a gallery, a welcome addition to the contemporary programming of the Glenbow-Alberta Institute, which was established as a showcase for the varied collections of Eric L. Harvie in 1966. (Now the Glenbow Museum, it moved into spacious new quarters in 1976.) The adjacency of the Banff Centre, where Takao Tanabe (see p. 286) ran the art department from 1973 until the end of the decade, has assured a steady stream of visiting artists, but there has perhaps been too much coming and going for any lasting sense of continuity to develop.

Nonetheless the artistic scene in Calgary had a special character during the seventies that was enhanced by the innovative performance art as well as by the irreverence for artistic conventions of some of the printmakers. Two teachers at ACA—John Will from Waterloo, Iowa, and after 1975 Gary Olson from Minneapolis—are particularly important in this regard. Among the painters, JOHN HALL (b.1943) stands out.

Hall was born in Edmonton, studied at ACA (1960–5) and for a year at the Instituto Allende in San Miguel de Allende, Mexico. He has explained how in seeking his way as an artist he found it impossible 'to use a gestural brush mark or abstract forms', pursuing instead his own particular vision of realism. By 1969 he was painting large pictures—*Untitled Triptych* (University of Calgary), for instance, is over five-and-a-half metres wide—of still-life subjects he had assembled of loose bundles of cloth, plastic sheeting, aluminum foil, or other materials in a highly realistic, virtually deadpan manner. Because of the apparently arbitrary nature of the subject matter, and the objective, undiscriminating way that every surface glint, every fold, every shadow of the subject is carefully rendered—in greatly enlarged size—on the flat canvas, these paintings can be read in a formal sense as abstractions.

In 1971 Hall was hired by the University of Calgary to teach in its recently established art department. The 'still-lifes' he created to be the subjects of his paintings gradually became elaborate maquettes, incorporating various kitsch objects such as a kewpie doll and plastic roses in the large triptych *Doll* (NGC) of 1971. Roses, in fact, became a special

John Hall. *Trogon*, 1978. Canvas, 152.4 × 152.4. MAG.

interest. He and RON MOPPETT (b.1945)—a friend from Woking, Surrey, who immigrated to Calgary aged twelve, and who also graduated from ACA (1967), followed by a year at the Instituto Allende—organized a large, multifaceted exhibition on the rose as a motif in Western culture, *The Rose Museum*, that was shown at the Glenbow-Alberta Institute in July 1974, and subsequently toured nationally. Moppett, who was curator of the ACA gallery as well as a painter, also made collages and assemblages he called 'paintings'. One of these was *Rose-Case* (John and Joice Hall) of 1974, consisting of an old sweater (to which a defaced picture of a rose has been stapled) bolted with washers to a canvas, divided into three vertical sections by leather straps, with a loose picture-wire hung across,

wound round with an old rag, and the whole spattered with paint. John Hall carefully photographed it, and working from that source painted it three-and-a-half times life-size. He has explained that his version of *Rose-Case* (the artist) was about testing the possibility that an artist can appropriate any source material, idea, or image simply by painting it, and thus give it new meaning.

Hall's maquettes grew even more elaborate, consciously complying with and confronting the widely held tenets of formalist painting that espoused flatness, and consistency of tension across the whole surface, while exploiting a range of textures and tones and self-referential content. Paintings like *Trogon (MAG), of 1978, challenge the exclusivity of the sort of abstraction that dominated in Edmonton. By any objective standard of judgement the composition, the handling of the paint, the texture, form, and colour, the skilful painterly incidents in Hall's paintings are aesthetically satisfying. They should also satisfy formalist dictates because, while perhaps realistic, they are neither narrative nor illustrative. They seek to refer to nothing other than their own particular nature. What we actually have in Trogon, however, is the methodical, dispassionate, enlarged rendering of a photograph-a photograph of a maquette that Hall has also created. The maquette-a fraction of the size of the finished canvas-was assembled from materials and objects chosen mainly for their shape, colour, or texture, although he often used roses, and we can only assume that other elements are also chosen for reasons of personal significance. The elements were bolted, strapped, stapled, tied, bunched, gathered, and arranged in accordance with the need for flatness and other formal concerns, but in a painting like Trogon the ritualistic aspect of the self-conscious display, and particularly the configuration of the elements, are also sexually suggestive.

No other painter in Calgary during the seventies achieved the rich complexity, the satisfying combination of intellectual substance and sheer physical presence contained in Hall's work. His wife, JOICE HALL (b.1943)—who is also from Edmonton and a graduate of ACA (1965)—has followed other, though clearly related, concerns, with a long series of very large eccentrically shaped and hinged canvases she calls *Celebration Landscapes*. She has described them as 'Landscape ideas that function allegorically as they are descriptions of one thing (conjugal union) under the image of another (natural landscape); the penis becomes a tree; the vagina a flower; bed clothes become hills; colour, shape and emotion combine to create a feeling of ecstasy for growth in nature and growth in human love.'

WINNIPEG

Winnipeg boasts the oldest public art gallery and the oldest art school in western Canada, both established in 1913. In LeMoine FitzGerald (see p. 163ff.) the city also had one of the pre-eminent Canadian artists of the day. Virtually the only artist of real merit in Winnipeg (particularly after the master print-maker, W.J. Phillips, moved to Calgary in 1941), Fitz-Gerald was principal of the Winnipeg School of Art for twenty years. The year after his retirement in 1949 the school was taken over by the University of Manitoba, and an American, William Ashby McCloy, a graduate of the University of Iowa, was appointed first director. He brought two more Iowa graduates with him to teach, and when he left in 1954 he was replaced by yet another, Dick Williams. In 1965 the school was moved to the Fort Garry campus of the university, south of the city.

The Winnipeg Art Gallery moved into a striking new building in the centre of the city in 1970, and throughout the seventies it occasionally presented exhibitions of local alternatives to painting. Nevertheless painting remained the predominant artistic activity in Winnipeg, as it did throughout most of western Canada. When Ken Lochhead arrived there in 1964 to take up his new position at the School of Art, he found a small, somewhat disparate group of painters, not unlike the situation he had just left in Regina. By the time he left in 1973 to teach at York University in Toronto, the situation had hardly changed, nor would it change by the end of the decade.

BRUCE HEAD (b.1931)—Winnipeg-born and a graduate of the School (1953)—was a graphic designer for the CBC who was best known during the period for his cleanly coloured, geometrically based three-dimensional shaped canvases. TONY TASCONA (b.1926), from St Boniface, was also a graduate of the School (1952) who demonstrated a highly refined sense of design in his clean geometric paintings (produced in enamel on aluminum later in the decade). ESTHER WARKOV (b.1941), another native of Winnipeg and a graduate of the School (1961), created multiple-panelled figure paintings with a limited palette of muted hues. They are in some cases autobiograpical, often unashamedly nostalgic and whimsical, and as often sharply ironic. Madonna of the Golden Pears (MAG), of 1968, is typical. An older woman dressed in an old-fashioned black dress is shown seated in profile while a hairdresser tidies her hair. She faces a mirror that reflects two floating pears and three cherries, and the upper body of a bearded man wearing a bowler hat. An extra panel has been added to accommodate the height of the mirror, and another carries angel wings that sprout from the man's back. Beyond but in line with this is a

tondo that shows an empty bridal gown standing against a sky of billowy clouds.

DON REICHERT (b.1932), from Libau, Man., graduated from the School in 1956, and then spent two terms at the Instituto Allende (1957–8) and a period of independent study at St Ives, Cornwall (1962–3), before joining the faculty in 1964. He also attended the Olitski session at Emma Lake (1964), as well as sessions in 1965 and 1967. Reichert's work of the late sixties relates areas of modular geometric forms (not unlike ceramic tiles) to grounds of freely worked amorphous colour. All-over colour fields dominated in his work by the mid-seventies, but were superseded by extremely large, expressive colour paintings that are evocations of particular landscapes and were actually painted out of doors on unstretched canvas laid on the ground at the site.

One teacher at the School at this time stands out above all the others (like FitzGerald before him). IVAN EYRE (b.1935) may even some day challenge FitzGerald's eminent position in the history of art in Winnipeg. Born in Tullymet, Sask., and raised partly in other prairie villages and partly in Saskatoon, he took after-school classes under Ernest Lindner while in high school, as well as evening classes from Eli Bornstein in his final year. He then studied for his BFA at the University of Manitoba School of Art (1953–7). After a year of working as a draftsman, he entered the graduate program at the University of North Dakota in Grand Forks (1958–9). Subsequently hired by the School of Art back in Winnipeg, he has taught there since.

By the mid-sixties Eyre had identified and set out to develop his basic concerns as an artist. *Mythopoeic Prairie II* (WAG), of 1965, shows a stretch of Winnipeg-area prairie, slightly rolling and spotted with clumps of scrub brush. The horizon is high and the emphasis is on the land, which is described mainly through variations in texture or density of drawing. Up through the middle of the picture is a partly overgrown, straggly pile of discarded farm machinery, an old car, pails, a fallen structure, and at the centre, mounted on a rough circular table, is a crude, enigmatic figure tied to a Y-shaped crucifix. It is a very concrete, specific image of an abandoned prairie farmstead being reclaimed by nature, except for the disturbing figure in the centre. (When he was in Grand Forks, Eyre visited the Minneapolis Institute of Arts where he saw the German Expressionist Max Beckmann's huge, allusive triptych of 1945, Blindman's *Buff*—ostensibly a scene at a masquerade party. It impressed him deeply, with its shallow space jammed with large, incongruous figures, and its undercurrents of sexuality and violence. The strange crucified figure in *Mythopoeic Prairie II* could have been at the party.) Deliberate yet utterly

Ivan Eyre. Highwater, 1978. Canvas, 178.0 \times 167.7. AGO.

mysterious, it drives every bit of sentimentality from what otherwise would have been close to a maudlin scene in the 'barn-and-buggy' realist vein.

Following a fifteen-month trip to Europe in 1966–7 Eyre began to paint strangely forbidding table-top still-lifes put together in his small studio from bits and pieces that were to hand. These intense, crowded paintings often contain mysterious distorted figures in the background. Then in 1969 he rented a loft space with large windows as a studio in downtown Winnipeg, and his work slowly began to open up, becoming less claustrophobic in feeling—though muted earth hues, dark mystery, a sense

of irrational, violent forces (all focused in the vaguely threatening tabletop still-lifes) still permeated nearly every canvas. In *Balck Women* (MMFA) of 1970, where soldiers and the landscape of war fill the upper third of the canvas, a still-life dominates the foreground, about to pitch forward from a sharply inclined ledge. The angular, tortured figures, with heavy dark lines and shadows everywhere, and the jammed-up, shallow space and undercurrent of violence, still evoke the power of Max Beckmann's paintings.

Interest in Ivan Eyre's work grew steadily through the late sixties and early seventies. After a successful exhibition in Frankfurt in the summer of 1973, he and his wife decided to build a house and studio on land they had acquired in St Norbert, south of Winnipeg, looking down to the LaSalle River across what Eyre calls 'raw bush'. This landscape began to appear in Eyre's paintings, often-as in Manitou (Province of Manitoba), of 1973—as though glimpsed from a cave or a hole cluttered with foreground still-lifes. Gradually the landscape emerged until, as in Touchwood Hills (NGC), of 1973, it stood free, unencumbered by man or structures. Valleyridge (Private collection), of 1974, was the first painting completed in the new studio. Landscape did not remain his only concern for long (figures-often self-portraits-and looming still-lifes also preoccupied him), but it was probably his main interest for the balance of the decade. and it clearly opened up many new possibilities. As we can see in *Highwater (AGO), of 1978, landscape is revealed through fine, detailed drawing, harking back to the technique in Mythopoeic Prairie II. Visually splendid, with open areas contrasted against dense, clotted sections, the busy texture mounding up against clear-cut land forms, this painting is lighter, more open, and more variously coloured than his earlier workwith wonderfully intense yet naturalistic blues, greens, and burnished golds. The oppressive foregrounds are gone, but these landscapes are still unsettling. The space seems compressed, as though we are looking through a telephoto lens. 'The darkness has moved underground,' Eyre once remarked, 'but there are some who still see it lurking behind the membrane of subject matter.'

Painting based on Native traditions also began to develop in the West during the period, spearheaded in the early seventies by the formation in Winnipeg of Professional Native Artists, Inc., partly inspired by developments surrounding the work of Norval Morrisseau. DAPHNE ODJIG (b.1925), an Odawa from the Wikwemikong Reserve on Manitoulin Island in Ontario, was the unofficial leader, and her print-shop, the Wah-sa Gallery, which opened in 1971, served as headquarters. There were seven members (they enjoyed calling themselves 'The Group of Seven'): as well as Odjig, a self-taught painter, the most prominent were Carl Ray, mentioned already in relation to Morrisseau; ALEX JANVIER (b.1935), a Chipewyan from the Le Goff Reserve in Alberta, who studied art in Calgary, graduating from the ACA in 1964; and JACKSON BEARDY (1944–84), a Woodland Cree from Island Lake Reserve in northern Manitoba, who spent one year in commercial-art training at the Technical Vocational High School in Winnipeg (1963–4). Quite unconnected with these artists, but a painter equally deserving of note, is ALLEN SAPP (b.1928), a Plains Cree from the Red Pheasant Reserve in northwestern Saskatchewan. Untrained, except for a little guidance he received from Wynona Mulcaster in Saskatoon over the winter of 1967–8, Sapp paints heavily textured, moody scenes of childhood memories of life on the reserve that are deeply felt and often powerfully moving.

VANCOUVER

The resurgence of Native cultural values across Canada during the sixties and early seventies was not manifested in painting in British Columbia, but in carving, reaching a brilliant level of invention and execution in the work of the Haida, Bill Reid (b.1920). While it is clear that the direction this recent development has taken is due entirely to the strong tradition of carving among the Native peoples of the Coast, it is still interesting that of all of the artistic centres in Canada it was Vancouver that most enthusiastically embraced alternatives to painting during the same period.

Various factors contributed to this state of affairs. The UBC Fine Arts Gallery was an important early centre of experimental activity, and in 1966 Iain Baxter, a teacher in the Fine Arts Department at UBC, and his wife Ingrid created the N.E. Thing Co. to provide a framework for their installation- and conceptual-art activity. Also in 1966 a group of people that included Baxter—who was by then artist-in-residence at the Centre for Communications and the Arts at Simon Fraser University—and the architect Arthur Erickson, began meeting at Jack Shadbolt's home to explore the ideas of Marshall McLuhan. In 1967 they obtained a Canada Council grant to establish a centre for multi-media investigations called Intermedia. When Intermedia was dissolved in 1971 the many prominent Vancouver artists involved—people working in film, video, installation and performance art—formed other groups, the most important being the Western Front, which was established in 1973.

There was nevertheless a remarkable proliferation of fresh new painting in Vancouver in the mid-sixties, mainly the work of recent graduates of the Vancouver School of Art (VSA). Although stylistically diverse, the

new Vancouver painting shared bright colours, radical form, a youthful audacity, and often a sense of humour or irony—characteristics that brought a number of painters national attention.

CLAUDE BREEZE (b.1938), born in Nelson, B.C., but raised in Saskatoon, studied there with Ernest Lindner, then at Regina, graduating in 1958, followed by a year at VSA. Breeze's first solo exhibition, a show sponsored by Jack Shadbolt at the New Design Gallery in 1965, featured large expressively painted figure pictures of usually violent scenes. *Sunday Afternoon: From an Old American Photograph* (Department of External Affairs, Ottawa), of 1965, which is over three-and-a-half metres tall, shows two lynched Blacks hanging from a tree, their lower legs being consumed by the pyramidal flames of a huge fire. Partly in dramatic black and white and partly in vivid colour, it catapulted Breeze onto the national stage, thanks to an uproar precipitated by its reproduction in *artscanada* a year-and-a-half after the show.

BRIAN FISHER (b.1939), born in Uxbridge, England, and raised in Regina, undertook studies at the School of Art there in 1957, but moved in 1959 to VSA to complete his training with Roy Kiyooka. After graduating in 1961, he spent two years at L'Accademia di Belle Arti in Rome. Back in Vancouver, Fisher began to exhibit, about the same time as Breeze, large mandala-like paintings built up of carefully applied straight lines in bright candy colours that vibrate optically when they cross. Works such as Passage (VAG), of 1966, owe something of their elegant expansiveness to Roy Kiyooka's paintings of the time. BODO PFEIFER (b.1936), born in Düsseldorf, Germany, studied for one year at the École des Beaux-arts in Montreal (1961-2), for another in Hamburg, Germany, and then with Kiyooka at VSA (1963-5). His untitled, often very large geometric abstractions of the mid-sixties-built up, somewhat like Fisher's, of intensely coloured lines or stripes (although with large areas of unmodulated colour as well)—also relate to the sense of measure and balance manifested in Kiyooka's work.

The Toronto-born GARY LEE-NOVA (Gary Nairn, b.1943) also studied at VSA (1960–1, 1962–3, with a year at the Coventry College of Art in England in between). The paintings he began to exhibit widely in 1967 (he had one-man shows that year at the Carmen Lamanna Gallery in Toronto, the 20/20 Gallery in London, Ont., and the Bau-Xi Gallery in Vancouver), with their ironic plays on slick packaging and popular painting conventions, brought a taste of British Pop Art to the Vancouver scene. *Menthol Filter Kings* (VAG) of 1967, with its elegant colour and visual puns or optical effects, confronts the coloured geometric painting of Fisher and Pfeifer with wry humour.

Michael Morris. The Problem of Nothing, 1966. Canvas, 137.0 × 152.5. VAG.

The most substantial, extended body of work produced in Vancouver during the period is that of MICHAEL MORRIS (b.1942). Born in Saltdean, Sussex, he settled in Victoria with his family four years later. Encouraged by his mother, an art teacher, Morris entered the University of Victoria to study art in 1960, but transferred two years later to VSA, where he studied under Shadbolt, Don Jarvis, and Kiyooka. Graduating in 1964, he received the following year a Canada Council fellowship that allowed him a post-graduate year at the Slade in London, where he worked (1965– 6) under Harold Cohen, among others. While there Morris painted a series of studies in gouache that, like the early work of Gary Lee-Nova, reflect the general ambience of current British art (the painter Richard Smith particularly impressed him)—a kind of irreverent geometricism in mouth-watering bright colours that, through various tricks of perspective, blows the picture-plane apart. Back in Vancouver in the summer of 1966, he began to work up some of his gouaches to canvas. The first was

**The Problem of Nothing* (VAG), which won a purchase prize in a VAG juried exhibition later that year. It cheekily confronts the sober formal analysis then so commonly employed as the 'solution' to working out painterly 'problems', while presenting itself as a somewhat enigmatic yet substantial object. Tasteful in colouring (in stripes of red, greys, and blue), the painting derives its impact from the presence of a cartoon speech-balloon that—in terms of the shape, rhythm, colour, and direction of the stripes it contains—is completely at variance with the rest of the picture. Yet the result is harmonious, resolved, and funny.

Stimulated in part by contact with some of the principal figures of the California scene (an influence as well on Lee-Nova and some of the other important Vancouver artists), Morris subsequently developed more complex visual schemes. Employing his distinctive sense of colour and his decorative-dramatic sense of form, he produced large painted objects that are simultaneously elegant and vulgar—celebrations of plastic glamour that somehow avoid slipping into excess. Still carefully built up through the methodical application of narrow bands of colour, they sustain an essential humanity that the careful viewer discerns in the slight wobble of the hand-drawn stripes. In a group of huge paintings Morris made in 1969, the *Letter* series, this subtext of humanity is heightened by the insertion of two vertical channels of angled mirrors, equally spaced to form a triptych. Ambiguous, striking, and elegant through force of colour and repeated forms, these *Letter* paintings—his last for more than a decade—are grandly public.

When Morris returned to Vancouver in the summer of 1966 he arrived with Harold Cohen, his Slade teacher, and helped him install an exhibition at the VAG. He stayed on, assisting in other curatorial duties, and later in the fall became involved with the new Simon Fraser University Centre for Communications and the Arts. Some of his contemporaries later left Vancouver (Breeze moved to London, Ont., to teach, in 1972); others turned, like Morris, to new concerns (Lee-Nova, an innovative film-maker, also became involved with installation art). During the seventies the important names in art revolved around the Western Front— Glenn Lewis (b.1935) was a key figure, as was the performance artist Gathie Falk (b.1928)—and the N.E. Thing Co. A number of sculptors emerged from this performance-installation ambience, notably Liz Magor (b.1948), Dean Ellis (b.1948), and Richard Prince (b.1949); and two art historians, Ian Wallace (b.1943) and Jeff Wall (b.1946), began to attract attention with rigorous photo-based work.

With some five artist-run facilities active at the close of the decade, Vancouver remained the most active and exciting art scene in the West. And although those who were on the leading edge of developing attitudes in the city were uninterested in painting, it persisted nonetheless, nurtured in the two art schools (UBC Fine Art Department, and VSA, relocated in new facilities on Granville Island as the Emily Carr College of Art in 1980), where a few of the instructors maintained its viability by their example. Enthusiasm for Toni Onley's spare, judicious landscapes increased during the decade. (He taught at UBC.) Gordon Smith continued to develop as a painter while teaching at UBC, and interest in his work grew steadily, particularly in the seventies when his reduced but full notational landscapes superseded the bright, complex geometric pictures of the mid-sixties that, in retrospect, seem concerned more with local trends than with conviction. But the one painter of the 'old guard' who remained at the centre of things, both intellectually and socially, was JACK SHADBOLT (see p. 285 ff.), who continued to advance the boundaries of his art.

After retiring as Head of Drawing and Painting at VSA in 1966, Shadbolt was able to devote more time to his art, and by the early seventies it was clear that this would result in a remarkable flowering. Honoured with an LL.D. from the University of Victoria in 1973, he received two more honorary degrees—from Simon Fraser University and UBC—in 1978, the year of a major exhibition at the VAG devoted to his painting of the previous seven years.

Shadbolt's basically expressionist style, and his abiding interest in the multi-levelled suggestive possibilities of imagery that seeks mythopoeic intensity, led him to a reconsideration of Emily Carr's engagement with the themes of West Coast Native art (this was bolstered by the scholarly investigations of Carr's life and art by his wife, Doris Shadbolt). The ambiguous scale and dramatic points-of-view that characterized the work of his early maturity in the late forties-when he first explored Native themes-again dominated, though in greatly enlarged formats. His discovery of a new, larger watercolour board, a number of which he would join together as the supports for his big pictures, allowed him to work in his favourite media, watercolour and inks, augmented now by fluid acrylic and latex. Surrealistic butterflies, plants, and other aspects of the regenerative element in nature that had always been central to his understanding of life occupied him still, but in new, fantastic formats. (After a trip to India in 1975 he made a charcoal drawing that is over twenty metres long!) His constant interest-evident in *Little Bride (Mr and Mrs Bau-Xi Huang, Vancouver) of 1972-in the essentially emotive drive of creative generation, combined with his reinvigoration of Native forms, makes manifest the primal impulses underlying all expression.

Jack Shadbolt. *Little Bride*, 1972. Mixed media, 152.4 \times 101.6. Mr and Mrs Bau-Xi Huang, Vancouver.

Before leaving the west coast, mention should be made of E.J. HUGHES (b.1913), a reclusive painter who has lived in a small village near Victoria since 1946. Although he began selling his paintings through Montreal's Dominion Gallery in 1951, it was only with a retrospective exhibition organized by Doris Shadbolt at the VAG in 1967 that the full range of his powerful, highly detailed and intensely coloured landscapes of the B.C. coast was revealed.

MONTREAL

In Montreal a sense of commitment to painting was sustained during the period by those artists who had established clear concerns in the late fifties and early sixties. Chief among them was GUIDO MOLINARI (see pp. 292–3), whose work continued to evolve at a steady pace. His structuring of colour in dynamic relationships—accomplished since about 1963 solely by arranging vertical stripes of equal width on his canvases—evolved in the later sixties into wider stripes. This tendency was clear in the selection of works he exhibited as one of the two Canadian representatives at the *XXXIV Biennale di Venezia* in 1968, although in the catalogue of that exhibition he remarks: '... it's difficult to get too spread out, because then the quality of the stripes changes; then, they would be really large rectangles and I would not like that too much.'

The following spring, however, Molinari showed at Montreal's Galerie Sherbrooke a huge triptych (each section 290 × 230 cm.), *Dyad Brown-Blue, Dyad Orange-Green, Dyad Green-Red* (NGC), each canvas composed of two colours in only four wide bands, like long rectangles. He, and some commentators, were interested in at least two aspects of this departure. First, these large areas of homogeneous colour present a new 'fictional space' into which the attentive viewer can enter mentally and become totally involved in the pure colour/space experience. Secondly, the colour remains dynamic, not only between hues but within each broad band or rectangle, where each colour area appears more 'material' at its periphery and more like pure coloured light in its central region.

Molinari continued to experiment with this new dynamic in works whose large areas of colour are variously arranged—in two ranks of four rectangles each, for instance, as in *Rectangular Opposition No. 2* (Private collection) of 1969; or in two rectangles, both diagonally bisected forming a triangular shape at the centre, as in *Homage to Barnett Newman* (Private collection) of 1970; or simply bisecting the whole canvas diagonally, as in each of the three elements of *Blue Triptych* (Private collection) of 1973. These paintings are all large (approaching three metres on the longest side), presumably the better to effect the enveloping colour/space phenomenon.

Towards the end of 1973 Molinari put aside such experiments based on repeated coloured forms of the same size for a new series based on developing dynamic colour relationships between triangular forms of different sizes within his large rectangular canvases. After about eighteen months he left that behind and returned to wide vertical bands again, but for the first time using cool, unsaturated colours of very light tone, such as in *Trapeze* (NGC), of 1977. His next move was dramatic. During

1978 and the first half of 1979 he painted seventeen massive canvases (the three largest being three by over six-and-a-half metres, the smallest 228 \times 198 cm.), which he exhibited together at Montreal's Musée d'art contemporain early in the fall of 1979. He calls them the *Quantificateur* series, in order to emphasize his concern for the quantity of the constituent elements. Indeed the wide bands of colour—all dark hues ranging from warm reddish-browns through to something close to black—are incredibly saturated. They are so dense that the materiality of the colour predominates for a while over our sense of it as space and, finally, as dark light. In some cases the tonal values between the two colours are so close that we perceive the difference only with intense concentration—which assures our entry into the dynamic colour/space that is the work's *raison d'être*. The *Quantificateur* exhibition was the commanding artistic experience of the decade in Montreal: the triumph of painting.

Claude Tousignant (see p. 292ff.) also continued to explore the range of possibilities of his art: in the choice of colour and the size of the colour elements, and, to a greater extent than before, in the shape of the canvas. During the late sixties and early seventies he worked (like Molinari) in series. In 1969 he essayed his first diptych, *Duo 66* (Private collection), made up of two circles, each with six wide-banded concentric rings of colour. These larger areas of colour set up a dynamic relationship similar to that in Molinari's paintings of the time.

Later in 1969 Tousignant began work on the *Ovale* series of oval-shaped canvases—his first change of format since 1965. This was followed by the *Diagonal* series (1971–2): long thin canvases, rounded at the ends but straight on the sides like extended race tracks, two or three of which are hung side-by-side diagonally on the wall. Breaking away from the radiating circle emphasized the relationships between the colour bands, thereby enhancing the colour dynamic. Nonetheless, in 1972 he returned to the circle, but in pairs—as in *Le Bleu et le noir* (Private collection) of 1972—and with very wide bands of colour. Each canvas of *Le Bleu et le noir* has only two colours: a blue central circle surrounded by black in one, a black circle surrounded by blue in the other.

This greatly reduced configuration introduced the sense of colour as an enveloping space, and it led Tousignant, as it did Molinari, to consider his paintings as elements in an articulated environment—virtually an architectural experience of space. The result was an exhibition of a series of *Diptyches* at the Musée d'art contemporain late in 1980. Though not as dramatic as Molinari's exhibition of the year before, it was in its way as imposing. There were twelve circular canvases from 1978 through 1980 (each 259 cm in diameter), divided into two groups of six, one with three bands of colour each, the other with two. The colours—an inventive range of grey tints—are still, almost passive, although in the two-colour group in particular—*Non-lieu* 4 (Private collection) of 1980 is the latest and the most successful—a vast central area is held in subtle tension by a second subtly related hue that has shrunk to the outer perimeter like an elegant retaining ring.

Interest in such pure colour painting was heightened in Montreal during the later sixties with the appearance of a new painter, YVES GAUCHER (b.1934). The range and intensity of the work of both Molinari and Tousignant was stimulated and enhanced during the seventies by his investigations. Gaucher too was born and raised in Montreal. He started to study art at the MMFA school in 1954 but switched that fall to the École des Beaux-arts. Expelled two years later for insubordination, he was readmitted to study printmaking with Albert Dumouchel on the strength of an exhibition at Galerie l'Échange in 1957. When he completed the course three years later he bought his own intaglio press and began experimenting with embossed printing. For the next few years he devoted himself to print-making, to considerable acclaim. (His important series En Homage à Webern-Gaucher is also a musician-began to appear in 1963.) The following year Gaucher returned to painting (he had painted while at the École and immediately after) and developed a series, Danses Carrées (Square Dances), a group of square canvases turned diagonally, painted one solid colour-a grey in *Le Cercle de Grande Réserve (AGO) of 1965, for instance—upon which is arranged a symmetrical pattern of thin bar-like lines and/or squares. The colours are intense-the central four lines of *Le Cercle de Grande Réserve* are green, the others a complementary pink, the four little squares blue-and have been carefully chosen to heighten the throbbing optical effect that results in the areas where lines almost converge.

Gaucher moved into a less visually kinetic format and strategy in 1966, painting a series of large, rectangular canvases of one colour, broken up with symmetrically arranged long thin horizontal bars—called 'signals' or 'silences': either or both words are used in the titles—usually in two colours, that are seared into the pure colour ground. These were superseded by a group he calls *Ragas*, after the classical Indian music, in which the 'signals' or thin lines are complemented by a wider stripe that crosses the canvas near the bottom. Then in 1968 he made a series of grey canvases, each of a subtly different hue, with grey 'signals', also of a slightly different hue or tone, arranged asymmetrically. He planned to make twelve of these *Alaps*—his original name for them, after the slow, unrhythmic improvisational prelude of the Raga—but made more than

Yves Gaucher. Le Cercle de Grande Reserve, 1965. Canvas, 215.9 × 215.9. AGO.

forty. They brought him international attention.

Gaucher showed three of his new *Grey on Grey* canvases (still then called *Alaps*) in an exhibition of Canadian art at the Edinburgh Festival late in the summer of 1968. The British critic and curator Bryan Robertson enthusiastically described them as 'possibly the most beautiful and original—and awe-inspiring—paintings I've seen since the advent of Pollock and Rothko.' An exhibition of twenty-two canvases from the series, ranging in size from 180 cm square to 2.75×4.5 metres, was mounted by the Vancouver Art Gallery the following spring, and shown subsequently in Edmonton and at the Whitechapel Gallery in London, England. Gaucher next organized the grey fields by dividing them with

horizontal white lines extending right across the canvas. In *Rouge/Bleu/ Vert* (AGO), of 1971, three different 'greyed' hues are stacked horizontally, offering in one canvas an interactive experience similar to the effect created by a number of the *Grey on Grey* paintings seen together.

Persisting with this new format, Gaucher had by 1972 increased the saturation of the colours and reduced the horizontal white lines to one. Paintings from the following year consist only of horizontal colour bands of varying widths and degrees of saturation, such as *Brun, Jaune et Rouge* (the artist). They convey a remarkable sense of measured quantity, of colour as a substantial element. By 1974 they contain usually four horizontal bands of equal width, and resemble a Molinari painting lying on its side. Unlike a Molinari, however, they seek not to create a dynamic colour experience but a chromatic equivalence among the elements, a sense of resolution in the later pictures of the series where wider bands of lighter tone are balanced against narrower ones of more saturated colour. This becomes most clear in works of a year or so later, such as *Deux Bleus, Deux Gris* (the artist) of 1976.

Later in 1976 Gaucher complicated the structure of his paintings by introducing a diagonal element. This move is most impressive in a group of pictures of 1978—all diptychs or bipartite canvases—he calls *Jericho: An allusion to Barnett Newman*. Each of the two elements of a work is divided diagonally into two parts of unequal size resulting in a whole that suggests a part of a truncated triangle. Huge paintings—usually almost three by five metres—in the earlier part of the series they are close in their air of dark gravity to Molinari's *Quantificateur* series of the same period. Late that year Gaucher, simply by combining the two elements into one canvas, created in *Er-Rcha* (the artist), a monolithic, intense red trapezium on a white ground that strains the rectangular shape of the huge canvas. He, like Molinari and Tousignant, had come to the making of paintings that are environmental in their commanding appropriation of space.

Although these three artists, all working with unmodulated colour on a vast scale, dominated the Montreal painting scene during the seventies, they were not the only painters of note. Jacques Hurtubise (see p. 296) continued with his electrifying optical effects through the mid-sixties (moving to the literally electrical, he produced a group of neon pieces in 1968); but in 1970 he adopted a more formal manner, dividing large canvases into eighteen squares, each bursting with acidic-coloured diagonal zigzag motifs that are, as one commentator has observed, geometricized abstractions of the formalized 'splashes' that mark his work of the early sixties.

Gradually Hurtubise returned to extravagant drips and splashes,

applied, beginning in 1972, to small canvas squares that he would later rearrange and then assemble for the finished painting. These seemingly spontaneous, accidental splashes were painstakingly painted according to a predetermined scheme. Late in 1977 he returned to single large canvases, abandoning all vestiges of a grid. Still images of spontaneity and rapid gesture, the forms nevertheless began to take on a degree of deliberate figuration. Though colour remained important, great rounded mounds of urgent, jagged brushwork—contoured with an illusion of depth—had become the primary focus of his work.

JEAN MCEWEN (see p. 296) stopped using oil paints and glazes in 1965. Turning away from the textured, heavily worked surfaces that had become his trademark, he used acrylic with masking tape to achieve cleaner, more precise forms in a tripartite configuration. Pure colour had come to the fore. In 1970, however, he returned to oils and varnishes, producing the next year a series of pictures on square canvases called Miroir sans image. These offered the richly worked, burnished surfaces of layered pigment that had preoccupied him before 1965. Another series of 1975, Les Jardins d'aube, and subsequent paintings of the following two years feature feather-like veils of white over coloured areas that recall his Jardin de givre series from twenty years earlier. McEwen seeks a rich, patina-like resonance in his work, and these explorations of his own painting history were not only appropriate but proved a stimulating preparation for the canvases of his Suite Parisienne, painted in Paris between September 1977 and June 1978. Transparent, vaporous concentrations of radiant colour, they were the most sensuous paintings to come from a Montrealer's brush during the decade.

CHARLES GAGNON (see p. 297), a remarkable photographer and filmmaker as well as a painter, turned away from painting in 1969 but worked his way back about four years later, determining, finally, that 'it's not ridiculous at all, it's the most important thing, it's the only way to see yourself truly objectively.' His paintings of the seventies present large areas of freely various, luscious brushwork, not unlike the handling in his paintings of the previous decade, but more evenly distributed over the surface of the picture and often limited to tones of one greyed hue. These fields of activity are then set off by black margins or other framing devices. In the *Cassation* series, however, as we can see in **Cassation/ Dark/Sombre* (AGO) of 1976, the field is framed at the top and sides by a clearly distinct margin that is nonetheless treated in exactly the same manner as the central element, giving the strange effect of a door cut through airy space. Painted in various tones of bluish violet, the brushwork is emphatic, engaging us with its figuration in front of a deep,

Charles Gagnon. Cassation/Dark/Sombre, 1976. Canvas, 228.9 × 203.9. AGO.

undefined pictorial space, while sparkling, refreshing drips of paint remind us constantly of the reality of the surface and of the activity of the making. Gagnon's paintings of the seventies are bold affirmations of the act of painting and of the vision that sustains it.

Some Pop artists emerged in the late sixties—the Montreal print-makers Pierre Ayot (b.1943) and Gilles Boisvert (b.1940), for example—whose European-influenced, conceptually based approach emphasized photoimagery and questioned painting's relevance. This is also true of Edmund

Alleyn (b.1931), an interesting Quebec City artist who returned to Canada in 1971 after fifteen years in Paris and, in part, of GUY MONPETIT (b.1938), a Montrealer who spent one year in Paris (1964–5), but whose characteristic paintings are of flat, simple, mechanical devices that embody compositional dynamics. They are less visualized paintings than ideas.

Any sense in Montreal of a generation's succeeding the prominent colour painters was subsumed in the early seventies, however, by the massive adoption of alternative artistic modes. Although institutions did not directly encourage this tendency, as they had in Vancouver and Halifax, they did play a role. The École des Beaux-Arts was occupied by disgruntled students in 1968—reflecting the surge of counter-cultural activity rampant in large cities throughout the western world at the time, although the Montreal students found their specific model in Paris. Their action led to the takeover of the École program by the new Université du Québec à Montreal the following September. A Musée d'art contemporain was established in 1964 but did not begin to respond to such forces until more than a decade later.

Yves Robillard, a teacher at UQAM, who had helped found the multidisciplinary group Fusion des Arts in 1964, actively fostered alternatives to traditional painting-the recent history of which he chronicled in the three-volume Québec Underground 1962-1972, published by Médiart in 1973. Médiart, founded early in 1972 by Normand Thériault and others, was part of the attempt to redefine Québécois art: the prominent colour painters did not have to be the inevitable heirs to the Automatistes. Alternative activity was also bolstered by the establishment of a parallel gallery, Véhicule, in the fall of 1972, and the magazine Parachute three years later. Five government-assisted artist-run spaces had appeared by 1980 and, because of the decline of commercial galleries following the election of the separatist Parti Québécois in 1976, they virtually dominated exhibition possibilities. This active Montreal scene nurtured some important conceptual, performance, photo, and installation artists. But painting survived in the seventies, thanks almost entirely to the confident, personal growth of its most prominent adherents.

TORONTO

Multimedia activities were pursued by individuals and small groups in Toronto throughout the sixties. Even the Volunteer Committee of the AGO recognized this interest when, in 1965, it solicited the help of Dennis Burton, Gordon Rayner, Richard Gorman, Harold Town, and Walter Yarwood to stage a 'Happening' in the Gallery as a fundraiser. The Isaacs

Gallery served as a venue for a range of screenings, readings, and performances of various sorts. The Isaacs Gallery Mixed Media Ensemblea group made up of Burton, Robert Markle, Rayner, Udo Kasemets, and others-staged some exciting evenings in November 1965 and in February and March 1966, followed by a tour of universities in Hamilton, Kingston, London, and Windsor. Among the 'institutions' supporting alternative activity in Toronto in the 1970s were The Electric Gallery, founded by Sam and Jack Markle in the spring of 1970; the Nightingale Arts Council, created in the fall of 1970 when a number of installation artists talked Chris Youngs into turning his Nightingale Gallery into a non-profit organization (following a fire, it opened—with an exhibition of conceptual art from NSCAD—as A Space in April 1971, the first alternative gallery in the city to be funded by the Canada Council); Art Metropole, an archives, video library, and bookshop started by General Idea, a group of installation artists, in the fall of 1973; Proof Only, an art newsletter begun in November 1973 (it became Only Paper Today in September 1974); and the Music Gallery, founded by Michael Snow and others in January 1976. By 1980 there were seven artist-run spaces in Toronto, more than anywhere else in the country.

Toronto remained throughout the period the principal art market-place in the country. Every painter discussed in this chapter exhibited there, keeping the vital issues of painting to the fore. Painting's irrelevance was demonstrably just one of many current opinions. The New School of Art was also important in maintaining painting as a viable option for young art students. It was established in 1965 by Dennis Burton and Robert Hedrich, with John Sime, who had been operating the Hockley Valley School in the summertime at nearby Orangeville since 1962. Sime ran these and The Artists' Workshop (a part-time school geared to hobbyists) as The Three Schools through the seventies. The New School offered a four-year studio course devoted to preparing sculptors and painters, taught by practising artists on a part-time basis. Burton, Hedrick, Markle, the sculptor Arthur Handy, and later Coughtry and Rayner were the core of the teaching staff. The School was a haven for painting skills in the late sixties and early seventies as OCA drifted into irrelevancy and then underwent an upheaval after hiring an English conceptual artist, Roy Ascott, as president in 1971, and abruptly firing him the next spring when his reforms were seen to have virtually destroyed the College. A new degree course in studio at York University around the same time offered yet another option for painting students. But essential to the continuation of painting was the example of established artists who grew and developed in their work.

The three Painters Eleven veterans who had kept to the fore in the early sixties each maintained general prominence throughout the seventies, but the work of only one, Jack Bush, interested younger painters. WILLIAM RONALD (see p. 250 ff.), who had virtually stopped painting in 1965, went on in the following year to host a TV show on the arts in Toronto, and remained a notable TV and radio performer until the mid-seventies. He was soon painting periodically, and in June 1968 began a commission of a mural for the National Arts Centre in Ottawa, a giant (13.5 × 18.0 m.) swirl of broad twisting ribbons of colour that was received enthusiastically when it was completed the following year. He had a one-man show again in Toronto in 1970.

Ronald has said of his art, 'I perform on the canvas', and in the early seventies he reached a new level of audacity by taking a show on the road and painting before an audience. To crank up the pressure, he wore a flamboyant white suit and was accompanied by a rock band and a stripper. The paintings he produced were surprisingly good. He relied on the format of his most successful years—a great centred mass of paint hung on a grid-like background—but, as in Brandon: 'The Bleeding Hearts' (Barry Callaghan, Toronto) of 1972, there is an electricity, a charged concentration of spontaneous energy. Like all his good paintings, Brandon is a record of a great event. His studio paintings of the early seventies, on the other hand, are heavily worked, the central shape built up of small gobs of paint that, as in Sumiko (the artist) of 1974, spread out to almost cover the canvas. Their density is fascinating, but their obsessive, exaggerated nature seems overwrought in comparison with earlier pictures. By the end of the decade it seemed that Ronald had found, in a plan to paint abstract 'portraits' of each of Canada's sixteen prime ministers, a project of sufficient scale and public risk to elicit another great performance.

Ronald's abrupt withdrawal from the painting scene and his gradual return are reflected in the few—only three—exhibitions he held in Toronto over the fifteen years following the Mirvish show of 1965 (see p. 297): at the Dunkelman Gallery in 1970, and at the Morris Gallery in 1975 and 1978. (A retrospective was staged at the Robert McLaughlin Gallery in nearby Oshawa in January 1975.) Not surprisingly, his work figured hardly at all in the debates that swirled around the issue of painting's future in Toronto.

HAROLD TOWN (see p. 256 ff.), on the other hand, held a total of sixtyfour one-man shows across Canada and in the United States from 1965 to 1980. No other painter enjoyed so much public exposure. He had represented Canada at the XXXII Biennale di Venezia in 1964, exhibited at the Sears Vincent Price Gallery in Chicago five times between 1966 and 1971, and had twenty-five exhibitions (mainly of drawings) in Toronto during the fifteen years in question. A retrospective was organized by the Art Gallery of Windsor in the fall of 1975, a reduced version of which was shown at a provincial government gallery in the Macdonald Block at Queen's Park in December and January 1976. But it was as a writer—an acerbic essayist and reviewer as well as the author of books on Albert Franck (1974), and, with David Silcox, on Tom Thomson (1977)—that Town's presence was felt among other painters in Toronto.

A recent monograph by David Burnett on Harold Town's work, Town (1986), describes the two series that occupied him in the late sixties—the highly optical, quasi-geometric, multi-levelled tape-and-cut-produced Silent Lights, and the formal but funny, simplified, hard-edged designs Town calls Stretches-as appearing 'trapped rather than transformed by their virtuosity', and declares this period 'the least vital' for Town's paintings. On the other hand the Parks and Snaps that followed during the seventies, Burnett feels, 'demand much closer consideration than they have hitherto received.' The Parks-like Park No. 1 (Canada Council Art Bank) of 1970-which set a small, dense, freely worked area (the park) against an almost-overwhelming hard-edged, 'constructed' surround (the city), were not properly considered when first exhibited because their 'character . . . was set against the expectations of painting of the time'. The Snaps-like In Memory of Emilio del Junco (the artist) of 1974–5, made by 'snapping' a taut, paint-laden string against the canvas to produce a thin, splattered line of colour, the chromatic effects developed through multiple layers of snaps and the forms composed by masking off areas with cut tape-were first shown in Toronto at the Mazelow Gallery in December 1973 and again in October 1975. As Burnett points out, they were met 'with general rejection or indifference', though this was not the last word on them. Burnett quotes another Toronto critic, Gary Michael Dault, in a remark of 1985: 'I now think they're among the most original non-representational paintings ever made.' But in the seventies these two series appeared to be so laden with irony that they suggested parody: in the Parks of currently fashionable formalist abstraction, and in the Snaps of the relentlessly programmatic painting that had risen in response to conceptual art.

It was only JACK BUSH (see pp. 254 ff.) of the Painters Eleven survivors whose work remained of intense interest among both local painters and collectors world-wide. He represented Canada at the *IX Bienal de São Paulo* in 1967, and showed regularly at Waddington Galleries in London, Eng., at the André Emmerich Galley in New York, at the new David

Jack Bush. Arabesque, 1975. Canvas, 223.5 × 294.5. Hirshhorn Museum, Washington, DC.

Mirvish Gallery in Toronto beginning in 1966, and in Montreal (Galerie Godard-Lefort until 1976, then Waddington Galleries), as well as in galleries in Vancouver, Boston, Los Angeles, and Zurich. There was a oneman show at the Boston Museum of Fine Arts in 1972, and a major retrospective of the post-Painters Eleven years organized by Terry Fenton for the AGO in 1976. Bush died part-way through its tour early in 1977.

Bush's work, though far from static, evolved slowly during this period of unprecedented success for a Canadian painter. Two closely related changes, however, gave his later paintings a distinctive appearance. Early in 1969 he introduced an autonomous shape on a broad coloured field that recalled his 'figure-ground' compositions of about a decade earlier. *Scoop* (Mrs Jack Bush, Toronto), of February 1969, is one of the earliest of these departures from the tightly abutted arrangements of coloured bands and bars that had attracted international attention in the midsixties, although the tendency—as we can see from *Lilac* (Mr and Mrs David Mirvish, Toronto) of 1966—was always there. This renewed interest in figuration gained added impetus in April when an attack of angina suggested to him a kind of imagery—large, rapidly descending 'blips' of colour against an unmodulated field, as in *Sudden* (Michael Steiner, New York)—that heightened his expressive intent.

By the end of the year Bush had worked up the texture in his grounds, thereby enhancing the tension between them and the by now iconic figures embedded in them. The texture increased over the next years, achieved by dragging more-saturated pigment over the established ground. This resulted in a dense, rich field that often resembles large sheets of lusciously coloured linoleum. By 1975, with a painting like *Arabesque (The Hirshhorn Museum, Smithsonian Institution, Washington, D.C.), he was no longer working his ground systematically in a single direction, but brushing it freely into airy, cloud-like fields of indeterminate depth. The 'figures' had also become lighter, more lyrical, more painterly, caught in natural, rhythmic movement. During Bush's last years this openly lyrical intent was underlined by titles that relate to music, and by an increase in the size of his canvases-Salmon Concerto (AGO) of 1975, for instance, is over five metres long-that encouraged a sense of developing narrative incident. As we will see, these moves were followed closely by a new generation of painters in Toronto and contributed directly to a sustained interest in the evolving craft.

Although JOYCE WIELAND (see p. 300 ff.) and MICHAEL SNOW (see p. 299 ff.) moved to New York in 1962, they still exhibited in Toronto and maintained many other contacts until their return late in 1971. Snow was the sole Canadian representative at the XXXV Biennale di Venezia in 1970 and was given a retrospective at the AGO the same year. Wieland was featured in a large and imaginative solo exhibition at the NGC in 1971. Quilts became her principal static art form after she stopped painting in 1965, and she devoted much time to film-making-her consuming interest in the seventies, at least until the commercial release of her feature-length movie, The Far Shore, in 1976. By the end of the decade, however, she showed signs of renewed interest in painting. Snow, having gradually turned his painting into an extended sculptural piece, the Walking Woman Works (see p. 309), left off in 1965 to follow his growing interest in photorelated art and to give more time to film and music. Although a majorexhibition of his work-organized by the Centre Georges Pompidou in Paris in 1978 that toured to Lucerne, Rotterdam, Bonn, Munich, and Montreal the following year-included only photo-based work, sculpture, a sound piece, and film, Snow too began to show interest in painting again.

At least four of the other Isaacs Gallery artists who had dominated the painting scene in Toronto in the early sixties maintained significant, if intermittent, presences in the city as painters. In 1970 DENNIS BURTON (see p. 301) was hired as chairman of the Drawing and Painting Department at OCA (in the midst of the turmoil there), but a year later returned to The New School as director, a position he held until the summer of 1975,

when he received a Senior Canada Council Grant that afforded him a year of painting. (Gordon Rayner filled in as director.) He returned to The New School in 1976, but owing to financial difficulties there he broke away the following summer and with Rayner, Graham Coughtry, Robert Markle, and a handful of other artists started yet another school, Arts' Sake Inc. Then in the summer of 1979 he left Toronto to accept the position of artist-in-residence at the Emily Carr College of Art in Vancouver. He has taught there ever since.

In the late sixties Burton began keeping notebooks about everything that interested him, including art history and painting techniques. Using some of the images and ideas from these, often with extended texts, he made dense, elaborate collages, which after 1968 became his principal creative outlet. In 1971, however, he devised a strategy of mechanically transferring to canvas greatly enlarged, randomly selected sections of the marks left when he would quickly pull and turn a loaded watercolour brush on a piece of card to 'point' it. These calligraphic paintings, as he calls the often-imposing black-and-white abstractions, were shown at the Isaacs Gallery in November 1972. He was now working more on his notebooks than on painting, and his paintings over the next few years reflect his personal musings on issues of art history. Up-Tight News (Indusmin Limited, Toronto) of 1974, for instance, is based on an analysis of a close-up detail of the lower right-hand portion of Willem de Kooning's Gotham News, a painting in the collection of Buffalo's Albright-Knox Art Gallery that was an early touchstone of Abstract-Expressionism for artists of Burton's generation in Toronto (see p. 301). Other paintings at this time confront the influence of Robert Motherwell's work. These analytic abstractions were shown at the Isaacs Gallery in February 1976. His next show, three years later, featured large lettered paintings that are visually similar to some works of Greg Curnoe (whom Burton admires), but with a decidedly different 'voice'. Nearly exhausted by the struggle to keep first The New School and then Arts' Sake going while maintaining a presence as a practising artist, he later recalled, 'I didn't want to paint anymore.'

GRAHAM COUGHTRY's brilliant and critically acclaimed *Two Figure Series* exhibition of 1964 (see pp. 307–8) was succeeded two years later by a show at the Isaacs Gallery that extended some of the principles involved in the series but presented them in a radically different form. On large shaped canvases of two or more hinged elements, his figures were painted in simplified, flat forms of reduced colour in acrylic. Some critics liked them. Coughtry, finally, did not. The next year, after the death of his father, he travelled to Ibiza for a short rest and stayed for four years.

He did no painting but drew quite a bit, played music, and shot some film.

Back in Toronto in 1971, Coughtry found a studio on Spadina Ave in the same building he had inhabited before leaving for Ibiza. (The area had become a favoured artists' neighbourhood, with its cheap restaurants, Grossman's Tavern, Gwarztman's Art Supplies, and inexpensive, large, high-ceilinged spaces above the stores.) He started painting, in oils again, working from a film he had made in the summer of 1970 of the daughter of critic Barrie Hale playing in the surf of a secluded Mediterranean cove. From Polaroid snapshots of particular frames, taken on a film editor, he first developed images of a figure pulling up out of the water. In the later parts of this Water Figure series the figure is totally submerged, barely present beneath the surface. Filling the whole image, the surface is like a palpable picture plane; its constant, finally enveloping involvement with the figure could be an extended metaphor for the key figure-ground relationship central to formalist abstraction. The last paintings of the Water Figure series resemble the colour-field painting that was supported by formalist critics at the time. The series was shown at the Isaacs Gallery in 1973.

Coughtry has stated that his *Water Figure* canvases are predicated on the figure, whether it is evident to the viewer or not. A group of larger, more open colour-field paintings of 1973 addresses the water theme without a figure, but the next year he worked on another large canvas based on other footage shot in Ibiza. *Reclining Figure Moving No.* 25 (Gallery One, Toronto), which took nearly a year to complete, was shown with related studies in acrylic and pastel on paper at the Isaacs Gallery in June 1975. The model, rolling back and forth on a bed, was shot from a standing position at the foot of the bed. In the painting the field of activity is thus very shallow. Even though the picture-plane is stretched by the thrust of the lower legs of the figure, it is ultimately recognized. This clearly articulated visual arena becomes a metaphor for the boundaries to human activity that arise when imaginative striving confronts convention. The drawing and the brushed colour are brilliantly adept and sensuously involving.

In mid-February 1978—ironically on St Valentine's Day—Coughtry underwent open-heart surgery. By October he was in a new studio at King and Dufferin, again painting the figure. A show at the Isaacs Gallery in January 1980 was hailed, reconfirming the relevance of painting that exploits the full potential of its material nature while affirming its origins in the human condition.

There is little evidence that GORDON RAYNER (see p. 301 ff.) may have

suffered the insecurities that so many painters felt about the relevance of their work during the later sixties and seventies. A go-straight-aheadand-do-it sort of person who wears his sensibility on his sleeve, he became a useful role-model for younger painters because he enjoys making paintings, has a natural sense of colour, an easy grasp of form, and delights in the physicality of materials and in playing off surprising juxtapositions to bring out the best of both. Because he used staining with acrylics in the Magnetawan pictures of 1964–5 (see p. 306) he became interested in the similar technique of the American colour painter Morris Louis. A discussion with Jack Bush about Louis's recent work encouraged him to explore Clement Greenberg's theories, and led to a small number of Post-Painterly canvases. *Justa Juxta* (Art Gallery of Windsor) of 1968 is one of the best. Despite a distinct degree of elegance, it is a raw, emphatic, one-shot painting, like the earlier Magnetawan pictures.

In 1974, using materials at hand, Rayner began to make collages, mixed in with drawing and, later on, held together by expressive painting. These became his main occupation, between travel and some teaching, for the next four years. Often large, like Sky Sky Flood (Canada Council Art Bank, Ottawa) of 1976, they are not unlike the paintings before and after his Post-Painterly interlude of the late sixties that often include objects. A gift from Dennis Burton of a book on oriental carpets in 1978 got Rayner back to painting; the powerful traditional designs suggested a mental armature for spectacular painterly flights. Rayner's art is essentially of a whole, every picture reflecting his wide practical experience as a painter, his extensive travel and love of Eastern culture, and his absolute devotion to what he calls the 'jungle' on the Magnetawan River. All of this is strained through a sensibility that combines his interior 'environment' with the outer one and emerges, in his best paintings, in the most joyously sensuous painting that Toronto-and indeed Canada-has ever seen.

Even though JOHN MEREDITH (see p. 310) was only thirty-three when *Seeker* was first exhibited, it and his other paintings of the later sixties, such as **Ulysses* (VAG) of 1968, have a venerable air. These glittering, radiating images, despite their apparently hurried, smudged black lines and roughly blocked-in colour, represent weeks of close, detailed work. Meredith produces highly finished coloured ink studies on fine wove paper that are then painstakingly transferred to the larger canvas. Using a squared grid, he replicates every nuance of his dragged or smudged line, every variation in the density of the coloured inks. This results in a painting that appears spontaneous and expressive, yet that has been considered with obsessive care. Perhaps most remarkable is that the

John Meredith. Ulysses, 1968. Canvas, 182.9 × 243.8. VAG.

colour—a background of dark blue in *Ulysses*, with central rings of red and other patterned forms of yellow, purple, and burnt orange—is as balanced, brushy, and harmoniously arranged in the painting as in the ink drawing. The oils even have the appearance of ink-like translucency.

Meredith's emphasis on process and control made his painting seem increasingly pertinent in the seventies. In fact, in the works exhibited at the Isaacs Gallery in 1973 the apparent disparity between means and effect increased: they appear more hurried in execution, more expressive and spontaneously gestural than those of the late sixties. *Japan* (Canada Council Art Bank) of 1972—a huge triptych over seven metres wide looks as though its dense black washes were thrown on in a frenzy during a passing thunderstorm, yet every subtle twist and turn of the brush is evident in the original ink study. Meredith's next show, almost four years later in March 1977, presented work that openly emulates Oriental brushpainting; it suppresses his hitherto strong colour and recreates in large the delicate, ambling line of Eastern practice. Not only acts of determined will, but reflections of a special sensibility, these paintings manage in their quiet, solid way to be as monumentally heroic as the nobly hieratic

images that had brought Meredith to the front of the Toronto painting stage more than a decade earlier.

Along with Jack Bush, these four artists of the Isaacs Gallery who kept painting alive for themselves during the late sixties and seventies also kept it alive for others in Toronto. One other highly committed painter also contributed substantially to the sense that painting still offered possibilities for realizing a personal vision in a profoundly moving public way. GERSHON ISKOWITZ (see p. 310) gradually became a part of the progressive Toronto art scene during the early sixties, but when he began to show regularly with Gallery Moos—first in October 1964, and then virtually every February or March from 1966 to the end of his life—the consistently high quality of his painting attracted a following. A stint of teaching at The New School (1967–70) drew the attention of the younger artists, and during the seventies his Spadina Avenue studio was one of the important places for them to visit. He gained national recognition after representing Canada at the XXXVI Biennale di Venezia in 1972.

Iskowitz's art did not change much during this period. It could be argued that after satisfactorily disengaging colour and atmosphere from the representation of landscape elements, while maintaining the essence of an encompassing landscape experience, he had only to alter colours and their configuration in order to achieve a limitless variety of moods and feelings. But it was not quite that easy. A significant turning occurred in 1967 when, in works such as Autumn Landscape No. 6 (Toronto-Dominion Bank), he broke the streaming amalgam of colours that had evolved from earlier paintings of trees into a field of individual cotton-candy-like puffs of colour brushed sensitively into a light, slightly blushed ground (or exposed through it). They look a bit like an orchard viewed from directly overhead and, after the photographer John Reeves told Iskowitz that they reminded him of flying over northern Manitoba, he arranged a trip to Churchill, where he was taken up in a helicopter. It did look like his paintings. He was captivated by the experience of taking off—rushing up against and then over the land-and landing. These memories, reinforced occasionally by similar experiences in later years, were added to others that would affect his work.

Iskowitz worked only at night under artificial light, in oils, a laborious process. He would build up a picture slowly, applying a colour, then when it had dried applying another over it, leaving only parts of the previous layers exposed, thinly veiling others, or obscuring some parts entirely. In this way he achieved the richly dense yet often vaporous areas of colour seen in *†*Uplands H (AGO) of 1972, for instance, as well as the brilliant flashes of colour that float in, not on, the broader fields.

Uplands H, and the other ten paintings in that series, stand a bit apart from most of Iskowitz's work of the seventies in possessing a discrete shape of mainly one colour. But this is allowed to flow off two edges, and is ambiguous both in nature and in being thoroughly integrated materially into the fabric of the picture, thanks to his painting technique. Some other paintings have fairly broad areas of solid colour (though always with hints of other hues beneath); and in still others similarly coloured elements cluster into forms. But that is the extent of articulation Iskowitz pursued. In keeping the compositional structure so reduced, he clearly wanted colour—not in a disembodied sense, but colour as lovingly brushed paint—to be as free as possible to sing its glorious scale of stirring human emotions.

Though not every senior painter in Toronto during the late sixties and seventies was committed to an expressively colouristic, painterly abstraction, it was that distinctive Toronto development out of Abstract Expressionism that would most influence the painters of the next generation. RONALD BLOORE (see p. 280 ff.), who moved to Toronto in 1966 to teach at York University, pursued a contrary approach, working with white oils on masonite, creating images that resemble natural cellular structures by shaping the paint into delicate ridges—reliefs that he refined and polished by sanding. He first showed in Toronto at Dorothy Cameron's Here and Now Gallery in 1962, and again in 1965 (paintings of 1960 to 1965). In 1968 and throughout the seventies his austere, light-enlivened panels were shown regularly at the Jerrold Morris Gallery.

Some visionary figurative painters also achieved prominence during the period. LOUIS DE NIVERVILLE (b. 1933) was born in Andover, England, and raised in a large family in Ottawa and Montreal. (His father was a career officer in the RCAF.) Like Bloore, he showed with Dorothy Cameron until her conviction on obscenity charges-laid during Eros '65, a courageous and artistically impressive exhibition of Canadian erotic art she put together in 1965-forced her to close her gallery. Like Bloore, de Niverville then began showing with Jerrold Morris. Though virtually untrained, he quickly attracted attention with his somewhat awkward, colourful, naïve scenes of summery pleasures. He believes that he only 'really started to paint' in 1967, when he began to explore a range of painterly effects and, working with painted cut-outs to make large collages, discovered the resonance arising from the juxtaposition of apparently disjunctive forms in a dream-like, surrealist space. In 1972 he began working with an airbrush, which enhanced the ambiguous nature of his paintings. Like The Enclosure (AGO) of 1975, they are often large (almost three metres wide in this case), and their depiction of ostensibly innocent

pastoral scenes is rendered deeply menacing through skilled manipulation of light and shadow.

CHRISTIANE PFLUG (1936–72), who brought her troubled life to an abrupt end in the waters of Lake Ontario in April 1972, was, like de Niverville, virtually without formal art training. Born Christiane Schütt in Berlin, she went to Paris in 1953 to study fashion design, and there married a young medical student, Michael Pflug, in 1956; they moved to Tunis later that year. In 1959 Christiane immigrated to Canada to live with her mother. (Michael, who continued his medical studies in Paris, came to Toronto the following year.)

Pflug's first exhibition—drawings, mainly of dolls in various life-like poses—was at the Isaacs Gallery in 1962. Over the next two or three years she worked up canvases on the same theme—paintings, such as *Interior at Night* (CIL Collection) of 1965, of painstaking realism that were shown at the Isaacs in 1964. She subsequently concentrated on studies of family and friends, posed in or near her kitchen, that incorporate views through windows and doors. Her last paintings—views from her apartment window in different seasons—always include at least part of nearby Cottingham School. Deeply moving yet unsettling, Pflug's work reveals a fundamental alienation, despite its tendency towards the generalization and idealization of form. She once explained: 'I would like to reach a certain clarity, which does not exist in life.'

WILLIAM KURELEK (1922–77) also exhibited at the Isaacs Gallery during these years. Although he kept somewhat apart from the other artists of the gallery—where he worked as a framer until he was able to support himself from the sale of paintings—he enjoyed their respect. When he died he had the broadest public following of any contemporary artist in Canada. Kurelek was born at Whitford, Alberta, some 120 km. northeast of Edmonton, and raised from the age of seven on a farm at Stonewall, Manitoba, just north of Winnipeg. His Ukrainian parents did not understand his early desire to be an artist, and he enrolled at OCA in Toronto after having completed a BA at the University of Manitoba—against his father's wishes. Kurelek spent only one year at OCA (1949–50), then hitchhiked to Mexico to study at San Miguel de Allende. When that did not work out, he proposed to travel in Europe; but having raised enough money for the trip by 1952, he decided to go to London, both to study art and to seek treatment for his chronic fits of depression.

Kurelek spent seven years in England; he suffered a nervous breakdown, was hospitalized and subjected to electro-shock therapy, converted to Catholicism, and found his vocation as a painter, and as a Christian propagandist. His first show at the Isaacs Gallery in 1960 included work going back a decade: complicated, symbolic self-portraits, scenes of western farm-life from his youth, pictorial metaphors of mental anguish and self-doubt, illustrations of religious parables, and harsh, violent warnings of impending Armageddon—all painted in a highly detailed, sensitively but strongly coloured naïve naturalism that some viewers likened to the work of Bosch or Brueghel.

Kurelek's style did not change appreciably over the years following this début, but he was remarkably prolific, and expanded each of the above themes to encompass a range of subjects and interests. He would have preferred, he claimed, to paint only Christian pictures, but bowed to public pressure in creating long series of paintings on aspects of Canadian life in all regions of the country and among various ethnic groups. He became world-famous as an illustrator/author of children's books, an aspect of his career that was developed by May Cutler of Tundra Books, Montreal, in the early seventies. His work in this vein is always charming and often touching, particularly when emotion is conveyed through deeply felt landscape. But his deepest feelings went into the works of Christian propaganda, which invariably present unity of conception, forceful imagery, harsh but brilliant colour, and obsessive, personal detail that is disturbingly powerful. In the Autumn of Life (AGO) of 1964 shows, in close, objective detail, Kurelek's father's retirement farm near Hamilton, Ont., from an elevated point of view, with the whole family assembled in front of the house for a photo; on the far-distant horizon Hamilton is being destroyed by a nuclear bomb; in the foreground, across the road from the farm, Christ-being savaged by wild dogs-hangs on a cruciform tree, unnoticed by the family. Kurelek, who often posted written statements beside his paintings, explained that this work was 'a premonition of the disaster that will befall our materialistic society because it is so bent on pursuit of security and prestige, it ignores God. . . .' He died of cancer in 1977, having fitted a lifetime's worth of painting into only some twenty-five years.

An amazing number of artists entered the Toronto scene during the late sixties and early seventies. As elsewhere, most were attracted to alternative modes, but there were still many who found reason to commit themselves to painting (unlike artists in Vancouver or Montreal). Most of these new painters took their lead from the often painterly colour abstraction that then typified much advanced painting in Toronto. Eight who leaned more towards formalism than painterliness were linked with Jack Bush in an exhibition at the David Mirvish Gallery in January 1976 called simply *A Selection of Painting in Toronto*. None (other than Bush) had shown previously with Mirvish (four were actually 'borrowed' for

388 | The Death and Rebirth of Painting

the occasion from other Toronto dealers). The youngest in the show were ERIK GAMBLE (b.1950) and PAUL SLOGGETT (b.1950). Sloggett, from Campbellford, Ont., had graduated from OCA in 1973; Gamble, from Toronto, had studied at Central Tech and The New School of Art. HOWARD SIMKINS (b.1948), also from Toronto, who graduated from York University in 1972, was a relative newcomer too, though he already had a dealer, the Jared Sable Gallery. The other five were by then well established.

KATE GRAHAM (b.1913), who was close to Bush's age, had turned seriously to painting only in 1962. A friend of Bush, she had had her first commercial exhibition-paintings in homage to the American poet Emily Dickinson—at the Carmen Lamanna Gallery in 1967. Born Kathleen Margaret Howitt in Hamilton, Ont., she studied at the University of Toronto (BA, 1936), and soon after married Wallace Graham, a doctor. After his death she decided to commit herself to full-time painting. The Lamanna exhibition was followed by one at the Pollock Gallery in 1971 featuring work inspired by a trip that summer to Cape Dorset in the Eastern Arctic. Four more times before 1977 Graham visited Cape Dorset, where the spare topography and intense summer colours provided her principal inspiration during the decade, although the work of Bush and other colour painters shown at the Mirvish Gallery-in particular the earlier American landscape master Milton Avery (1855-1965)-were shaping influences as well. She had solo exhibitions at Pollock (again in 1973 and 1975), at Mirvish later in 1976, and at Klonaridis Inc. beginning in 1979. Her distinctive flowing lines of stained colour, formed into evocative symbols of recalled landscape elements, as in Algonauin Reflections (Westburne Industries, Montreal) of 1978, broadened the concept of abstraction based on landscape experiences explored by such painters as Gershon Iskowitz and Gordon Rayner.

Landscape and nature experiences underlie the art of PAUL FOURNIER (b.1939) as well. Born in Simcoe, Ont., he was raised in Hamilton and received his only painting instruction while a student at Central Secondary School there. His earliest work, shown at the Westdale Gallery in Hamilton in 1962 and at Toronto's Pollock Gallery the next year, usually involves a built-up figure or landscape form centred and shrouded in a dark atmospheric field. This emerging or forming central shape—similar to Tony Urquhart's paintings of the early sixties—occupied Fournier until about 1968, when the last vestiges of landscape had been eliminated from his stained canvases, and glorious, pervasive colour took over.

Fournier concentrated on colour through the seventies, first re-introducing texture (creating thick, crusted surfaces by mixing his acrylic with cellulose) and later figuration. His *Parrot Jungle* pictures of 1974–5 present brightly coloured bird shapes clustered on delicate pastel grounds, and his *Florida Mirrors* (1976–7), painted after a trip to Florida in 1975, play with the image of an elaborately framed mirror—with a table and objects in front of it—reflecting a landscape, a theme he explored in full consciousness of Matisse.

Fournier exhibited in the Mirvish show 'courtesy of the Pollock Gallery', where he had held eight shows between 1963 and 1974. He next exhibited solo at the David Mirvish Gallery in 1977, and after that gallery closed he signed up with Klonaridis Inc., where he first showed in 1979. (Alkis Klonaridis had been the manager of the David Mirvish Gallery.) Fournier's work of the late seventies differs from the *Florida Mirrors* in being more airy, 'brushy' in handling, and of far vaster scale. It suggests, as in *Azure Drift* (Westburne Industries, Montreal), huge clouds of colour surrounded by darting concentrations of pigment—not unlike a Baroque or Rococo room decoration. Romantically allusive, with a certain cosmic dimension, it is also an extravagant celebration, in the Toronto manner, of the pleasures of paint.

DANIEL SOLOMON (b.1945), who was born in Topeka, Kansas, and took his BFA at the University of Oregon (1963–7), arrived in Toronto in 1967. He first exhibited at the Isaacs Gallery in1971, and showed there again in 1973 and 1974. By the time of the Mirvish show in 1976 (to which he was 'lent' by Isaacs, although he was subsequently handled by Mirvish), Solomon was covering his large canvases with a field of saturated hue, articulated by clean-edged ribbons that variously frame or section the picture. Later he also acknowledged a more painterly concern in his pictures; but the large bars of juxtaposed hues in his work of the next year, such as *Oasis* (the artist), which though shaped like brushstrokes are flat and unmodulated, suggest a still-dominant adherence to Post-Painterly principles.

MILLY RISTVEDT-HANDEREK (b.1942) was born in Kimberley, B.C., and studied at the Vancouver School of Art (1960–4). Her first exhibition was at the Carmen Lamanna Gallery in 1968. She showed large, hard-edged colour paintings—like *Space Poem for Charles Olson* (AGO) of that year that relate in the symmetry of their structure to the painting of the American Frank Stella, but they also have an affinity with the 'colour bar' works of Jack Bush. At Lamanna again in 1969 she exhibited work that also relates to that of Bush, and again in 1970, after she had moved to Montreal.

In Montreal—where she shared a studio with the sculptor Henry Saxe— Ristvedt's work moved away from that of Bush, but still maintained a relationship to that of certain American colour - field painters, particularly Jules Olitski. Soon after moving back to the Toronto area in 1973, Ristvedt was articulating large fields of intense colour with a few straight lines, and by 1975 the fields assumed a more brushed appearance and the lines reflected gesture. *Strawberry Dreams* (Canada Council Art Bank) of 1975 displays a radiant field enlivened with two broad, scumbled swipes and seven glancing lines. In 1976 she moved to Tamworth, near Kingston, Ont., where her work evolved increasingly towards painterliness, revealing an evident love not only of colour but of paint's other seductive qualities.

DAVID BOLDUC (b.1945) was born in Toronto, attended OCA for one year (1962-3), and after painting on his own, studied for a year (1964-5) at the Montreal Museum of Fine Arts School under the Plasticien, Jean Goguen. Early in 1966 he began to break into the Montreal scene and participated in several group shows. But he returned to Toronto (he has maintained his Montreal connections), found a studio on Spadina Ave, and in November took a job in the conservation department of the Royal Ontario Museum. The Plasticien-influenced painting he did in Montreal-only Curve and Line No. 1 (MMFA) of 1966 seems to have survived—had by then been superseded by groupings of shaped canvases that while geometrical in plan have contoured surfaces that carry a simple geometric colour design across the assembled pieces. These were featured in his first oneman show at the Carmen Lamanna Gallery in 1967. Although the visual ambiguities of straight-line geometry on curved surfaces are fascinating in works like Variable Mix-up (NGC) of 1967, it is the forceful yet stillelegant colour relationships that are memorable. But Bolduc soon put colour aside, working first with minimal constructions of stretched white vinyl and then with simple structures made of rope, wood, and mirrors. Meanwhile a Canada Council Junior Grant of 1968 allowed him to quit his job at the Museum in the summer and travel with his wife in Europe, then on through Turkey overland to Nepal, returning home via Uzbekistan and Moscow eight months later. They travelled to Europe again in June-July 1970 and saw the great Matisse retrospective at the Grand Palais in Paris. Back home again, he returned to painting.

Responding to the current interest in formalist painting, heightened at that moment by the exhibitions of American colour-field painting featured at the newly enlarged David Mirvish Gallery, Bolduc established a distinct identity within the genre with works like *Mystic Rose* (AGO) of 1973. Their glorious colour an amalgam of usually two inter-worked hues, presenting a surface that is open and replete with painterly incident yet palpably material, they are commanding and cool, yet attentive to detail. Judicious peripheral markings of saturated colour—often pigment

David Bolduc. Wo, 1976. Canvas, 243.8 × 198.1. Concordia University, Montreal.

straight from the tube—strike minor chords that resonate subtly. In annual shows at Lamanna through 1975 a broadening technique could be observed as Bolduc explored methods of bringing a sense of particularity to each work. Colour was the main force, presenting a range of moods, never too dramatic nor too passive but always conveying a spe-

392 | The Death and Rebirth of Painting

cific nature. Like some of his contemporaries, he moved the markings at the edges about, sometimes into the field. Then in 1974 he began to make marks at the centre of the canvas, lines of intense hue—again, usually pigment directly from the tube—that form an image resembling a semaphore signal.

This sign functions like some ancient decorative device that still evokes the power of the image from which it has evolved, imparting to the whole painting the quality of an artefact that demands to be examined closely for meaning. As with a piece of ancient pottery or carpet, every aspect of these paintings seems to suggest a clue to their source. As though in response to this new dimension, Bolduc began to vary the treatment of the colour grounds to a much greater degree, often painting over earlier pictures to create more allusive fields for the arcane sign to inhabit. The sign itself assumed various forms, though it remained simple and purposeful, and, as in **Wo* (Concordia University, Montreal) of 1976, it was skilfully situated to bring the whole painting into play.

After the 1976 Mirvish show Bolduc left the Lamanna Gallery and exhibited the next year with Mirvish. (He went to Klonaridis when Mirvish closed.) While retaining in his paintings the basic format of richly worked ground and central form, he expanded it to an ever-greater variety of considered treatment. The sign might open like a fan, or suggest a plant form, or—as in Pablo's Theme (George Brady, Toronto) of 1977—a cubist construction. It could be a collage element; a piece of corrugated cardboard worked into the field with bead-like stitches of pure pigment, or a card quartered in alternating black and white like a surveyor's marker, planted majestically in a deep, vaporous ground. Landscape forms, lurking in some earlier pieces, now could be manifest, or a ground might be patterned with small crosses, suggesting an embroidered textile (Bolduc collects tribal carpets and related material), or be embellished with a shining grid or a fluid run of colour like a ceramic glaze. Like others in Toronto who had re-established a sense of continuity with Western painting's venerable history during the seventies, Bolduc found a working framework that situates his activity within a meaningful tradition-the making of decorative objects of commanding presence. The significant embellishing he practises and celebrates rises directly from the broadest cultural base—a fundamental human urge to enrich life by offering evidence of the particularly moving kind of pleasure conferred by the practised, skilful conjunction of hand and mind.

These artists featured in Mirvish's *Selection of Painting in Toronto* exhibition—most of whom subsequently joined the Mirvish 'stable'—were not the only new abstract colour painters of importance in the city, though

they cover most bases, and reflect particularly well the intuitive nature of such painting in Toronto. Bolduc, especially in the late seventies, intelligently focused many concerns that he shared with his colleagues, including some of the earlier generation, such as Gordon Rayner. A few others should be mentioned to suggest the range of activity in the area. Toronto-born ALEX CAMERON (b.1947) and PAUL HUTNER (b.1948) both studied at The New School, Cameron in 1967-70 and Hutner in 1967-9. Cameron, who was Jack Bush's studio assistant from 1972 to 1976, is notable for his use of evocative, often recognizable imagery in his large, lyrical abstractions, such as Wheels for Johnny Staccato (AGO) of 1976, with its prominent motorcycle wheel. Hutner, who worked part-time around the Mirvish Gallery, paints complex yet exuberant canvases of interlocking curvilinear forms (often like greatly enlarged silhouettes of draftsman's curves), overlaid with cursive script, the whole coloured in ways that obscure the literal forms, much as in casual note-pad doodling. This colouring is the dominant ordering device that marshalls potential chaos into often masterful broad waves of swelling movement.

JOSEPH DRAPELL (b.1940), born in Humpolec, Bohemia (now Czechoslovakia), slipped away while on a tour to Austria in 1965 and eventually sought refuge in Canada, settling in Halifax where he worked for an architectural firm and began to exhibit. He studied at Cranbrook Academy in Michigan (1968–70), where he met Jack Bush during a short residency there. After graduation he moved to Toronto, and the next year had exhibitions at both the Robert Elkon Gallery in New York and the Dunkelman Gallery in Toronto. Drapell's characteristic nature-inspired paintings of the later seventies present a large circular form of intense colour—almost electric blue in *Nation* (AGH) of 1976, for instance—that radiates beyond the confines of the canvas. The colour is fanned out with a special device, creating faint striations that suggest natural growth.

HAROLD KLUNDER (b.1943) was born at Deventer in The Netherlands but was brought to Canada as a child of eleven. He studied art at Central Tech in Toronto (1960–4), and worked for six years in commercial design before turning full-time to painting. Because his first commercial exhibition, with Jared Sable, was in 1976, he emerged on the scene near the end of the period under discussion. The thick impasto, urgent brushwork, and intense, expressionistic colour of his paintings—parts of which often resemble enlarged details of classic American Abstract Expressionism—presage events at the turn of the new decade. Within his savage surfaces are coloured bars that at a cursory glance seem to have been scattered like pick-up sticks, but on closer inspection show an intricate, geometric interrelationship.

394 | The Death and Rebirth of Painting

During this period Toronto also had abstract painters of the rigorously programmatic sort that were working elsewhere in Canada. Four came together in an exhibition at the AGO in June 1975, two of whom have since become prominent. RIC EVANS (b.1946) was born in Toronto and studied at Central Tech (1964–6) and then at OCA (1967–9). JAAN POLDAAS (b.1948), who was born in Kristjanstad, Sweden, studied architecture at the University of Toronto (1967–70). Both painters of sensitive control, they described their common interests in the catalogue of the 1975 show as 'reduced means, serial format, denial of illusion and illustration'. Their contributions to the exhibition were summarized as follows: 'Ric Evans paints 6" vertical bands of artist's oil colour on a ground of latex interior house paint, on canvases $3' \times 6'$.' 'Jaan Poldaas paints $4' \times 4'$ composition-board panels with house paint of system-prescribed colour.'

The most inventive of these programmatic painters appeared only in the second half of the decade. DAVID CRAVEN (b.1946) was born in London, Ont., and attended the University of Western Ontario (BA 1969). After studying at OCA in Toronto (1970-3), he first exhibited at the Jared Sable Gallery in 1975, with one-colour paintings that superficially resemble some of Ron Martin's of that time. Craven distributed an apparently given amount of paint evenly about the canvas in great looping arcs with a squeegee or some other pushing device that left a precise track of its progress. The paintings shown at Sable-Castelli (the gallery changed its name in 1976), in his second exhibition there in 1977, are also monochromatic and equally predetermined in form. Again Craven moved the paint with a device-here a paint-scraper with teeth-that left clear evidence of the direction of its movement and the pressure with which it was applied to the canvas. All of the movement of the paint relates to predetermined lines that were incised into it. The heaviest pressure, and therefore the thinnest coat, was applied within the crossing of lines near the centre of the canvas, producing an image of a lightly striated form's being suspended on taught strings. In some cases two canvases are joined to produce a larger piece, with a lighter shape at the centre of each canvas.

In 1978 Craven exhibited a group of pictures at Sable-Castelli in which painting was reduced to a preparatory mechanical step. After painting strips of canvas with shiny black enamel, he drew a tile-spreader across them while the paint was still wet, gouging a line to the bare canvas and leaving a ridge of paint beside each gouge. He then assembled a number of standard-size wooden sheets, cut a piece out of one corner as the first compositional move, and proceeded to complete the composition by gluing the strips of canvas to this support while joining the gouged lines in such a way as to create one continuous line. This composing—within

David Craven. Cincinatti, 1978. Canvas on panel, 244.2 × 305.1. AGO.

the most reduced range of options—was the principal 'creative' act. As can be seen in **Cincinatti* (AGO) of 1978, the need to stay within the bounds of the wooden support, and the creation of the jerky, patched-together line, necessitated the overlapping of the canvas. Although not apparent in photographic reproduction, the result is a wonderfully enlivened surface, criss-crossed with barely visible lines revealed dramatically, as one moves in front of the work, by shifting reflections on the shiny enamel paint. Though every decision in the making of these paintings is revealed to the attentive viewer, they are nevertheless confidently serene, manifestly complete.

Abstraction dominated Toronto painting in this decade, as it had in the sixties. But one painter achieved prominence early in the seventies with large, involving canvases painted from photo images; and another, in the second half of the decade, slowly built a reputation with personal, idiosyncratic image paintings that, as it turned out, led the way to new developments. JAMES B. (SANDY) SPENCER (b.1940) was born in Wolfville,

396 | The Death and Rebirth of Painting

N.S., and studied art history at Acadia University (1958-61). He moved to Toronto in 1962 to study at OCA, graduating in 1966. In 1971 he exhibited at the Jerrold Morris Gallery a group of large canvases of women in erotic poses, painted as faithfully and objectively as possible from photos in 'men's' magazines. These works hardly hinted at what would be revealed in his next show, at Hart House in December 1972: four huge paintings of waves breaking on beaches, again painted from photographs—a black-and-white in the case of Wave No. 1 (NGC), and coloured slides in Wave No. 2, No. 3, and No. 4 (all NGC). In the small Hart House Gallery they presented an intense, enclosing environment, but when viewed separately their real significance emerges. Their depiction of waves is incidental to their aesthetic force, which arises from the steady, even quality of Spencer's painting. Though faithful to the patterns of the photo-image, he was obliged by the scale of the paintings to deal with each part he worked on as if it were an abstract form. This demanded a concentration on the activity of painting that charges these huge objects with a human presence—the real 'meaning' of the works.

SHIRLEY WIITASALO (b.1949), who was born in Toronto and studied at OCA (1967-8), began her career exhibiting abstractions. Although evidently talented as a painter, and active on the scene (she is married to sculptor Robin Collyer), she began to attract critical attention only with an exhibition at the Carmen Lamanna Gallery in October 1974. This show, called My Nature, included some fairly large canvases (just under two metres on the longest side), each presenting a schematic image-leaves in one case, a map-like view of a lake in another—against a sensitively coloured ground. Wiitasalo continued to seek to convey through simple images what she has called the 'essential energy and strength' of all things in biennial exhibitions at the Carmen Lamanna Gallery-convinced that painting from personal attitudes would provide 'an indication toward a future'. This trust in the ability of direct images to convey meaning has not been misplaced. By the end of the decade Wiitasalo had achieved an impressive level of expression in her work while maintaining her commitment to the pursuit of personal significance. The result is an often witty and always convincing resolution that satisfies both public and personal needs. In *The Shortest Route (AGO) of 1978, for instance, the literal message is clear as we anticipate the playing out of the old saw's punchline ('... is often the longest way around'). Wiitasalo's painterly skills emphasize the sense of recklessly careering towards unanticipated disaster: the paint of the little cars, bright red on the right, blue on the left, is 'streaked' behind them to indicate speed; the road, brilliantly clear, is smoothly unimpeding; the lush, menacing green of the

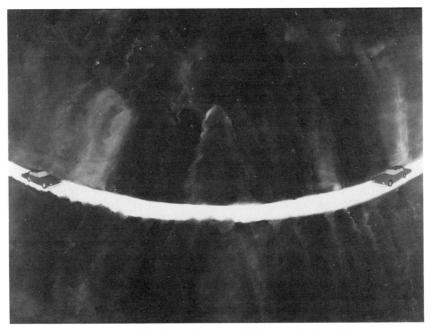

Shirley Wiitasalo. The Shortest Route, 1978. Canvas, 167.6 × 228.9. AGO.

precipitous landscape engulfs everything but the route to disaster; and a vile, purplish haze lingers near the cars, suggesting their inevitable doom. The painting incarnates high anxiety in a generalized image that is so diagrammatic and so skilfully painted that we understand it as the representation of an idea, not an incident. It presents anxiety for unanxious consideration. Wiitasalo's paintings are as rich, sensual, and allusive as any totally abstract work, but at the same time they convey ideas with a directness that is unequivocal.

Painting had survived the somewhat exaggerated rumours of its demise. It is evident, in retrospect, that it actually underwent renewal during this decade-and-a-half of intense debate about the proper forms and subjects for art. Not only did the leading senior painters in most cases find strength and conviction through a re-examination of the work of their early maturity, but painting as a whole was strengthened by the 'rediscovery' of the magnificent accomplishments of Henri Matisse and other seminal figures in the history of twentieth-century painting. In Toronto in particular—where painterly abstraction had established a strong base—

398 | The Death and Rebirth of Painting

many younger artists continued to be attracted to the discipline. The widespread theoretical debates that generally characterized the art of the period also engendered a new, distinctive approach to painting, based on clearly defined concepts and emphasizing process. Figurative painters who had matured in the mid-sixties were joined in the next decade by younger artists whose innovative, emblematic imagery opened yet further possibilities.

That all of this was a genuine manifestation of renewal would be confirmed in the early eighties with the rise in the major centres of yet another 'generation': the so-called Neo-Expressionists, committed to large-scale, painterly figuration. They would forge yet another link in a chain of tradition going back over three hundred years in Canada.

Acknowledgements

These acknowledgements constitute an extension of the copyright page.

JACK BUSH, Arabesque © 1988, reproduced with the permission of the Jack Bush Estate. Hirshhorn Museum and Sculpture Garden, Smithsonian Institution, Museum Purchase, 1976, photograph reproduced with permission of the Hirshhorn Museum and Sculpture Garden. Painting with Red © 1988 and The White Cross © 1988 are reproduced with permission of the Jack Bush Estate.

EMILY CARR, Potlatch Figure, Big Raven, Sky, Forest Landscape II are reproduced with the permission of the Vancouver Art Gallery.

JACK CHAMBERS, 401 Towards London No. 1, 1968–9. Art Gallery of Ontario, Toronto. Gift of Norcen Energy Resources Limited, 1986. Acc. no. 86/47.

PARASKEVA CLARK, Petroushka. National Gallery of Canada, Ottawa.

GRAHAM COUGHTRY, 2 Figures XII, 1963. Art Gallery of Ontario, Toronto. Gift of Reuben Wells Leonard Estate, 1964. Acc. no. 63/43. Reproduced by courtesy of the Isaacs Gallery, Toronto.

DAVID CRAVEN, *Cincinatti*, 1978. Art Gallery of Ontario, Toronto. Purchased with assistance from Wintario, 1978. Acc. no. 78/117.

GREG CURNOE, Family Painting No. 1—In Labour © Greg Curnoe 1988 'VIS*ART'. The Camouflaged Piano or French Roundels © Greg Curnoe 1988 'VIS*ART' and Corners © Greg Curnoe 1988 'VIS*ART', The National Gallery of Canada, Ottawa.

PATERSON EWEN, *The Great Wave: Homage to Hokusai*. Art Gallery of Windsor Collection. Purchased with the assistance of the Ontario Ministry of Culture and Recreation through Wintario, 1978. Photograph by Saltmarche, Toronto.

IVANEYRE, *Highwater*, 1978. Art Gallery of Ontario, Toronto. Gift of Norcen Energy Resources Limited, 1986. Acc. no. 86/52.

LE MOINE FITZGERALD, From an Upstairs Window, Winter. National Gallery of Canada, Ottawa.

JOHN FRASER, *Mount Baker from Stave River*. Collection of Glenbow Museum, Calgary, Alberta, Canada.

CHARLES GAGNON, *Cassation/Dark/Sombre*, 1976. Art Gallery of Ontario, Toronto. Purchased with assistance from Wintario, 1976. Acc. no. 78/128.

YVES GAUCHER, Le Cercle de Grande Réserve © Yves Gaucher 1988 'VIS*ART. Art Gallery of Ontario, Toronto. Gift from the McLean Foundation, 1966. Acc. no. 65/23.

JOHN HALL, Trogon. Mendel Art Gallery. Photograph by A.K. Photos, Saskatoon.

GERSHON ISKOWITZ, *Uplands H*, 1972. Art Gallery of Ontario, Toronto. Purchase 1977. Acc. no. 77/26. Photograph by Larry Ostrom, Art Gallery of Ontario.

JOSEPH LÉGARÉ, L'Incendie du quartier Saint-Jean à Quebec, c. 1840. Art Gallery of Ontario, Toronto. Purchase, 1976. Acc. no. 76/210. Photograph by Larry Ostrom, Art Gallery of Ontario.

400 | Acknowledgements

RON MARTIN, Lovedeath Deathlove No. 15. The National Gallery of Canada, Ottawa.

JOHN MEREDITH, Ulysses. Reproduced by courtesy of the Isaacs Gallery, Toronto.

DAVID MILNE, The Boulder, Carnival Dress, Dominion Square, Water Lilies and the Sunday Paper, White Poppy, Ollie Matson's House in Snow are reprinted under license of the David Milne Estate © 1988.

GUIDO MOLINARI, Angle Noir © Guido Molinari 1988 'VIS*ART'. Mutation Rythmique No. 9 © Guido Molinario 1988 'VIS*ART'.

MICHAEL MORRIS, *The Problem of Nothing*, Vancouver Art Gallery (66.19). Photograph by Jim Gorman/Vancouver Art Gallery.

CHRISTOPHER PRATT, Night Window, Mira Godard Gallery. Photograph by T.E. Moore.

GORDON RAYNER. Magnetawan No. 2, reproduced by courtesy of the Isaacs Gallery, Toronto.

J.-P. RIOPELLE, Abstraction © J.-P. Riopelle 1988 'VIS*ART'.

OTTO ROGERS, *Sunset Stillness*. Mendel Art Gallery, No. 67.9. Photograph by Creative Professional Photographers Ltd.

PHILIP SURREY, *The Crocodile*, 1940. Art Gallery of Ontario, Toronto. Collection Art Gallery of Ontario. Gift from the Albert H. Robson Memorial Subscription Fund, 1949. Acc. no. 48/35.

AURÈLE DE FOY SUZOR-CÔTÉ, Youth and Sunlight. National Gallery of Canada, Ottawa.

CLAUDE TOUSIGNANT, OEil de Boeuf © Claude Tousignant 1988 'VIS*ART'.

EH. VARLEY, *Dhârâna*, 1932. Art Gallery of Ontario, Toronto. Gift from the Albert H. Robson Memorial Subscription Fund, 1942. Reproduction courtesy Mrs Donald McKay/F.H. Varley Estate. *The Cloud, Red Mountain*, c. 1928. Art Gallery of Ontario, Toronto. Bequest of Charles S. Band, 1970. Reproduction courtesy Mrs Donald McKay/F.H. Varley Estate.

HORATIO WALKER, *Ploughing—The First Gleam at Dawn*. Musée du Québec. Photograph by Patrick Altman.

JOYCE WIELAND, Time Machine Series ${\ensuremath{\mathbb C}}$ Joyce Wieland 1988 'VIS*ART', Nature Mixes ${\ensuremath{\mathbb C}}$ Joyce Wieland 1988 'VIS*ART'.

SHIRLEY WIITASALO, *The Shortest Route*, 1978. Art Gallery of Ontario, Toronto. Purchased with assistance from Wintario, 1978. Acc. no. 78/19.

The publisher would also like to thank the following artists and other copyright holders for permission to reproduce their paintings: MARCELBARBEAU, RONALD BLOORE, DAVID BOLDUC, ESTATE OF PAUL-ÉMILE BORDUAS, DENNIS BURTON, ESTATE OF JACK CHAMBERS, ALEX COLVILLE, CHARLES COMFORT, DAVID CRAVEN, PATERSON EWEN, IVAN EYRE, ESTATE OF LEMOINE FITZGERALD, JOHN HALL, ESTATE OF LAWREN S. HARRIS, ESTATE OF EDWIN HOLGATE, JACQUES HURTUBISE, ESTATE OF GERSHON ISKOWITZ, ESTATE OF A.Y. JACKSON, ROY KIYOOKA, RON MARTIN, MICHAEL MORRIS, KAZUO NAKAMURA, ALFRED PELLAN, CHRISTOPHER PRATT, OTTO ROGERS, CARL SCHAEFER, JACK SHADBOLT, PHILIP SURREY, ESTATE OF F.H. VARLEY, SHIRLEY WIITASALO, TIM ZUCK.

There are a few copyright owners who have not been located after diligent inquiry. The publisher would be grateful for information enabling them to make suitable acknowledgement in future printings.

Index

Paintings given italicized page numbers are illustrated. Colour reproductions are indicated by Roman numerals.

- Abstract Expressionism, 232, 241, 251, 258, 260, 262, 264, 266, 268, 269, 270, 279, 280, 283, 297, 301, 305, 306, 380, 385, 393
- 'Abstracts at Home', Toronto (1953), 252, 253, 255
- Académie Colarossi, Paris, 104, 105, 158
- Académie Julian, Paris, 91, 94, 95, 98, 100, 104, 105, 120, 125, 129, 132, 133, 139, 157, 203, 213
- Académie Matisse, Paris, 203
- Académie Ranson, Paris, 219
- Accademia di Belle Arti, L', Rome, 362
- Alberta College of Art, 327, 354, 356, 361
- Albright School of Art, Buffalo, 312
- Albright-Knox Art Gallery, Buffalo, 301, 380
- Allan, George, 56, 58
- Alleyn, Edmund, 373
- American Abstract Artists, 257, 258, 260, 262, 263, 264
- American Scene painting, 164, 187, 199
- André Emmerich Gallery, New York, 298, 377
- Andrew Morris Gallery, New York, 280
- Anonymous: Mrs Charles Morrison, c.1825, 39
- Antoine's Art Gallery, Montreal, 241n.
- Arcade Gallery, London, Eng., 249
- Ariss, Herb, 312
- Armory Show, New York (1913), 159n., 171, 203
- Armstrong, William, 70–2; The Arrival of the Prince of Wales at Toronto, 71, 72; Thunder Cape, Lake Superior, 71, 72
- Arneson, Robert, 348

Arp, Hans, 198n.

- 'Art abstrait', Montreal (1959), 293, 294
- Art Association of Montreal (AAM) 34, 87, 105, 124, 126, 127, 129, 132, 191, 192, 207, 209, 213, 214, 215, 216, 220; Spring Show, 110, 115, 117, 143, 159n., 179, 203, 205, 206, 210, 211, 218
- Art Directors' Club, Toronto, 258
- Art Gallery of Ontario (AGO), 328, 376, 378, 379, 394
- Art Gallery of Toronto (AGT), 162, 188, 238, 239, 251, 251n., 254, 272
- Art Nouveau, 146
- Art Institute of Chicago, 208
- 'Art of Our Day', Montreal (1939), 212
- artscanada, 316
- Art Students' League, New York, 120, 164, 170, 181, 186, 188n., 209, 214, 276, 278, 285, 286
- Art Students' League, Toronto, 139, 181, 182, 184
- Arthur Tooth & Sons, London, Eng.: see Tooth Gallery
- Arts & Letters Club, Toronto, 139, 140, 142, 188
- Arts Club, Montreal, 209
- Arts' Sake, Toronto, 380
- Askevold, David, 344
- Association of National Non-Profit Artists Centres (ANNPAC), 317
- Atelier, Montreal, 208, 209, 211
- Ateliers d'Art Sacré, Paris, 216, 217
- Atkinson, William E., 125; Willows, Evening, 125

'Automatisme', Paris (1947), 231 Automatistes, 226, 230–2, 236–8, 257, 291, 291n., 292, 296, 299, 332, 374 Avery, Milton, 388 Ayot, Pierre, 373

'Baie Saint-Paul Primitives', 249n.

- Baillairgé, François, 30, 41
- Banff Centre, 277, 278, 284, 352, 354
- Banff School of Fine Arts: see Banff Centre
- Barbeau, Marcel, 226–7, 228, 232, 239, 240; Le Tumulte à la mâchoire crispée, 229, 231; Forêt vierge, 233
- Barbeau, Marius, 59, 62, 159, 160
- Barbizon school, 110, 119, 120, 126, 133, 203
- Barnes Foundation, Merion, Pa, 278, 279
- Barnett, Will, 278, 349
- Bassano, Jacopo, 7
- Bates, Maxwell, 277-8
- Battcock, Gregory, 316
- Bau-Xi Gallery, Vancouver, 362
- Baxter, Iain and Ingrid, 361
- Bayefsky, Aba, 248
- Bazin, Jules, 13
- Beal Technical School, London, Ont., 311, 312, 327, 328, 333, 338
- Beardy, Jackson, 361
- Beatty, William, 139–40, 141, 144; The Evening Cloud of the Northland, 140; A Dutch Peasant, 140
- Beau, Henri, 104
- Beaucourt, François Malepart de, 40; Portrait of a Black Slave, 40; Mme Trottier dite Desrivières, 40, 40
- Beaucour, Paul Mallepart de Grandmaison dit, 15; Ex-voto des trois naufragés de Lévis (attrib.), 17; Ex-voto de Notre-Dame de Liesse (attrib.), 17; Ex-voto de l'Aimable Marthe (attrib.), 17, 17
- Beausac, Countess Ingeborg de, 264
- Beaver Hall Group, 191-2
- Bécard de Granville, Charles, 10
- Beckmann, Max, 277, 358
- Bell, Clive, 133
- Bellefleur, Léon, 253, 291
- Bell-Smith, Frederic Marlett, 83
- Bell-Smith, John, 82-3
- Belzile, Louis, 290, 294
- Bennett, Arnold, 133

- Bercovitch, Aleksandre, 212, 213
- Berczy, William, 31, 34; Joseph Brant, 31, 32; The Woolsey Family, 31, V
- Berger, Jean, 13
- Bergeron, René, 236n.
- Bergman, Eric, 164
- Bernhardt, Sarah, 99
- Berthon, George Theodore, 35–7, 67; Bishop Strachan, 35; William Henry Boulton, 35; Chief Justice Sir John Beverley Robinson, 35; The Three Robinson Sisters, 36; Mrs Wm Boulton as a Bride, 36, 36
- Bethune, Dr Norman, 185, 213
- Bibliothèque Saint-Sulpice, Montreal, 117
- Biéler, André, 199, 208
- Bienal do São Paulo, Brazil (1951), 170; (1967), 377; (1969), 323
- Biennale di Venezia (1964), 376; (1966), 339; (1968), 367; (1970), 379; (1972), 325; (1976), 325; (1978), 331
- Biennial of Canadian Painting (1968), 333
- Bierstadt, Albert, 87
- Bignon Gallery, New York, 225
- Biloul, Louis, 214
- Binning, B.C., 170, 285, 286; Ships in Classical Calm, 285
- Bisttram, Emil, 201
- Blair, Robert, 293
- Blomfield, James, 157
- Bloore, Ronald, 279, 280, 281–3, 348, 385; Painting No. 1, 281; The Establishment, 281; Painting, June 1960, 281, 281
- Boas, Franciska, 228
- Bobak, Bruno, 287, 339
- Boisvert, Gilles, 373
- Bolduc, David, 390–3; *Curve and Line No.* 1, 390; *Variable Mix-up*, 390; *Mystic Rose*, 390; Wo, 391, 392; *Pablo's Theme*, 392
- Bolduc, Yvonne, 249n.
- Bonnard, Pierre, 300
- Bonnat, Léon, 95, 104
- Borduas, Paul-Émile, 118, 216–19, 221–5, 226–46, 249, 250, 251, 251n., 255, 260, 264, 269, 289, 290, 291, 291n., 292, 303n., 313; Autoportrait, 217; Maurice Gagnon, 217, 218; Adolescente, 218; La Femme à la Mandoline, 222, 223; Harpe brune, 224; Composition, 224, XXIX; La Danseuse jaune et la Bête, 225; 9.46 or L'Écossais redécouvrant l'Amérique, 228; Automatisme 1.47 (Sous le vent de

Index | 403

l'île), 231, 232, 238; Au paradis des châteaux en ruines, 238; Bleu, 238; Floraison massive, 238; Les Signes s'envolent, 239, 240; Figure aux oiseaux, 239; Forces étrangères, 241; Les Baguettes joyeuses, 241; Pulsation, 242, 242; Fond blanc, 243, 244; Goéland, 243; L'Étoile noire, 243, 244, 245, 245; Fence and Defence, 245, XXX

- Bornstein, Eli, 349, 350, 358
- Bosch, Hieronymous, 387
- Boston Museum of Fine Arts, 273-4, 378
- Botkin, Henry, 263
- Botticelli, Sandro, 341
- Bouchard, Mary, 249n.
- Bouchette, Joseph, 29; Kilbourn's Mill, Stanstead, Quebec, 30, 30
- Bouguereau, William, 92, 94, 99
- Bourassa, Napoléon, 49
- Bourget, Bishop, 81
- Bowman, James, 50-1, 59
- Boyle, John, 327; Seated Nude, 328; Midnight Oil: Ode to Tom Thomson, 328
- Bozak, Robert, 327
- Brakhage, Stan, 318
- Brandtner, Fritz, 166, 213
- Brant, Joseph, 31
- Breeze, Claude, 362, 364; Sunday Afternoon: From an Old American Photograph, 362
- Brekenmacher, Jean-Melchior: *see* François, Père
- Breton, André, 198n., 227, 231–2, 239
- Breughel, Pieter, 387
- Bridle, Augustus, 141
- Brigden's art firm, 164, 186, 214
- British Columbia College of Arts, Vancouver, 195–6, 197
- British Empire Exhibition, Wembley, Eng. (1924), 155
- Brittain, Miller, 276; Man and Woman, 276
- Brooker, Bertram, 155, 166, 170, 187–91, 198, 199; Sounds Assembling, 188, 189; Snow Fugue, 190; Piano! Piano!, 190; Torso, 190, 190; Blue Nude, 191; Entombment, 191
- Brooklyn Museum Art School, 277
- Brown, D.P., 338
- Brown, Eric, 160, 161, 162, 163, 179, 195
- Browne, Archibald, 125; Benediction, 125
- Brownell, Franklin, 125, 185, 186; *The Beach*, *St Kitts*, 125
- Bruce, William Blair, 99; La Joie des néréides, 99

- Brymner, William, 93–5, 99, 100, 105, 120, 121, 125, 127, 128, 129, 130, 132, 134, 136, 142, 143, 191, 192, 193, 206, 207; Two Girls Reading, 93, 94; A Wreath of Flowers, 94, 95; Early Moonrise in September, 126, 126; Evening, 126; The Coast of Louisbourg, 126
- Buchanan, Donald, 133, 210
- Budden, John, 62
- Bulkeley, Richard, 24
- Burchfield, Charles, 183, 336
- Burnett, David, 377
- Burnett, Hamilton, 65
- Burton, Dennis, 301, 303, 305, 374, 375, 397, 380, 382; Intimately Close-in, 301; The Game of Life, 305, 305; Up-Tight News, 380
- Bush, Jack, 254-5, 256, 260, 263, 266, 270, 283, 297, 298-9, 301, 313, 350, 376, 377-9, 382, 384, 387, 388, 389, 393; Village Procession, 254; The Old Tree, 255; Holiday, 260; Reflection, 260, 266; Theme Variation No. 2, 266; Painting with Red, 266; The White Cross (Spot on Red), 270, XXXII; Dazzle Red, 299; Scoop, 378; Lilac, 378; Sudden, 378; Arabesque, 378, 379; Salmon Concerto, 379

Cabanel, Alexandre, 92, 95, 103

Cage, John, 297

- Cahén, Oscar, 253–4, 255, 256, 258, 259; Vegetation, 254, 313; Painting on Olive Ground, 257, 258
- Calas, Nicolas, 316
- 'Calgary group', 277
- California Institute of Arts, 345
- Cameron, Alex, 393; Wheels for Johnny Staccato, 393
- Cameron, Dorothy, 272, 303, 385
- Canada House Gallery, London, 325
- Canadian Abstract Exhibition, Oshawa, 253
- Canadian Art: see artscanada, 316
- Canadian Art Club, 112, 123, 124, 125, 128, 129, 131, 132, 134, 135, 136–7, 138, 139, 140, 141, 142, 143, 144, 147, 149, 207
- Canadian Artists Representation (CAR), 320, 324
- Canadian Art Museum Directors' Association, 320
- Canadian Educational Museum, Toronto, 83, 99
- Canadian Group of Painters (CGP), 166, 178-

- 82, 190–2, 197, 199, 200, 211, 212, 213, 251n., 254, 260
- Cappello, Luigi, 114
- Carmen Lamanna Gallery, Toronto, 329, 331, 333, 362, 388, 389, 390, 391, 392, 397
- Carmichael, Frank, 142, 150, 155, 180; *Autumn Hillside*, 150
- Carnegie Institute, New York, 241
- CAR: see Canadian Artists Representation
- Carr, Alice, 157
- Carr, Emily, 156–63, 171, 194, 198, 207, 211, 285, 365; War Canoes, 157; Autumn in France, 158; Potlatch Figure, 158, 159; Big Raven, 160, 161; Forest, British Columbia, 161; Forest Landscape II, 162, XXII; Sky, 162; Cedar, 163
- Casson, A.J., 155, 177, 179; Golden October, 180
- Catlin, George, 51-2, 55
- Cauchon, Robert, 249n.
- Caughnawaga Museum, 6
- Centennial Exposition, Philadelphia (1876), 107, 123
- Central Ontario School of Art and Design, Toronto, 102
- Central Technical School, Toronto, 253, 255, 300, 388, 393, 394
- Centre Georges Pompidou, Paris, 379
- Cézanne, Paul, 135, 165, 209
- Chabert, Abbé Joseph, 104
- Chambers, Jack, 311–12, 317–20, 321, 323, 327; Messengers Juggling Seed, 311, 312; Olga and Mary Visiting, 312; Hart of London, The, 318; 401 Towards London No. 1, 318–19, 319; Sunday Morning No. 2, 320; Victoria Hospital, 323
- Champaigne, Philippe de, 43
- Champlain, Samuel de, 1
- Charlesworth, Hector, 147, 155
- Charon de la Barre, François, 11
- Chase, William Merritt, 120
- Chauchetière, Père Claude, 5
- Chenier, Richard, 352
- Cherry, Herman, 349
- Chester, Don, 348
- Children's Art Centre, Montreal, 213
- Cizek, Franz, 181
- Clapp, W.H., 130–1, 158; Morning in Spain, 130, 130
- Clark, John, 344
- Clark, Paraskeva, 184-5, 186, 247; The Pink

- *Cloud*, 185; *Self-portrait*, 185; *Petroushka*, 185, 185
- Clarke, Austin C., 303
- Clench, Harriet, 50, 57
- Cockburn, James, 22; Passenger Pigeon Net, St Anne's Lower Canada, 22; Quebec Market, 22, 23
- Cohen, Harold, 363
- Cohen, Leonard, 303
- Colarossi Academy: see Académie Colarossi
- Collège Notre-Dame, Montreal, 226
- Collège Sainte-Marie, Montreal, 237
- Collège Saint-Sulpice, Montreal, 217
- Colonial and Indian Exhibition, London (1886), 100, 109
- Colorado Springs Fine Art Center, Nevada, 349
- Colour-Field Painting, 316
- Columbia University, New York, 279
- Colville, Alex, 274–6, 338, 339, 340; Infantry Near Nijmegen, Holland, 274; Nude and Dummy, 274; Child and Dog, 275; Woman, Man and Boat, 276; Couple on Beach, 275, 276
- Comfort, Charles, 186–7, 249, 254; Prairie Road, 186; The Dreamer, 186, 187; Young Canadian, 186, 187; Tadoussac, 187; Lake Superior Village, 187; Pioneer Survival, 187
- Comingo, Joseph Brown, 26
- Conder, Charles, 132-3, 134
- Confederation Art Gallery, Charlottetown, 339
- Conger, W.S., 50
- Congrégation de Notre-Dame, Montreal, 11
- Conseil des Arts et Métiers, Montreal, 214
- Constable, John, 108, 109, 111
- Constant, Benjamin, 120
- Contemporary Art Society (CAS), 212-16,
 - 218-19, 221, 223, 225, 226, 235
- Cook, Nelson, 35
- Copley, John Singleton, 25
- Corbeil, Gilles, 114
- Corbeil, Maurice, 225
- Cormier, Bruno, 234
- Corot, Camille, 119
- Cosgrove, Stanley, 215–16, 218, 290; Madeleine, 215
- Coughtry, Graham, 299–300, 300n., 301–2, 303, 307, 314, 375, 380–1; Figure on a Bed, 300; Interior Twilight, 301–2; Corner Figure,

307; Two Figure Series XI, 307, 308, 380; Two Figure Series XIX, 307; Water Figure series,

- 381; Reclining Figure Moving No. 25, 381
- Courtauld Institute, University of London, 280
- Couturier, Père Marie-Alain, 217, 221, 225, 232
- Cowley, Reta, 284
- Cox, Kenyon, 120
- Craven, David, 394-5; Cincinatti, 395, 395
- Creative Gallery, New York, 255
- Cresswell, William, 68, 99; Landscape with Sheep, 68
- Crisp, Arthur, 171
- Crowley, Aleister, 133
- Cubism, 191, 220, 221, 254, 255, 256, 313
- Cullen, Maurice, 100, 126–9, 132, 133, 134, 142, 147, 206; The Mill Stream, Moret, 127; Logging in Winter, Beaupré, 127, 127, 133; Winter Evening, Québec, 128, 128
- Cunningham, Merce, 297
- Curnoe, Greg, 311, 312–14, 318, 320–7, 328, 332, 335, 380; Family Painting No. 1–In Labour, 313, 314; The Camouflaged Piano or French Roundels, 321, XXXV, 323; 24 Hourly Notes, 322; Weekly Notes, 322; Daily Notes, 322; Cityscape, 322; View of Victoria Hospital, First Series, 323; View of Victoria Hospital, Second Series, 323, 325; Nude No. 4, 325; Homage to van Dongen, 325; Corner, 325, 326, 335; 1 Iron, First Hole, Thames Valley G.C., with Delaunay Sky, 325; Homage to van Dongen (Sheila) No. 1, 326
- Cutler, May, 387
- Dada movement, 304, 304n., 305, 313, 314, 315, 321
- Dali, Salvador, 198n.
- Dallaire, Jean, 290
- Daly, Charles, 35
- Daly, Kathleen, 182
- Danby, Ken, 337; Fur and Bricks, 338; At the Crease, 338
- Darrah, Anne Clarke, 352
- Dault, Gary Michael, 377
- David, Jacques-Louis, 35
- David Mirvish Gallery, Toronto, 297, 353, 376, 378, 387, 388, 389, 390, 391, 393

- Davies, Thomas, 19; The Falls of Ste Anne, 20, II
- de Kooning, Willem, 239, 240, 2511., 301, 380; *Woman*, 240; *Gotham News*, 301, 380
- Delaunay, Robert, 325, 326
- Demuth, Charles, 165
- Denis, Maurice, 117, 216, 218
- De Niverville, Louis, 385; The Enclosure, 385
- Derain, André, 212
- de Repentigny, Rodolphe ('Jauran'), 290, 291
- Desjardins, Abbé Louis-Joseph, 42-3
- Desjardins, Abbé Philippe-Jean-Louis, 42-3
- Dessailliant de Richeterre, Michel, 13; *Ex*voto du capitaine Edouin (attrib.), 14; *Ex*voto de l'Ange-gardien (attrib.), 14, 15
- De Stijl, 291
- Desvallières, Georges, 216
- de Tonnancour, Jacques, 223, 235, 238, 2511., 268, 293, 299, 313
- Dewdney, Selwyn, 336
- Dominion Gallery, Montreal, 163, 211, 224, 242, 366
- Doon School of Fine Arts, Kitchener, 271
- Doyon, Charles, 223
- Drapell, Joseph, 393; Nation, 393
- Dreier, Katherine, 177n., 188
- Dresden Academy, 253
- Drury, Thomas, 50
- Dubois, Pierre, 217
- Dubuffet, Jean, 260–1
- Duchamp, Marcel, 171, 177n., 224, 232, 304, 304n., 324, 328
- Dufferin, Lord, 86, 87
- Dufy, Raoul, 212
- Duguay, Rodolphe, 207
- Dulongpré, Louis, 38–40; James McGill, 39, 39
- Dumouchel, Albert, 369
- Duncan, Douglas, 184, 238, 248-9, 258
- Duncan, James, 32–4, 60; Montreal from St Helen's Island, 33, 33; The Gavazzi Riot, Montreal, 33–4
- Duncanson, Robert, 81, 82, 87
- Dunkleman Gallery, Toronto, 376, 393
- Dunlap, William, 32
- Dunning, George, 299, 300n.
- Durand-Ruel Gallery, New York, 207
- Duval, Paul, 266, 267
- Dyonnet, Edmond, 254

Eagar, William, 27-8

Eakins, Thomas, 96, 99, 100, 125

Eastern Group, 212, 214 Eaton, Wyatt, 93; The Harvest Field, 93 Eaton's Art Gallery, Toronto, 251 Échourie, L', Montreal, 290, 293 École des Arts et Métiers, Sherbrooke, 216 École des Beaux-Arts, Montreal, 186, 208, 209, 213, 214, 215, 216, 223, 224, 226, 227, 228, 268, 289, 290, 292, 293, 362, 369, 374 École des Beaux-Arts, Paris, 91, 93, 98, 103, 104, 120, 127, 213, 219 École des Beaux-Arts, Quebec, 219, 232, 289 Ecole du Meuble, Montreal, 217, 224, 236, 289 Edinburgh International Festival, 322 Edmonton Art Gallery, 353; Hairy Hill Exhibition (1971), 353 Edson, Allan, 81-2; Mount Orford, Morning, 82, 82; Trout Stream in the Forest, 82 Église des Saints-Anges, Lachine, 217 Église du Saint-Enfant-Jésus, Montreal, 114 'Eight, The', New York (1908), 171 Elie, Robert, 238 Elkon, Robert, 298 Ellis, Dean, 364 Emily Carr College of Art, 365, 380 Emma Lake, 278, 279, 283, 284, 344, 349, 350, 352, 353, 358 Erickson, Arthur, 361 Ernst, Max, 198n. 'Espace 55', Montreal (1955), 291 'Espace Dynamique', Montreal (1960), 294 'Étapes du Vivant, Les', Montreal (1951), 238 Evans, Ric, 394 Ewen, Paterson, 291, 328, 331-6; Lifestream, 332-3; Diagram of a Multiple Personality, 332; Close Up, 332-3; Untitled (Blue Monochrome), 333; Traces Through Space, 333; Rain Triptych, 333; Artesian Well, 333; Thundercloud as Generator I, 333; Thunder Chain, 334; How Lightning Worked in 1925, 334; Rocks Moving in the Current of a Stream, 334; Solar Eclipse, 334; Eruptive Prominence, 334; Bandaged Man, 334; Portrait of Vincent, 334; The Great Wave: Homage to Hokusai, 334-5; 335; Moon Over Water, 336; Cloud Over Water, 336; Gibbous Moon, 336 Exhibition of Unaffiliated Artists, 251, 253

Exposition Internationale du Surréalisme,

Paris (1947), 232

- Eyre, Ivan, 358–60; Mythopoeic Prairie II, 358, 360; Black Women, 360; Manitou, 360; Touchwood Hills, 360; Valleyridge, 360; Highwater, 359, 360
- Fairley, Barker, 175, 247
- Falardeau, Antoine-Sébastien, 48
- Falk, Gathie, 364
- Fanshawe College, London, 327
- Fauteux, Roger, 226-7, 228
- Fauvism, 135, 136, 158, 171, 203, 205, 206, 220
- Favro, Murray, 327, 328, 333
- Fenton, Terry, 280, 353, 378
- Ferguson, Gerald, 344, 345
- Fergusson, John Duncan, 158
- Ferron, Marcelle, 232, 237; Yba, 232
- Field, Robert, 25–6, 28; Lieutenant Provo William Parry Wallis, 25, 26
- 'First Papers of Surrealism', New York (1942), 233
- Fischl, Eric, 344, 347
- Fischer Fine Art Gallery, London, 339
- Fisher, Brian, 362; Passage, 362
- FitzGerald, LeMoine, 155, 163–70, 186, 189– 91, 199, 214, 286, 357, 358; Late Fall, Manitoba, 163; Summer Afternoon, 164; Williamson's Garage, 164, 165; Doc Snider's House, 165, 165, 166; The Jar, 166, 167; Green Selfportrait, 167; Rocks, 167; The Little Plant, 168, 169; From an Upstairs Window, 169, 170; Green and Gold, 170
- Forest City Gallery, London, 324
- Forrestall, Tom, 276, 339
- Forster, J.W.L., 122
- Fortin, Marc-Aurèle, 207; Landscape at *Ahuntsic*, 208
- Forum Gallery, New York, 318
- Fournier, Paul, 388–9; Parrot Jungle, 388–9; Florida Mirrors, 389; Azure Drift, 389
- Fowler, Daniel, 68, 74–5; *The Wheelbarrow*, 74, 75; *Fallen Birch*, 75, X1
- Franchère, Joseph, 104
- Franck, Albert, 251, 253, 254, 256, 377
- François, Claude: see Luc, Frère
- François, Père (Jean-Melchior Brekenmacher), 14; Le Père Emmanuel Crespel (attrib.), 15
- Franquelin, Jean-Baptiste, 10

Index | 407

Fraser, Carol, 347

- Fraser, John, 69, 84, 85, 86, 87, 88–9, 90, 106– 7, 125; *A Shot in the Dawn, Lake Scugog,* 84, 85, 89–90; *Mount Baker from Stave River, at the Confluence with the Fraser on Line of CPR,* 89, XIII
- Free Art Studios (Imperial Academy of Fine Arts), Leningrad, 185
- French & Co. Galleries, New York, 279
- Friedrich, Carpar David, 80
- Fulford, Robert, 268, 270
- Furie, Sidney J., 300n.

Fusion des Arts, Montreal, 374

- Gadbois, Louise, 216, 218; Le Père Marie-Alain Couturier, 216
- Gagnon, Charles, 297, 372–3; Hommage à John Cage, 297; Cassation/Dark/Sombre, 372, 373
- Gagnon, Clarence, 129–30, 132, 143, 178, 207; Oxen Ploughing, 129; Les deux plages: Paramé et Saint Malo, 129; La Croix du chemin, l'automne, 129, 130; Village dans les Laurentides, 130
- Gagnon, Maurice, 211, 217, 222, 224
- Galerie Agnès Lefort, Montreal, 244, 318
- Galerie Denyse Delrue, 294
- Galerie du Luxembourg, Paris, 231
- Galerie du Siècle, Montreal, 332
- Galerie Godard-Lefort, Montreal, 378
- Galerie Jeanne Bucher, Paris, 219
- Galerie l'Actuelle, Montreal, 292, 293, 294n., 332
- Galerie L'Échange, Montreal, 369
- Galerie Maeght, Paris, 232
- Galerie Moos, Toronto, 337, 384
- Galerie Saint-Germain, Paris, 244
- Galerie Sherbrooke, Montreal, 367
- Gallery of Contemporary Art, Toronto, 243, 269, 303, 310
- Gamble, Eric, 388
- Gaucher, Yves, 369–71; En Homage à Webern, 369; Danses Carrées, 369; Le Cercle de Grande Reserve, 369, 370; Ragas, 369; Alaps, 369; Grey on Grey, 370, 371; Rouge/Blue/Vert, 371; Brun, Jaune et Rouge, 371; Deux Bleus, Deux Gris, 371; Jericho: An allusion to Barnett Newman, 371; Er-Rcha, 371

Gauguin, Paul, 92, 133 Gauvreau, Claude, 226-7, 230, 234, 241n., 332 Gauvreau, Pierre, 226, 227, 232, 236; Sans titre, 232 Gavin Henderson Galleries, Toronto, 254 Gérôme, Jean-Léon, 92, 93, 98, 120 Gibb, James, 62 Gibb, Phelan, 158 Gilbert, G.S., 35 Gilhooly, David, 348 Gill, Charles, 104 Glackens, William, 133 Glasgow Institute, 111 Glenbow-Alberta Institute (Glenbow Museum), 354 Glyde, H.G., 277, 352 Godwin, Ted, 280, 348 Goguen, Jean, 294, 390 Goldberg, Eric, 212, 213; Figures, 213 Gomez, Ric, 348 Gordon, Dave, 333 Gordon, Hortense, 255, 258-9, 262 Gorky, Arshile, 239 Gorman, Richard, 306, 374; Kiss Good-Bye, 307 Goupil Gallery, London, Eng., 110, 125 Graham, Kate, 388; Algonquin Reflections, 388 Grand Séminaire, Québec, 1 Grange Studio, Toronto, 181 Graphic Associates, Toronto, 299, 300, 300n., 302 Grasset, Eugène, 100 Green, Art, 344 Greenberg, Clement, 265, 266, 270, 283, 284, 298, 349, 353, 382 Greenshields, E.B., 120 Greenwich Gallery, Toronto, 300-1, 303, 312; see also Isaacs Gallery Greer, John, 347 Griffiths, James, 68, 69; Flowers, 69, 70 Grip Limited, Toronto, 142 Group of Seven, 60, 112, 123, 128, 138, 149-55, 156, 160, 161, 164, 166, 174, 175, 177, 178, 179, 180, 182, 186, 188, 189, 192, 197, 199, 201, 202, 212n., 254, 272, 273, 289 Guérin, Paulin, 45

- Guggenheim Fellowship, 166, 184, 248
- Guggenheim Museum, New York, 188n.

- Guyon, Abbé Jean, 9; La Mère Jeanne-Francoise Juchereau dite Saint-Ignace (attrib.), 9, 10
- Hague School, 119, 120, 124, 203
- Halifax Chess, Pencil and Brush Club, 24
- Hall, John, 354; Untitled Triptych, 354; Doll, 354; Rose Case, 356; Trogon, 355; 356
- Hall, Joice, 356; *Celebration Landscapes*, 356 Hals, Frans, 122
- Hambidge, Jay, 188n., 201
- Hamel, Eugène, 49
- Hamel, Théophile, 47–8, 51, 80, 91; Autoportrait (1837), 46, 47; Autoportrait (1846), 47; L'Abbé Edouard Faucher, 46, 48; Sir Allan MacNab, 48
- Hamilton Technical School, 253, 255
- Hammond, John, 273n.
- Handy, Arthur, 375
- Harding, J.D., 74
- Harper, Russell, 51, 58, 65, 72
- Harris, Lawren, 132, 138, 140, 141–2, 143, 144, 147, 149, 150, 151, 153, 154, 155, 160, 166, 170, 174, 177, 180, 181, 182, 191, 198, 199–201, 247, 273, 284–5, 285n.; Old Houses, Wellington Street, 139; The Drive, 140; Snow II, 147; Shacks, 149; Elevator Court, Halifax, 151; Lake Superior, 151, 152; Maligne Lake, Jasper Park, 152, 152, 153, 154; Mount Lefroy, 152; Winter Comes from the Arctic to the Temperate Zone, 201; Poise, 201; Involvement 2, 201; Composition I, 201, XXVI, 284; Mountain Spirit, 285; Nature Rhythm, 285
- Harris, Lawren P., 273-4, 341; Tank Advance, Italy, 274; Project, 274
- Harris, Robert, 95–6, 99, 100, 125; The Chorister, 95; The Fathers of Confederation, 96, 97; Sir Hugh Allan, 96, 97; Meeting of the School Trustees, 96; Harmony, 96, XIV
- Hart House (HH), Toronto, 184, 248, 251, 253, 254, 255, 262, 266, 300, 397
- Hartmann, Sadakichi, 124
- Harvie, Eric L., 354
- Haukaness, Lars, 277
- Hawthorne, Charles, 199
- Haynes, Doug, 352; Banzo's Last Stand, 352
- Head, Bruce, 357

- Heade, Martin Johnson, 86
- Healy, Julia Schmitt, 347
- Hébert, Adrien, 207
- Hébert, Louis-Philippe, 126
- Hedrick, Robert, 303, 306, 375
- Heer, Louis-Chrétien de, 40; *Mme Gabriel Cotté* (attrib.), 39, 40
- HENDERSON, JAMES, 278
- Henri, Robert, 122, 133
- Henry Morgan Galleries, Montreal, 208, 213, 221
- Here and Now Gallery, Toronto, 272, 303, 385
- Heriot, George, 20; Ruins of the Intendant's Palace, Quebec, 20; West View of Château-Richer, 20, 21
- Hermitage Theatre, Montreal, 233
- Heward, Prudence, 193–4, 213, 214; Girl on a Hill, 193; Dark Girl, 194, 194; Farmer's Daughter, 194
- Hewton, Randolph, 143, 191, 203, 214; Portrait of Audrey Buller, 192
- Hicks, Edward, 26
- Hind, Henry Youle, 72
- Hind, William G.R., 68, 72–4, 157; *The Game* of Bones, 72; X; Self-portrait, 73, 73
- Hitchcock, Alfred, 276
- Hodgkins, Frances, 158
- Hodgsen, John, 100
- Hodgson, Tom, 255, 258, 268; Red Lanterns, 258; This is a Forest, 258
- Hofmann, Hans, 199, 239, 251, 253, 255, 258, 260, 265, 287
- Hokusai, Katsushika, 334
- Holgate, Edwin, 155, 177, 192, 193, 207, 208, 215, 216, 289;*Nude*, 192, *193*
- Hope, William R., 131
- Hôpital-Général, Montreal, 11
- Hôpital-Général, Québec, 7, 13
- Hopper, Edward, 341
- Hôtel-Dieu, Québec, 14
- House of Hambourg, Toronto, 301, 303
- Housser, Fred, 178, 181, 200
- Housser, Yvonne McKague, 180–1, 200; Cobalt, 181
- Howard, John G., 34
- Hudson River School of Painting, 107
- Hughes, E.J., 366
- Humphrey, Jack, 198–9, 212, 214, 276; Draped Head, 199, 200

Huot, Charles, 103, 114; Le Premier parlement de Québec, 103; La Bataille des Plaines d'Abraham, 103, 103

- Hurley, Robert Newton, 284
- Hurtubise, Jacques, 296, 297, 371-2

Hutner, Paul, 393

- Impressionism, 125, 127, 130, 131, 137, 145, 206; Impressionists, 102, 119
- Indépendants, Les, Quebec and Montreal (1941), 221
- Inness, George, 107
- Institut Canadien, 81
- Instituto Allende, Mexico, 279, 354, 355, 358, 386
- Institute of Fine Arts, New York University, 280
- Intermedia, Vancouver, 361
- International Society of Sculptors, Painters and 'Gravers, 120, 135
- Isaacs, Avrom, 268, 303
- Isaacs Gallery, Toronto, 301, 303, 304, 305, 306, 307, 314, 317, 375, 379, 380, 383, 384, 386, 389; Mixed Media Ensemble, 375
- Iskowitz, Gershon, 310, 384–5, 388; Summer Sound, 310; Autumn Landscape No. 6, 384; Uplands H, 384–5, XXXVI
- Jackson, A.Y., 60, 105, 115, 132, 142, 143, 144, 145, 146, 147, 149, 150, 153–4, 155, 160, 175, 177, 179, 180, 181, 182, 191, 194, 204, 207, 211n., 247, 277; The Edge of the Maple Wood, 142; Terre Sauvage, 143, 144; Frozen Lake, Early Spring, Algonquin Park, 145, XX, 146; The Red Maple, 145, 146; First Snow, Algoma, 150; Winter Road, Quebec, 151; Early Spring, Quebec, 153; Laurentian Hills, Early Spring, 154, 154; Entrance to Halifax Harbour, 155; Algoma, November, 179, 180; Alberta Foothills, 179

Jackson, Henry, 60

- Jacobi, Otto, 78–9, 81, 82, 83, 87; The Splügen Pass, 78; The Falls of Ste Anne, Quebec, 78, 79
- Jacquier dit Leblond, Jean, 14; Marie Madeleine repentante, 14; Madone tenant son enfant, 14
- Janvier, Alex, 361

Jared Sable Gallery, Toronto: see Sable-Castelli Gallery

Jarvis, Alan, 269

- Jarvis, Donald, 286, 363
- Jefferys, C.W., 139, 140, 188n.
- Jérôme, Frère, 226
- Jérôme, Jean-Paul, 290
- Jerrold Morris Gallery, Toronto, 298, 385, 396
- Johnson Art Galleries, Montreal, 206
- Johnston, Frank, 142, 147, 149, 150, 160, 164, 165, 177, 186
- Jones, Brian, 327
- Jones, W.H., 27
- Jonson, Raymond, 201
- Jordon Gallery, Toronto, 270
- Judd, Donald, 349
- Judson, William Lees, 96
- Julian's: see Académie Julian
- Julien, Simon, 41
- Juneau, Denis, 294
- Kandinsky, Wassily, 177n., 212, 188, 188n., 198, 201, 274
- Kane, Paul, 35, 37, 50–60, 67, 72, 73, 89, 157; Indian Encampment on Lake Huron, 52, 53; The Falls on the Upper Pelouse River, 54, 54; White Mud Portage, 55, 56; The Man That Always Rides, 56, VIII; Mah-Min or 'The Feather', 56, 57; The Death of Big Snake, 57
- Kasemets, Udo, 375
- Kennedy, Garry Neill, 344, 345
- Kenderdine, Augustus, 278
- Kensett, John F., 86
- Kepes, Gyorgy, 181
- Kernerman, Barry, 303
- Kerr, Illingworth, 354
- Kerr-Lawson, James, 132, 135
- Keszthelyi, A.S., 163
- King, William Lyon Mackenzie, 112
- Kitchener-Waterloo Art Gallery, 268
- Kiyooka, Roy, 279, 280, 288–9, 289n., 348,
 - 362, 363; Barometer No. 2, 288, 288
- Klee, Paul, 300
- Kline, Franz, 264, 265
- Klonaridis Inc., Toronto, 388, 389
- Klunder, Harold, 393
- Knowles, Dorothy, 284, 349
- Kokoschka, Oskar, 310
- Kootz, Samuel, 264

- Kootz Gallery, New York, 264, 268, 269, 297
- Krieghoff, Cornelius, 23–4, 33, 36, 58–66, 80; The Ice Bridge at Longueuil, 60, 61; Winter Landscape, 61; Montmorency Falls in Winter, 62; Self-portrait, 63, 63; After the Ball, chez Jolifou, 63; Owl's Head, Lake Memphremagog, 64, IX; Coming Storm at the Portage, 64, 64; Merrymaking, 64, 65; The Blacksmith Shop, 66

Krieghoff, Émilie, 59, 61

- Krieghoff, Emily, 61
- Kubota, Nobuo, 303
- Künsthalle, Düsseldorf, 339
- Kurelek, William, 386–7; In the Autumn of Life, 387
- Laing Galleries, Toronto, 269, 270, 301
- Lane, Fitz Hugh, 86
- Larose, Ludger, 104, 207
- Latitude 53 Gallery, Edmonton, 353
- Laurencin, Marie, 212
- Laurens, Jean-Paul, 95, 105, 120, 203
- Laval, Bishop, 7
- Lawson, Ernest, 132, 138
- Le Ber, Pierre, 11–12; Marguerite Bourgeoys (attrib.), 11, 12
- Leduc, Fernand, 226–7, 228, 229, 231, 232, 240, 291, 291n., 292, 296; Dernière campagne de Napoléon, 229, 230; Noeud papillon, 291
- Leduc, Ozias, 106, 113–18, 207, 216, 217; Les Trois Pommes, 114, 115; L'Enfant au pain, 114, 115, XVII; Mon portrait, 115, 116; Pommes vertes, 117; Fin de journée (Les Portes de fer), 117, 118; Paysage de neige, 117
- Lee-Nova, Gary, 362, 363, 364; Menthol Filter Kings, 362
- Lefebvre, Jules, 98, 104
- Légaré, Joseph, 24, 43–5; Paysage au monument Wolfe, 43; George IV, 44; Cascades de la Rivière Saint-Charles à Jeune Lorette, 44, 44; L'Incendie du quartier Saint-Jean à Québec, vue vers l'ouest, 45, VI; Les Ruines après l'incendie du Faubourg Saint-Roch, 45
- Léger, Fernand, 225, 226, 227
- Legros, Alphonse, 95
- Leighton, A.C., 277
- Lemieux, Jean-Paul, 289; Lazarus, 289
- Letendre, Rita, 291
- Lewis, Glenn, 364

- Lewis, Wyndham, 191
- Lhote, André, 290
- Librarie Tranquille, Montreal, 290, 290n.
- Lindner, Ernest, 284, 349, 358, 362; Decay and Growth, 284
- Linnen, John, 35
- Lismer, Arthur, 142, 143, 145, 147, 150, 155, 160, 175, 178, 179, 180, 182, 331, 332; The Guide's Home, Algonquin, 145; A September Gale, Georgian Bay, 150
- Lochhead, Kenneth, 278, 279, 280, 283, 348, 350, 357; Dark Green Centre, 283
- Lockerby, Mabel, 192, 213
- London Art Gallery, 333, 340
- London Film Makers Co-op, 318
- London Public Library and Art Museum, 268, 313, 313n., 314
- Lorca Gallery, Madrid, 317
- Lortie, Gérard, 246
- Los Angeles County Museum of Art, 283
- Louis, Morris, 381
- Luc, Frère (Claude François), 3, 6, 9; La France apportant la foi aux Indiens de la Nouvelle-France (attrib.), 3–4, 6–9, 1; Assomption (1635), 7; Sainte-Famille, 7; Assomption (1671), 7, 8; Immaculée Conception, 8; Saint-Joachim et la Vierge Enfant, 8; La Vierge et l'enfant Jésus, 8; Jean Talon (attrib.), 9; Monseigneur de Laval (attrib.), 9; Sainte-Famille à la Huronne (attrib.), 9; Une Hospitalière soignant Notre Seigneur dans la personne d'une malade (attrib.), 9
- Lucie, François, 54
- Luke, Alexandra, 253, 255, 258–9, 262, 263 Lycée Pierre Corneille, Montreal, 241
- Lycee Fielle Comenie, Montreal, 24
- Lyman, John, 158, 159n., 202–8, 209, 211–12, 214, 216, 218–19, 225, 226, 247; A Brunette, 204; Profile of Corinne, 204, 205; Adventure in Ochre, 204; Floral Caprice, No. 2, 204; Nude Girl, Scherzo, 204; Wild Nature, Impromptu, 1st State, 204; Reading, 206, 206; Woman With a White Collar, 211, XXVIII

Mabie, Don, 353

- MacCallum, Dr James, 123, 140, 141-2, 143,
- 144, 145, 149, 150
- McCarthy, Pearl, 256
- McCloy, William Ashby, 357
- McCullough, Norah, 192

McCurry, H.O., 209, 212n.

- MacDonald, J.E.H., 139, 140, 141, 143, 144, 145, 147, 148, 149, 150, 151, 152–3, 154, 155, 181, 182; By the River, Early Spring, 140, 141; Tracks and Traffic, 140; Fine Weather, Georgian Bay, 142; The Tangled Garden, 147; Falls, Montreal River, 149; The Solemn Land, 149; Autumn in Algoma, 149; Sea Shore, Nova Scotia, 151; Mountain Snowfall, Lake Oesa, 153, 153
- Macdonald, Jock (J.W.G.), 195, 197–9, 249, 251, 253, 255, 260–2, 263, 264, 265, 266, 270– 2, 277, 278, 279, 285, 301, 306, 313, 354; Lytton Church, British Columbia, 197; Formative Colour Activity, 197; Fall, 198; Russian Fantasy, 249, 250; Obelisk, 261, 262, 265; White Bark, 262; Airy Journey, 265; North Wind, 265; Heroic Mould, 271; Fleeting Breath, 272; Earth Awakening, 272; Nature Evolving, 271, 272; All Things Prevail, 272
- MacDonald, Thoreau, 182
- McDougall, Clark, 336, 337
- MacEwen, Gwendolyn, 303
- McEwen, Jean, 291, 296–7, 372; Meutrière traversant le bleu, 296; Miroir sans image, 372; Les Jardins d'aube, 372; Jardin de givre, 372; Suite Parisienne, 372
- McFadden, David, 324
- McGill Faculty Club, Montreal, 211
- McInnes, Graham, 211
- McKague, Yvonne, 182; see also Housser, Yvonne McKague
- McKay, Arthur, 278, 279, 280, 281, 282–3, 348; Effulgent Image, 282, 283
- MacKenzie, Hugh, 338
- McLaughlin, Isabel, 182, 194; Tree, 182
- McLaughlin, R.S., 182
- MacLeod, Pegi Nichol, 186; Torso and Plants, 186
- McLuhan, Marshall, 191, 361
- McNairn, Ian, 287
- MacTavish, Newton, 128
- 'Magic Realists', 337
- Maillard, Charles, 228
- Maitland, Sir Peregrine, 27
- Malcolmson, Harry, 298
- Mâle, Émile, 117
- Manitou Arts Foundation, 337
- Marcel-Béronneau, 203
- March, Peter, 35

- Marie de l'Incarnation, 4
- Marlborough Fine Art Gallery, London, 339
- Markle, Robert, 303, 375, 380
- Marquet, Albert, 135
- Marsh, Mrs Leonard, 211
- Marsil, Tancrède, 231
- Martha Jackson Gallery, New York, 242–3, 244
- Martin, Ron, 328–31, 333, 394; Conclusions and Transfers, 329; World Paintings, 329; One-Colour Paintings, 329; Bright Red Paintings, 329; Water on Paper, 330; Black Paintings, 331; Lovedeath Deathlove No. 15, 330, 331; In Pursuit of the World, 331
- Martin, Thomas Mower, 68, 69, 106, 157; Summer Time, 69
- Massey, Vincent, 175, 195
- Massey Commission (the Royal Commission on National Development in the Arts, Letters and Sciences), 249
- Masson, Henri, 199
- 'Matière Chante, La', Montreal (1954), 241n.
- Matisse, Henri, 135, 171, 203, 205, 209, 212, 226, 353, 389, 390
- Matisse, Pierre, 227
- Matta, Roberto, 228
- Matthews, Marmaduke, 68, 69; Hermit Range, Rocky Mountains, 69
- Maugham, Somerset, 133
- Maurault, Olivier, 117, 216, 217
- Mazelow Gallery, Toronto, 298, 377
- Mead, Ray, 253, 255, 259, 292n.
- Mechanics' Institute: Halifax, 27, 27n.; Montreal, 29; Toronto, 35
- Médiart, Montreal, 374
- Mednikoff, Reuben, 199
- Meissonier, Ernest, 92, 94
- Mellors Gallery, Toronto, 175
- Memorial University, St John's, 339, 340
- Menard, René, 117
- Mendel Art Gallery, Saskatoon, 349
- Meredith John, 310, 382–4; Seeker, 310, 382; Ulysses, 382, 383; Japan, 383
- Meyer, Hoppner Francis, 35, 37
- Miller, Kenneth Hayes, 164
- Miller, Muriel, 110, 111
- Millet, Jean-François, 93, 119, 124
- Milman, Adolf, 192
- Milne, David, 170–6; Billboard (Columbus Circle), 171; The Boulder, 171, 172; Shell

Holes and Wire at the Old German Line, 172; Carnival Dress, Dominion Square, Montreal, 173, 173; Water Lilies and the Sunday Paper, 173, 174, 175; Young Poplars among Driftwood, 176; White Poppy, 176, XXIII; Ollie Matson's House in Snow, XXIV

Minimal Art, 316

Mira Godard Gallery, Montreal and Toronto, 339

Miró, Joan, 198n.

Modigliani, Amedeo, 212

- Moholy-Nagy, Laszlo, 181
- Molinari, Guido, 292, 293, 294, 332, 367–8, 369, 371; Emergence, 292; Angle noir, 292, 293; Equivalence, 294; Hommage à Jauran, 296; Mutation rythmique No. 9, 296, XXXIII; Dyad triptych, 367; Rectangular Opposition No. 2, 367; Homage to Barnett Newman, 367; Blue Triptych, 367; Trapeze, 367; Quantificateur series, 368, 371

Moll, Gilbert, 327

- Monastère des Ursulines, Québec, 3
- Mondrian, Piet, 177n., 188, 243, 245, 291
- Monet, Claude, 102
- Monpetit, Guy, 374
- Montreal Museum of Fine Arts, (MMFA), 34, 237, 238, 268, 291, 292, 299, 331, 348, 369, 390
- Montreal Society for the Encouragement of Science and Art, 43
- Montreal Society of Artists, 34
- Montross Gallery, New York, 124, 171
- Monument National, Montreal, 207
- Moore, Henry, 285
- Moppett, Ron, 355; Rose Case, 355
- Moreau, Gustave, 203
- Morgan, Cleveland, 209
- Morgan, James, 129, 203
- Morgan-Powell, S., 205

Morgan's: see Henry Morgan Galleries

- Morisset, Gérard, 2, 9, 11, 13, 15, 222
- Morrice, James Wilson, 105, 121, 125, 127, 128, 129, 132–6, 138, 158, 202, 203, 205, 209, 211, 219; Prow of a Gondola, Venice, 133; Return from School, 133, XIX; Quai des Grands-Augustins, 134; The Ferry, Quebec, 134, 134; Village Street, West Indies, 136, 136; Ice Bridge over the St Charles River, 203

Morris, Edmund, 120-1, 123, 125, 128, 132, 134, 135, 136; Girls in a Poppy Field, 120;

Indian Encampment on Prairie, 121; Cove Fields Quebec, 121

- Morris Gallery, Toronto, 376
- Morris, Kathleen, 193
- Morris, Maria, 27
- Morris, Michael, 363; The Problem of Nothing, 363, 363; Letterseries, 364
- Morrisseau, Norval, 336–7, 360, 361; Warrior with Thunderbirds, 337
- Morton, Douglas, 280, 348
- Motherwell, Robert, 239, 241, 251n., 380
- Mount Allison University, Sackville, N.B., 273; School of Art, 273, 274, 276, 335
- Mousseau, Jean-Paul, 226–7, 228, 232, 237, 291, 2911., 292, 332; Bataille moyenâgeuse, 232
- Mrs Charles Morrison (anon.), 38
- Muhlstock, Louis, 214, 248, 253; Sous Bois, 214
- Mulcaster, Wynona, 350, 361
- Munich Academy, 310
- Murillo, Bartolomé Esteban, 51
- Murray, Robert, 321
- Musée d'Art Contemporain, Montreal, 368
- Musée d'Art Moderne de Paris, 232
- Musée du Québec, 220, 237
- Musée National d'art moderne, Paris, 290
- Museum of Fine Arts School, Boston, 199
- Museum of Modern Art, New York, 241
- Nakamura, Kazuo, 252–3, 259, 262; *Waves,* 259, 260
- Nasgaard, Roald, 329
- National Academy of Design, New York, 199
- National Archives of Canada, 19
- National Arts Centre, Ottawa, 376
- National Film Board, 290, 300
- National Gallery of Canada (NGC), Ottawa, 86, 95, 100, 124, 140, 155, 160, 163, 179, 187, 197, 209, 212n., 219, 238, 240, 268, 270, 280, 329, 333, 340, 379
- National Museum, Ottawa, 159
- N.E. Thing Co., Vancouver, 361, 364
- Neilson, H. Ivan, 131
- 'Neo-Dada', Toronto (1961–2), 305, 314
- Neumann, Ernst, 209
- New Design Gallery, Vancouver, 362

New School of Art, Toronto, 375, 379, 380, 384, 388, 393

- Newman, Barnett, 278–9, 280, 294; Stations of the Cross, 280
- New Realism, 316
- Newton, Gilbert Stuart, 26
- Newton, Lilias Torrance, 192, 193; Portrait of Eric Brown, 192
- Nichols, Jack, 248; Sick Boy With Glass, 248
- Nicolas, Père Louis, 5, 8
- Nicolaides, Kimon, 184
- Nicoll, Marion, 277
- Nihilist Spasm Band, 314, 322, 324, 328
- Noland, Kenneth, 284, 298, 349
- Non-figurative Artists' Association of Montreal, 291, 296
- Norman Mackenzie Art Gallery (NMAG), Regina, 280, 280n., 353
- Northern Vocational School, Toronto, 274
- Notman, William, 81, 83, 84, 88
- Notman-Fraser photographic firm, 84, 106– 7, 123
- Notre-Dame-de-la-Recouvrance, 1
- Notre-Dame-de-Montréal, 104, 216
- Notre-Dame-de-Québec, 7
- Nouveaux Plasticiens, 294
- Nova Scotia College of Art and Design (NSCAD), 339, 343-8, 375
- O'Brien, Edward, 85
- O'Brien, John, 29; Halifax Harbour Sunset, 29, IV
- O'Brien, Lucius R., 69, 84–6, 90, 95, 106; Sunrise on the Saguenay, 86, 86; Kakabeka Falls, Kaministikwia River, 87, 88; A British Columbian Forest, 88, XII
- O'Connor, Roderic, 133
- Odjig, Daphne, 360-1
- Ogilvie, Will, 175, 184, 210
- Ohio State University, 344
- Ojibwa Cultural Foundation, 337
- Olitski, Jules, 284, 352, 353, 390
- Olson, Gary, 354
- Ondaatje, Kim, 320, 327
- Onley, Toni, 287, 365
- Ontario College of Art, Toronto (OCA), 153, 180, 181, 182, 187, 250, 254, 255, 256, 260, 272, 290, 299, 301, 303, 306, 310, 313, 325,

- 327, 337, 338, 344, 375, 379, 386, 388, 394, 397 Ontario Institute of Painters, 268 Ontario School of Art, Toronto, 99, 102 Ontario Society of Artists (OSA), Toronto, 69, 83, 84, 85, 95, 107, 115, 120, 123, 140, 142, 144, 147, 255, 256, 260 Optical Art, 316 Orozco, José Clemente, 216, 248 Osgoode Hall, Toronto, 35 Osler, Sir Edmund, 56, 123 Osmond, Dr H., 279n. Ostiguy, Jean-René, 117 Owens, John, 273n. Owens Art Gallery, Sackville, N.B., 273 Owens Art Institution, Saint John, 273 Ozenfant, Amédée, 285 Ozenfant Academy, London, 285
- Ozenfant School, New York, 349
- Pailthorpe, Dr Grace, 199
- Painters Eleven, 256–7, 260, 262–9, 272, 283, 292n., 297, 299, 301, 376, 377
- Palardy, Jean, 218, 289
- 'Paris Painters of Today', Washington (1939), 219
- Parizeau, Marcel, 213, 217, 220
- Park Gallery, Toronto, 266-8, 270, 303
- Parkyns, George Isham, 26
- Parma Gallery, New York, 332
- Parsons, Bruce, 344, 347

Parsons School of Design, New York, 297

- Pascin, Jules, 212
- Passedoit Gallery, New York, 239, 240–1, 241n., 249
- Peacock, Graham, 352
- Peel, Paul, 96, 98–9, 100, 311; *Devotion*, 98, 98; A Venetian Bather, 98, XV; After the Bath, 99
- 'Peintures surréalistes', Montreal (1942), 223
- Pellan, Alfred, 201, 219–22, 223, 224–5, 226, 227, 235, 289, 290, 291; Jeune Comédien, 220, 221, 223; La Fenêtre ouverte, 221, 221, 224; Le Couteau à pain, 222, 224; La Magie de la chaussure, 225; Quatre femmes, 225
- Pelletier, Gérard, 236
- Pemberton, Sophie, 157

Pennsylvania Academy of Fine Arts, Philadelphia, 96, 99, 100, 101, 278 Pepper, George, 182 Perehudoff, William, 349-50; Prairie No. 4, 350 Perron, Maurice, 236 Petit Séminaire, Québec, 9 Petrov-Vodkin, Kuzma, 185 Pfeifer, Bodo, 362 Pflug, Christiane, 386; Interior at Night, 386 Phillips, W.J., 164, 186, 357 Photographers Gallery, Saskatoon, 349 Picasso, Pablo, 209, 212, 226 Picture Loan Society, Toronto, 184, 238, 247, 248, 251, 251n., 253, 255, 258 Pierre Matisse Gallery, New York, 240 Pierron, Père Jean, 4, 9 Piers, Harry, 26 Piles, Roger de, 7 Plamondon, Antoine Sebastian, 24, 45-8, 91; Thomas Paud, 45; Soeur Saint-Alphonse, 47, VII; La Chasse aux tourtes, 46, 47; Autoportrait, 47 Plaskett, Joe, 278 Plasticiens, Les, 290-4, 2911., 390 Poldaas, Jan, 394 Pollock, Jackson, 239, 240–1, 251n., 262, 279, 280, 313, 370; Cathedral, 239 Pollock Gallery, Toronto, 328, 337, 388 Pommier, Abbé Hugues, 2-3, 9; Le Martyre des Pères Jésuites chez les Hurons (attrib.), 2; La Mère Marie-Catherine de Saint-Augustin (attrib.), 2, 2; La Mere Marie de l'Incarnation (attrib.), 2-3 Pop Art, 316, 362, 373 Porteous, Charles, 124 Post Impressionism, 171, 207 'Post Painterly Abstraction', Los Angeles (1964), 283 Poussin, Nicolas, 4, 6, 8, 56 Pratt, Christopher, 276, 339-43; Euclid Working, 340; Self-portrait, 340; Woman at a Dresser, 341; Night Window, 341, 342; March Night, 342; Me and Bride, 342-3; French Door, 342 Pratt, Mary, 340, 343; Eviscerated Chickens,

343; Cod Fillets on Tinfoil, 343

Precisionist painting, 165

Prendergast, Maurice, 132-3, 171

Prevost, Sir George, 25

Price, Uvedale, 19

Prince, Richard, 364

'Prisme d'yeux' group, 235, 238

Proctor, A. Phimister, 132

Professional Art Dealers' Association of Canada, 320

Provincial Institute of Technology and Art, Calgary, 199, 277, 278, 279, 354; see also Alberta College of Art

Professional Native Artists Inc., 360

Pyle, Howard, 139

Rabinowitch, David and Royden, 327, 333

Raddall, Thomas, 24

Raphael, 51

- Raphael, William, 78, 79–80, 81, 82, 84, 87; Behind Bonsecours Market, 79, 80
- Rauschenberg, Robert, 297, 304n.

Ray, Carl, 337, 361

Rayner, Gordon, 301, 303, 305, 306, 374, 375, 380, 381–2, 388, 393; Homage to the French Revolution, 305; Magnetawan No. 2, 306, 306; 382; Justa Juxta, 382; Sky Sky Flood, 382 Read, Herbert, 198–9

Read, Herbert, 190–9

Recollet Chapel, Québec, 7

Redfield, Edward, 122

Refus global, 234–7, 256, 290n., 332

Regina College, 278, 279, 280; School of Art, 278, 348, 362

'Regina Five', 280, 283, 284

Region Gallery, London, 324, 332

Reichert, Don, 358

Reid, Bill, 361

Reid, George, 69, 92, 95, 99–103, 104, 106, 120, 125, 139; Mortgaging the Homestead, 100, 101, 102; Forbidden Fruit, 101, 102; Vacant Lots, 102

Rembrandt van Ryn, 122

Renaud, Louise, 227

Reynolds, Sir Joshua, 25

Rho, Adolphe, 114

Richardson, T.M., 69

Riopelle, Jean-Paul, 226–7, 228, 231–2, 236, 240, 242, 249, 296; *Abstraction, 232, 233*; *Knight Watch*, 240

Ristvedt-Handerek, Milly, 389–90; Space Poem for Charles Olson, 389; Strawberry Dreams, 390

Rivera, Diego, 248 Riverside Museum, New York, 256 Robbe-Grillet, Alain, 322 Robert Elkon Gallery, New York, 393 Robert-Fleury, Tony, 94, 104 Roberts, Goodridge, 208-11, 212, 214, 331; Nude on Red Cloth, 209, 210, 210; Hills and River, Laurentians, 210; Nude, 211 Roberts Gallery, Toronto, 255, 256, 266, 272 Robertson, Bryan, 370 Robertson, Clive, 353 Robertson, Sarah, 193, 194; In the Nun's Garden, 193 Robertson Gallery, Ottawa, 256 Robillard, Yves, 374 Robinson, Albert, 143, 191 Robinson, Boardman, 164, 209 Rogers, Otto, 350-2; Sunset Stillness, 350-1, 351; Mondrian and the Prairie Landscape, 352 Ronald, William, 249, 250-3, 254, 255, 262-3, 264-5, 267, 268-9, 270, 297, 280, 300, 301, 303, 310, 375; In Dawn the Heart, 251, 252, 262; A Nearness and a Clearness, 262; Central Black, 263, 264, 265, 268; The Visitor, 268-9; Gypsy, 269, XXXI; Brandon: The Bleeding Hearts, 376; Sumiko, 376 Rosa, Salvator, 44 Rosenberg, Henry, 207 Ross, James, 110, 126 Rothenstein, William, 133 Rothko, Mark, 239, 251n., 265, 296, 350, 351, 370 Rousseau, Théodore, 119 Roussel, Claude, 339 Royal Academy of Fine Arts, Madrid, 312 Royal Canadian Academy of Arts (RCA), 69, 85, 95, 100, 107, 112, 115, 120, 126, 134, 155, 163, 187, 212, 254 Royal College of Art, South Kensington, 203 Royal Military Academy, Woolwich, 18, 20 Royal Ontario Museum (ROM), Toronto, 121, 390 Royal Society of Canada, 289, 290 Roy-Audy, Jean-Baptiste, 41; Portrait de l'Archiprêtre P. Fréchette, 41, 42 Rubens, Sir Peter Paul, 4 Ruptures inaugurales, 231 Ruskin, John, 119 Ryder, Albert Pinkham, 336 Ryerson, Egerton, 83, 107

Sable-Castelli Gallery, Toronto, 388, 393, 394 Sacré-Coeur Chapel, Notre-Dame-de-Montréal, 104 'Sagittaires, Les', 224, 225 Saint-Charles, Joseph, 100, 104 St Clair, Bruce, 338 St Pierre, Corinne, 205 Salon, Paris, 92, 94, 95, 100, 101, 104, 105, 119, 127, 203 Salon d'Automne, Paris, 130, 135, 136, 158, 219 Sandham, Henry, 83, 106; Beacon Light, Saint John, 83 San Francisco Museum of Art, 249 Sanouillet, Michel, 314 Sapp, Allen, 361 Sarto, Andrea del, 51 Saskatoon Arts Centre, 349 Sauvé, Paul, 236-7 Savage, Annie, 193 Sawyer, William, 60 Saxe, Henry, 389 Scarlett, Rolph, 188n. Schaefer, Carl, 175, 182-4, 186; Ontario Farmhouse, 183, XXV; Storm Over the Fields, Hanover, 183, 184; February Thaw, Norwich, Vermont, 184; Carrion Crow, 184 Schmela Gallery, Düsseldorf, 244 School of Design, Chicago, 181 School of Paris, 211, 212, 214 Schwitters, Kurt, 328 Scott, Adam Sherriff, 254 Scott, Charles H., 197 Scott, Gerald, 300 Scott, Marian, 213, 253, 292; Endocrinology, 213; Atom, Bone and Embryo, 213 Scott & Sons, W., 134, 206, 208, 211 Sears Vincent Price Gallery, Chicago, 377 Seath, Ethel, 213 Seidenberg, Savely, 184 Séminaire de Québec, 7 Seton, Ernest Thompson, 122 Shadbolt, Doris, 163, 288, 365, 366 Shadbolt, Jack, 278, 285-6, 361, 362, 363, 365-6; Presences after Fire, 286; Winter Theme No. 7, 286, 287; Little Bride, 365, 366 Shahn, Ben, 300 Sheeler, Charles, 165, 341 Sheldon-Williams, Inglis, 278 Shuebrook, Ron, 344

Shukhayev, Vasily, 185 Short, Richard, 19 Sidney Janis Gallery, New York, 240 Silcox, David, 377 Sime, John, 375 Simkins, Howard, 388 Simmins, Richard, 268 Simon, Lucien, 219 Simon Fraser University, 361, 364 Simpson, Sir George, 52, 53, 58 Slade School, London, 95, 352, 363, 364 Sloan, John, 209 Sloggett, Paul, 388 Smith, Gordon, 286, 365; Orchard, 286 Smith, Jori, 212, 214, 218, 289; La Petite Communiante, 214 Smith, Matthew, 203, 205 Smith, Richard, 363 Smyth, Hervey, 18-19; Six Views of the Most Remarkable Places of the Gulf and River St Lawrence, 19 Snow, Michael, 299–300, 302–3, 305, 308–10, 314, 321, 379; A Man with a Line, 300; Secret Shout, 302, 302; Lac Clair, 302; Beach-hcaeb, 309, XXXIV; Walking Woman, 379 Société Anonyme, 177, 188, 212 Société des artistes français, Paris, 92 Society of Artists and Amateurs of Toronto, 50 Society of Canadian Artists, 65, 81, 82, 83, 84 Society of Six, 131 Solomon, Daniel, 389; Oasis, 389 Sommerville, Martin, 60 Sorbonne, Paris, 290 Spencer, James B. (Sandy), 395-6; Wave No. 1; No. 2; No. 3; No. 4, 396 Spendlove, F. St George, 33 Sproule, Robert A., 32 Stedelijk Museum, Amsterdam, 246 Stella, Frank, 188, 298, 389 Stella, Joseph, 188 Stevenson, Macaulay, 125 Stouf, Jean-Baptiste, 41 Strathcona, Lord, 110 Stuart, Gilbert, 25 Studio Building, Toronto, 143, 179; group, 144, 147, 148, 247, 248 Sullivan, Françoise, 228, 234, 239, 332 Sures, Jack, 348

Surindépendants, 219

Surrealism, 198, 199, 220, 225, 227, 231–3, 236, 239, 241, 249, 250, 254, 255, 256, 313; Surrealists, 198n., 223, 224, 228–9, 239, 251n.

Surrey, Philip, 214, 221; The Crocodile, 215, 215

Sutherland, Graham, 254, 256

Suzor-Coté, Marc-Aurèle de Foy, 104, 115, 131, 147, 207; La Mort de Montcalm, 104; La Jeunesse en plein soleil, 104, 105; Settlement on the Hillside, 131, 131

Symbolism, 207, 216

Tagore, Rabindranath, 195

Talon, Jean, 1, 7

Tanabe, Takao, 286, 354

Tascona, Tony, 357

Tate Gallery, London, 155

Tazewell, S.O., 35

Technical Collegiate Institute, Saskatoon, 284

Tekakwitha, Kateri, 6

Teyssedre, Bernard, 226

Thauberger, David, 348

Thériault, Normand, 374

Thomson, Tom, 123, 142, 144, 147, 148–9, 174, 328, 377; Northern Lake, 144, 145; Moonlight, Early Evening, 144; Parry Sound Harbour, 145, 145; Northern River, 146; Autumn Foliage, 147, XX1; Petawawa Gorges, 148, 148; The West Wind, 148; The Jack Pine, 148

Tobey, Mark, 160

Todd, Robert Clow, 23, 48; The Ice Cone, Montmorency Falls, 23, III

Tomlin, Bradley Walker, 239, 251n.

Tonks, Henry, 213

Toogood, Wendy, 353-4

Tooth Gallery, London, 244, 269, 270

Toronto Art Museum, 137

Toronto Art Directors' Club, 258

Toronto Society of Arts, 59, 67

Toupin, Fernand, 290, 294

Tousignant, Claude, 292–6, 332, 368–9, 371; Les Asperges, 293; Verticales jaunes, 294; OEil de boeuf, 294, 295; Transformateur chromatique, 295; Duo 66, 368; Ovale series, 368; Diagonal series, 368; Le Blue et le noir, 368; Diptyches, 368; Non-lieu 4, 369

Town, Harold, 256, 258, 259, 265, 267, 269– 70, 297–8, 374, 376–7; Dead Boat Pond, 258, 269; Side Light, 270; Landscape, 270; Tyranny of the Corner—Glass of Fashion Set, 298; Great Divide, 298; Silent Lights, 377; Stretches, 377; Parks, 377; Snaps, 377; In Memory of Emilio de Junco, 377

Transcendental Painting Movement, 201

Trinity College School, Port Hope, Ont., 274 20/20 Gallery, London, 324, 333

Tyler, Parker, 264

- Université de Montréal, 290
- Université de Moncton, 339
- Université Laval, 1n., 43
- University of Alberta, 352
- University of British Columbia, 285, 286, 361, 365; see also Emily Carr College of Art
- University of Buffalo, 312, 344
- University of Manitoba, 357, 358
- University of New Brunswick, 339
- University of Regina, 277; see also Regina College
- University of Saskatchewan, Saskatoon, 278, 279, 279n., 284, 349
- University of Toronto, 280
- University of Western Ontario, London, 312, 324, 334
- Upper Canada Provincial Exhibition, 67, 68, 74, 75, 85
- Urquhart, Tony, 311, 312, 317, 320, 388; In Hiding, 312
- Utrillo, Maurice, 212
- Vale, Florence, 253, 256
- Valentine, William, 28–9; Reverend William Black, 28; Self-Portrait, 28
- Valentine's, New York, 211
- Valkenberg, R.F., 251
- Vancouver Art Gallery (VAG), 162, 197, 249, 364, 365, 370
- Vancouver School of Decorative and Applied Arts (Vancouver School of Art), 195, 197, 280, 285, 286, 288, 348, 361, 362, 365, 389
- Vanderpant, John, 195

Van Doesburg, Theo, 291

- van Dongen, Kees, 325, 326
- Van Gogh, Vincent, 92, 327
- Van Horne, Sir William, 88
- Varley, Fred, 142, 143, 145, 147, 150, 154, 155, 160, 177, 194–7, 198, 214, 248, 285; Stormy Weather, Georgian Bay, 150; Vincent Massey, 154; The Cloud, Red Mountain, 195, XXVII; Vera, 195–6; Dhârâna, 196, 196
- Varvarande, Robert, 300
- Vaudreuil, Marquis de, 12
- Véhicule Gallery, Montreal, 374
- Verner, Frederick Arthur, 69, 89–90; Indian Encampment at Sunset, 89, 89; The Upper Ottawa, 90, 90
- Viau, Guy, 227, 237
- Viau, Jacques, 227, 237
- Victoria School of Art & Design, Halifax, 147, 207; see also Nova Scotia College of Art and Design
- Villeneuve, Robert de, 10
- Vincent, Bernice, 327, 328
- Vogt, Adolphe, 78, 80, 81, 82, 87; Niagara Falls, 80, 81
- Vouet, Simon, 6
- Vuillard, Edouard, 171

Waddington Galleries, London, 377

- Wah-sa Gallery, Manitoulin Island, 360
- Walker, Byron (Sir Edmund), 124
- Walker, Horatio, 106, 121, 123–5, 126, 132, 136, 137, 171; Oxen Drinking, 124; Ploughing—The First Gleam at Dawn, 124, XVIII
- Wall, Jeff, 364
- Wallace, Ian, 364
- Warkov, Esther, 357; Madonna of the Golden Pears, 357
- Washington University, St Louis, Mo., 280
- Watson, Homer, 106–13, 114, 115, 117, 123, 124, 125, 126; The Death of Elaine, 107; Landscape with River, 107; Coming Storm in the Adirondacks, 107; The Pioneer Mill, 107, 110; The Stone Road, 108, 108; Before the Storm, 109, XVI; A Ravine Farm, 109, 110; Logcutting in the Woods, 110, 111; The Flood Gate, 111, 112
- Waugh, S.B., 35, 50-1
- Webber, Gordon, 181, 292, 293, 299; Skating in the Park, 181

Weber, Max, 209 Weissenbruck, Johannes, 120 Wentworth, Sir John, 25 Western Front, Vancouver, 361, 364 Westdale Gallery, Hamilton, 388 Western Ontario Exhibition (1965), 328 Westminister School of Art, London, Eng., 156 Weston, W.P., 197 Whale, Robert, 68, 75-7; General View of Hamilton, 75, 76; The Canada Southern Railway at Niagara, 76, 77 Whitechapel Gallery, London, 370 Whistler, James McNeil, 109, 119-20, 133, 207 Wieland, Joyce, 300, 303, 304, 308, 310, 379; Time Machine Series, 304, 304; Heart-on, 304; Nature Mixes, 309, 310 Wiitasalo, Shirley, 396-7; The Shortest Route, 396-7, 397 Wilde, Oscar, 108, 109 Wilkie, D.R., 123 Wilkin, Karen, 353 Will, John, 354 Williams, Dick, 357 Williams, Richard, 299, 300, 300n. Williamson, Curtis, 100, 121-3, 125, 126, 132, 133, 136, 307n.; Klaasje, 122; Fish Sheds, Newfoundland, 122, 122; Archibald Browne,

418 | Index

123

Willingdon Arts Competition, 193 Wilson, R. York, 254 Wilson, Richard, 75 Wilson, Robert 'Scottie', 248-9; The Bird Head-Dress, 248 Winnipeg Art Gallery (WAG), 164, 340, 357 Winnipeg School of Art, 164, 186, 214, 357, 358 Winter, William, 254 Winterhalter, Franz, 35 Wittenborn and Schultz Gallery, New York, 239 Women's Art Association, Toronto, 254 Wood, Grant, 187 Wood, W.J., 199 'Woodland' School, 337 Woolford, John Elliott, 26 Wychwood Park, Toronto, 69 Wyeth, Andrew, 338, 340

Yancey, Jimmy, 299 Yarwood, Walter, 256, 259, 265, 374; *The Lost Place*, 259 Youngs, Chris, 375

Zadkine, Ossip, 212 Zuck, Tim, 345–7; *Boat at Anchor*, 346, 347